BIG PICTURE, SMALL SCREEN

THE RELATIONS BETWEEN FILM AND TELEVISION

BIG PICTURE, SMALL SCREEN
THE RELATIONS BETWEEN FILM AND TELEVISION

Edited by

John Hill and Martin McLoone

Acamedia Research Monograph 16

UNIVERSITY *of* LUTON PRESS

British Library Cataloguing in Publication Data
A catalogue record for this book is available from the British Library

ISBN: 1 86020 005 2
ISSN: 0956-9057

Series Editor: Manuel Alvarado

Published by
John Libbey Media
Faculty of Humanities
University of Luton
75 Castle Street
Luton, Bedfordshire LU1 3AJ
England

CONTENTS

Acknowledgements

The editors would like to thank Carol Kyle, Mervyn McKay and Willie Norris for their help with the preparation of this book.

Stills appear courtesy of the BBC, Channel Four, S4C, BFI Stills, and Temple Films

The editors would also like to thank Alan Parker for kind permission to reprint his *Film on Four* cartoon which originally appeared in *Sight and Sound* in 1984.

1

Introduction

John Hill and Martin McLoone

I t seems clear that the film and television industries are now closer together than ever before. While, in the 1950s, it may have been regarded as the enemy of cinema, television (along with the new delivery systems of video, cable and satellite) has since become a major source of funding and revenue for the film industry and has effectively ensured the cinema's survival. In Europe, in particular, film production has become increasingly dependent upon television finance and, in Britain, television has more or less become the film industry. Television has also emerged as the most common site for watching films so that, while cinema attendances have declined in recent years, the viewing of films, on TV and video, is now more popular than ever.

It is these increasingly close relations between film and television which this volume seeks to investigate. What is the history of involvement between film and television in the US, Europe, Britain and Ireland? What are the sources of television finance for film and what are the consequences for the types of films made? Have filmmaking conventions changed as a result of television influence or have distinct film and television aesthetics survived? What are the experiences of practitioners working in both film and television? What is the relationship of film and television to cultural identities in Britain and Ireland and is co-operation between film and television particularly important for small countries such as Ireland, Scotland

and Wales? These are just some of the questions which the essays which follow address. In doing so, they attend to four separate but, nonetheless, inter-connected areas of enquiry: economics, aesthetics, technology and cultural address.

Economics

To a large extent, it has been economics which has fuelled whatever convergence there has been between film and television. As Peter Kramer shows in the book's opening chapter, Hollywood took an early financial interest in television and the hostility which characterized the relations between film and television in the 1950s was only a temporary interlude. The current drive towards the integration of film and television interests by media conglomerates is not therefore a new phenomenon but one with historical precedents. Indeed, what Kramer's discussion brings out quite vividly is the historically contingent nature of the relationship between film and television and the varied commercial and technological forms it has taken.

This variation is even more evident when the North American experience is contrasted with that of Europe. European television has been much less driven by commercial imperatives than its US counterpart and the co-operation between film and television which has occurred within European countries has more characteristically been linked to public service values. John Hill charts the historical evolution of these arrangements and shows how British television, in particular, has become the major source of support for British film production. A telling indication of the extent of this support was provided by the popular British film magazine *Empire's* guide to 'who's who' in the British film industry for 1995. Entrants were ranked in order of judged importance and top of the list was Michael Grade, Chief Executive of Channel Four. Also included in the top ten were David Aukin, Channel Four's Head of Drama, and Mark Shivas, Head of Films at the BBC.[1] It is therefore fitting that these central figures within the British film and television industry should also contribute to this volume. Michael Grade provides an assessment of Channel Four's past achievements and current problems, David Aukin wittily identifies the main planks of his commissioning policy for *Film on Four* and Mark Shivas reviews the record of the BBC. Although this dependence upon television by the film industry has sometimes been lamented for leading to too 'small' a cinema, it is nonetheless the kind of cinema which the economics of the international film industry make most feasible. A case study of Stephen Frears, whose career has straddled the film-television divide more than any other British director, suggests some of the virtues which a 'small' cinema can possess while an interview with Verity Lambert reviews some of the issues raised by working in both television and film. Both Stephen Frears and Verity Lambert, along with a number of other contributors to this

volume, participated in a forum on the relations between film and television at the University of Ulster in April 1994. It was the aim of that event that media academics and practitioners should be brought into productive dialogue. This is an ambition which has carried over into this book and explains the mix of scholarly discussion and 'working reports' which is a distinctive feature of what follows.

Aesthetics

The growing economic links between the film and television industries has also provoked discussion concerning the aesthetic consequences for film of its growing involvement with television. Feature films have historically provided a major source of programming for television and, as Paul Kerr indicates, television has itself used the cinema as a resource for specialist film programmes (just as cinema has exploited television for its opportunities for publicity). On the more general questions concerning the aesthetic relations between film and television, however, there is no ready agreement among the book's contributors. Charles Barr, for example, admires television's capacity to relay the 'live event' and feels that the passing of live television drama, as a result of an increasing use of videotape and film, represents something of a cultural loss. For in spite of television's undoubted versatility, Barr argues that the one characteristic that remains unique to broadcasting, and which distinguishes it from the cinema, is this ability to relay the live event in real time. It also offers considerable dramatic potential and it is this which has been lost in the move to a largely pre-recorded aesthetic.

Martin McLoone, on the other hand, argues that since, in the past, cinema was envisaged as a domestic form and television as a theatrical one, there is no essential difference between the two media. Rather, he follows Kramer in arguing that the manner in which they have been developed and adapted reflects the strategic and economic needs of the respective industries rather than the aesthetic potential or limitations of either. For too long in Britain, however, the assumption has been that television is *essentially* a 'live' medium, better suited as a relay of the immediate than as a medium of recorded entertainment. As a result, television drama in Britain developed according to an aesthetic more akin to the theatre, especially the naturalist stage, than to the cinema, as was the case in the US. The result has been to the detriment of television drama in Britain, severely limiting the aesthetic potential that a closer relationship with the cinema brings.

John Ellis, however, argues that cinema and television are actually moving further apart aesthetically, and this can be seen in the way in which the respective media use new digital technologies for very different purposes. Thus, cinema employs computer-generated special effects to create for the audience an impossible spectacle in an entirely believable way and

a totalizing narrative secure in the knowledge of its own eventual closure; television, as a medium of information and immediacy, grounded in a world of fact, attempts to predict an unknown narrative closure through endless speculation and analysis, using computer graphics to enhance its speculative approach. Ellis explores the nature of this divergence through an analysis of the Hollywood blockbuster, *Speed* (1994), in which television's characteristic modes are used as an element in the film's narrative. What emerges from this analysis is the proposition that the cinema, in terms of its narrational and representational conventions, is omniscient while television is ubiquitous and each has found its own distinctive aesthetic, secure in its difference from the other.

The difference in viewing experience is also central to the aesthetic debates about the cinema and television and is explored by Peter Kramer in his discussion of the 'lure of the big picture'. It is also an issue which Rod Stoneman addresses in his wide-ranging series of thoughts on the relations between film and TV. Thus, while cinema offers the focused social experience of high-definition, widescreen images, television reduces this to a small low-definition image, with vastly inferior sound, in the distracted environment of the home. In broadcast television, these problems are confounded by other indignities – constant interruptions for advertisements in commercial television; the 'trimming' of the films to meet television's more stringent censorship requirements and, perhaps worst of all for the cinéaste, the virtual re-making of the original film in the panning and scanning techniques that are required to fit the widescreen cinematic image into television's aspect ratio. At this point, the aesthetic debate slips into a consideration of technology.

Technology

As many of the contributors to the book argue, Hollywood's strategy of differentiating its product from that of the small screen depends on the development and exploitation of the big screen and the technologies of cinema exhibition. To some extent, though, this has built up problems for later when the films are released onto cable, video and television. It is ironic, then, that it was the film industry itself which later developed the technology which effectively 're-makes', through panning and scanning, the widescreen movie for television. As the importance of the theatrical life of a movie has declined in financial terms and the importance of its small screen life has grown, this problem of different screen ratios has, inevitably, become increasingly pressing for the film industry. There are two answers to the problem: to release the films onto video, cable and network television in a letterbox format or to take cognizance at the production stage of the fact that most people will see the finished film on the small screen and to shoot it accordingly. Because the industry believes that only the 'discriminating' film enthusiast is likely to tolerate the letterbox effect (which,

nonetheless, is becoming more common), it is the latter course which has been followed in the main. There is nothing 'essential' in the cinematic experience that requires the use of widescreen formats and its use, and its slow decline in recent years, are the result of the same kind of strategies and contingencies that have always dictated the development and use of the technologies of cinema. These strategies have invariably been dictated by economic rather than by purely aesthetic factors and if the economics of the film industry in the US requires that even the big-budget 'event' movies must take cognizance of the limitations of the small screen, they will invariably do so. Perhaps it is salutary to reflect, in this regard, that if the final budget for *Waterworld* (1995) is really the $200 million that has been speculated in the press, it is the small screen that will mostly decide whether or not the film goes into profit.

As Dan Fleming's essay makes clear there is nothing essential either in television's current inability to deal with the widescreen image or the sophisticated sound that now is central to the theatrical experience. The technology has existed for some time to provide widescreen television, with high definition images and good quality stereo sound. This will not be mass-produced until an economic imperative makes it inevitable. In the US, especially, this does not seem likely in the near future. After all, American television still operates on the relatively low-definition 525 lines, despite the rest of the world operating on 625. New digital and more sophisticated analogue technologies have created a multitude of possibilities for the development of the audiovisual industries worldwide. If Fleming is correct, then the direction that this will take will be dictated more by the economic ambitions of the global, integrated audiovisual industries than by any purely aesthetic or technological considerations. This will mean, in turn, that the role of national or indigenous industries in maintaining a sense of local culture will assume a particular significance.

Cultural Address

While there may be some disagreement among the contributors to this volume about the aesthetic consequences of the closer economic links between film and television, there is general consensus that the two industries in Europe must continue to co-operate if cultural diversity is to be celebrated and cultural contradictions explored. As McLoone argues, the European industries must learn to live with Hollywood if some sense of national culture is to be preserved and developed within the global audiovisual culture which American film and television now represents. This process is explained by John Hill and involves the strategic alliance of the film and television industries operating within a public service ethos and accommodated by the kind of enlightened state support schemes which have been a feature of many countries in Europe.

5

Far from being seen as rivals, therefore, the common theme of this volume is that the film and television industries in the US have always managed to forge strategic alliances in the face of economic and technological change. New such alliances are crucial to Europe today, and especially to its many diverse cultures, not only for the survival of film and television as industries, but also for their survival as an important and popular expression of national and cultural identity. As Andrea Calderwood, Head of Drama at BBC Scotland, indicates, the alliance between film and television in small countries such as Scotland has been particularly important not only in developing an industry but in cultivating a cinema grounded in local realities. Dave Berry pursues these arguments in the case of Wales while Robert Cooper, Head of Drama at BBC Northern Ireland, assesses the situation there. In comparison to other European countries, television in the Republic of Ireland has made only a modest contribution to filmmaking (and many of the successes of the past period, such as *My Left Foot* [1989] were financed by British television companies). Producer Ed Guiney, therefore, suggests one way in which the Irish broadcaster RTE might assist the development of new low budget Irish films. In doing so, he is making an argument which resurfaces at various points in the book and suggests that it is economically unrealistic for European cinema to compete head-on with Hollywood. From this point of view, an alliance between film and television may be seen to provide not only the most economically prudent form of cinema for European countries but also the one most likely to offer a culturally distinctive alternative to Hollywood's 'global' norm. However, as Hill's article makes clear, the relationship between film and television which has evolved in Europe has also depended upon political policies which have rendered it financially practicable. Thus, despite the drive towards increased deregulation and competitiveness in the media industries, many contributors identify a continuing commitment to the principle of public service broadcasting as central to the maintenance of a worthwhile film and television culture. As John Caughie argues, the importance of a national cinema or a national television is that it should not only provide representations of the nation (which have an appeal in the international market) but also be representative of its full diversity.

References

1. 'Power!', *Empire*, June 1995, pp.56-57.

PART ONE:

HISTORY AND AESTHETICS

2

The Lure of the Big Picture: Film, Television and Hollywood

Peter Kramer

In the 1970s, it was still possible to hold on to a few basic truths about mainstream American cinema: Hollywood was in the business of producing movies, the appropriate place to see movies was the cinema, and going to the cinema was a distinctive cultural experience. It seemed that the Hollywood majors had weathered the post-war decline of cinema attendances and the break-up of the studio system. They were now producing fewer and more expensive films to be shown in smaller, much less luxurious multi-screen theatres primarily to young audiences. In order to secure their survival, most of the studios had become part of huge conglomerate organizations which could compensate for the volatility of audience demand for films with their steady revenues from other industrial sectors (such as consumer goods and financial services). Hollywood had found a comfortable position vis-à-vis television, the now dominant mass medium, as the junior partner in a symbiotic relationship with the three networks (ABC, CBS, NBC). While the production of films for theatrical release was the studios' main business, they picked up additional revenues from television by selling the broadcasting rights of their theatrical releases, and by using the production capacities of their old film factories to churn out television series and made-for-TV movies.

The production of films for theatrical release had changed considerably since the studio era, moving away from assembly-line mass production – executed by employees on long-term contracts under the supervision of all-powerful producers and studio heads – towards more independent production units put together specifically for individual projects. In many instances, control of the production process was now being handed over to directors, a development welcomed by all those who deemed the director to be the legitimate 'author' of a film, its creative centre and organizing intelligence. There was great hope that 'the movie brats', a new generation of filmmakers, brought up in the 1950s and 1960s on a steady diet of theatrical and televisual screenings of films past and present, trained at film schools and in exploitation filmmaking, well-versed in popular entertainment as well as film art, influenced by the political and cultural movements of their time, could find critical and popular acclaim with an aesthetically innovative as well as socially relevant cinema, exemplified by films such as *The Godfather* (1972) and *Taxi Driver* (1976).[1] Thus, at the end of the decade, Michael Pye and Lynda Myles celebrated the work of Francis Ford Coppola, George Lucas, Brian De Palma, John Milius, Martin Scorsese and Steven Spielberg as a return to the Golden Age of American cinema, the studio era of the 1920s, 30s and 40s:

> They inherited the power of the moguls to make films for a mass audience. And they know the past of cinema like scholars; they grew with it and through it. In their world anything can refer back to movies. Knowledge and power and spectacular success all make them the true children of old Hollywood.[2]

Within a few years, this optimistic view of the importance and quality of contemporary American cinema became untenable, despite substantial improvements in film exhibition and steadily increasing box office revenues. By the mid-1980s, the rapid diffusion of cable television and home video had turned the domestic television set into the primary outlet for movie entertainment, increasingly by-passing and marginalizing the theatrical release. The Hollywood studios were being integrated more fully into less diversified conglomerates, which operated in the fields of entertainment products, communication infrastructure and consumer electronics and regarded movies as key software for the services and products they offer. Furthermore, theatrical exhibition was dominated increasingly by a new breed of blockbuster (best exemplified by the Lucas/Spielberg fantasy adventures *Star Wars* [1977] and *Raiders of the Lost Ark* [1981]), which met with little acclaim in academic film criticism. Variously described as regressive and escapist, overcalculated and driven by special effects and merchandising possibilities, superficial and overly simplistic in narrative construction and characterization, the output of the major studios since the late 1970s seems largely irredeemable, even for those critics who have a genuine concern for popular cinema.[3] As a result, the bulk of academic criticism has revolved around readings of a few outstanding films

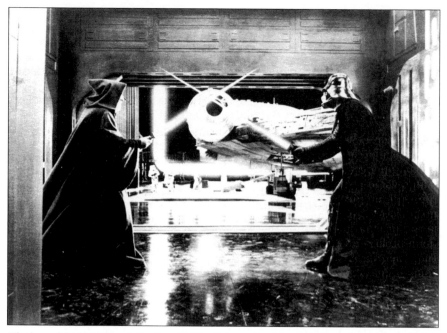

'The lure of the big picture': Ben Kenobi (Alec Guinness) and Darth Vader in *Star Wars* (1977)

rather than a sustained analysis of the most popular films and cycles.[4] At the same time, contemporary Hollywood as a whole has typically been subsumed under the catch-all category of the 'postmodern', embracing – and tending to privilege – other media and entertainments such as television and pop music. Thus, alongside *Blade Runner* (1982), it is MTV and Madonna which have been favoured illustrations of the claims critical theory has made about contemporary culture.[5]

Mass media scholars have also argued that the American cinema no longer exists as a separate and self-contained industry offering a distinct product.[6] Movies are produced by multinational entertainment conglomerates as an integral part of their cross-media marketing strategies which sell a fairly narrow range of closely-related cultural products (films, television shows, books, records, merchandising) through an ever-increasing number of delivery systems ranging from traditional movie theatres and retail chains to futuristic electronic information superhighways, which tend to address a fragmented mass audience of private consumers rather than theatre crowds. Many researchers view these developments critically, because subcultural, regional and national identities are increasingly displaced by an international mass culture, and communal experiences by individualized acts of consumption. Furthermore, existent and emerging spheres of cultural production are rapidly brought under the control of an

ever decreasing number of corporate players, which tend to focus their operations on extremely high-cost production and limited access to their distribution systems, thus actively suppressing competition and diversity.[7]

There is a tendency in contemporary debates, then, to condemn mainstream American movie production and cinemagoing on aesthetic and political grounds, or to deny its specificity by locating it as a part of either an integrated multimedia entertainment industry or a more general postmodern condition. This makes it difficult to explore the continuing fascination of big screen entertainment, and even to maintain the distinction between cinema (the theatrical exhibition of films) and domestic small screen media as separate economic operations and cultural spheres. Yet, while it is possibly true that the majority of movies today have more of a chance to make a significant financial or cultural impact via the small screen *after* their short theatrical run, the release of 'major' motion pictures continues to have a strong appeal to, and a powerful hold on, the people filling movie auditoria and creative individuals aspiring to make movies. Every year a small number of films achieve 'event' status upon their theatrical release, attracting huge crowds, providing extraordinary sensual and emotional thrills, and temporarily impressing themselves on public debate and everyday conversation. That it remains difficult to predict which films will enter this élite group adds to their mystique. The studios' enormous investments in the production and promotion of their top releases generates more box office flops than successes, and the annual hit lists contain as many surprises as calculated blockbusters. The excitement of the studios' huge gamble and of audiences' unpredictable choice might help to explain why, despite the riches and popularity to be gained in other media, participation in a major motion picture production remains, for countless executives, television producers, and pop stars in the US and abroad, a burning ambition and the ultimate touchstone of popular cultural achievement.

It would seem, then, that if cinema is alive today at all, it is all but identical with the 'big picture'. At the same time, it is clear that the reign of the big picture in movie theatres is closely connected to the proliferation of domestic media technologies centred on the television screen. While the capacity of small-screen media to provide alternatives to Hollywood blockbusters for the domestic viewer is increasing, new home-delivery systems such as cable and video tend to feature those blockbusters as their most attractive programming. And while it could be said that cable and video have thus domesticated movies (that is they have brought them within the confines of the home), the revenues from these media are invested by the film industry in the ever more extravagant public staging of cinematic spectacles in movie theatres. Big screen spectacles rely for their revenues on small screen media, and these in turn rely for their appeal on movies, which, when replayed on domestic small screen media, carry with them the grandeur and mystique of cinema. The theatrical presentation of expensively-made movies to paying audiences who willingly and whole-

heartedly submit themselves to the power and excess of big screen specta-
cles remains an important cultural experience which is able to infuse the
more mundane and casual use of domestic technologies with special
meaning. The lure of the big picture is significant precisely because it
reaches into the living room.

In the remainder of this essay, I would like to put the present-day relation-
ship between cinema and small screen media in the United States as it has
evolved since the 1970s, into a wider historical perspective. It is my
contention that the present state of affairs is best understood as an intensi-
fication of past structures of the film industry and film culture rather than
as a radical break with them. For example, we can find a precedent for
contemporary entertainment conglomerates and cross-media marketing in
the major companies dominating the studio era. These companies not only
owned movie theatres, film distribution networks and Hollywood-based
production plants, but also made frequent forays into legitimate and variety
theatre, recorded music, radio and television, involving mergers and
takeovers and the constant transfer of popular formats and performers
between media. We can also find precedents for today's blockbusters in the
enormously successful and highly influential big pictures of the studio
era (such as *Gone With the Wind* [1939]) and even before (such as *The Birth
of a Nation* [1915]). And we can see the present production system with
its semi-independent units and its director-superstars as an extension of
the operations of the great independent producers of the studio era, most
notably Sam Goldwyn and David O. Selznick who were chiefly responsible
for the biggest pictures of them all in terms of budgets, critical acclaim
and box office revenue. Then as now, the big picture was a prestigious
endeavour, attracting the film industry's top personnel, and a gamble,
involving a considerable investment in an unusual product which did not
fit into the regular output and release schedule of the major companies but
aimed to find an audience on the basis of its unique qualities. Also, we can
see the present orientation of the film industry's output of telefilms and of
a significant portion of its blockbusters (most notably Lucas, Spielberg and
Disney productions) towards domestic family entertainment as a return to
the concerns of pre-1950s mainstream cinema, which not only addressed
itself to a family audience, but also habituated that audience to regular
attendance, thus turning the familiar space of the theatre into what was
effectively a glorified version of home.

Finally, and perhaps most importantly, we can find strong parallels
between the integration of movies and domestic media technologies today
and the very beginnings of moving pictures in the late nineteenth century.
Originally conceptualized by Thomas Edison as a complement to his phono-
graph, in the early 1890s the motion picture apparatus had been expected
to help forge a technological link between the home and the outside world,
by bringing representations of the world into the home (together with
the phonograph and still photography) and by facilitating direct communi-

cation with the world (in combination with telephony). However, the success of the theatrical projection of films to paying audiences after 1895 meant that film technology became identified with the big screen and theatrical spaces. According to Roy Armes, the huge economic and cultural impact of big screen theatrical presentation constitutes 'film's uniqueness' within the general proliferation of technologies of sound and image reproduction:

> It was the only one of the new media to be developed as a public entertainment and to adopt a theatrical, rather than a domestic mode. All subsequent developments in the reproduction of sounds and images have been directly home-oriented.[8]

For Armes, the entry of movies into the home via broadcast television in the 1950s and the transformation of movies into a basically domestic entertainment by cable and video in the 1980s is hardly surprising as it follows the model of telephony, still photography, sound recording on disc and tape as well as wireless long-distance communication, radio and television.

Taking Armes' grand overview as a starting point, I will explore, in the following sections, key periods in the closely and complexly-intertwined histories of cinema and domestic media technologies.[9] The first section traces the changing conceptualization and marketing of motion pictures in turn-of-the-century America, concentrating on what we may call the 'televisual imagination' which guided early developments in the field of sound and image reproduction. I will chart the transition of Edison's motion picture apparatus from its original conception as a domestic technology to its use in big screen theatrical entertainment, giving rise to the modern film industry (known as 'Hollywood') which is separated from equipment manufacturing and based on the theatrical projection of films. The second section explores the move towards re-integration of domestic media technologies and theatrical film entertainment during the first television boom of the late 1920s and early 1930s, outlining the competition and co-operation between Hollywood and the communications industry, as well as the various schemes put forward for the future shape of television. The third section concentrates on the multi-faceted attempt of a rapidly changing film industry to participate in the commercial exploitation of television technology in the late 1930s and after World War II and outlines some of the reasons for Hollywood's failure to wrest control away from the radio networks, which forced it to settle for a subsidiary role as television's main programme provider. Threading through these historical case studies is the fascination of inventors, filmmakers and audiences alike with the large screen theatrical projection of moving images, life-like and larger-than-life at the same time. While this fascination with the big picture would seem to be an elusive phenomenon, difficult to describe and even more difficult to explain, it clearly is a driving force behind the invention and evolution of film and television, leading to some surprising twists in the tale of their development.

From Domestic Technology to Theatrical Entertainment: Thomas Edison, the Televisual Imagination and the American Motion Picture Industry, 1891-1915

From its very beginnings, the commercial exploitation of moving pictures in the United States was characterized by the twin concerns of producing technical devices for domestic use, and of reproducing the public spectacle of drama and even opera and, beyond the theatrical stage, the spectacle of the world itself. The first twenty years or so of American moving pictures were dominated by the technological, legal and entrepreneurial schemes of Thomas Edison, who had previously made his name and money with a variety of inventions, including the light bulb, improvements on the telegraph and telephone, and a sound recording device called the phonograph. Most of these were first used by businesses, yet were ultimately targeted at the mass market of domestic consumers. It is no coincidence, then, that for the first public presentation of his motion picture apparatus on 20 May 1891, Edison invited delegates of the convention of the National Federation of Women's Clubs to his laboratory,

> where Mr. Edison himself was present and exhibited to them the kinetoscope, the invention that he is about perfecting, by which the gestures of a speaker are accurately reproduced, while the spoken or sung words are reproduced by the phonograph.[10]

This display together with an interview Edison gave for the May issue of the *World's Columbian Exposition Illustrated,* generated massive publicity for his latest invention, which created the illusion of movement by displaying a rapid succession of photographs inside a box to be viewed through a peephole (similar to previous motion picture toys which had used drawings). Yet, significantly, Edison and other commentators described the new invention less as a recording and replay device than as an instrument of instantaneous transmission of audiovisual signals, which today we would call television. And instead of a peephole device, Edison promised big screen spectacles:

> I hope to be able by the invention to throw upon a canvas a perfect picture of anybody, and reproduce his words.... And when this invention shall have been perfected...a man will be able to sit in his library at home, and, having electrical connection with the theatre, see reproduced on his wall or a piece of canvas the actors, and hear anything they say.[11]

Thus, Edison envisioned the future integration of existing media technologies, merging the capacity to record sounds and images of his phonograph and motion picture device with the long-distance transmission of signals provided by the telegraph and the telephone, so as to bring the theatre and the whole world into the home, and to move imaginarily the domestic users

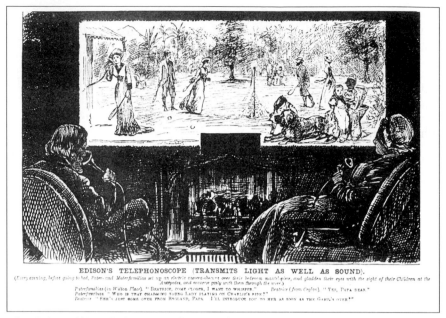

EDISON'S TELEPHONOSCOPE (TRANSMITS LIGHT AS WELL AS SOUND).

'The whole world into the home': *Punch*, 9 December 1878

into whatever surroundings they desired to be in. This was Edison's clearly articulated vision even before, in August 1891, he submitted the patent applications for his motion picture camera (the kinetograph) and the peep-hole viewing device (the kinetoscope), which served as the basis of his dominance of the American motion picture industry for the following two decades, and before he started construction of his motion picture studio in December 1892, where regular production of twenty-second films showing workplace scenes and variety displays (of strong men, acrobats, dancers, boxers) began in earnest in January 1894.[12] What was to become 'the cinema' arose, then, out of what I would suggest could be called Edison's 'televisual imagination'.

This imagination was shared by many of his contemporaries, and it had been around for decades. Indeed, when in February 1878, amidst a flurry of innovations in photography and less than two years after Alexander Graham Bell's patent of the speaking telegraph or telephone, a patent was issued for Edison's phonograph, *Punch* was inspired to print a cartoon imagining the logical consequence of all these developments: 'Edison's Telephonoscope (Transmits Light as Well as Sound)'. The cartoon depicted an older couple in front of a massive wide screen moving image display, 'an electric camera-obscura over their bedroom mantel-piece', showing their daughter on a tennis court in Ceylon. With both parents and daughter holding on to telephone receivers, they are able to 'converse gaily...through

the wire'.[13] Thus, the big screen literally putting the home in contact with the world outside, blurring and dissolving the boundaries between the most private spaces and the public sphere, was the perceived end point and centre piece of late nineteenth century developments in media technologies. This theme (now, however, evoking videotape rather than television) also dominated what, according to Gerald Mast, was 'perhaps the earliest published report on motion pictures intended for the American public in general', appearing in *Harper's Weekly* in June 1891. George Parsons Lathrop concluded his article as follows:

> We seem to be nearing a time when every man may realize the old philosophical idea of a microcosm – a little world of one's own – by unrolling in his room a tape which will fill it with all the forms and motions of the habitable globe.[14]

Compared to these grand visions, the initial exploitation of motion pictures by the Edison Manufacturing Company from April 1894 onwards was a rather modest endeavour. Instead of using a big screen, Edison marketed kinetoscopes, that is peephole devices, and instead of targeting the mass market of domestic consumers with an affordable product, he sold expensive coin-in-the-slot machines for $200-300 through several agents to entertainment entrepreneurs.[15] These entrepreneurs placed the kinetoscopes in amusement parlors and other public spaces, often alongside Edison's phonograph which had been deployed (at a price of about $200) in the same way since 1890, after its initial unsuccessful marketing as an office dictaphone.[16] While the public intially flocked to put their nickels into slots so as to be able to view brief film loops, the professional market for kinetoscopes soon reached saturation point, and by the summer of 1895, despite the introduction of the kinetophone (a combination of kinetoscope and phonograph), machine sales slumped badly.[17] Edison had to re-launch motion pictures in the form of new products or new applications.

In his phonograph business, Edison had decided in 1894 to offer a cheap model of his professional machine to the domestic market. The home phonograph was to be used in conjunction with a large catalogue of recordings of comic sketches and popular music as a private entertainment medium. While Edison was temporarily restrained by legal entanglements from implementing this new policy, his main competitor, the alliance of the American Graphophone Company and the Columbia Phonograph Company, began to capture the domestic market with a $75 model in 1894 and, then in the winter of 1895/96, with a massive advertising campaign promoting machines available for as little as $50. The ads featured the picture of a family gathered around the horn of a small phonograph, which was celebrated as 'the machine that talks – and laughs, sings, plays, and reproduces all sound', a machine 'so simple that even a child can make it pour forth the most enchanting selections of the world's greatest Musicians, Singers, Actors, and Speakers.' In 1896, Edison

responded by offering his own Home Phonograph for $40. By the following year $10 and $20 models were widely used, and the focus of the phonograph business had definitely moved out of offices and amusement arcades into the American home.[18]

With this re-orientation, the phonograph business belatedly followed the example of two leading companies in closely-related media industries, the Bell Telephone Company and George Eastman's photographic business, which were to grow into corporate giants AT&T and Eastman Kodak and exert enormous influence on the development of both the motion picture and television industries. The Bell organization had targeted the mass market of domestic users as early as 1883, and in 1893 almost a third of the circa 260,000 telephones it had installed in the United States were located in private residences rather than businesses. When Bell's patents and thus its monopoly expired in 1893/94, the market exploded and within less than fifteen years over six million telephones were installed by Bell and its competitors, mostly in middle-class urban households and on farms.[19] The launch in 1888 of George Eastman's Kodak camera, which was designed specifically for private use by amateurs rather than for professional use by portrait photographers, reporters, artists and such like, was another success story. Marketed with the slogan 'You press the button – we do the rest', the Kodak camera, loaded with a roll of film allowing up to one hundred exposures, sold for $25. By the mid-1890s over 100,000 cameras had been sold, generating enormous business for the sale of Eastman raw film stock and the processing of exposed film rolls in the Eastman plant.[20] Furthermore, between 1891 and 1896 scientific and technological developments concerning the wireless transmission of electrical signals and of photographic images made the audiovisual connection of the home to the whole wide world, as envisioned by the 'televisual imagination', a distinct possibility.[21]

Thus, after decades of speculation and innovation, existing media technologies were, in 1895/6, converging on the American home and serving a rapidly expanding market of private consumers. In this context, the logical way for Edison to revive his flagging kinetoscope business would seem to have been to enter the domestic market and place his motion picture peepshow alongside the phonograph, telephone and still camera in the home. However, also in 1895/96, a number of European and American inventors and entrepreneurs combined Edison's motion picture technology with the principles of the magic lantern, that is the projection of images onto screens for the enlightenment and entertainment of spectators, which for over two centuries had been the basis of a flourishing and rapidly developing commercial theatrical enterprise. Following the example of the magic lantern, the display of motion pictures on the big screen, by for example Robert Paul in England and the Lumière brothers in France, initially as a scientific demonstration in laboratories and at congresses, then as an educational and entertaining spectacle for paying audiences

at expositions and in theatres, made an enormous impact. It opened up a new professional market for manufacturers of motion picture devices such as Edison, and provided the basis for what was to become known as 'the cinema' – the commercial projection of motion pictures as a theatrical entertainment.[22]

The potential of this new market for motion pictures was demonstrated in the United States as early as May 1895, when a group of American inventors opened a storefront theatre on Broadway in New York to entice customers to pay to see their 'eidoloscope' or 'magic lantern kinetoscope'. The response of the press was enthusiastic:

> Life size presentations they are and will be, and you won't have to squint into a little hole to see them. You'll sit comfortably and see fighters hammering each other, circuses, suicides, hangings, electrocutions, ship-wrecks, scenes on the exchanges, street scenes, horse-races, football games, almost anything, in fact, in which there is action, just as if you were on the spot during the actual events. And you won't see marionettes. You'll see people and things as they are.[23]

Instead of having to bring the world into the home, it now seemed equally exciting and lucrative to use motion pictures to bring the world into the theatre. Edison's entry into this new market came rather late, but it proved to be decisive. Early in 1896 his company started to manufacture motion picture projectors to be sold via his kinetoscope agents to theatrical entrepreneurs and showmen. A major publicity campaign accompanied the machine's grand première as 'Edison's Vitascope' at Koster & Bial's Music Hall on 23 April 1896. This première received an ecstatic reception by audiences and the press, and thus successfully launched the vitascope as a device to be displayed by showmen in established entertainment institutions all over the United States.[24] From then on, Edison concentrated his motion picture business on selling both the projectors and the films, which showmen needed to renew the appeal of their motion picture displays, and he also used his original patents to assert legal control of this market in the United States.

Film programmes were intially slotted into established variety entertainments (vaudeville, fairgrounds, amusement parks, travelling exhibitions and so on), presenting audiences with technological novelty, sensual spectacle, magical tricks, comic sketches, illustrated lectures, visual newspapers and, from the early 1900s, increasingly stories. Audience response to, and demand for, moving picture presentations fluctuated wildly, and began to stabilize only when extended narratives were pioneered mainly by the Edison Manufacturing Company, most notably with Edwin S. Porter's *The Great Train Robbery* in 1903. When the popularity of story films had established the long-term viability of filmic entertainment as an attraction

in its own right (rather than as a mere component of live variety programmes), from 1905 showmen converted storefronts and opened purpose-built movie theatres in large numbers to present film shows at a very low price (hence the name 'nickelodeon').[25] The cinema soon became the most popular of all theatrical entertainments, with about 3,000 moving picture houses operating in the United States in 1907 and 10,000 in 1910, and anywhere between 14,000 and 20,000 in 1914, many of which by now had been upgraded in terms of size, decor, service and admissions fee so that they came to be known as 'movie palaces'.[26]

While exhibition was clearly the most dynamic sector of the film industry, the Edison Manufacturing Company and other equipment manufacturers, in particular the American Mutoscope and Biograph Company, largely controlled film production and distribution in the United States into the 1910s, shooting films increasingly in purpose-built studios and gradually building up massive production capacities. With varying degrees of success Edison and Biograph attempted to use their patents on film technology to regulate the industry and to extract maximum revenues from all companies involved in it. Through the Motion Picture Patents Company (formed in 1908), they licensed film producers and movie theatres for a fee and, through the General Film Company (formed in 1909), they monopolized distribution, offering movie theatres a regular supply of split-reel and one-reel films (1,000 feet, which would run about fifteen minutes) for a daily change of programme. Although it did not survive the rapid growth and transformation of the cinema market in the early 1910s, the Edison/Biograph duopoly in many ways established the pattern for the future organization of American cinema culture and industry. A small number of firms gathered a substantial portion of overall industry revenues; considerable investment in production plants facilitated the mass production of filmic entertainment; frequent programme changes and low admission prices (compared to other theatrical entertainments) habituated mass audiences to the cinemagoing experience. The next generation of motion picture entrepreneurs, mostly central European Jewish immigrants who had started out in the retail trade and entered the film industry at the exhibition end during the nickelodeon boom, adapted this system to the mass production and distribution of comparatively high cost multiple-reel feature films from 1912 onwards. These features were presented on weekly changing bills together with a support programme of short films and live variety acts in the splendid surroundings of movie palaces to cinemagoers attending regularly once a week. This new film industry and film culture eventually came to be known as 'Hollywood'.[27]

At the same time, however, Edison returned to the original conception of his motion picture apparatus as a domestic consumer product by launching the Edison Home Projecting Kinetoscope in 1912. With this, he tried to enlarge dramatically the market for motion picture hardware which, despite the dominance of the mass production of films for theatrical

exhibition, still accounted for a substantial portion of his film-related revenues (almost forty per cent in 1908).[28] Edison's home projector directly followed on from numerous attempts by American and European companies to sell both cameras and projectors in the domestic market still seen by many as the ultimate destiny of all media technologies.[29] Movie pioneer Siegmund Lubin, for example, declared in 1906 that 'the time will come when the life moving picture machine will be a part and parcel of every up-to-date home.'[30] The Edison Home Projecting Kinetoscope cost between $75 and $100, less than half the price of professional equipment, and it was to be used in conjunction with a large catalogue of previous theatrical film releases as a domestic entertainment medium, similar to Edison's home phonograph (which did good business with about 50,000 machines sold in 1911 alone) and much like video today. However, by 1915 only about 500 Home Projecting Kinetoscopes had been sold, mainly it seems because the machine was still too expensive and the film catalogue was restricted to one-reelers which had become an outmoded format due to the success of multiple-reel features in movie theatres.[31] Like most of the other attempts to sell motion picture equipment to domestic consumers, Edison's home cinema had to be considered a failure, unable to compete with big theatrical pictures, the biggest of which, D.W. Griffith's $100,000 Civil War epic *The Birth of a Nation*, started its long run in legitimate theatres and movie houses for an unprecedented top admissions price of $2 in January 1915, eventually earning millions of dollars.[32] When later that year Edison discontinued his home projector business, it was the clearest possible sign that the immediate future of motion pictures did not belong to equipment manufacturers and domestic consumption, but to the production and distribution of feature films for public presentation as the centrepiece of an evening's entertainment at the movie theatre.

Theatrical Features, Synchronized Sound and the First Television Boom: Hollywood and the Communications Industry, 1925-1932

In the second half of the 1920s, a consolidated film industry again had to confront the leading corporations in the field of domestic media technologies, when these corporations introduced a series of innovations concerning the recording of sound and the transmission of both sounds and pictures. As radio turned into a domestic mass medium and the 'televisual imagination' finally became a reality, a new market was opened up in the American home for Hollywood, and the major companies quickly diversified their operations into popular music and broadcasting while also converting their film studios and theatres to sound. Both the consolidation of the film industry and its diversification strategies during this period are best exemplified by Adolph Zukor's movie business. Soon after his successful release in the United States of the European Sarah Bernhardt vehicle *Queen Elizabeth* as a special four-reel film attraction in 1912, Zukor became the

dominant force in the American motion picture industry by organising the mass production and regular (weekly or twice-weekly) release of full-length feature films through his Famous Players Film Company and numerous follow-up and subsidiary corporations which were later subsumed under the name Paramount. Through the use of exclusive contracts, with top stars from Mary Pickford to Rudolph Valentino and top directors such as Cecil B. DeMille, and an aggressive programme of horizontal and vertical integration, which merged existing film studios, distributors and theatre chains into one massive combine, Zukor's Paramount came close to monopolizing the American cinema on several occasions.[33] Competition was provided by several rival organizations, most importantly by Zukor's former business partner Marcus Loew, who completed the formation of Metro-Goldwyn-Mayer as a production subsidiary of his chain of about 200 cinemas in 1924. In 1925/26 Zukor responded by taking control of the powerful Balaban and Katz theatre organization, and merging it into Paramount's Publix subsidiary, thus creating what was, with over 350 houses, by far the largest cinema chain in the United States.[34]

In the mid-1920s, then, the motion picture industry was again tightly controlled by two major corporations surrounded by several smaller players. Each of these companies combined a film factory based in and around the Los Angeles suburb of Hollywood, with a world-wide distribution network and a national theatre chain whose headquarters were in New York. Unlike the earlier Edison/Biograph duopoly, the control of the film industry by Paramount and Loew's/MGM and, to a lesser extent, Fox, First National and Universal, was not based on patents concerning motion picture equipment, but on exclusive long-term contracts with stars and other creative personnel necessary for the production of high quality feature films, and on ownership of the biggest movie palaces in the most popular locations charging the highest admissions fees for the first showing of major features. In the mid-1920s, the majors controlled almost ten per cent of the 15-20,000 movie theatres in the United States, and their films were also in great demand by theatres in which they had no investment, so that overall they could gather more than fifty per cent of total box office revenues in the United States. The film industry was commonly known as 'Hollywood', referring to its most glamorous aspect, the production of feature films and the extravagant life-styles of their stars, directors and producers in Los Angeles. Yet, Hollywood is perhaps better understood as an industry based on the real estate value of theatres in prime urban locations (which constituted up to ninety per cent of its assets) and the revenues generated from their box offices and from international film distribution, with marketing experts and theatrical managers staffing the New York corporate headquarters and issuing budgets and production plans for the filmmaking community in Los Angeles. The main purpose of a major film corporation's production plant on the West Coast was to supply its theatre chain and distribution network with a steady flow of products, about fifty features and numerous short films per year. In turn the steady

revenues from exhibition and distribution, with more than forty million cinema tickets being sold every week in the United States (which meant that more than a third of the population attended once a week), were used partly to fund Hollywood's expensive productions and extravagant life-styles.[35]

The film industry's equilibrium was disturbed by the rapid growth of radio and the experimental display of television throughout the 1920s, which posed a potential threat to Hollywood's theatrical business. Between 1923 and 1925, the film business had grown only modestly (overall receipts up from $336 million to $367 million, weekly attendance up from forty-three million to forty-six million), even stagnating in 1924-1925. The radio business, on the other hand, had multiplied: from 1.5 million radio sets sold by 1923 (generating revenues of over $50 million for equipment manufacturers in 1923 alone) to four million sets installed by 1925, generating hardware revenues of over $150 million in that year and reaching an audience of fifteen million people.[36] Various commentators voiced concern about the likely impact of radio's provision of free domestic entertainment on the theatre business (both movies and plays).[37] Surprisingly, the film industry's first response was to use radio for publicity purposes. Beginning in 1923 Samuel Rothapfel, the manager of the Capitol in New York, with 5,300 seats the largest movie house in the world (and by 1924 part of the Loew's combine), had pioneered live broadcasts from the cinema, using the variety performers featured in the elaborate stage presentations which opened up the movie programme, with the intention of enticing radio listeners to come and see the live show and the current feature at the Capitol. In his 1925 book *Broadcasting: Its New Day*, Rothapfel suggested that his strategy could provide a sound economic basis for the broadcasting industry. Up to this point, radio programming had primarily been financed by companies such as the Radio Corporation of America (RCA) which had originally been set up in 1919/1920 by General Electric and other leading manufacturers of electrical equipment in association with AT&T to co-ordinate radio broadcasting and receiver sales in the United States. RCA financed radio programmes to promote receiver sales, yet in the long run, with market saturation coming ever closer, a new set of sponsors for programming would have to be found. Like many other commentators, Rothapfel felt that blatant advertising for consumer goods paid for by their manufacturers would alienate listeners, and instead he suggested a symbiosis with the film industry.[38]

Harry Warner, president of Warner Bros. Pictures, a comparatively small but rapidly expanding motion picture organization, which set up a radio station in March 1925 to promote its current releases, suggested that the film industry should run a national network of stations:

> (P)rograms could be devised to be broadcast before and after show hours, tending to create interest in all meritorious pictures being released or playing at that time.... Artists could talk into

the microphone and reach directly millions of people who have seen them on the screen but never came in contact with them personally or heard their voices. Such programs would serve to whet the appetites of the radio audience and make it want to see the persons they have heard and the pictures they are appearing in.[39]

Increased radio activities by Warners, First National and Universal followed, culminating in the announcement that the two leading film corporations, Paramount and Loew's, planned to create their own radio networks 'for dramatizing and advertising first-run motion pictures', as the *New York Times* reported in May 1927.[40] A month later, both Paramount and the Columbia Phonograph Company, a leading record producer, were involved in the setting up of the second national radio network in the United States. Unlike the National Broadcasting Company (NBC), a network of radio stations connected by wires leased from AT&T and set up by RCA in 1926 to promote further receiver sales, the Columbia Broadcasting System (CBS) was established with the intention of generating its own income by selling advertising time. Although CBS would only own a few stations outright, it intended to establish a network of affiliate stations across the United States (again connected by AT&T wires). CBS would provide the programmes, pay affiliates for broadcasting them and in turn sell access to the vast national audience which could thus be reached to advertisers. This scheme relied heavily on attractive programming enticing radio listeners to tune in to CBS affiliates rather than to other stations, and this programming could best be provided by companies specializing in the production of popular entertainment, such as Columbia and Paramount. However, around the time of CBS's première broadcast on 18 September 1927 both Paramount and Columbia withdrew (the latter only leaving its name).[41] So while film companies failed to implement most of their radio schemes, there was no doubt about Hollywood's intention to assert control over broadcasting so as to prevent it from seriously competing with movie theatres for their patrons' time, and instead to turn radio, alongside film production, distribution and exhibition, into another subsidiary sector of a fully integrated media industry revolving around the theatrical projection of Hollywood movies. This strategy provided the model for the film industry's engagement with television, which began in earnest in the late 1920s.

In 1928 and 1929 numerous experimental television stations started regular transmissions. This first television boom in the United States followed the public demonstrations of moving picture transmission by C. Francis Jenkins on 13 June 1925 and, more importantly, by an AT&T research team on 17 April 1927.[42] These demonstrations had provided different perspectives on the medium and Hollywood's likely involvement in it. Jenkins transmitted pre-recorded film material onto a small screen and, despite poor picture quality, he announced in his 1925 publication *Vision by Radio, Photographs, Radio Photogram* that '(t)he new machine will come to

the fireside as a fascinating teacher and entertainer...with photoplays, the opera, and a direct vision of world activities'.[43] Like earlier visionaries, Jenkins saw television as a domestic technology putting the home in touch with the theatre and the world itself, providing information and entertainment, combining live transmissions ('direct vision') with the use of prerecorded 'photoplays'. This tied in nicely with Loew's/MGM's highly publicized broadcasts in 1927 of 'aural' versions of their newsreels (with an announcer describing the images and relating the news stories) and, in December, of its first 'telemovie'. The top MGM release of the season, *Love* (1927) starring Greta Garbo and John Gilbert, was relayed into homes across the country, featuring a narrator supported by music and sound effects:

> (A)n entire motion picture will be broadcast in detail when Ted Husing will describe *Love*...as it unreels before his eyes in a special performance at the Embassy theater...he will act as the "eyes" for the audience in telling the screen story of *Love*.[44]

Although it remained a singular event, this experiment together with Jenkins' vision clearly pointed to the secondary exploitation of Hollywood's big pictures in future domestic displays.[45]

AT&T's more widely publicized experiments, however, were concerned with point-to-point live transmissions of visuals, which were intended, as project coordinator Herbert E. Ives wrote, 'primarily as an adjunct to the telephone', thus realizing the 1878 *Punch* cartoon's vision of 'Edison's Telephonoscope' and potentially opening up a huge market for the sale of videophone receivers.[46] Yet, the *New York Times* commented:

> (T)he commercial future of television...is thought to be largely in public entertainment – super-newsreels flashed before audiences at the moment of occurence, together with drama and musical shots on the ether waves in sound and picture at the instant they are taking place in the studio.[47]

The ambiguous reference to 'public entertainment' hinted at yet another possible use for television, namely the relay of television's audiovisual spectacle into theatres for a big screen display in front of paying audiences. Indeed, between 1928 and 1931, there was a series of technological innovations aimed at the projection of televised pictures onto a big screen, usually using an intermediate stage of instantaneously recording them onto film before projection.[48]

Amidst demonstrations of televisual innovations and debates about the new medium's future impact, the big equipment manufacturers such as RCA, General Electric and Westinghouse set up experimental television stations (fifteen were in operation by the end of 1928) with a view of creating new markets for the sale of domestic hardware, by offering television reception

as an upgrading of the radio set.[49] At this point, Paramount finally respond-ed with a substantial investment in the broadcast industry by buying a half interest in CBS. The deal was announced at a Paramount stockholders' meeting in January 1929, at which CBS president William S. Paley explained the rationale for this alliance with special reference to television:

> (Television) is sure to come. And with this amalgamation of interests we are prepared. Columbia can lean on Paramount for the new problems entailing actual stage presentations in full costume to be broadcast, and Paramount knows it has an outlet in presenting its television features to the public.[50]

Whether as a theatrical big screen entertainment or a domestic small screen medium, transmitting live studio performances or pre-recorded photoplays, the Paramount/CBS combine had the necessary infrastructure, resources and talent to exploit television. Theatre television would provide a new attraction in Paramount's still expanding vast cinema chain (of close to 1,000 houses): 'Visualize world-series baseball games, football games, automobile and horse races, transmitted the instant they occur on supersized, natural color, stereoscopic (theater) screens', declared Paley enthusiastically.[51] Home television, on the other hand, could be expected to generate huge profits from advertising due to CBS' ability to produce popular programming, drawing on Paramount's expertise in staging elabo-rate shows and producing short and feature-length telefilms, as well as on the possibility of broadcasting Paramount's theatrical releases. Paramount/CBS seemed prepared for all eventualities, and on 21 July 1931, CBS' New York TV station started broadcasting a regular 49-hour weekly schedule.[52]

While the film industry was thus diversifying into broadcasting, encroaching on the territory controlled by the leading communications companies such as RCA and AT&T, it was itself the target of an aggressive marketing campaign by the communications industry. In the early 1920s, AT&T's marketing division Western Electric had innovated electrical sound repro-duction, which allowed for dramatic improvements in the quality of musical recordings and in the amplification of recorded sounds. After licensing leading phonograph manufacturers, Western Electric signed an agreement in 1925 with Warners to develop a viable sound-film system as part of the studio's expansion programme. Within a year, Warners, through its Vitaphone subsidiary, began the regular release of programme packages including musical short films and silent features with pre-recorded orchestral soundtracks. These were initially aimed at smaller movie houses that were not affiliated to one of the major chains and, unlike the big movie palaces, could not afford top variety performers and large orchestras to perform as part of the evening's entertainment programme. However, when Warners' *The Jazz Singer* (released in October 1927) and *The Singing Fool* (September 1928), two silent melodramas which incorporated 'vitaphoned' song sequences featuring Broadway superstar Al Jolson, became two of the

biggest box office hits since *The Birth of a Nation*, synchronized sound quickly turned into a new industry standard. Fuelled by an unprecedented box office boom, Paramount, Loew's and other leading film companies rapidly converted their studios and theatres to sound at the enormous cost of up to $500 million, most of which was paid to equipment manufacturers, most notably Western Electric, which thus achieved its original objective of finding new markets for AT&T's electrical sound equipment.[53]

By the beginning of the 1930s, then, the Hollywood majors of old (Paramount, Loew's and Fox) and of recent years (Warners) were greatly expanded and highly diversified corporations, inseparable from the communications industry. They were heavily indebted to AT&T, and were busily buying up record companies and music publishing houses, which were of special interest to them now that their business, at least for a while, revolved around musical features.[54] Most importantly, with their ownership of film studios, record companies and music publishers, they controlled key software for the rapidly expanding broadcasting sector, and with their ownership of theatre chains, radio stations and Paramount's involvement in CBS's television experiments, the majors controlled a range of delivery systems for their entertainment products. Hollywood's diversification was easily matched by RCA which, by the late 1920s, was a dominant force in a variety of media: radio broadcasting (the two leading radio networks were run by its NBC subsidiary), television broadcasting (through ownership of several experimental TV stations and huge investments in television research and development), manufacturing of broadcast receivers, recorded music and gramophone production (having acquired the Victor Talking Machine Company RCA, one of the leading companies in this field, in 1929) as well as film production, distribution and exhibition (through the creation of a RKO in 1928, a new major film company set up partly to promote RCA's sound-on-film system).[55] Under the leadership of RCA/RKO and Paramount/CBS, the integration of all media industries, comprising both sound and image reproduction, domestic technologies and cinema, equipment manufacturers and record and film production companies, was well under way.

The centrality of theatrical feature films for the newly (re-) integrated media industries was highlighted by several commentators at the time, most notably Robert E. Sherwood, whose article 'Beyond the Talkies - Television', published in *Scribner's Magazine* in July 1929, offered a sweeping analysis of media developments in the preceding years and a prescient outlook on the future.[56] Sherwood stated that, although actual broadcasts so far had been 'crude', 'all the big radio and electrical corporations are aware that television is not only inevitable but imminent'. He predicted that following and surpassing the example of radio, television advertising was a powerful promotional tool and, despite all criticism of the commercialization of broadcasting, it would become the main source of revenues for the new medium: 'The advertisers will continue to pay most of the cost

of broadcasting, and the radio manufacturers, who profit by the sale of (television) receiving sets, will continue to pay the rest'. After listing variety acts, news and sports as popular future programming for television, he concluded his article with

> the final and most important aspect of television: the broadcasting of talking moving pictures. It is significant that the movies should have learned to talk at this particular time, just when the radio is threatening to cast off its cloak of invisibility. It is a strange coincidence, but it is not by any manner of means an accidental one. It was carefully premeditated.

According to Sherwood, the big electrical and radio companies introduced sound to Hollywood so that Hollywood would be able to produce the key programming needed for the success of television:

> The film industry, once powerful and arrogant, is rapidly being reduced to the position of a 'subsidiary'.... It will be part of that vast and superbly organized scheme by which entertainment is to be delivered, free of charge, to the multitude.

With live appearances by performers and announcers kept to a minimum, the television schedules would be filled with filmed programming to be produced by the Hollywood studios, using both their traditional entertainment formats ('full-length photoplays, with the usual attendant short subjects – comedies, scenic pictures, news reels, etc.'), and instructional films. Of course, with Hollywood entertainment freely available on the domestic television screen, 'a considerable number of theatres are destined to close their doors', and 'the great mass of the population...will see the inside of a theatre, movie or otherwise, only rarely'. Only specialized movie houses which differentiated their programme from television entertainment would be able to survive. Sherwood ended his article with an indictment of the theatre as 'an impractical institution in this age of transportation and communication'. While, thanks to modern household technologies such as dishwashers and indeed television, the home was 'becoming a pleasanter place in which to live', when going outside the home, recreation seekers would certainly prefer not to 'go inward, to the most congested spot in the most congested district' where movie houses and other theatrical establishments were located; instead 'they will go outward, in quest of fresh air and elbow room'.

The substance of Sherwood's predictions turned out to be astonishingly accurate, yet his timing was off. The developments he described only took effect in the first decade after World War II. In the early 1930s, the poor picture quality of the low-definition mechanical system used in the first television boom could not in any way compete with the grandeur and splendour of the big movie screen, with which it was constantly compared.

This made it impossible for the new medium to deliver attractive programming enticing a sufficient number of consumers to buy sets. By 1933, the boom had collapsed and most stations had discontinued their regular television broadcasts. Furthermore, while films, especially silent cartoons, were occasionally used in television programming, the majority of programmes were live broadcasts.[57] The most important reason for the marginalization of all pre-recorded material both in early television and in radio broadcasting was the very success of commercial network radio pioneered by CBS. By the early 1930s, both CBS and NBC had a rapidly growing number of affiliate radio stations reaching up to half of the American population. Advertisers were eager to buy time slots in the networks' nation-wide programming, rather than continuing to buy time from individual stations for locally specific broadcasts. The radio networks' emphasis on live programming relayed to affiliate stations from their New York studios through telephone lines leased at high prices from AT&T, strengthened the ties between networks and their affiliates. This made sure that CBS and NBC were seen as the only conduit for direct advertising messages to a national audience, and they were thus able to gather the vast majority of advertising expenditures on broadcasting. Pre-recorded material (entertainment programmes including messages from the sponsor), on the other hand, threatened to undermine this position because this material could easily be distributed through the mail to stations for local broadcasts all over the country, reaching a national audience with a unified advertising message without having to deal with the networks and AT&T at all. Thus, it was the networks' emphasis on live programming which secured their control of commercial broadcasting. However, it also led them to relinquish control over the actual programmes, which were increasingly packaged and produced by advertising agencies such as N.W. Ayer and J. Walter Thompson on behalf of the leading manufacturers of consumer goods. The agencies' rapidly growing radio production departments developed programme concepts, prepared scripts, hired performers, rehearsed and revised the actual performance, and did not even enter the network's radio studio until the final rehearsal before the live broadcast.[58]

Due to the collapse of the television boom and radio's emphasis on 'live' programming controlled by networks and advertising agencies, the Hollywood majors gradually withdrew from broadcasting (albeit only temporarily). The retreat of the film companies, which were still primarily theatrical enterprises, was hastened by the depression that belatedly affected moviegoing after 1930, and by 1933 had brought down weekly attendances by a third. This meant that drastically reduced box office revenues no longer met the cost of film production at the majors' Hollywood production plants and that the film companies were unable to service the debts incurred during the massive expansion programme of the preceding years. Apart from Loew's, the majors made huge losses (with Paramount, Fox and RKO going into receivership), and assets had to be sold off, mainly theatres and interests in other industries. At the beginning of 1932, CBS

bought back its shares from Paramount to become a separate corporation again and, in the same year, RCA gradually began to sell off RKO, which was a clear indication that the communications industry could do very well without Hollywood. However, the close connection between the theatrical medium of cinema and the domestic medium of radio continued through the exchange of creative personnel. From the early 1930s, radio stars were heavily featured in films, and, more importantly, the appearance of Hollywood's larger-than-life stars proved to be an important element of radio programming, so much so that radio production soon began to relocate to Los Angeles. Yet, with radio production in the hands of advertising agencies, the majors could not fully exploit the popularity of their stars on radio, and profited only indirectly through the publicity radio appearances generated for their latest theatrical releases – which was how they had first conceived of the use of radio in the mid-1920s.[59]

The Battle for Control of Commercial Television: Hollywood, the Networks and Bigger Pictures, 1938-1953

When after the end of World War II, television finally and irrevocably got under way, the Hollywood majors had made a spectacular recovery from the financial collapse of the early 1930s, and they were again important players in the competition for control of the new medium. However, by far the strongest forces in this final move to television were the radio networks, supported by corporate giants RCA and AT&T and by government agencies. The networks saw television as an extension of their advertising-based sound broadcasting delivered 'live' into millions of American homes. In a replay of many of the debates and experiments of the first television boom, from the late 1930s the Hollywood majors tried a variety of ways to exploit the new medium for their own purposes, including the setting up of television stations with a view to constructing their own networks, the introduction of theatre television as a new technological attraction which might equal the success of musical and talking pictures ten years earlier, and subscription television services which charged domestic viewers for the home delivery of Hollywood films. These developments are again best exemplified by the activities of market leader Paramount. Soon after Paramount had recovered from the financial collapse of the film industry in 1932/33, it resumed its diversification into broadcasting, acting in accordance with the recommendations of the film industry's leading trade organization, the Motion Picture Producers and Distributors Association (MPPDA). In 1936/37, the MPPDA had conducted an enquiry into the relationship between Hollywood and television and had arrived at firm conclusions, summed up in the following trade magazine headline: 'Film Industry Advised to Grab Television'.[60] When, in 1938, Paramount acquired a substantial interest in the Allen B. DuMont Laboratories, one of the

leading companies in the field of television research and equipment manu-
facturing, its main objectives were to develop television applications which
could be used in Paramount's vast chain of 1,200 movie theatres, and to set
up a domestic delivery system for its theatrical releases.[61]

Hollywood's renewed investment in television was a precautionary measure
in the light of an imminent second television boom. This second boom had
been carefully masterminded by RCA and was based on its high-definition
electronic television system which could be expected finally to deliver the
picture quality missing from the earlier mechanical systems. Throughout
the 1930s, RCA poured five to ten million dollars into the development of
electronic television, more than all its American competitors combined.
With the clearly stated intention of developing television along the lines
of advertising-based 'live' network broadcasting as practised by its radio
subsidiary NBC, RCA constructed a new television studio and installed
a transmitter in the Empire State Building in New York in 1935, with
experimental television broadcasts of both 'live' and filmed programmes
beginning in 1936. In the same year RCA, together with AT&T, introduced
coaxial cables capable of transmitting high-definition motion pictures,
thus making the future networking of television stations possible. By 1938,
there was also considerable interest by advertisers in the new medium,
although, when compared to radio, the prospect of much more powerful
audiovisual sales messages had to be weighed against the increased costs
of sponsoring television programmes.[62] In 1938, then, at the brink of
the second television boom, Paramount (with DuMont) and RCA/NBC were
again pitched against each other, as they had been between 1929 and 1932
at the height of the first boom.

On 30 April 1939, RCA concluded the experimental phase of its electronic
television system and started regular broadcasts from its New York station,
addressed to the general public which was now able to buy costly, yet
affordable, television receivers from RCA and other manufacturers such
as DuMont and Philco, and the boom finally got under way, albeit more
slowly than anticipated. RCA's new television service was inaugurated with
a 'live' transmission of the opening ceremony of the New York World's
Fair, and about 100 to 200 receivers were tuned in. By the end of 1941,
thirty-two television stations were under construction across the United
States. The two radio networks NBC and CBS held licenses in three major
cities each, and Paramount together with DuMont held licences for five
stations. Following the model of radio, these groups of stations were seen
as the basis for the setting up of competing television networks. Yet, during
the first two years of this rapid expansion of television services, their
economic viability was undermined by a variety of problems. Due to the
lack of standardization amongst competing television systems, receiver
sales languished, with only a few thousand being sold across the United
States. And due to a considerable delay in the official authorization of
commercial television services, that is services paid for by sponsors

sending out commercial messages, this crucial source of income for television operators was blocked. These problems were finally solved in the spring of 1941, when the National Television System Committee (NTSC) agreed on a television standard, and the Federal Communications Commission (FCC) finally authorized commercial telecasting. By this time, however, industrial capacities were increasingly employed for military purposes, and soon after the entry of the United States into World War II in December 1941, the manufacturing of radio and television equipment was officially banned and commercial television's weekly programming was reduced to as little as four hours. Thus, in effect, the second television boom was delayed until 1946.[63]

While television was in hiatus between 1942 and 1946, the film industry's position in the media marketplace was strengthened, when after years of stagnation in the second half of the 1930s, cinema attendances and box office receipts returned to and surpassed the record levels of 1930. From 1943 to 1946, weekly attendance figures were at an all-time high of 82-84 million (out of a total population of about 130 million), and, between 1941 and 1946, box office receipts doubled to a record $1.69 billion. The profits of the major companies also returned to, and eventually topped, pre-depression heights.[64] Just as the box office boom of the late 1920s led to Hollywood's huge expenditure on the conversion to sound, expanded theatre chains and investments in broadcasting, so the increased revenues of the war years encouraged the majors to make crucial new investments in television. Following Paramount's example, Fox, Warners and Loew's/ MGM had all applied for licences in key cities by 1946, thus hoping to set up the cornerstones of their own television networks, and MGM and RKO had founded television departments, which were intended to produce pre-recorded material for telecasting. United Artists, a leading distributor of independent films, had already been active for several years in the field of selling television rights to theatrical releases past and present.Furthermore, in 1942 Paramount and Fox had jointly invested in the Scophony Corporation of America, a leading firm in the development of subscription television systems and of large screen television, which together with DuMont's innovations was intended for use in their theatres. And, in 1944, Paramount had begun to consolidate its television interests by applying for licences for two national microwave relay networks, which would link their television stations and their theatres, thus allowing the Hollywood major both to operate a television network addressed to a mass audience of domestic viewers (who could either receive 'free' television supported by commercial sponsors, or pay a subscription fee for particularly attractive programme services) and a nationwide chain of cinemas featuring 'live' television programming in addition to their traditional movie fare. Although war-time restrictions and AT&T's monopolistic control of long-distance wire transmissions forced Paramount to drop this plan, it did signal the company's serious intention to take control of television. This was confirmed by the fact that, together with DuMont, Paramount operated four

of the first nine commercial television stations actually going on air out of the dozens that had received licenses during the early 1940s. In the mid-1940s, then, it seemed that Paramount was about to establish the same level of control over television that it had in the film industry (with owner-ship of 1,400 first class movie theatres amounting to about ten per cent of the total seating capacity of cinemas in the United States).[65]

The very seriousness of Hollywood's attempt to take over television became an important factor in its almost complete failure during the first decade after the war, because it reinforced long-standing concerns about the majors' monopolistic practices. The Federal Communications Commission (FCC), which issued licences for broadcast operations, was strongly opposed to all of Hollywood's varied uses of television technologies, and instead supported the established broadcast interests NBC and CBS in their plan to transfer the model of commercial network radio to television. In fact, the FCC's concern about monopolistic practices in the broadcast industry had first been directed against the radio networks in an investigation launched in 1938, which resulted in a 1941 decision forcing NBC and CBS to divest their talent agencies and requiring NBC to sell off one of the two radio networks it operated (this network became the American Broad-casting Company, ABC, in 1944). Having successfully curtailed the influence of the radio networks, the FCC then turned its attention to Hollywood's television interests, motivated in particular by an important 1946 District Court decision in the long-running anti-trust action against the majors (the so-called Paramount case), which the Justice Department had started in 1938, charging the majors with conspiring to restrain trade and to monopolize the production, distribution and exhibition of films. The 1946 ruling found the majors guilty of these charges and prohibited them from engaging in certain trade practices such as price fixing and block booking (whereby independent exhibitors were forced to book groups of films rather than being able to select the most attractive ones). While the defendants put in an appeal, the FCC, on the basis of the 1934 Communications Act which authorized the commission to refuse licences to companies convicted of monopolistic practices, stalled the majors' applications for TV stations until the appeal was heard. Furthermore, following its 1947 decision to limit the number of TV stations that could be owned and operat-ed by any one party to five, the FCC applied this rule very strictly to Paramount and DuMont, which between them already held five station licences. The FCC did not accept their argument that, since they were separate companies, each should be allowed to own and operate five TV stations. Finally, in 1948, the Supreme Court not only confirmed the lower court's decision in the Paramount case but also, in effect, required the majors to divorce their theatre chains and reduce greatly the size of those chains. While the majors signed decrees consenting with the Supreme Court ruling (with Paramount also agreeing to divest all Scophony stock), they withdrew their applications for station licences because it was now clear that the FCC would refuse to grant them.[66]

With the majors out of the running for station ownership and thus unable to branch out into network television (with the exception of the five stations controlled by Paramount and DuMont), the FCC allocation plan for television frequencies ensured the rapid consolidation of NBC and CBS's TV network operations. Throughout the 1940s, the FCC issued TV licences in such a way that bunching of stations in the most attractive markets (that is the major urban conurbations) would be avoided and coverage of all areas of the United States could be achieved instead. This meant that even big cities were serviced by only two or three stations, and most of these were either owned and operated by NBC or CBS, or by one of their radio affiliates. Together with newspaper groups, radio stations had been among the earliest entrants into the television industry, and those radio stations affiliated with NBC and CBS were inclined to reproduce this profitable relationship for their TV off-shoots. Consequently, NBC and CBS quickly gathered a far-reaching line-up of affiliate stations, covering most of the United States, and in many areas having little or no competition from independent stations or smaller networks (ABC or DuMont). Since NBC and CBS also had a long-standing arrangement with AT&T concerning the lease of its telephone lines for long-distance transmissions between broadcast stations, they were able to hook up their affiliates for nation-wide 'live' broadcasts originating from their New York studios (however, the national grid of coaxial cables necessary for TV transmissions was only completed in 1952). Even with all these advantages, the cost of station construction, programme development and payments to affiliates still exceeded NBC and CBS's advertising revenues into the early 1950s by several millions of dollars. However, the networks could sustain these losses because they had other sources of income. RCA heavily supported NBC's television operations in order to promote receiver sales, and CBS made huge profits during the radio boom of the 1940s. Under these conditions, neither ABC nor the Paramount-backed DuMont network (which ceased operations in 1955) could effectively compete with the established networks. By the end of the four-year freeze on the licensing of new TV stations, which the FCC had declared in 1948 because of problems with frequency allocations and interference, the more than 100 TV stations on air were under the firm control of NBC and CBS, which had thus successfully replicated their radio duopoly, again strengthening the ties with their affiliates through 'live' programming.[67]

Hollywood's exclusion from the operation of TV stations and networks was particularly damaging in the light of the explosive growth of television set ownership and the simultaneous decline of cinema attendances during this period. At the end of the war, there had only been about 8,000 television receivers in the United States, yet with extended TV services returning and sets on sale again in 1946, the number of television households exploded: 14,000 in 1947, 172,000 in 1948, 1 million in 1949, 3.9 million in 1950, 10.3 million in 1951, and 15.3 million in 1952, that is a third of all American households (or about fifty million people). Hollywood, on the

other hand, was losing about ten per cent of its theatrical audience every year from 1947 to 1952, bringing down weekly attendance figures from eighty-two million in 1946 to forty-three million in 1952. From 1946 to 1952, box office revenues were down by a quarter to $1.25 billion (this drop was less drastic than that of attendances due to increased ticket prices), while the revenues of television stations and networks were growing rapidly in the early 1950s, with, for example, a forty per cent increase to $324 million in 1952.[68] Rather than seeing the rise of television as the main cause for cinema's decline, it is perhaps more accurate to see both of these developments as symptoms of an underlying change in the life-style of the American middle class, which Robert E. Sherwood had already outlined in his 1929 article: an increased focus on the home (now increasingly a house in the suburbs) and family life (with increased birth rates during the so-called baby boom), increased reliance on the help and comfort provided by domestic appliances (affordable due to the switch of industrial mass production from military hardware to consumer goods), and a shift in preference away from theatrical entertainments towards outdoor recreation such as gardening, sports and travelling.[69]

When the Hollywood majors confronted a rapidly declining theatrical market in the late 1940s without being able to profit from the rise of commercial telecasting, the projection of televisual transmissions onto big screens in movie theatres became a particularly attractive proposition for them. Despite enormous growth rates in set ownership of more than 1,000 per cent in 1947/48 and almost 600 per cent in 1948/49, domestic television was not yet a mass medium. It reached only a small fraction of American homes, while every week Hollywood was still drawing the equivalent of half of the American population into its theatres. Furthermore, TV programming had to be cheap as advertising revenues were low due to the limited audience that TV's commercial messages could reach. The huge movie theatre chains, on the other hand, were able to pay for the 'live' transmission into their houses of expensive stage shows, of important news events such as political speeches or of big sporting occasions such as championship boxing matches. They could offer these transmissions either instead of, or in addition to, the regular film programme, and thus entice potential cinemagoers with brand new attractions, possibly halting or reversing the decline in attendances this way. If widely and successfully implemented, these relays might even convince the public that television was in fact a theatrical medium like film, rather than a domestic medium like radio. In 1947 and 1948 there were numerous demonstrations of theatrical television, most notably by RCA and Paramount, with Warners, Loew's and Fox also introducing their own systems. These demonstrations were followed by the installation of theatre television systems in the flagship theatres of the major chains, where live transmissions of spectacular events became a regular part of the programme. By 1952, over 100 movie theatres had been equipped with theatre television. Further expansion, however, was prevented by a variety of problems. Installation costs were quite high

(ranging from $15,000 to $35,000), and many theatres could not afford this, especially after the divorcement and reduction in size of the leading chains which followed the consent decrees in the Paramount case. Transmission costs were also high, as lines had to be leased from AT&T at a high price, and more cost-effective simultaneous transmissions to a number of theatres were difficult to arrange because of the limited availability of lines. The majors' many applications for separate frequencies for the broadcasting of special events into a network of far-flung theatres were finally rejected in 1953 by the FCC in line with the commission's earlier opposition to Hollywood's involvement in television. Finally, theatre television was not the big sensation that it had been expected to be, and its installation did not lead to a significant increase in box office revenues. Thus, the boom in theatre television collapsed in 1952/53, at which time television became firmly established as a domestic mass medium.[70]

By 1953, then, the position of the Hollywood majors within the American media industries had changed dramatically from their dominance of a booming theatrical market and their apparently imminent takeover of television during the war years. The majors' attempt to establish televison as a theatrical entertainment had failed, and they had also been excluded from the operation of commercial TV stations and networks delivering 'free' audiovisual entertainment into a rapidly growing number of American homes. At the same time, the drastic decline in weekly cinema attendances from the war-time peak of eighty-four million to half that number in 1953, which was worse even than the drop caused by the depression in the early 1930s, severely undermined the film industry's financial position. Furthermore, instead of catering for a regular patronage of the equivalent of half or even two thirds of the American population wanting to see a new film every week, Hollywood now had to deal with the fact that many former patrons stayed away from the movie theatres altogether, while those who still attended went less frequently. The film industry's long-standing policy (first implemented by the Edison/Biograph duopoly around 1908) to provide a regular output of films for a mass audience of habitual moviegoers was thus called into question. This challenge to the fundamental operating principles of Hollywood was further intensified by the government's anti-trust action which forced the majors, between 1948 and 1952, to sign decrees consenting to their disintegration into much smaller corporate units. Although the last divestitures were not completed until 1957, by 1953 each of the formerly vertically integrated majors (with the exception of Loew's/MGM) had been cut apart into two separate corporations, a production-distribution firm and a theatre chain, and the size of those chains had been reduced drastically. In December 1949, for example, Paramount was split into Paramount Pictures Corporation (owning a Hollywood studio, a distribution network, about 380 theatres in foreign countries, stock in DuMont and a TV station in LA, with total assets of $109 million) and United Paramount Theatres (owning 1,400 theatres in the United States, half of which the company was required to sell off, and

a TV station in Chicago, with total assets of $84 million).[71] This separation destroyed the traditional rationale (in place since the 1920s) for the existence of the film industry's huge production plants in Hollywood: that of servicing the programming needs of theatre chains, whose guaranteed box office revenues in turn provided the funds necessary for the maintenance of studio complexes and the payment of salaries for thousands of employees on long-term contracts. Divorced from their theatrical businesses, the much smaller corporate units in the production and distribution sectors which emerged from the anti-trust action had to re-orient themselves in the rapidly changing media marketplace of post-war America.

The strategies which the major producer-distributors eventually adopted were clearly outlined by leading independent producer Samuel Goldwyn as early as 1949.[72] Goldwyn, a contemporary of Adolph Zukor and Marcus Loew, had entered the film industry in 1913, yet instead of becoming the chief exceecutive of one of the vertically integrated major companies, Goldwyn had been running, since 1923, his own independent studio, concentrating his efforts on a small output of comparatively expensive films released through United Artists and RKO. Many of his productions won considerable critical acclaim including numerous Academy Awards, yet the backbone of his business was a string of outstanding box office successes. Goldwyn produced three of the six top hits of the 1930s, as well as the biggest success of the 1940s – *The Best Years of Our Lives* (1946), which also won seven Oscars. Furthermore, Goldwyn had been the mentor of the second most successful independent producer in Hollywood, David O. Selznick, whose 1939 superproduction *Gone With the Wind* had quickly become the highest grossing film of all time, and whose 1946 film *Duel in the Sun* joined *Best Years*, Disney's *Snow White and the Seven Dwarfs* (1937) and *The Birth of a Nation* (1915) in the top five.[73] Interestingly, none of these five most successful films in Hollywood history up to this point, nor the two films which had initiated Hollywood's conversion to sound, *The Jazz Singer* and *The Singing Fool* (both made in 1927/28 as special features by Warners), had been made by one of the major studios as part of their regular release schedule. Instead they had been produced and marketed as special events, for which top ticket prices were charged during long runs in their initial limited release.

In his prescient 1949 article 'Hollywood in the Age of Television', Goldwyn argued that this kind of specialized and individualized independent theatrical film production and distribution, best represented by the operations of his own studio (as well as those of Selznick International Pictures and Disney's animated feature unit), would receive a tremendous boost from the rise of domestic television. Similar to Robert E. Sherwood's predictions twenty years earlier, Goldwyn was convinced that television services into all American homes revolving around pre-recorded filmic entertainment would soon become a reality. The film industry would find a new source of income from releasing 'the flickering shadows of old

films which have reposed in their producers' vaults for many years' to television, and from 'creating motion pictures designed explicitly for this new medium'. With such films freely available to all Americans at home, '(i)t is going to require something truly superior to cause them not only to leave their homes to be entertained, but to pay for that entertainment'. The major studios' highly industrialized mode of production geared towards the regular output of large numbers of films was unsuited to this differently-constituted theatrical market, although it would, of course, be perfectly suited to satisfying the enormous demand of television for new filmic product. Movie theatres, on the other hand, would come to rely on special productions, expensively hand-crafted and outstanding in terms of content, artistic ambition and technical quality: 'Pictures like these, far above the average today, will have to be the norm in the future.' Thus, instead of competition between the film and television industries, Goldwyn saw them as allies who 'can quite naturally join forces for their own profit and the greater entertainment of the public', as long as the film industry accepted its limited role as television's main programme provider. At the same time, the major studios' 'monopolistic controls and practices' in the theatrical market which 'have hurt independent production' would finally be removed to allow for a new division of labor between specialized independent units producing theatrical features and highly industrialized studio production delivering a massive output of telefilms:

> The certainty is that in the future, whether it be five or ten or even more years distant, one segment of our industry will be producing pictures for exhibition in the theatres while another equally large section will be producing them for showing in the homes.[74]

In many ways, the year 1953 marked the beginning of the major producer-distributors' successful implementation of the dual strategy outlined in Goldwyn's article. In that year, United Paramount Theatres (which was still the largest cinema chain in the US with 600 houses) managed to get permission from the FCC to take over the struggling ABC network, and immediately launched an extensive campaign to bring in minor and major Hollywood studios to produce programmes exclusively for telecasting which would differentiate ABC's output from the live shows of NBC and CBS. By 1955, Disney and Warners had signed up with ABC to become major telefilm producers. The other major studios and the two larger networks followed with similar arrangements, and soon Hollywood produced far more material for television (mainly half-hour situation comedies and one-hour drama series) than it did for movie theatres. Being able to demand substantial licence fees from the now dominant mass medium, the majors also gradually released their film libraries to television. In turn, the TV networks, having established themselves as the main providers of audiovisual entertainment and advertising messages to a nation-wide mass audience, largely displaced their traditional dependence on live shows

put together by sponsors and advertising agencies, with an emphasis on pre-recorded material bought in from Los Angeles-based film production companies. Thus, Hollywood became the main programme provider for television, and television became the primary outlet for the bulk of Hollywood's production as well as an important secondary outlet for its theatrical releases.

While this symbiotic relationship between Hollywood and television emerged in the mid-1950s, there was also a mini-boom at the box office, brought about largely by the majors' release of a series of big budget widescreen blockbusters, beginning with *The Robe* in 1953. As Goldwyn had suggested in 1949, the majors did indeed apply the principles of big budget independent production to an increasing share of their theatrical output, releasing staff from long-term contracts and moving towards semi-independent production units put together on short-term contracts for specific projects. Investment in individual theatrical releases increased to allow for technological innovation (such as colour and wide-screen processes), location filming and extended shooting schedules, and creative personnel were often given more control, in an attempt to produce 'special' films with unique qualities able to attract cinema audiences in their own right. Instead of servicing the programming needs of movie theatres providing habitual cinemagoers with a new show every week, from now on the majors were aiming to produce a few massive hits, each promising a unique cinematic experience to an audience which had fallen out of the habit of going to the movies and needed added incentives to buy a ticket. At the same time, with their huge output of telefilms, the majors continued to service their traditional audience of habitual viewers who were now located in front of domestic television sets rather than in theatres. Their telefilm subsidiaries retained many aspects of the earlier mode of studio production (such as longer-term contracts, brief shooting schedules, tight managerial control of the production process) so as to be able to provide the regularity and continuity of audiovisual entertainment programming which these viewers expected. Thus, the old studio system was transferred to telefilm production, while the (semi-)independently produced 'big' picture became the norm for major theatrical releases.[75]

Conclusion

From their very inception in the late nineteenth century, moving pictures have been caught up in the televisual imagination – a vision of the whole world being made available to everyone in the privacy of their homes by means of the technologies of sound and image reproduction. At various points in the development of film as an applied technology, a commercial enterprise and a cultural form, visionary entrepreneurs and commentators from Thomas Edison to William S. Paley, Robert E. Sherwood and Samuel Goldwyn proclaimed the inevitability of moving pictures eventually entering the home, physically on 'tape' or immaterially 'on the air', so as to fulfill

the entertainment needs of millions of domestic consumers. In a parallel development, the ever renewable and often surprisingly powerful appeal of the projection of moving pictures onto big screens, from the first commercial displays in 1895/6 to the full-length features of the early 1910s and the sound films of the second half of the 1920s, the widescreen spectacles of the mid-1950s and the blockbusters of today, allowed for a revolutionary transformation of theatrical entertainment. By cannibalizing variety formats, legitimate drama, musical entertainment and roller-coaster rides, and by turning their 'live' attractions into mass-reproduced and widely-circulated artifacts, moving pictures, placed at the centre of an evening's entertainment at the theatre, gave rise to what is arguably the most popular form of public entertainment in history – the cinema. In an ongoing struggle, which began in the late nineteenth century and is intensifying again today, various interest groups, ranging from the giant corporations of the electrical and communications industries to producers, filmmakers and indeed consumers, have tried to shape and control the manifold uses of film technology, conceptualizing and exploiting it in many different and ever-evolving ways – as a strictly public and theatrical cultural form, as a primarily private and domestic medium or as a complex synthesis of both.

Already at the time of the nickelodeon boom, when the cinema first became a theatrical institution in its own right in the United States, several commentators realized that the spectacle of the large screen projection of moving pictures in theatres might help to promote their domestic use, as the initial theatrical release of films was likely to make them more attractive to private individuals wishing to project them at home. This realization informed speculations about the future centrality of Hollywood movies for television programming from the late 1920s onwards (and also, indirectly, the extensive use of Hollywood stars and genres by radio producers, especially in the 1930s), and it underpins the cable and video industries of today. On the other hand, beginning in the 1920s, Hollywood realized the powerful appeal of radio appearances of its stars, radio dramatizations of its stories and glimpses of its films in television commercials, which provided the unique opportunity to make an instantaneous sales pitch to the largest possible audiences in the comfort of their homes, enticing them to join the public spectacle of a movie show in a nearby theatre. In the light of this mutually beneficial relationship between theatrical projection and domestic display of moving pictures, it is not surprising that even after the film industry, in the early 1910s, was finally established as a theatre-based business, separated from electrical hardware manufacturers and communications companies eyeing the domestic market, a close relationship continued to exist between these industrial sectors, leading from their temporary integration during the first television boom and again in the decade after 1938, to what looks like an inevitable and perhaps permanent fusion of the major Hollywood studios with the television, video, cable, telephone and consumer electronics industries which began in the late 1980s.

Whether the major studios operated as separate entities, or whether they were joined with corporations in related fields, they always depended on the habitual consumption of their products and the steady revenues generated from that habit for the maintenance of their expensive production facilities in Hollywood and the associated glamorous life-styles of their key personnel. Until the late 1940s, theatrical entertainment was a sufficiently large and dependable source of income, and the major studios were affiliated with huge theatre chains. Yet with the decline of the moviegoing habit and the legally enforced separation of the production-distribution sector from theatrical exhibition in the late 1940s, the studios had to concentrate on new markets and new corporate allies, which they found in the domestic entertainment industry. By the mid-1950s, television provided the studios with a major outlet for their films, yet only a minor source of income, the majority of which still had to be generated in an increasingly volatile and hit-driven theatrical market. In the 1980s, however, cable and video began to provide a vast and secure source of income matching the size and reliability of the theatrical market in the earlier era, and the studios became affiliated with corporate partners in the field of domestic technologies.

Contrary to many predictions about the negative impact of new technologies on film exhibition, this affiliation has not led to a reduction in size or status of the theatrical market; it has merely increased its reliance on hits. Within an integrated media industry, dependent as ever on regularity of output and habitual consumption, these hits play an essential role, and will no doubt continue to do so. Following the pattern of the momentous cinematic events of the past – such as the release of *Star Wars, The Robe, Gone With the Wind, The Jazz Singer, The Birth of a Nation, The Great Train Robbery* and indeed, the grand première of 'Edison's Vitascope' – the big pictures of today serve to celebrate, and occasionally to redefine, the unique qualities of the theatrical film experience itself. In doing so, they renew the pleasures of, and give a special meaning to, the habits of film production and consumption, which are now largely practised at home.

References

1. Francis Ford Coppola's *The Godfather* soon became the highest grossing film of all time when it was released in 1972. Together with its 1974 sequel, it also topped the list 'The Best American Films Of The Decade' in a survey of international critical opinion conducted by James Monaco in 1978. Martin Scorsese's *Taxi Driver* shared eighth place in this list, while also ranking amongst the top fifteen top box office hits of 1976. See James Monaco, *American Film Now: The People, the Power, the Money, the Movies* (New York: Plume, 1979), pp.412-20, and Cobbett Steinberg, *Reel Facts* (New York: Vintage, 1981), pp.443, 445.

2. Michael Pye and Lynda Myles, *The Movie Brats: How the Film Generation Took Over Hollywood* (New York: Holt, Rinehart and Winston, 1979), p.7.

3. Monaco's *American Film Now* was an early and very thorough critical attack in 1979, dealing with all aspects of the American film industry, ranging from corporate structures and strategies to the art and politics of filmmaking. Mark Crispin Miller's collection *Seeing Through Movies* (New York: Pantheon, 1990) constitutes an equally forceful and comprehensive condemnation of contemporary American cinema. Political critiques attacking the majority of Hollywood's output since the late 1970s are presented, for example, by Robin Wood, *Hollywood From Vietnam to Reagan* (New York: Columbia University Press, 1986), and Michael Ryan and Douglas Kellner, *Camera Politica: The Politics and Ideology of Contemporary Hollywood Film* (Bloomington: Indiana University Press, 1990). A more empirical and less overtly critical analysis of Hollywood's operations in the 1980s and 1990s has recently been developed in Justin Wyatt, *High Concept: Movies and Marketing in Hollywood* (Austin: University of Texas Press, 1994).

4. As a cursory, yet fairly broadly-based survey of critical essays published in academic journals over the last ten years or so revealed, analytical and interpretive efforts are concentrated on a very small and totally unrepresentative sample of films, most notably cult films such as *Blade Runner* (1982), *The Terminator* (1984) and *Blue Velvet* (1986) and box office hits with post-feminist credentials of some kind (*Alien/Aliens* [1979/1984] *Fatal Attraction* [1988] *Thelma and Louise* [1991] *The Silence of the Lambs* [1991]). In the mainstream of academic film criticism, there are hardly any thorough discussions of, for example, Lucas and Spielberg's megablockbusters.

5. Again, examples are far too numerous to be listed here. Possibly the most sustained discussions of contemporary American cinema along these lines can be found in Norman K. Denzin, *Images of Postmodern Society: Social Theory and Contemporary Cinema* (London: Sage, 1991), and Timothy Corrigan, *A Cinema Without Walls: Movies and Culture After Vietnam* (London: Routledge, 1991).

6. A recent example is Janet Wasko, *Hollywood in the Information Age* (Cambridge: Polity, 1994).

7. These issues are addressed with particular reference to audience use of media technologies in W. Russell Neuman, *The Future of the Mass Audience* (Cambridge: Cambridge University Press, 1991). Neuman discusses research on established media such as book and newspaper publishing, telecommunications systems (e.g. the telephone), radio and television broadcasting and cable services, as well as movies in order to evaluate present and future developments concerning the transformation of these established media into an integrated digital electronic network.

8. Roy Armes, *On Video* (London: Routledge, 1988), p.34.

9. Apart from Armes' book, my work has also been inspired by Vincent Porter's survey essay 'The Three Phases of Film and Television', *Journal of Film and Video*, vol.36, no.1, Winter 1984, pp.5-21.

10. *Orange Chronicle*, 23 May 1891, quoted in Gordon Hendricks, *The Edison Motion Picture Myth* (Berkeley: University of Los Angeles, 1961), p.111. Edison's original 'Motion Picture Caveat I' of October 1888 saw the motion picture apparatus as a parallel development and complement to the phonograph: 'I am experimenting upon an instrument which does for the Eye what the phonograph does for the Ear, which is the recording and reproduction of things in motion, and in such a form to be both Cheap practical and convenient.' (original spelling and punctuation, reprinted in Hendricks, ibid., p.158).

11. *World's Columbian Exposition Illustrated*, May 1891, quoted in Hendricks, *The Edison Motion Picture Myth*, p.104.

12. Charles Musser, *Before the Nickelodeon: Edwin S. Porter and the Edison Manufacturing Company* (Berkeley: University of Los Angeles Press, 1991), pp.31-44.

13. Albert Abramson, *The History of Television, 1880 to 1941* (Jefferson, NC: McFarland, 1987), pp.6-9. The cartoon appeared in 'Punch's Almanac for 1879', *Punch*, 9 December 1878, p.11. It is reprinted in Ian Christie, 'The Wizard of Oz', *Sight and Sound*, vol.5, no.5, May 1995, p.26.

14. George Parsons Lathrop, 'Edison's Kinetograph', *Harper's Weekly*, 13 June, 1891, reprinted with a brief introduction by Gerald Mast in his *The Movies in Our Midst: Documents in the Cultural History of Film in America* (Chicago: University of Chicago Press, 1982), pp. 8-12.

15. Musser, *Before the Nickelodeon*, pp.44-47. The prices listed in this section have to be multiplied by a factor of about ten to arrive at the equivalent prices today.

16. Roland Gelatt, *The Fabulous Phonograph* 1877-1977 (London: Cassell, 1977, 2nd revised edition), pp.17-45.

17. Musser, *Before the Nickelodeon,* pp.47-56.

18. Gelatt, *The Fabulous Phonograph*, pp. 55-7, 69-71; the advertisement is quoted on p.69.

19. Claude Fischer, *America Calling: A Social History of the Telephone to 1940* (Berkeley: University of California Press, 1992), pp.41-50.

20. Douglas Collins, *The Story of Kodak* (Harry N. Abrams, 1990), pp.46-72. By comparison, Edison sold only about 1,000 kinetoscopes, plus 45 kinetophones. Most machines were sold in 1894 and 1895, and the market for them had disappeared completely by 1900. See Gordon Hendricks, *The Kinetoscope* (New York: G.P.O., 1966), pp.125, 143.

21. Abramson, *The History of Television*, pp.19-20; and Erik Barnouw, *A Tower in Babel: A History of Broadcasting in the United States: Volume I - to 1933* (New York: Oxford University Press, 1966), pp.9-12.

22. Charles Musser, *The Emergence of Cinema: The American Screen to 1907* (New York: Scribner's, 1990), Chs.1 and 3.

23. *New York World*, 28 May 1895, p.30, quoted in Musser, *The Emergence of Cinema*, p.96.

24. Musser, *The Emergence of Cinema*, Ch.3, and *Before the Nickelodeon*, Ch.4.

25. Musser, *The Emergence of Cinema*, Chs.4-14.

26. Eileen Bowser, *The Transformation of Cinema*, 1907-1915 (New York: Scribner's, 1990), Chs.1 and 8.

27. Bowser, *The Transformation of Cinema*, Chs.5, 12, 13; and Musser, *Before the Nickelodeon*, Chs.11-13.

28. Musser, *Before the Nickelodeon*, p.457.

29. Patricia R. Zimmerman, 'Entrepreneurs, Engineers, and Hobbyists: The Formation of a Definition of Amateur Film 1897-1923', in Bruce A. Austin (ed.) *Current Research in Film, Volume 3* (Norwood: Ablex, 1987), pp.163-188, and Ben Singer, 'Early Home Cinema and the Edison Home Projecting Kinetoscope', *Film History*, vol.2, 1988, pp.37-69.

30. *Views and Film Index*, 28 July 1906, quoted in Singer, 'Early Home Cinema', p.41.

31. Singer, 'Early Home Cinema', pp.44-6, 49-62.

32. By 1917, the film had earned its distribution company about $5 million, out of an estimated overall box office gross of up to $60 million, which made it by far the highest grossing film of the silent era. See Richard Schickel, *D.W. Griffith* (London: Pavilion, 1984), pp.244-281.

33. Bowser, *The Transformation of Cinema*, Ch.13; Richard Koszarski, *An Evening's Entertainment: The Age of the Silent Feature Picture, 1915-1928* (New York: Scribner's, 1990), Ch.3; Douglas Gomery, *The Hollywood Studio System* (London: Macmillan, 1986), Ch.2.

34. Douglas Gomery, *Shared Pleasures: A History of Movie Presentation in the United States* (London: BFI, 1992), pp.32-62; and Michael Conant, *Antitrust in the Motion Picture Industry* (New York: Arno, 1978), p.25.

35. Richard Maltby, 'The Political Economy of Hollywood: The Studio System', in Philip Davies and Brian Neve (eds.), *Cinema, Politics and Society in America* (New York: St. Martin's, 1981), pp.42-58; and Gomery, *The Hollywood Studio System*, Ch.1.

36. Gary Edgerton, 'Radio and Motion Pictures: A Case Study of Media Symbiosis', *Mass Communication Review*, vol.8, Winter 1980/81, p.23. cf. Joel W. Finler, *The Hollywood Story* (London: Octopus, 1988), p.288 for slightly different figures on the film industry.

37. Michele Hilmes, *Hollywood and Broadcasting: From Radio to Cable* (Urbana: University of Illinois Press, 1990), p.42.

38. Samuel L. Rothapfel and Raymond F. Yates, *Broadcasting: Its New Day* (New York: Century, 1925), p.156, quoted in Hilmes, *Hollywood and Broadcasting*, p.34.

39. Moving Picture World, 5 April 1925, p.436, quoted in Hilmes, *Hollywood and Broadcasting*, pp.34-5.

40. Hilmes, *Hollywood and Broadcasting*, pp.33-45; quotation from *New York Times*, 24 May 1927, cited on p.38.

41. Hilmes, *Hollywood and Broadcasting*, pp.38-43, 50-3; cf. Barnouw, *A Tower in Babel*, pp.219-224.

42. Joseph H. Udelson, *The Great Television Race: A History of the American Television Industry 1925-1941* (University of Alabama Press, 1982), pp.26-31.

43. C. Francis Jenkins, *Vision by Radio, Photographs, Radio Photograms* (Washington: Jenkins Laboratories, 1925), p.12, quoted in Udelson, *The Great Television Race*, p.27.

44. *New York American*, 17 December 1927, quoted in Hilmes, *Hollywood and Broadcasting*, p.45.

45. It is also worth noting that with Eastman Kodak's entry into the amateur camera and home projector market in 1923, setting a new 16mm standard and offering an impressive selection of films, including recent Hollywood releases, home movie projection finally became a reality for hundreds of thousands Americans in the mid-1920s. See Singer, 'Early Home Cinema', pp.47-8.

46. Herbert E. Ives, 'Television', *Bell System Technical Journal*, vol.6, October 1927, p.551, quoted in Udelson, *The Great Television Race*, p.31.

47. 'Far Off Speakers Seen As Well As Heard Here in a Test of Television', *New York Times,* 8 April 1927, p.1, quoted in Udelson, *The Great Television Race*, pp.31-2.

48. Abramson, *The History of Television*, pp.128, 133, 153, 162-3, 165.

49. Udelson, *The Great Television Race*, pp.37-9.

50. William S. Paley, address, St. Louis, January 1929, quoted in William Boddy, '"Spread like a monster blanket over the country": CBS and television, 1929-1933', *Screen*, vol.32, no.2, Summer 1991, p.176.

51. William S. Paley, 'Radio and the Movies Join Hands', *Nation's Business*, vol.17, no.11, October 1929, p.237, quoted in Udelson, *The Great Television Race*, p.47.

52. Boddy, '"Spread like a monster blanket"', pp.177-8; and Udelson, *The Great Television Race*, pp.58-9.

53. Douglas Gomery, *Shared Pleasures*, Ch.10; Gomery, *The Hollywood Studio System*, Ch.5; Gomery, 'The Coming of Sound: Technological Change in the American Film Industry', in Tino Balio (ed.) *The American Film Industry* (Madison: University of Wisconsin Press, 1985, 2nd revised edition), pp.229-251; and Gomery, 'The Singing Fool', in Peter Lehmann (ed.) *Close Viewings: An Anthology of New Film Criticism* (Tallahassee: Florida State University Press, 1990), pp.370-81. Weekly cinema atten-

dances increased from forty-six million in 1925 to eighty million in 1930. Box office revenues doubled and the number of movie theatres increased by about 5,000 during this period. The number of cinemas wired for sound went up from 100 in 1928 to 800 in 1929 and 8,900 in 1930. See Finler, *The Hollywood Story*, p.288; cf. Edgerton, 'Radio and Motion Pictures', p.23, for slightly different figures.

54. Gomery, 'The Coming of Sound', pp.248-51, and Gomery, *The Hollywood Studio System*, pp.109-10.

55. Armes, *On Video*, Ch.2; Barnouw, *A Tower in Babel*, esp. Chs.2, 4; and Udelson, *The Great Television Race* Chs.1-4.

56. Robert E. Sherwood, 'Beyond the Talkies - Television', *Scribner's Magazine*, July 1929, pp.1-8. For further contemporary discussions of the uses of television see James L. Baughman, 'The Promise of American Television, 1929-1952', *Prospects*, no.11, 1987, pp.119-134.

57. Udelson, *The Great Television Race*, Ch.3.

58. Hilmes, *Hollywood and Broadcasting*, Chs.3-4.

59. Gomery, *The Hollywood Studio System*, Chs.2 and 6, Hilmes, *Hollywood and Broadcasting*, Chs.3-4, and Richard Jewell, 'Hollywood and Radio: Competition and Partnership in the 1930s', *Historical Journal of Film, Radio and Television*, vol.4, no.2, 1984, pp.125-41.

60. 'Film Industry Advised to Grab Television', *Broadcasting*, 15 June 1937, p.7, cited in William Lafferty, 'Film and Television', in Gary R. Edgerton (ed.) *Film and the Arts in Symbiosis: A Resource Guide* (Westport, CT: Greenwood, 1988), p.276.

61. Gomery, *The Hollywood Studio System*, Ch.2, and Lafferty, 'Film and Television', p.277. Paramount's diversification was paralleled by Warners' increased investments in radio in the mid- to late 1930s, including ownership of stations and of an equipment manufacturer, trading in pre-recorded radio programming, and the thwarted plan to back and expand the Mutual Broadcasting System network, a potentially serious rival to CBS and NBC. In 1936/37 leading independent film producer David O. Selznick and his business partner John Hay Whitney seriously considered heavy investments in the Farnsworth Television Corporation, which was RCA's main rival in the development of a viable electronic television system. See Christopher Anderson, *Hollywood TV: The Studio System in the Fifties* (Austin: University of Texas Press, 1994), pp.28-37.

62. Udelson, *The Great Television Race*, Ch.4.

63. ibid., Chs.5 and 6.

64. Finler, *The Hollywood Story*, pp.286-8.

65. Lafferty, 'Film and Television', pp.278-86; Douglas Gomery, 'Failed Opportunities: The Integration of the U.S. Motion Picture and Television Industries', *Quarterly Review of Film Studies*, Summer 1984, pp.219-28; Douglas Gomery, 'Theatre Television: The Missing Link of Technological Change in the U.S. Motion Picture Industry', *The Velvet Light Trap*, no.21, 1985, pp.54-61; and Timothy R. White, 'Hollywood's Attempt at Appropriating Television: The Case of Paramount Pictures', in Tino Balio (ed.) *Hollywood in the Age of Television* (Boston: Unwin Hyman, 1990), pp.145-63.

66. Erik Barnouw, *The Golden Web: A History of Broadcasting in the United States: Volume II - 1933 to 1953* (New York: Oxford University Press, 1968), pp.168-174; Gomery, 'Failed Opportunities', pp.224-7; and White, 'Hollywood's Attempt', pp.145-9.

67. Tino Balio, 'Introduction to Part 1' and James L. Baughman, 'The Weakest Chain and the Strongest Link: The American Broadcasting Company and the Motion Picture Industry, 1952-60', both in Balio (ed.) *Hollywood in the Age of Television*, pp.3-40, 91-114.

68. Figures taken from Finler, *The Hollywood Story*, pp.288-9, Lafferty, 'Film and Television', p.281, and Tino Balio, 'Introduction to Part 1', p.15. Some scholars use different sets of figures; cf. Fredric Stuart, *The Effects of Television on the Motion Picture and Radio Industries* (New York: Arno, 1976), p.11 and Conant, *Antitrust*, Ch.1.

69. Gomery, *Shared Pleasures*, Ch.5.

70. Gomery, 'Theatre Television', passim. Similar problems beset subscription television which Paramount and others tried to introduce in the early 1950s. Costs were high, installation rates and use of domestic pay-TV facilities during commercial tests were disappointing, and there was enormous opposition by the public in general and the FCC in particular to the idea that certain television services were not delivered into the home for free, but would have to be paid for. See White, 'Hollywood's Attempt', pp.155-61.

71. Conant, *Antitrust*, Ch.6; and Gomery, *The Hollywood Studio System*, p.49.

72. Samuel Goldwyn, 'Hollywood in the Age of Television', *Hollywood Quarterly*, Winter 1949/50, reprinted in Mast (ed.), *The Movies in Our Midst*, pp.634-9.

73. A. Scott Berg, *Goldwyn: A Biography* (London: Sphere Books, 1990), Chs.3-19; Finler, *The Hollywood Story*, pp.276-7.

74. Goldwyn, 'Hollywood in the Age of Television', passim.

75. Balio, 'Introduction to Part 1', Baughman, 'The Weakest Chain and the Strongest Link', and John Belton, 'Glorious Technicolor, Breathtaking CinemaScope, and Stereophonic Sound' in Balio (ed.) *Hollywood in the Age of Television*, pp.3-40, 91-114; Robert Vianello, 'The Rise of the Telefilm and the Networks' Hegemony Over the Motion Picture Industry', *Quarterly Review of Film Studies*, Summer 1984, pp.204-18; William Boddy, 'The Studios Move into Prime Time: Hollywood and the Television Industry in the 1950s', *Cinema Journal*, vol.24, no.4, Summer 1985, pp. 23-37.

3

'They Think It's All Over': The Dramatic Legacy of Live Television

Charles Barr

If there is a canon of classic TV plays, then *Marty* (1953), written by Paddy Chayefsky and directed by Delbert Mann, certainly belongs to it. Originally broadcast on the NBC network in May 1953, it was an automatic inclusion in the series of (American) archive plays that was shown on American television in 1981, and soon afterwards in Britain, early in the life of Channel Four, under the title *The Golden Age of Television*.

The play's opening scene is set in the butcher's shop where Marty (Rod Steiger) works, and establishes him as a New Yorker in his 30s from a large Italian family, unmarried but under pressure to find a wife. The scene ends on a close-up of Marty, and a slow dissolve takes us into scene two. On the left of the frame is a TV set showing a baseball game, on the right is an electric clock: the movement of the second hand being visible, we can read the time as 4.54 (p.m.) and 25 seconds. The camera draws back and round, revealing that we are in a bar (the barman glances up at the TV screen), and comes to rest on two men – Marty and a friend – who are seated next to each other at a table. We pick up their conversation and listen for some time, until the camera moves off again and retraces its path, more quickly now, up to the clock and the TV set. The baseball game is still on, and the time, as the scene fades out, is 4.57 p.m. and 40 seconds.

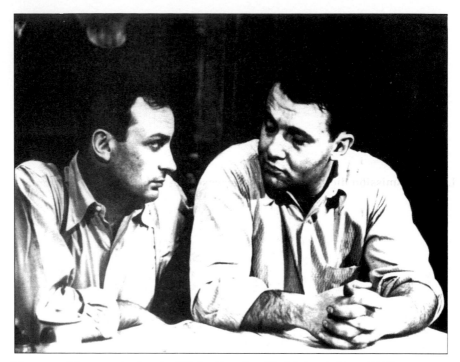

'The sense of danger endemic to live TV': Joe Mantell and Rod Steiger in *Marty* (1953)

Why shoot it this way? The formal symmetry is obtrusive, and the bar setting could have been established by less elaborate devices. The return to the clock might be read as a directorial flourish akin to that of the lengthy first shot of Welles's *Touch of Evil* (1957), which opens on a close-up of a timing device being set and ends at the moment when the bomb explodes. We have been watching an unbroken single-camera take lasting for some minutes; in the case of *Marty*, three and a quarter.

But in contrast to the dynamism of the Welles scene – intricately choreo-graphed camera virtuosity, following an intermittently moving car – the *Marty* scene is mainly a static recording of the men's conversation, the dramatic point of which is precisely its aimless and repetitive quality. The return to the clock underlines this: we're still in the same place, nothing has progressed, time has simply passed.

Ironically, the clock has a quite different meaning for the actors and pro-duction team. While the scene is being played on the floor of the TV studio, we can be sure that the gallery where director and colleagues sit, high above it, will have been dominated by a similar clock, measuring out trans-mission time second by second. Every second counts in keeping to the

scheduled broadcasting slot, and in handling each transition between cameras, between scenes, and between sets. One reason for the slow movement down to the actors' conversation, via TV set and clock and barman, is a very practical one: to allow Rod Steiger to move rapidly from one studio set to another, take off his butcher's apron, and be ready for his next scene. One effect of the image of the clock is to act self-reflexively, as a playful, or alternatively a grim, reminder of how TV drama is – or was – enslaved to the clock. For this is, of course, live television: the play went out live in 1953, and is available to us now only because a film recording of the image was made, off the screen, at the time of transmission.

Live transmission did not, of course, necessitate the single-camera long-take strategy; indeed, every other scene in this play is shot by the more conventional method that cuts between two or more cameras. Single-camera increases the sense of danger endemic to live TV: if the camera breaks down on air – not an unknown occurrence[1] – there is no other (as far as we can tell) in a position to take over. Shooting the bar scene in one long take is a way of making palpable both this danger and the sense of duration that is – or was – so central to TV studio drama: within the scene, their 'real time' on screen equals our real time as we watch, measured out by the clock which is also that of the control room.

The baseball game, shown alongside the clock on the screen within the screen, can be read, I would argue, in a similar self-reflexive way. Watching a TV play is – or was – rather like watching a baseball game. More to the point, directing a TV play is – or was – like directing sports coverage.

Is, or simply was? One of the points of this essay will be to consider whether the conventions of live transmission still leave any residue, have any meaning, for television fiction today.

Jean Renoir made the sport/drama analogy explicit in 1958, when he and Roberto Rossellini did a joint interview with André Bazin on the subject of 'Cinema and Television'.[2] At the time, both directors were working on projects to be shot on film, but financed by, and at least primarily for, television. At this stage in his career, Renoir explains,

> I am trying to extend my old ideas, and to establish that the camera finally has only one right – that of recording what happens.... This means working rather like a newsreel cameraman. When a newsreel cameraman films a race, for instance, he doesn't ask the runners to start from the exact spot that suits him. He has to manage things so that he can film the race wherever it happens.

What this means, in terms of his current Jekyll and Hyde project (which became *Le Testament du Dr Cordelier* [1961]), is that

> I would like to make this film in the spirit of live television. I'd like to make the film as though it were a live broadcast, shooting each scene only once, with the actors imagining that the public are directly receiving their words and gestures.... the actors and technicians must feel that every movement is final and irrevocable.

In other words, set up the pro-filmic event as though it were a sporting event, and capture it with the cameras. Both the contest and the TV studio drama take place in closed arenas that are subdivided by intricately plotted lines. Their actions are at the same time thoroughly predictable – at a given signal, the runners will run in this direction in these lanes, the actors will perform these pages of script, observed in each case by cameras whose position and function are planned in detail – and tensely unpredictable. It's true that in the race, or the baseball game, nobody knows the outcome in advance, whereas the end of a TV drama, as of a stage play, is usually as tightly scripted and rehearsed as the beginning and middle; but an actor could dry or even die, or a camera could fail or the scenery fall over, and, even without such disasters, their possibility does help to build a sense of danger, of dramatic tension, into the live performance.[3] The fact that the 'magic' of live TV, as of the theatre, is often the focus of a somewhat shallow anecdotal nostalgia should not stop us from acknowledging that live is different, and that Renoir knew what he was talking about.

In 1958 there was still something bold, pioneering, almost paradoxical, in his attempt, as a senior filmmaker, to build bridges between TV drama and cinema. But things were rapidly changing. A new generation of American directors and writers was starting to come through from New York TV into Hollywood cinema, often to adapt their own TV successes: they included Chayefsky and Delbert Mann with *Marty* (1956), and Arthur Penn with his more radically re-worked film of Gore Vidal's *The Left-Handed Gun* (1958). It was also an important transitional moment in television's development, in that 1958 saw the first use in Britain of the new videotape technology recently developed in the United States. Initially cumbersome, this technology soon became more flexible, and within a few years it would render the live transmission of fictional material virtually obsolete. What had previously been two distinct modes of dramatic fiction – film, and live transmission – seemed to be converging, in a way that formed part of an inexorable broader process. More cinema films on TV, more TV-generated projects in the cinemas; more crossover of personnel and of material; bigger TV screens, smaller cinema screens – these are all aspects of the post-1958 convergence between film and television.

This convergence meant a blurring of what had commonly been seen as a clear structure of oppositions between the two media, on the level not only of institutional framework, economics of consumption, and so on, but of

'language' and aesthetics. Typical of many confident pronouncements from the pre-videotape era is John K. Newnham's, in a book dated 1948 (and he is, in this passage, discussing fiction alongside non-fiction):

> There you have the strongest appeal of television. It is life while it is happening. That is why it is wrong to associate it with the cinema. It is a different medium entirely, although much of the presentation technique may be similar to that of films.[4]

After the triumph of videotape and the phasing out of live drama, a new orthodoxy developed: that there was no significant difference in the language of the two media. Stuart Hall's influential 1976 essay on Television and Culture asserts that:

> Despite its massive heterogeneity, there does seem to us a single, coherent language of television to which all its different practices can be referred. This language is, for all practical purposes, indistinguishable from the cinema.[5]

Hall backs this up with quotes first from François Truffaut's 1960 film *Shoot the Pianist* ('television is a cinema that you go to in your own home'), and then from the British critic Christopher Williams, to the effect that its language is 'just like the movies'.

This line now seems to be quite widely accepted, along with the notion that one ought not to 'fetishize' the live element in television: after all, it's all image, it's all mediated, and live TV fiction anyway belongs firmly in the primitive past. To privilege the live potential of the medium is to defer to its 'relay' function, an attitude which is (a) culturally snobbish in subordinating TV to more established media, and (b) naive, in assuming that a neutral/ transparent relay is possible. I caricature this position, but not much. See, for instance, the start of William Boddy's essay in the collection *Television in Transition*, an important scholarly landmark in that it brings together papers from the first International Television Studies Conference, held in London in 1984. Boddy's is the one essay out of fifteen seriously to address questions of TV history, and is sceptical both of the 'Golden Age' mystique attached to American 1950s drama (see the anthology title under which *Marty* and other canonical plays were re-broadcast in the early 1980s) and of the way the television medium was conceptualized in those far-off days.

> The theoretical speculation which emerged was frankly amateur and produced a number of dubious and poorly-argued essentialist claims for the medium.... Little of this quasi-theorising has been subjected to subsequent analysis, and this blindspot of television historiography, as much as the dearth of empirical studies on early television, has contributed to the myth of the medium's 'Golden Age'.[6]

As his subsequent book on *Fifties Television* confirms [7] (a more accurate title for it would be *Fifties American Television*), Boddy is a formidable scholar, and his line is a plausible one; yet I feel one should be cautious about dismissing so wide a range of early practice and early theorising.

Substitute the word cinema for television in the lines just cited, and you could take them for a quotation from one of the British 'new wave' of film theorists of the early 1960s. Their – our – polemic was directed against an old guard of film historians and theorists who had never fully come to terms with the reality of synchronized sound, and whose classic principles and classic films dated mainly from the 'Golden Age' of silent cinema.[8] That polemic was necessary, and successful; and yet it was by no means the last word. Equally necessary and successful has been the work of a subsequent wave of scholars who went back to explore pre-1930 cinema, and the critical discourses surrounding it, in a fresh spirit, neither crudely essentialist nor dismissively patronising. The work on this period carried out by people like – to name just a few – Bordwell, Bowser, Burch, Fell, Musser, Salt, Staiger, and Thompson, has undeniably increased the understanding of the history and aesthetics of the medium, enabling us to see silent and sound, old and new, primitive and classical, within a lucid overall perspective.[9] Old discourses about film history and theory became part of the evidence rather than – or at least rather than solely - something to disagree with. John Fell's dedication of *Film Before Griffith* to earlier generations of scholars, on the grounds that they 'made new understandings possible', is not only generous but shrewd.[10]

Commissioned to contribute, in 1977, to the first Edinburgh TV Festival on the topic of 'Criticism and TV Drama', I discussed the imbalance between histories and theories of, respectively, cinema and television. Since this paper has not had much of an after-life, I will presume to quote from it:

> Film theory has always been very conscious of the early days of the medium, of the silent work of Lumière and Méliès, Porter and Griffith, Pudovkin and Eisenstein, and to a lesser extent of the audience and institutions for whom these men worked, seeing these early years as being of first importance to any investigation of the aesthetics and social relations of the medium.... TV criticism on the other hand continues to pay little regard to the medium's formative years. What is the equivalent of the 30-odd years of silent cinema? If there is one technical development of an impact comparable with the coming of sound, it is I suppose the less spectacular and more gradually transforming one of videotape....

The landscapes of ancient and modern television are very different, but:

> There are also continuities, which are at least in some ways
> comparable with those between silent and modern cinema. A
> main task for historians/theorists of both media is to sort out the
> nature of the continuities and their implications: steering a course
> between the equally negative ideas that (a) the early limitations
> define the 'essence' of the medium, by which we have to continue
> to be bound, and (b) that we can wipe them out of consideration
> as having nothing to teach us about the medium at all.[11]

This still seems to me to be a valid claim. All I have got around to doing
since 1977, however, is to reiterate the call for this kind of attention to
television history, and the only people I am aware of having seriously
embarked on it are John Caughie, another veteran of the 1977 event, and
Jason Jacobs.[12] This is not to say that scholarly work on TV history has
been lacking. In researching this essay, I've read or re-read large amounts
of such work, much of it sophisticated and informative, and concerned
precisely with the shifting relations between television and cinema: I
particularly value the essays collected in the 1984 television issue of the
(American) *Quarterly Review of Film Studies,* and the 1988 book *On Video*
by the British critic Roy Armes.[13] But even they don't really tackle my own
agenda, partly because they just don't seem to have much actual interest
in, or feeling for, old (primitive?) programmes, old ways of doing things,
as those historians like Burch and Musser assuredly, and indispensably, do
in the case of early cinema.

One notorious obstacle to research on very early television is the fact that
most of its output was evanescent, transmitted live, and not recordable,
whereas a lot of texts survive from the first years of cinema. This relates to
a wider difference: the 'language' of television is more diverse than that of
film and has been subject to continuing change of a more radical kind. At
least until the recent impact of computer technology, the material basis of
cinema has remained what it was in 1895: the projection, using a beam of
light, of an image previously recorded onto a transparent base. If there isn't
this intermediate process, and time gap, between capturing the image and
showing it, then it is not what we call cinema. Television, in contrast, was
developed as a device for capturing and showing images simultaneously, or
virtually so: images of the present, not of the (distant or recent) past. This
basic property of television has, like that of cinema, endured: the process of
transmitting the image of a face to a viewer in the next room, in the pioneer
experiments, is in principle the same as the live transmission of the play
Marty from the studio into American homes in 1953, or more recently of
cricket from Australia to England, or (arguably the most marvellous
achievement of television to date) of the images from the moon and
then more distant bodies to Mission Control on earth. But whereas
cinema cannot, by definition, diversify into present-tense or live images,
television has diversified into past-tense ones, and done so, moreover, in a

complicated variety of ways that are not always easy for even the informed viewer to distinguish. Part of the time, television glories in its present-tense powers, part of the time it doesn't bother with them, and it's hard to speak about the medium's aesthetic relation to cinema without trying to see it whole, and in terms of its historical development.

As Lynn Spigel has recently put it, 'we do not have a body of literature on the development of representational conventions in television (such as exists for cinema)'.[14] In no way do I have the competence, or the space, to start filling this gap; what follows is simply an attempt to set out and comment on some significant stages in television's formal and technological diversification, referring both to Britain and to America. In the course of her introduction to a collection of American essays, Ann Kaplan makes the point that

> the structure, form, content and context for British television are so radically different from those of its American counterpart that everything has to be rethought by critics in this country. Television scholarship is simply not exportable in the easy manner of film criticism.[15]

This has certainly inhibited the writing of histories. For instance, countries have not seen each other's live drama transmissions from the 'Golden Age' periods of the 1950s and 1960s, and even when they survive in recorded form, they are seldom exported, even to archives (the Channel Four drama series of 1982 which included *Marty* was a rare exception). Going still further back, television was, necessarily, even more localized and ephemeral, and even native investigators have to rely on secondary rather than primary material.

We may not have examples of television's initial output, but we do have access to the ways in which it was written about. In the discourse about television in Britain in the mid-1930s, a struggle becomes evident between those who stress television's status as an offshoot of radio – a medium whose recording capacities at this time are still limited, cumbersome and infrequently used[16] – and those who want to assimilate it to cinema, on the grounds that it too presents realistic moving pictures with soundtrack.

The latter tendency is represented by *World Film News*, successor to *Cinema Quarterly* as the critical voice of the British documentary movement. Documentary had a hegemonic role in the film culture of the period, and the magazine enjoyed high prestige. It was launched in April 1936, a time when the opening of the BBC's regular broadcast TV service was known to be imminent; its full title is *World Film News* (big letters) and *Television Progress* (small letters), and the first monthly issue carries a prominent 'Manifesto on Television' by a weighty quintet of names: three filmmakers (Alberto Cavalcanti, Thorold Dickinson, John Grierson) and two

film critics (Cedric Belfrage and Graham Greene).[17] For them, a reliance on direct transmission is retrograde for three main reasons. (1) It amounts to mere reproduction. 'We remember with concern that the tradition of radio is to REPRODUCE. We ask an assurance from the BBC that the new medium – at least in part – will be used to CREATE' (their capitals, not mine). (2) The production methods and visual strategies used for the standard transmissions are 'naive' and 'clumsy', allowing only 'the simplest forms'. (3) The unrecordable live broadcast gives us no object to hang on to, for critics to analyse and for apprentices to learn from. 'It has been difficult to build a body of criticism among the evanescent impressions of direct broadcast'.

The answer to all these problems is, predictably, film. (1) The use of film 'allows television a creative as distinct from reproductive role. Television as an art medium depends on the use of film'. We may hear an echo of Grierson's already well-known labelling of documentary as 'the creative treatment of actuality'. (2) 'Film eliminates clumsy methods of timing... Film permits effective and rich editorial work'. (3) 'A film basis for television will give to the BBC what it has long lacked: a body of established technical standards which personnel may consider and absorb and develop. It will give the BBC an effective body of criticism'.

What precisely the quintet have in mind by advocating 'a film basis for television' is explained neither in this manifesto nor in subsequent issues; it's hard to see how film could become the 'basis' for television broadcasting without destroying the main identity and attraction of the new medium.

Even in those early days, television did make use of film, but in clearly limited ways:

(1) *Telecine*. Pre-existing films could be shown on television via the Tele-cine Transmitter, defined in a 1930s technical handbook as

> A device for transmitting cinematograph pictures by means of television. It comprises an ordinary cinematograph film projector working in conjunction with a special form of television transmitter.[18]

Already in 1936 many items were shown this way: cartoons, newsreels, documentaries, and feature-film extracts. One of the first experimental broadcasts from the Radio Show at Olympia included Paul Rotha's documentary about book publishing, *Cover to Cover*. Such 'relays' of existing films were clearly marked off from live transmissions.

(2) *The Intermediate Film Process*. The BBC initially used two different television systems in competitive alternation: those of EMI/Marconi (based

on electronic scanning) and of Baird (mechanical scanning). It seems that, whereas in other respects EMI/Marconi produced better results, Baird's system gave a better telecine image. With perverse ingenuity, he and his team therefore rigged up a process whereby the (single, fixed) studio camera shot its material on film: this exposed film was rapidly processed and, within one minute of shooting, was transmitted via the telecine machine. The process was mechanically precarious, as well as being prodigal of film stock, and offered no serious competition to the EMI/Marconi system, which was declared the winner after a few months (in February 1937).[19]

While Intermediate Film may sound like a rather mad aberration on Baird's part, similar experiments did go on in other countries, particularly when projecting television to theatrical audiences.[20] The motivation was always to give to TV's own output something of the clarity and brightness of the film image, by providing a sort of delayed-action live transmission: as if live, only with a better quality picture. There was no question of treating the footage like film rushes by cutting and splicing it. The Baird team could, in theory, have exploited the full possibilities of film by shooting with multiple film cameras the various discussions, musical items, and so on, that had been brought into the Alexandra Palace studio, processing and editing the footage at leisure, and transmitting the result by telecine a few days later (and maybe the *World Film News* people had something like this in mind); but, leaving aside questions of expense and resources, this would have been seriously in conflict with the look-in see-it-now raison d'être of the new medium. Programming was either live relay or clearly-packaged bits of cinema film, not something in between.

(3) *Demonstration Films*. When television did, in that pioneer pre-war time, produce its own films, it was, paradoxically, in order to *simulate* the record of a live transmission. We do have a stock of images of early television which turn up from time to time in documentaries, and it's easy to read them as being some kind of actual recording of the transmitted image; they are, however, repeats or reconstructions, for a film camera, of what had originally gone out live.[21] The 'Television Demonstration Film' (a copy of which is held by the National Film and Television Archive) was regularly transmitted outside the standard broadcasting hours, so that salesmen would have something to show to prospective buyers of sets: this is what TV looks like, this is the kind of item that it shows. Besides giving us a misleadingly positive impression of the visual quality of TV's early images, these film reconstructions elide the problem of shot transition. Until after the war, it was not technically possible – not in Britain, anyway – to make a straight cut between two electronic studio cameras: the stability of the picture could only be maintained, across a shot change, by fades and dissolves. Initially, to replace one image by another in this way took – according to the testimony of one of the pioneer BBC producers, Cecil

Madden – 'a minimum eight seconds'.[22] Subsequently, under pressure from Madden and others:

> Over a period of months, the BBC and EMI engineers reduced the eight-second time-lapse... to four (seconds, and then) to about two, though the 'cut' was not finally achieved until after the war.[23]

In this and in other significant ways, television's difference from cinema was at least as striking as its similarity. Direct transmission was seen – by broadcasters, salesmen, and viewers alike – as its dominant mode, and there was, to repeat, no way of recording the television camera's own directly-transmitted images either on film or on tape, despite various experiments.[24] Once regular broadcasting had got properly under way, *World Film News* changed its critical line. A December 1936 editorial begins with what may be the first statement of a now-familiar opposition, and goes on to concede that the medium may, after all, have a closer affinity with radio than with film:

> With the British film in the doldrums, it is some satisfaction to know that our television is the best in the world.....
>
> There has been one immediate discovery. The actuality element is in the ascendant. Television takes over from radio the intimacy and the excitement of direct observation and, in this respect, cuts right away from an identity with film. Television is a process not of looking at but of looking in.[25]

In June 1937 the radio critic of the BBC's own weekly magazine *The Listener* starts to write occasional pieces about television. She is Grace Wyndham Goldie, later to become a formidable BBC producer.[26] The new medium, she writes in her first television review,

> has a vividness which we cannot get from sightless broadcasting and a combination of reality and intimacy which we cannot get from the films. Look! There is Ivy St Helier at the piano.... And amazingly, although we are seeing her in black and white and in two dimensions, just as we would in a film, the effect is quite different...

This difference is partly to do with the size of the screen, and the viewing situation; but

> there is something more. And it is in this something more that the appeal of television lies. Although what we are seeing is two-dimensional and black and white, it is not a film or a photograph. It is the real thing. That is Ivy St Helier herself.

> There is, in fact, much the same curious difference between television and the cinema as there is between a gramophone record and a broadcast.....

The difference is between past tense and present tense. Even the occasional use, within live pre-war studio drama, of pre-filmed inserts transmitted by the telecine process, does not challenge this difference, since the two modes seem as a rule to have been so palpably distinct, as critics were still pointing out some years after the war.[27]

World Film News followed *The Listener* by introducing, in August 1938, a regular TV column. 'Each month Thomas Baird will keep WFN readers fully informed on the progress and development of Television in Great Britain'. This Baird (no relation) came from documentary film, and he urged the BBC to transmit plenty of such films, but he was also looking, both in drama output and in actuality, for what was specific to television:

> The most exciting broadcasts have been the outside ones..... The Test Match broadcast indeed made most [cinema] newsreels look pretty silly. Here, with no time lag, was a brilliant account of the excitement of the game, and the amount of detail picked up by the carefully handled cameras was magnificent. The television camera cannot make a cut in the film sense, but the quick mix from bowler to batsman was an indication that television had something of its own to offer.[28]

Unfortunately, Baird's column was short-lived, since the magazine only lasted for a few more issues, and then, in September 1939, the television service in turn closed down, for the duration of the war.

In other pioneer countries too, the war put a brake on the expansion of domestic television, while stimulating researches that might have a military use. The resumption of television broadcasting in Britain, and of its expansion in the United States, was followed by a succession of significant developments: (1) cuts between television cameras (mid-1940s); (2) recording of the television image on film (late 1940s); (3) shooting of television material on film (early 1950s); (4) recording of the television image on tape (late 1950s); (5) editing of the tape-recorded image (1960s).

All these developments seemed progressively to reduce the technological and aesthetic distance between television and film. Taking them in order:

1. Cutting between cameras

By the time the television service resumed in June 1946, a clean cut between studio cameras was available as an alternative to the mix or fade-out/fade-in.[29] Clearly this development brings the fundamental syntax of television a bit closer to that of cinema. The old system of transition by

mixes must have created a curious combination of a throwback to the magic lantern technique of 'dissolving views', as taken over by some very early filmmakers, with a spatial organization familiar from mainstream cinema. Once the straight cut is in place, the standard multi-camera studio drama can be more clearly seen as employing a very basic, austere version of the Hollywood continuity system.[30] The 180 degree rule is automatically observed, since if one of the cameras 'crossed the line' it would appear in another camera's shot. Likewise the cameras can't, because of their bulk, get physically close enough to one another for there to be any chance of a cut flouting the 30 degree rule. Continuity of movement is assured by the simple fact that movement *is* continuous, and is observed by 'correctly' positioned cameras. It's not so much that television is deliberately assimilating itself to the conventions of 'classical cinema': more that, under the constraints of liveness, it is adopting a theatrical mode of performance (real time, coherent three-dimensional space) which cinema had, over the previous two decades or so, found it appropriate to (in a limited way) simulate. What cinema might have to do rather laboriously – creating the illusion of continuity across a set of separately-mounted shots – can be done with enviable ease by multi-camera live television. The down-side of this is that television lacks, at this stage, cinema's freedom to play around with space and time within the broad co-ordinates of the continuity system. In Metzian terms, all of its dramatic segments are 'scenes' (or, like the bar segment of *Marty*, 'autonomous shots'), with no time ellipses across cuts, even the unobtrusive ellipses that contribute to a Metzian 'ordinary sequence'.[31] At least, it has to work hard if it is to subvert, within a given segment, strict naturalistic/theatrical continuities of space and time, and it seems unlikely that in the early days it often did so, given the dominant 'relay' aesthetic of the period.

The obvious comparison is with early synchronized-sound cinema, whose initial technology enforced a similar strict continuity of recording, and led to a similar form of multi-camera coverage. Hitchcock makes the connection in his interview with Truffaut:

> We shot with four cameras and with a single sound-track because we couldn't cut sound in those days. That's why when they speak to me about the use of multiple cameras on live television, I say 'That's nothing new. We were already doing it in 1928'.[32]

While being a constraint which the cinema institution fought to overcome, these restrictions also had some attractive results in producing scenes of extraordinary 'theatrical' intensity, based on continuity of performance and palpable real-time duration. As a change from the better-known Hitchcock reference points, *Blackmail* (1929) and *Murder!* (1930), I would cite here the first film to be directed by James Whale: the 1930 Hollywood/British co-production of R.C.Sherriff's war play *Journey's End*, which Whale had already directed on stage in London and New York. The

intense real-time scenes in the dugout are varied only by occasional inserts of action on the battlefield above, shot silent, with sound effects added; the 1937 television version of the play seems, from John Caughie's account, to have operated in a similar way, with 'scenes from Pabst's *West Front 18*.... cut into the live drama'.[33] But we have, of course, no direct way of comparing the two productions, and of experiencing the all-mix transition system, since the recording of the television image was still many years in the future.

2. Recording on Film

Soon after the war, and as a result, it seems, of research carried out for military purposes,[34] it became possible to make viable off-air recordings onto film, the result being known in the United States as a kinescope, in Britain as a telerecording. For the first time, live broadcasts could be recorded and repeated. The main advantage of this, at least in Britain, was initially seen to be in the field of actualities: the Oxford/ Cambridge Boat Race was covered live in the afternoon, as it had been pre-war, and could now, from 1949, be screened as a news story in the evening as well.[35] The process really came into its own with the Queen's Coronation in June 1953. Telerecordings of the BBC's coverage of the ceremony served three functions: repeats on the BBC, next-day screenings on American TV (the film being rapidly processed and then sent on a chartered plane)[36] and – perhaps no more than incidentally – archival preservation. In addition to their own actuality spectaculars (e.g. the McCarthy hearings) the American networks made film recordings of a large number of dramas broadcast live from New York studios, in order to be able to give them delayed transmission in different time zones further west.[37] The BBC, too, without having the same pressing reason, began recording a few of their drama transmissions, and ITV companies followed suit when they began operations in (and after) 1955. We thus have a record of the famous 1954 BBC version of *1984*, adapted from George Orwell by Nigel Kneale and directed by Rudolph Cartier, as well as the bulk of the 1950s trilogy of *Quatermass* serials made by the same partnership. These are 'television films' only in the sense that they are TV material recorded on film; they are not constructed or edited as film, except insofar as they may have used some film inserts, transmitted on telecine within the live broadcast.[38] Moreover, their status remained firmly second-best to the live relay. Even when a drama had been safely telerecorded, any repeat would involve a second live performance rather than a transmission of the film record. Thus, *1984* was recorded, but its second scheduled broadcast a few days later was, following normal procedure, done live. In the States in the following year, 1955, the single scheduled broadcast of Rod Serling's play *Patterns* was so successful that a repeat was fitted in by critical demand; despite having a decent kinescope, which had presumably been used on the first night for delayed-time transmission to Western time zones, the network brought together cast and crew and sets all over again for a second

live transmission a month later.[39] It's unlikely that anyone considered doing otherwise, both for contractual reasons and because of the higher quality of the visuals in a direct transmission: these two factors testify to the radically other status, still, of TV drama. It might be stored on film, but it was different from film. (In contrast, the Queen was not asked to return to the Abbey, or to go over to America, to re-enact her Coronation, nor did she have a contract that precluded repeat screenings. The actuality film record thus came closer than the drama recording did to possessing the repeatability, as a whole or in extract form, of 'proper' film, and no doubt this helped to chip away at assumptions about the essential ephemerality of TV's output. At the same time, the cinema film, in colour, of the Coronation, reached places – geographical, psychological, aesthetic – that the telerecording didn't reach, and attracted huge audiences).

3. Shooting on Film

By this time, 1953, television had begun, particularly in the United States, to originate significant amounts of its own material on film. A report on the landscape of American television for *Sight and Sound* in 1954 by Philip Mackie (who would himself become a prolific writer of British TV drama) finds this development in full swing:

> A steady progression is going on. More TV shows are being put on film; the difference in production cost is negligible, the general convenience is greater, the fear of fluffs and errors is eliminated, and the final product can be shown and re-shown without any loss of quality in all the different time zones of the United States. So more and more TV production is moving from New York to Hollywood....[40]

Mackie goes on to make a useful distinction between two styles of TV film. One school of producers 'make their films look like films, with chases and running fights shot against location exteriors'. Such films would continue to proliferate. The mid-1950s saw a big expansion of filmed Western series, the entry of Alfred Hitchcock into telefilm production, and, in Britain, the opening up of ITV, whose sharpest entrepreneurs quickly recognized the economic possibilities of using film. ABC's *Robin Hood* was an early example of the quickly-filmed action series, repeatable and exportable, which constituted a profitable commodity. In contrast:

> Another school tries to reproduce on film the virtues and limitations of the 'live' show..... Groucho Marx, the keenest intelligence of our times, gets the best of both worlds: he acts his show in front of a studio audience just as if it were being televised 'live', and simultaneously films it, then simply cuts out the sub-standard or censorable gags.[41]

Shot on film but produced like a live programme: Dezi Arnaz explains production methods for
I Love Lucy (1951-55) at Motion Picture Centre Studio.

The pioneer of this system had been *I Love Lucy*, shot on film from its debut
in 1951. According to Erik Barnouw:

> Hollywood had not thought much of *I Love Lucy* as film art. It
> was produced like a live program, in one session before a studio
> audience in tiered bleachers, and was only filmed for possible
> re-use income.[42]

In other words it was shot in one continuous performance with multiple
cameras, and (except in an emergency) no retakes. Editing was a largely
mechanical process of following the pattern of cuts between cameras
that would have been done on air by the vision-mixer, had it been transmit-
ted live. If the kinescope process had offered the same visual quality as
actually shooting on film, that process would surely have been used instead.
Hollywood was entitled to be dismissive about the status of the Lucy and
Groucho shows as 'film art', since they were using film in such a consciously
limited way, for want of any better-quality system of recording and
trimming and re-using the live performance. In effect, they were waiting for
videotape.

4. Recording on Videotape

Like so many technological innovations (including synchronized film sound, Cinemascope, and indeed telerecording), videotape had been the subject of earlier researches and could no doubt, if given the right investment, have been developed sooner than it was. Abrahamson traces it back to Phonovision in 1927, an experimental Baird device for recording the primitive low-frequency television image, with sound, onto a gramophone disc.[43] The 1939 edition of the Newnes Television Manual states that 'Phonovision, at the present day, is merely a scientific curiosity, but it has many interesting possibilities'.[44] The huge expansion of the medium in the 1950s ensured that these possibilities would be fully explored.

Abrahamson and Barnouw are, as usual, invaluable in indicating some key stages.

> Another advance in television recording was made on November 11, 1951, when the Electronic Division of Bing Crosby Enterprises gave its first demonstration of a video tape recorder in black-and-white.[45]

After noting the limitations of these and other early 1950s efforts, Abrahamson, writing in 1954, concludes prophetically that

> It is expected that these problems will be overcome and that video tape recording will emerge from the laboratory capable of reproducing pictures indistinguishable from the original 'live' pickup. It is expected that this process will supplement if not supplant the film or visual recording.[46]

'Supplant' was right. In January 1957, following the re-election of the Eisenhower-Nixon team:

> The inauguration, for the first time, was recorded by a new process – *videotape*, which could record both picture and sound magnetically. At once superior to kinescope film, it doomed the kinescope.[47]

On British television, this new technology was formally unveiled in April 1958, within a regular edition of the current affairs magazine *Panorama*.[48]

The item has the same kind of archaeological fascination as a pre-Lumière film fragment. Presenter Richard Dimbleby begins by asking us to note the time on the *Marty*-style studio clock; he then talks us through some shots of a big machine (then named VERA – Vision Electronic Recording Apparatus) which 'is recording this programme'. At his command, the boffins stop the machine and rewind; we are shown the studio clock again, in the programme's present tense, then we jump back to the earlier clock image and watch the video recording, at the end of which Dimbleby re-orients and reassures us: 'That was VERA. This is me again here, now, really'.

The programme itself survives thanks to the process of telerecording: that is, a film record was made of a live programme ('here, now, really') which incorporates an innovatory videotape recording. That apparatus was still bulky and clumsy, like a primitive computer, and had difficulty in handling a cut between shots. The live programme, in showing us VERA, cuts between two cameras; the telerecording, on film, reproduces this cut accurately, but VERA herself, using tape, cannot quite manage this: on playback, there is a moment of wobble, of visual instability, across the cut, which is like a re-enactment of the original difficulty of making a straight cut between television cameras, pre-war. In addition, the visual texture of the video-recording, on playback, is much inferior to that of the telerecording itself.

It's an extraordinary 'time capsule', vividly bringing together, at a key moment of transition, the three available methods of conveying the television camera's image: live, recorded on film, recorded on tape. Despite the manifestly crude, primitive quality of this early demonstration, video-tape will not only, before long, render telerecording obsolete (see Abrahamson and Barnouw), but will have wider and more radical effects, eliminating whole areas of live broadcasting. The entry of VERA, in *Panorama*, is a bit like the moment in *The Jazz Singer* where Al Jolson speaks his first line of dialogue; nothing would be quite the same again. Except that VERA made no comparable public impression. Unlike that of synchronized sound in cinema, the impact of videotape was unspectacular and gradual.

At this stage, in 1958, the only obvious advantage of the new tape process was - as demonstrated by Dimbleby - that of immediate replay. Initially, it was not possible to edit the taped image, either by physical cutting or by selective re-recording (whereas there was, obviously, no problem about cutting a film recording).

5. Editing Videotape

Denis Forman really says it all, in a paper first given at the Edinburgh TV Festival in 1979, and reprinted in the BFI's Dossier on the first 25 years of Granada Television. Forman had joined Granada in 1955, and worked for them in many capacities, including that of Chairman. Like his Granada colleague Philip Mackie, quoted earlier, he had previous experience in the film world, and he too was involved in a variety of different formats of television production, from live to all-film; so he knows his subject:[49]

> In 1959 we were trembling on the brink of two convulsions: the introduction of the tape edit and of the dreaded film camera. The Mark 1 VTRs had been in position for something over a year when we heard the cry of 'Eureka!' from the engineering department. An ingenious and dexterous man had sliced the tape

with a razor blade along the scan line and rejoined it to another part of the videotape in such a way that the control track moved through without a bump and joined the two with a piece of sellotape. This, we thought, was rather more important than the invention of sliced bread. But we were to find that others had discovered it at the same time and earlier and that all were moving towards the next step, the electronic edit, which arrived very shortly afterwards.

This advance in technology was not altogether welcome to managements. Rules were set down - shows must be recorded in real time, edits must be authorised by a member of the board, there may be only two edits in a show, three edits, six edits, and as the months went by, a show may take no more than 50% more time than it did when it was being transmitted live. And so down the slippery slope towards the technique of the feature film.[50]

Even if resisted at the start, this move towards flexible editing had an unstoppable momentum, and was in the longer term welcomed by management. Video-recording made the standard studio product into not just a performance, but a potential commodity. In the words of another key figure, Michael Barry, whose posthumously published memoir looks back over a career, as director and administrator, that started in the pre-war BBC:

The completed production was (now) transportable, and could be screened at any time, anywhere. This was an irresistible convenience for the schedulers of programmes, and, indeed, for the makers, in the worldwide economy of television that was soon to develop.[51]

In a competitive home market, and a growing international market, the standardization of length and smoothing-out of production values that videotape editing facilitated had obvious advantages. 'Recording before transmission allowed studio faults to be corrected, and all material to be post-edited in the cutting rooms.'[52] If these possibilities existed, why not use them? In the course of the 1960s, the transmission of live fictional material virtually died out; it became standard practice to record onto videotape intermittently, in a stop/start manner, rather than in one continuous session, and to trim and re-order material freely after the event.

In all these respects, electronic studio television was becoming less distant from film than it had been hitherto, and there was a parallel growth in the actual use of film within television; Forman, in the lines just quoted, points to these two developments – videotape editing, and the use of the film camera – as happening simultaneously. As we have seen, some areas of television had already gone over to film, particularly in the United States;

'Planned, shot and edited as a "video movie"': John Carr, Jean Heywood and Tony Scoggo in *Boys From The Blackstuff*: Episode 5 'George's Last Ride' (1982)

in the 1960s, this process accelerated, and spread across more types of production. In the States, studio drama gave way to the 'TV movie'; in Britain, a growing proportion of dramas were shot on film, but disguised the fact by still carrying the label of television 'play'. The drama producer Kenith Trodd took stock of this change in 1977 by compiling an index of 301 such film/plays: the first is dated 1964, there are forty-two by the end of the decade, and the phenomenon takes off seriously in the 1970s. Introducing the Index, Trodd calls it a catalogue of

> all the authentic and whole 'single' fiction films so far made or being made for British TV. It is not a complete catalogue of television plays. Most plays were and are recorded on video tape in a television studio with up to five electronic cameras offering

pictures simultaneously. This method is radically different from filmmaking and I take the view that, at its best, it needs styles, talents, temperaments and product other than those appropriate to film. For me, it is another craft and form.[53]

The point is well made; however, TV plays-on-film were, at this time, also clearly distinct from cinema films – shot on 16mm, on very tight schedules, respectful of their scripts, publicized on the writer's name more than the director's, and a prey to 'ephemerality'. This was not the into-thin-air ephemerality of the old-style live production, but they still had no guarantee of a repeat and no chance of a theatrical release. They occupied a middle ground, then, between the cinema film and the traditional television drama.

Since then, there have been three major developments. Firstly, Trodd's 1977 statement that 'most plays... are recorded on video tape' has become obsolete. Almost all one-off drama is now made on film and does not disguise the fact: the anomaly of the play-on-film has been overtaken by series like *Film on Four* (Channel Four) and the BBC's *Screen One* and *Screen Two*. Secondly, as a result of a complex of contractual and technological changes, including the improvement in 16mm film quality, it has become possible for films made (at least primarily) by and for television to get shown in cinemas as well: *My Beautiful Laundrette* (1985) stands as a landmark example. Thirdly, the use of single-camera video has become common, in fiction as in non-fiction. Video has become so mobile and easy to edit, and its visual quality has so much improved, that the video camera can in effect be used as though it were a film camera, its output having the benefit of being cheaper and instantly re-viewable; you don't have to wait for rushes to be processed. Michael Barry's summary is a neat one:

> Nowadays, that is to say in 1985, a majority of television's narrative and fictional programmes are made as films, *or in the same manner as films.*[54] (my emphasis)

The five-part series *Boys from the Blackstuff* (1982), written by Alan Bleasdale and directed by *Armchair Theatre* veteran Philip Saville, was shot on film for one episode, and, for reasons of economy, on video for the others, without any stylistic difference being intended, or, evidently, noticed; it was planned, shot and edited as a 'video movie', designed to be 'utterly filmic'.[55] Both the team who made the series, and those who chronicle its production, embrace this as a positive development within the steady transformation of TV drama that I have been tracing. 'The use of film and filmic methods has been preferred by drama programme makers since the 1960s.... film has become the preferred production system for quality drama'.[56] In an influential 1980 essay, the writer-director David Hare described the multi-camera videotape system as 'the hopeless hybrid', embodying everything that is institutionally and aesthetically reactionary in

the medium.[57] The term 'hybrid' implies a status between live and film, but Hare evinces no interest in live television production. Theatre is for live drama; television, like cinema, is for film drama.

* * *

In 1937, George Orwell reflected on the revolution in transport systems:

> Here am I, forty miles from London. When I want to go up to London why do I not pack my luggage onto a mule and set out on foot, making a two days of it? Because, with the Green Line buses whizzing past me every two minutes, such a journey would be intolerably irksome. In order that one may enjoy primitive methods of travel, it is necessary that no other method should be available. No human being ever wants to do anything in a more cumbrous way than is necessary.[58]

Who would want to go back to the famously cumbrous, 'primitive' ways of live drama (as practised by the pioneers at the very time when Orwell was writing), now that such convenient alternatives have been developed? Nevertheless, walking still has its uses, and so does live television: we have simply ceased to associate it with fictional material.

The developments in television drama sketched out above constitute a steady move away from liveness and immediacy – from a live theatre mode (or, in terms of the old conventions, live radio) towards a cinematic mode. But in the non-fiction sphere there has been an equally striking move in the reverse direction, towards an ever greater immediacy, leaving the cinematic mode behind. By immediacy I don't mean lack of mediation: it's a question of time, and of how much of it elapses between the event and its screening. In the early days, news was served up mainly in the form of *newsreels*, either pre-existing cinema ones or or the BBC's own film compilations. Now, we think nothing of seeing news reports transmitted live, or almost live, from all over the globe, even on occasion from beyond it. Meanwhile, the same staple outside-broadcast items exert the same attraction as they did pre-war: Wimbledon and Test Matches, other sporting events, state ceremonial. They are no longer the same sort of 'innocent' relay they once were - to trace their growing sophistication at the interlocking levels of technology, form and finance would require a parallel essay to this one - but their attraction is still, at root, that of action transmitted live, in continuity, by a multiplicity of electronic cameras.

Moreover, the recorded version of this kind of transmission has, even when trimmed down to a highlights package, a quite different status from a news-reel-type *film* of the event. Unless the re-editing has been especially brutal, the original present-tense quality still comes across, in the images as in the commentary.

In 1977 the BBC put out, under the umbrella title of *Jubilee*, a series of plays looking back over the first 25 years of the present Queen's reign. One of them was set in 1966 and included a scene in which some characters watched the Final of the World Cup (England 4 West Germany 2) on television.[59] But when images of the game were cut in, they turned out to come not from the TV coverage but from a cinema newsreel. No more abruptly alienating moment can ever have been screened. Characters were suddenly having the logically impossible experience of watching a filmed and edited and post-dubbed record of an event that was supposed to be happening at that moment. 'They think it's all over – it is now!': what makes that last-minute line of commentary so memorable is the way it enacts the present-tense vividness possible in live television, as Kenneth Wolstenholme registers first the patriotic home crowd starting to spill onto the pitch, and then, without a pause, the final goal by Geoff Hurst. Seeing and hearing for the fiftieth time the recording of that moment, one still gets an experience that is different in kind from any past-tense film equivalent. It is hard to credit this, but precisely the same crass confusion was repeated in Granada's highly-researched thirteen-part history of the medium, *Television*, broadcast in 1985. The episode on sport and outside broadcasting dwelt upon the global impact made by the live transmission of the 1966 Final; yet the audiovisual illustration was, again, lifted from the newsreels, which offered more dramatic camera-angles, but not the remotest approximation to the television viewing experience.[60]

What I am feeling for here is some kind of analogy between the spheres of fiction and non-fiction. For TV drama, or for its critics, to discount the links with its live (or as-live) past is, arguably, as misguided as the assumption that a film version of the 1966 Final can stand in unproblematically for the live/recorded television transmission.

There is certainly a case to be made against David Haro's pro-film one. For him, the videotape mode of drama was 'the hopeless hybrid', but a lot of drama-on-film seems to me to fall into just this category, equally deficient in the strengths of good television and of good cinema: the kind of 'second-rate film' that Alfred Shaughnessy abjured in his briefing to collaborators on the series *Upstairs Downstairs* when it began production in 1971 ('Remember, television is electronic theatre, not second-rate film').[61] For every *My Beautiful Laundrette* there have been ten forgettable efforts making little impact on critics or audiences and earning no cinema release. And when a *Laundrette* does emerge, it tends to become a cinema event rather than a television one.

A 'television event' takes into account the difference between television time and cinema time, at one or both of the two significant levels: the time of scheduling, and the time dimensions of the programme itself. The really big one-off event will generally be a live transmission, its time thus dictated by, and co-terminous with, that of the game, the ceremony, the moon

landing, and so on. Conversely, and to state the obvious, situation comedies and soap operas, series and serials, recur at regular times of the day or week. Series like *Armchair Theatre, The Wednesday Play*, and *Play for Today* used to have the same high-profile regularity, but their successors do not. Shot on (or as-if) film, and lacking any residual sense of liveness, of 'electronic theatre', they seem to lack any reason to be shown sooner rather than later, at one time rather than another. Also, the trend towards fewer and more expensive films means that there is too little product to sustain regular slots.

Sitcoms and soap operas, meanwhile, preserve a link with 'primitive' television drama by being, for the most part, shot with multiple electronic cameras. Most sitcoms are still recorded in front of a 'live' studio audience; British soap operas may be recorded weeks in advance on a stop-start basis, but they still take place 'today', without, except on extraordinary occasions, overrunning into a second day within an episode. *Coronation Street*, the longest-running and still the most popular of British television dramas, observes a typically shrewd formal self-discipline. I recall, from a few years ago, a form of jump-cut which went directly from a character in an interior scene to the same character, differently dressed, walking along the street. This standard cinema strategy felt as wrong in *Coronation Street* as the football newsreel within the 1966 *Jubilee* drama. As far as I know, this has not recurred. The programme continues to observe, at least in a residual way, the convention of live theatre, and live television, that you allow an actor 'time' to change clothes, to move from set to set – as Rod Steiger genuinely had to be given time at the start of *Marty*. Lest this be written off as the staid formal conservatism of a stale soap opera, note that the same strategy of time and space management operates in the more dynamic context of a series like *Casualty*, which is also similar in the way it confines each story within a single day, or a single hospital shift.

All this is perhaps no more than a roundabout way of making the point that the centre of gravity in television fiction has shifted away from the single drama (or drama in a small number of parts) to the longer-running series and serial, and that the latter have generally retained closer links with television's past, and with its non-fiction present, in terms of production methods and aesthetics. Personally, I still regret the tendency of 'quality' drama to align itself so insistently with cinema, and the readiness of commentators to see this one-way movement as unproblematically progressive. Contextualising the production of *Boys from the Blackstuff*, Millington and Nelson look back to the pioneering influence of the Loach-Garnett team:

> This mode of production of television drama shot on film in actual locations.... was seen as progress towards a more authentic depiction of reality. A marked preference for film among television drama producers resulted, and film has since been characteristically regarded as free from certain technical

and institutional constraints of the electronic studio. This freedom has indeed allowed drama filmed for television to be related in terms of aesthetics to the cinema's 'exploring' of the actuality with which it deals, by contrast with electronic television's 'reproducing' of that actuality.[62]

It seems a somewhat simplistic conception of the ideological operations of the film medium. But rather than question the considerable achievements, on film (or sometimes quasi-film), of Loach and Garnett, Bleasdale and Saville, Hare and Frears and the rest, I would simply oppose the attempt to pull all self-respecting television drama in that one direction. Studio television doesn't have to slavishly 'reproduce actuality' any more than theatre does: like the theatre, it provides, to use Peter Brook's term, an 'empty space', and it depends how you fill it.[63]

I am spared the need to argue this case in any detail by the fact that it has already been convincingly, indeed stirringly, argued by Don Taylor, in the Epilogue to his recent account of a career as a television director and writer that goes back to the early 1960s. Like Michael Barry from the previous generation, he recognizes the reasons for change while regretting its one-way ruthlessness:

> In the last two or three years the process has come to its completion. The push that started in the sixties has been resolved into a situation where we now quite openly make films, some of them destined to enter their true ancestral home, the cinema. This has clarified the situation wonderfully. It has become clear that we now have two quite different ways of making television drama available to us.... If you want to make a film, make one.[64]

But to try to hold on to the other way as well is far from being just a 'Luddite approach'.[65] Orwell's Green Line bus does not have to be used for all journeys:

> The studio is the home of the metaphor, not the statement, drama as image, not as description.... The electronic camera, the playwright and the actor in a television studio present one of the most powerful creative triumvirates available to a dramatic artist today.[66]

Witness Alan Bennett's Talking Heads (1987), a series of six minimalist plays. The studio as an empty space; an actor and a camera; words. Alongside Taylor's general argument can be placed Albert Hunt's richly specific and perceptive analysis of the one play out of the six which Bennett himself directed: Bed Among the Lentils, with Maggie Smith as a vicar's wife.[67] The final scene lasts eleven and a half minutes, and is shot in one unbroken take, after nine minutes of which the camera slowly moves in

71

closer on her talking head. On the recording, Maggie Smith got one line slightly wrong; they therefore went back and shot the whole thing again, but decided in the end to keep the first take, despite the error. In the words of the 1958 Renoir interview I quoted earlier: 'The actors and technicians must feel that every movement is final and irrevocable'. And then Hunt makes explicit the very analogy that was at the centre of Renoir's argument:

> The tension between the fixed word (fixed in the past by a writer who has carefully composed it) and the recreation of that word in a present scrutinised by a camera from which it is impossible to hide creates something of the excitement of a sporting event televised live. The performer walking on the tightrope offers the possibility of falling off.[68]

This is my idea of a practice, and a criticism, that taps intelligently into the history and the ontology of the medium.

Reference

1. See, for instance, Arthur Penn's account of working in live television drama in Joseph Gelmis, *The Film Director as Superstar* (New York: Doubleday, 1970), p.211.

2. *Sight and Sound,* vol.28 no.1, Winter 1958-59, pp.26-27.

3. An account of the death of an actor in the middle of a live British drama transmission is given in a programme about the anthology drama series *Armchair Theatre: And Now For Your Sunday Night Dramatic Entertainment*, produced by Paul Madden for Microcraze Productions, screened on Channel Four on 8 February 1987.

4. John K. Newnham, *Television: Behind the Scenes* (London: Convoy Publications, 1948), p.11.

5. *Sight and Sound*, vol.45 no.4, Autumn 1976, p.249.

6. William Boddy, 'The Shining Centre of the Home: Ontologies of Television in the "Golden Age"', in Phillip Drummond and Richard Paterson (eds.), *Television in Transition* (London: BFI, 1986), p.125.

7. William Boddy, *Fifties Television* (Chicago: University of Illinois Press, 1993).

8. A seminal document here is the scathing review by V.F.Perkins of the British Film Institute's booklet *Fifty Famous Films 1915-1945* (London, BFI, undated but presumably late 1950s), in the undergraduate magazine *Oxford Opinion*, the film section of which, launched in this issue (no. 38, April 1959), was developed into *Movie* magazine (first issue June 1962). See also V.F.Perkins, *Film as Film* (Harmondsworth: Penguin Books, 1972), and Charles Barr, 'Cinemascope: Before and After' in *Film Quarterly*, vol.XVI no.4, Summer 1963.

9. See for instance: David Bordwell, Janet Staiger and Kristin Thompson, *Classical Hollywood Cinema* (London: Routledge, 1985); Noel Burch, *Life to Those Shadows* (London: BFI, 1990); John Fell (ed.), *Film Before Griffith* (Berkeley: University of California Press, 1983); Barry Salt, *Film Style and Technology: History and Analysis* (London: Starword, 1983); Charles Musser, *The History of the American Cinema: Volume 1, The Emergence of Cinema* (Berkeley: University of California Press, 1990); Eileen Bowser, Volume 2 in the same series, *The Transformation of Cinema* (also 1990).

10. John Fell, *Film Before Griffith*, p.v.

11. Charles Barr, 'Criticism and TV Drama', in the special issue of *Broadcast* published as the Official Programme of the Edinburgh International Television Festival, 1977, pp.33-35.

12. For this 'reiteration', see 'Television on Television' in *Sight and Sound*, vol.55 no.3, Summer 1986, pp.157-159. For John Caughie's work, see in particular his essay 'Before the Golden Age: Early Television Drama', in John Corner (ed.), *Popular Television in Britain* (London: BFI, 1991). For Jason Jacobs's work, see 'The Amateur Stage: BBC Television Drama 1938-1952' in *Norwich Papers* no.1 (University of East Anglia, 1994), pp.85-106; also his thesis on *Early British Television Drama* submitted for the degree of PhD at the University of East Anglia in September 1995.

13. *Quarterly Review of Film Studies* vol.9 no.3, Summer 1984: guest editor Nick Browne; other contributors include Beverle Houston, Douglas Gomery, Robert Vianello, Edward Buscombe. See also Roy Armes, *On Video* (London: Routledge, 1988).

14. Lynn Spigel, 'Installing the Television Set: Popular Discourse on Television and Domestic Space', in Lynn Spigel and Denise Mann (eds.), *Private Screenings: Television and the Female Consumer* (Minneapolis: University of Minnesota Press, 1992), p.15.

15. E. Ann Kaplan, 'Introduction' to Kaplan (ed.), *Regarding Television* (Los Angeles: American Film Institute, 1983), p.xi.

16. For details of the development of radio recording, and of attitudes towards it, see Erik Barnouw, *The Golden Web: A History of Broadcasting in the United States: Volume II -1933 to 1953*, (New York: Oxford University Press, 1968), e.g. pp.109, 163, 204, 241.

17. *World Film News*, vol.1 no.1, April 1936, p.9.

18. F.J.Camm, *Newnes Television Handbook* (London: George Newnes, 1934; sixth edition 1945), p.213.

19. For Baird and the Intermediate Film process, see Bruce Norman, *Here's Looking at You* (London: BBC and Royal Television Society, 1984), pp.106-7 and elsewhere. For the rejection of the Baird system, see pp.138-9.

20. Albert Abrahamson, 'A Short History of Television Recording', in Raymond Fielding (ed.), *A Technological History of Motion Pictures and Television* (Los Angeles: University of California Press, 1967), p.251. Reprint of a paper given in October 1954 and first published in the *Journal of the Society of Motion Picture and Television Engineers*, vol.64, February 1955.

21. Norman, *Here's Looking at You*, pp.187-8.

22. ibid, p.20.

23. ibid, p.136.

24. These experiments are summarized in Abrahamson, 'A Short History'.

25. *World Film News*, vol.1 no.9, December 1936, p.5.

26. Grace Wyndham Goldie joined BBC Television soon after the war as a Talks Producer, and at the time of her retirement in 1965 was Head of Television Talks and Current Affairs. She subsequently wrote an important, partly autobiographical, work of television history, *Facing the Nation: Television and Politics 1936-1976* (London: Bodley Head, 1977). Her first television review column is in *The Listener*, 16 June 1937, p.1196. For the next two years she continued to write mainly about radio, and only occasionally about television, but she switched to television in the issue of 30 March 1939, continuing until the service was closed down at the outbreak of war.

27. In his monthly 'Television Notes' column for the *New Statesman*, W.E.Williams was critical of a production of a James Bridie play on the grounds that 'it employed the method of intermingling film-sequences with the studio-production. In this hybrid

form the differences between the pre-fabricated scenes and the main body of the play are lamentably apparent - in pace, perspective, and lighting'. *New Statesman*, 23 December 1950, p.652.

28. *World Film News*, vol.3 no.4, August 1938, p.188.

29. The 1946 innovation of the direct cut is discussed by, for instance, Maurice Gorham in *Television: Medium of the Future* (London: Percival Marshall, 1949), p.24.

30. For the 'rules' of the Hollywood continuity system, see, for instance, successive editions of David Bordwell and Kristin Thompson, *Film Art: An Introduction* (fourth edition, New York: McGraw-Hill, 1993).

31. For the 'Metzian system' of formal analysis, see Christian Metz, *Film Language* (New York: Oxford University Press, 1974), pp 119-146.

32. François Truffaut, *Hitchcock* (London; Secker and Warburg, 1968), p.63.

33. John Caughie, in John Corner (ed.) *Popular Television in Britain*, p.29. According to Michael Barry, who joined the BBC Television Service as a producer early in 1938, this was the first such use of film within a drama transmission. Michael Barry, *From the Palace to the Grove* (London: Royal Television Society, 1992), p.27. For Grace Wyndham Goldie, reviewing this production, 'the experiment of combining film with direct television worked better than I could have believed possible'. *The Listener*, 17 November 1937, p.1076.

34. Abrahamson, 'A Short History', pp.251-2.

35. Gordon Ross, *Television Jubilee* (London: W.H.Allen, 1961), p.79.

36. Erik Barnouw, *The Image Empire: A History of Broadcasting in the United States: Volume III - from 1953* (New York: Oxford University Press, 1970), pp. 44-5.

37. Brian Winston, *Misunderstanding Media* (London: Routledge, 1986), p.88.

38. Nigel Kneale's introductions to the republished scripts of the three *Quatermass* serials give a useful sketch of developments in 1950s studio technology. *The Quatermass Experiment*, *Quatermass 2*, *Quatermass and the Pit* (all three: London: Arrow Books, 1979). In an article written soon after the transmission of the third of these serials, Kneale expressed pride in the unusually smooth way he and Cartier had contrived to integrate film material with live action. Nigel Kneale, 'Not Quite so Intimate', in *Sight and Sound*, vol.28 no.2, Spring 1959, pp.86-88.

39. Information given by Keenan Wynn, in his on-camera introduction to the screening of *Patterns* in the 1981 series *The Golden Age of Television*, shown on Channel Four the following year.

40. Philip Mackie, 'Six Hundred Hours a Week', *Sight and Sound*, vol.24 no.1, July-September 1954, p.48. Mackie worked in documentary film during and after the war, after which he joined the BBC and then (as Head of Drama) Granada Television. He wrote a wide variety of scripts including the studio series *The Caesars* (1968), and *The Naked Civil Servant* (1975, on film). He died in 1985.

41. ibid., p.48.

42. Erik Barnouw, *The Image Empire: A History of Broadcasting in the United States: Volume III*, p.7. For more detail on the filming strategy for *I Love Lucy*, see Thomas Schatz, 'Desilu, *I Love Lucy*, and the Rise of Network Television', in Robert J.Thompson and Gary Burns (eds.), *Making Television* (New York: Praeger, 1990), pp.117-135.

43. Abrahamson, 'A Short History', p.250.

44. F.J.Camm, *Newnes Television Handbook*, p.199.

45. Abrahamson, 'A Short History', p.253.

46. ibid.

47. Barnouw, *The Image Empire: A History of Broadcasting: Volume III*, p. 79. Barnouw's words leave it unclear whether he means that this was the first

programme, or simply the first inauguration, to be videotaped. According to Brian Winston, the first such broadcast was on 30 November 1956, when CBS transmitted a videotaped programme, with kinescopes held in reserve in case of any technical problems. See Brian Winston, *Misunderstanding Media*, p.90.

48. This *Panorama* item was included in a BBC tribute to Richard Dimbleby, presented by Ludovic Kennedy, broadcast in 1990, and subsequently marketed as a videotape: *Richard Dimbleby, Voice of the Nation* (BBCV 4436).

49. Forman was Director of the British Film Institute from 1948 to 1955, and then moved to Granada Television, becoming Chairman from 1974 to 1987. Among other projects, he initiated Granada's 13-part adaptation, shot on film in India and England, of Paul Scott's Raj Quartet novels, *The Jewel in the Crown* (1984).

50. Denis Forman, 'Television in 1959', in Edward Buscombe (ed.), *BFI Dossier No.9: Granada: the First 25 Years* (London: BFI, 1981) p.60. It was first given as a paper at the 1979 Edinburgh Television Festival, and published there in the official programme.

51. Michael Barry, *From the Palace to the Grove* (London: Royal Television Society, 1992), pp.174-5. Barry had died in 1988. The fact that his book had to wait so long, and did not find a mainstream publisher, says a lot about the marginal status of television history, outside certain very limited academic and popular/anecdotal categories.

52. ibid., p.174.

53. Kenith Trodd, 'The Trodd Index', in the special issue of *Broadcast* published as the Official Programme of the Edinburgh International Television Festival, 1977, pp.47-51.

54. Barry, *From the Palace to the Grove*, pp.128-9.

55. Bob Millington and Robin Nelson, *Boys from the Blackstuff: Making a TV Drama* (London: Comedia, 1986), p.42. Though I register some disagreement with them, this is certainly one of the best books written on any aspect of television.

56. ibid, p.42 and p.110.

57. David Hare, 'Ah! Mischief: the Role of Public Broadcasting', in Frank Pike (ed.), *Ah! Mischief: the Writer and Television* (London: Faber and Faber, 1982), p.47.

58. George Orwell, *The Road to Wigan Pier* (Harmondsworth: Penguin, 1962 edition), p.175.

59. *Ramsey*, by N.J.Crisp, directed by Paul Ciappessoni, transmitted on 22 May 1977.

60. For a fuller discussion of this Granada series, see Charles Barr, 'Television on Television', in *Sight and Sound*, vol.55 no.3, Summer 1986, pp.157-159.

61. Alfred Shaughnessy quoted in the 'Casebook' on *Upstairs Downstairs* put together by Catherine Itzin in *Theatre Quarterly* vol.2 no.6, April-June 1972, p.30.

62. Millington and Nelson, *Boys from the Blackstuff*, p.15.

63. Peter Brook, *The Empty Space* (London: McGibbon and Kee, 1968). Michael Barry provides a tantalising account of a youthful, and unrecorded, early-1950s experiment by Brook with the 'empty space' of the television studio: *Box for One*, a 'half-hour monologue by a hunted man in a telephone box'. Barry, *From the Palace to the Grove*, p.106.

64. Don Taylor, *Days of Vision* (London: Methuen, 1990), p.256.

65. ibid., p.264.

66. ibid., p.263.

67. Albert Hunt, 'Talking Heads: Bed Among the Lentils', in George W.Brandt (ed.), *British Television Drama in the 1980s* (Cambridge: Cambridge University Press, 1993), pp.19-39.

68. ibid., p.37.

Boxed In?: The Aesthetics of Film and Television

Martin McLoone

As part of its contribution to British Film Year in 1986, Thames Television made three documentaries under the generic title, *British Cinema: Personal View*. The most interesting of these (and incidentally, the most controversial) was the film written and presented by Alan Parker, *A Turnip-head's Guide to the British Cinema.*[1] This film ('Un Film de Alan Parker: Almost a Documentary', as the credits had it) distinguished itself by its unrelenting anti-intellectualism and its rather crass populism (Parker claimed to speak on behalf of the mass audience – the 'turnip-heads' of the title). Of course, the film was witty and amusing, sometimes self-deprecatingly so. Nonetheless, its notoriety resulted from the rather partisan (and partial) view of the state of the British film industry which it offered and the rather crude way in which it undermined the opinions of those (presumably the 'egg-heads') whose views on the matter differed from Parker's populism.

Thus, an interview with the then-director of the BFI, Anthony Smith, is treated with contempt by Parker. The camera pulls out from a screen showing a tightly-framed 'talking head' shot of Smith, to reveal Parker sitting at, and seemingly playing, a cinema organ as it rises out of the orchestra pit. The music swells to drown out Smith's words as his receding 'talking-head' attempts to defend the BFI. Parker then appeals to the

'turnip-heads' by talking over Smith's words. Visually and aurally, Smith is comprehensively undermined. This is a vicious, if clever, sequence which gives visual resonance to Parker's overall argument. He is not just 'anti-BFI', or 'anti-intellectual' : he is 'pro-cinema' in its most popular form and in the place where it is seen to its best advantage – the large-screen picture-palace represented by the organ. By implication, the BFI represents the visually-impaired, élitist and kill-joy cinema of the intellectuals. This polarization is reinforced in a later sequence in the film. Derek Jarman attacks the dominance of American cinema on British film culture and castigates the Academy Award-fixation of many mainstream British film-makers by likening the Oscars to a kind of cultural cruise-missile. Parker gives David Puttnam the last word on this matter – the notoriously caustic remark: 'Happily, an Oscar is one thing that Derek Jarman will never have to worry about, so I'm amazed that he even bothered to bring up the subject.'

The polarization evident in these sequences is, of course, the result of the film's machinations rather than a reflection of the situation in the real world. To achieve such a level of ungraciousness all round, and to arrive at such a clear-cut polarization of opinion, the film had to work hard to simplify complex and interrelated discourses and Parker's argument is full of contradictions and inaccuracies.[2] However, I have not returned to this ten-year old polemic just to offer a detailed critique of it now. Rather, I want to use it to raise again many of the issues which it addresses in its own idiosyncratic manner. These debates are as relevant today as they were then and the Parker film does at least have the virtue of laying bare the assumptions and prejudices that underlie the fixed opinions on all

Alan Parker's (1984) view of *Film on Four*.

sides. These prejudices are centrally concerned with the relationship between film and television and it is this aspect of the debate which I want to pick up here.

'Don't You Wanna Dream No More?'[3]

Parker's main thesis is that television 'boxes-in' the cinematic imagination of the filmmaker and the cinematic experience of the audience. It is to his credit that he tries to visualize what he means by this. In an early sequence, he is walking through the vast auditorium of one of the 'picture-palaces' of his childhood and he ponders:

> What is it that makes us want to give up all of this...magical place where the screen – the screen is so large you can hardly take in the edges... where the sound can be so exciting it can move the air around you, an excitement you think you can share with others... a place where our world becomes, I dunno, larger than us, where life isn't reduced to the size of a box in the living room?

He later visualizes and elaborates on this. In a long-shot of a cluttered sitting-room, we see the television set squeezed into the corner. Parker addresses the audience from the TV screen, caught in close-up and behind bars. As he speaks, the camera slowly zooms in on the small screen (an elaborate system of frames within frames). He argues:

> The American director, D.W.Griffith, transformed the scale and scope of film. He realized that the enormous width of history could be shown on the movie screen. (He was also, for his sins, the first to effectively use the close-up.) Now one of the problems, to my mind, of British movies is that most of our directors learn their trade on the small screen or the small stage. Also, too many of them have been brought up on the notion of film and not movies, with a consequence that most contemporary British films have admirable depth but no cinematic width – what's been called 'talking-heads' cinema...So few of our directors have been able to escape the confines of this box – of this cell. But occasionally they do. And when they do, it's magic, because then, it's real cinema.

From this, the film cuts to a long and elaborate tracking-shot from Roland Joffé's *The Killing Fields* (1984), the sequence in which the Khmer Rouge have taken over Pnomh Penh and are systematically expelling the civilian population from the city. A slow tracking shot to the left pans slowly to the right to reveal details of the chaos, losing momentarily the central characters, Sydney Schanberg and Dith Pran (Sam Waterston and Haing S. Ngor) as they attempt to escape in the pandemonium of soldiers and

refugees. The camera then pans back to the right to pick up the central characters again (they are the dramatic focus for the audience) only to lose them one more time as the long tracking shot ends in a slowly rising crane shot, revealing finally for the audience, the scale of displacement taking place as refugees stretch out into the middle-distance. The scene is a good example of what Parker has just been saying in relation to Griffith. It is a carefully choreographed shot, allowing the audience to experience the scale of the events at the same time as it witnesses incidental details of the tragedy which is unfolding. The dramatic tension for the audience is increased by the fear that, as the camera loses the central characters, they too may fall victim to the undisciplined brutality of the soldiers. In other words, the power of this sequence is derived from a dialectic between scale and detail, between our concern for the crowd and our concern for the individuals we have been encouraged to identify with.[4] It is the cinematic imagination of D. W. Griffith achieved with the technology and craft of the 1980s. For Parker's purpose, it works very well (ironically even on television) as a contrast to the 'imprisonment' of the small screen image. But it is a false contrast.

Crucially, it misses out the the importance of *both* 'width' and 'depth' to the success of epic cinema. In the case of *The Killing Fields*, over half the film is

'Individuals... plucked out in close-up from the "width of history"': Haing S. Ngor and Sam Waterston in *The Killing Fields* (1984)

a study in depth of one individual's obsession to discover the fate of another individual, both, as it were, plucked out in close-up from the 'width of history'. Parker, it seems to me, misses the significance of Griffith's use of the close-up and the *Turnip-head's Guide* has a sad irony about it because of this. To illustrate his point about 'the cinematic imagination', he chose to visit Hugh Hudson on the set of *Revolution* (1985). The documentary does give some idea of the scale and ambition behind Hudson's epic and the director himself confirms Parker's view of the cinematic imagination. By the time Parker's documentary was broadcast, however, the scale of *Revolution's* failure at the box office was known. Not only was it a monumental flop, it also helped to bring down its production company, Goldcrest, and so bring to a rather calamitous end, yet another renaissance of the British film industry.[5] (I wonder,too, if Parker had originally intended to illustrate his thesis by including a suitably epic scene from *Revolution*, but opted instead for *The Killing Fields* after the scale of the film's box office disaster was known).

Parker blames *Revolution's* failure on a poor script, but this rather disguises the extent of the artistic miscalculation over the film. In fact, the film is all epic width with no central dramatic depth. As Jake Eberts has written, after seeing an early post-production cut of the film, 'The result was not great. You could not avoid the fact that the the picture had no story and there was no relationship between the two leads' (Al Pacino and Nastassia Kinski). Even after the final edit, with soundtrack and effects added, Eberts rather forlornly reports, 'To our astonishment... the finished film was worse. The picture fell completely flat'.[6] Interestingly enough, Eberts and Ilott record the reactions of a number of people who had read early drafts of the screenplay before the film went into production and their comments are both perceptive and prescient. Amanda Schiff, from Goldcrest's development team, commented:

> What I found most disturbing of all was the lack of resonance. It's halfway between the epic and the intimate, but it doesn't relate the one to the other ... The fighting scenes are always doing the same things each time they occur – providing blood, thunder and excitement in lieu of real drama ... There is too much room for visual excess in this screenplay ... and although it would all be undoubtedly stunning and lovely to admire, it diverts attention from the basic lack of narrative drive ... in the story.[7]

And Goldcrest's script reader, Honor Borwick, delivered a crisp appraisal: 'It left me really cold, and, however epically it was filmed, I just don't think it is gripping or exciting enough to draw the audiences.'[8] Both these comments could have provided templates for the reviews of the film which appeared world-wide when it opened eighteen months later. Here was a film that was all 'width' and no 'depth'.

The interesting aspect of the *Revolution* affair, and the way in which Parker had set out to use the film in his polemic, is that behind the scenes lies the influence of Channel Four's *Film on Four* and the debate about film and television which its success gave rise to. Thus, one of the attractions of *Revolution* for Goldcrest at the time was that it allowed them to move beyond the restrictions and limited opportunities that the smaller co-productions with Channel Four seemed to imply. Terry Ilott summarizes Goldcrest's attitude to these small films:

> The problem with them was that, although their costs might be modest, so was their audience appeal. It was not enough to make £108,000 profit on an investment of £253,000, as Goldcrest was to do with *Dance with a Stranger*; it would take twenty-five such films, and for every one of them to be as successful, just to cover Goldcrest's £2.7 million annual overhead. What was needed was a couple of films of the stature of *Gandhi* or *The Killing Fields*. *Revolution* was of that scale.[9]

For the producers, then, there was a financial need to move beyond the television film. For the filmmakers, the reason to do so is aesthetic. In the *Turnip-head's Guide*, for example, Ken Russell argues that Channel Four's films are basically B-movies, even if some of them are very good B-movies. 'They are about "storms in a tea-cup"', he declared. 'I'm more interested in the vast ocean than a storm in a tea-cup'. And Parker himself visualized this through his two (fictionalized) 'turnip-head' usherettes, who groan when they see the tiny *Film on Four* image appear on the vastness of the big screen. One of them muses about the audience, 'It's not choc-ices we'll be serving them, but hot coffee to keep them awake'.

Now it is important to explore more fully the nature of the contrast that Parker has set up in this film. It illustrates very well a view of the two media which has tended to favour cinema ahead of television, based on a set of aesthetic and cultural assumptions which, especially in Britain, have actually stymied the aesthetic development of television fiction. The problem with Parker's thesis, of course, is that it only works if we are to accept the essentialism which underpins it – that cinema is essentially about 'the enormous width of history' and that television is essentially a 'talking-heads' medium. There is a clear implication in this that for the British cinema to survive and gain an audience, it must move up to the 'epic' scale of Hollywood. This, I want to argue, is a false contrast, since it opposes the extremes, rather than the characteristics, of the two media – television at its least 'adventurous' (aesthetically) and cinema in its big picture, 'event' mode. In terms of British television, it elevates routine practices and dominant cultural assumptions to the level of self-evident truths and as far as American cinema down the years is concerned, it is strangely amnesiac and visually-impaired in relation to the vast bulk of Hollywood's entertainment for the 'turnip-heads' (in which tight framing, fluid editing and dialogue have always been as important as epic sweep).

Nonetheless, this documentary does set up rather well the issues that are involved in discussing the aesthetic relationship between film and television and if we tease out the various elements alluded to by Parker, we can approach the problem in a systematic manner. There are four interrelated issues in Parker's polemic:

1. A contrast between the 'cinematic imagination' and the 'televisual imagination', which can influence, at production level, how films are conceived and shot.

2. A contrast between the cinematic experience and the televisual, influencing how viewers or audiences respond to the images they see.

3. The aesthetic implications of television's role in film production, especially, in the British context, the implications of Channel Four's *Film on Four* (and, of course, the more recent entry of the BBC into the process).

4. The idea of a 'national cinema', or at least the process by which other film cultures can co-exist with Hollywood, and the role that television might play in this.

These issues are, of course, crossed and counter-crossed by economic and technological considerations. It is important to consider the inter-relationship of all of these and to locate them in the history of the two media, for they raise in turn the question of the supposed 'essential' nature of film and television. However, to understand how these aesthetic debates in Britain took on a particular character, it is important to take a brief detour through the American experience and to consider the relationship between the Hollywood industry and the network broadcasters there.

Hollywood And Television:
The Development Of Peaceful Co-Existence

Recent historical scholarship on the early history of television in the USA has revealed a more complex interrelationship with Hollywood than has generally been assumed. William Lafferty, for example, has argued:

> Although conventional wisdom often assumes that the Hollywood film industry greeted the arrival of television as a threatening competitor, suspicious and disdainful of the young medium, historical evidence suggests instead that the motion picture industry had long maintained a substantial interest in the economic potential of television.[10]

He contends that in response to the emergence of television in the period between the 1930s and the 1950s, Hollywood adopted four consecutive approaches:

1. Direct investment in television and radio broadcasting stations and networks as a means of controlling the competing media's development and realising a financial return on that investment;

2. the exploitation of theatre television by which the 'immediacy' of television could be exploited within the basic model of motion picture exhibition;

3. the vending of the studios' vast film libraries to television broadcasters; and,

4. the production of films specifically for television.[11]

The first two options were unsuccessful for a variety of legal and economic reasons to do with the fact that, as Robert Vianello puts it, 'television was an industry in the process of monopoly formation; the film industry was in the process of monopoly disintegration'.[12] Since both Federal Government and the regulatory body, the FCC, favoured the emerging television networks over the film industry, neither the necessary legal nor technological infrastructure was forthcoming and Hollywood abandoned these avenues.[13]

The other two options formed the basis of what Lafferty refers to as the 'symbiotic relationship' between the film and television industries and what Vianello prefers to see as the networks' 'hegemony' over the motion picture industry. However it is characterized, it certainly implies a rather more complex relationship than is suggested in the polarized view of Parker's polemic. Indeed, to understand more fully the aesthetic implications of this relationship, I would suggest that there was really a fifth avenue the film industry took to deal with the rise of the television networks – a clearer product differentiation through the development and application to its cinema releases of the technology of filmmaking, especially, in the 1950s, widescreen formats, new colour systems and 3-D but, down to the 1990s, in the improvements in sound and the development of special effects technologies and computer imaging. This clear product differentiation has resulted in the increasing reliance by Hollywood on the blockbuster 'event' movie and it is to this aspect of the film industry which, I feel, Parker appeals in his concept of 'cinematic width'.

If we look, then, at these three successful strategies, we can consider in detail what the aesthetic implications have been for the film and television debate. It is important, I think, to note here, that there are really two relationships at stake. First, there is the relationship between television and cinema as *institutions* and second, between the respective *media* of electronic imaging (video) and film. These are not, to my mind, the same thing, though they are often talked about as if they were inter-changeable oppositions. Rather, they point to different production and reception issues and the crucial point is that the economic and strategic imperatives of the *institutions* will dictate how the respective *media* will be used and developed. It is the confusion over them that gives rise to much of the false

essentialism that lies behind, for example, the prejudices that emerge in the Alan Parker documentary. Let us consider, for example, the proposition that television is essentially a 'talking- heads' medium and that its essential characteristic is its immediacy.

In the formative years of television in both the USA and Britain, this proposition was widely accepted. However, the American experience suggests that this was abandoned early and a more pluralist definition of the medium became the norm. The portents were there right from the beginning, even in the fact that the Hollywood industry was interested in getting involved with the new medium. The networks, according to Robert Vianello, were committed to a 'live' programming strategy only for as long as it suited them. He suggests that this was not a matter of aesthetics but rested on clear economic and strategic needs – 'live' television, like 'live' radio two decades earlier, was used by the networks to justify their central-ized existence and to build up their empires of affiliate stations nationwide. If television were to develop as a medium of 'recorded' programming (i.e. feature films) then this would destroy the economic justification for having networks. By the late 1950s, however, the situation for the networks had changed and filmed programming became central to consolidating their power and influence.

This then raises certain questions about the so-called 'golden age' of 'live' drama on American television. Was this, after all, merely a tem-porary expedient, a 'primitive' stage necessary only to achieve certain commercial aims and to bridge an early period of development in the tech-nology of the new medium? The historical evidence would certainly suggest this, and though it would be foolish to decry the aesthetic achievements of this period (and the array of actors, writers and directors who passed through on their way to Hollywood), Vianello nonetheless is adamant that in the last analysis, '...the prestige of the "live" anthology drama, with its high culture theatrical and literary aesthetic, was a useful illustration of how the Networks served "the public interest" during the various monopoly practices of the fifties'.[14] There were innovations and genuine achieve-ments, certainly, but the combination of commercial pressure from the sponsors and the conservatism of the inherited traditions of Broadway 'social realism' meant that the vast majority of these 'live' dramas were mediocre and conventional. In Kenneth Hey's judgement, what he calls 'teletheatre':

> ...was a product of the McCarthyism then haunting the industry's executive suites and impinging on the lives of several creators. Thus, teleplays frequently made references to saying prayers, thanking God, avoiding communism, rejecting authoritarianism, loving America, trusting neighbors, distrusting strangers, admitting guilt, surviving difficulties, overcoming evil and the like... The 'dead centerism' and uniformity-of-taste

theories of television broadcasting clearly affected content and methodology of teletheater production, almost eliminating investigation of actual social conditions ...[15]

Live studio drama resulted from the early perception of television as a medium of immediacy and topicality, the primitiveness of the technology available and the networks' need to justify their affiliate empires but it was never, in America, theorized as the medium's essential characteristic, either by the network chiefs, the advertisers or the mass audience. (Lafferty, for example, quotes one industry observer, speaking as early as 1944: '...in spite of all that has been said about television's spontaneity, immediacy and intimacy... television in your home is really a motion picture and what makes a motion picture interesting should also attract and hold the television audience').[16] Corporate interests had their eyes on the potential of filmed drama. The contrast between the relative poverty of the studio-based video image and the potential of film was already apparent within the live drama anyhow. These plays were sponsored by the advertisers and each play typically had three acts interrupted by the sponsor's 'message'. This advertisement was very often in the form of a slickly-edited piece of film and the quality of the image and the pace of the editing reflected badly on the studio-bound play that contained it. [17]

The American audience had, by this time anyway, shown that when given the choice, it preferred film to live drama. Before the major Hollywood studios released their back-catalogues to television, many smaller studios and independent companies had already done so. Thus a range of B-movies, shorts, cartoons and serials, with the occasional A-feature and some foreign films, had become a staple of television programming. Perhaps they were originally conceived of as schedule-fillers, but once the sponsors and broadcasters realized that these films were attracting large audiences, the networks changed their minds and moved to supply filmed programming in greater amounts.[18] Increasingly, the schedules were filled with filmed series especially made for television, including the enormously popular *I Love Lucy* (1951-55), with Lucille Ball, made independently by her own company, Desilu, and shot on 35mm film. By the mid-1950s, the major studios had begun to release their cinema features to television and turned over much of their spare studio capacity to making filmed series to meet the networks' seemingly insatiable demands. Television in America became a medium of filmed drama, a fact that no doubt better reflected the tastes of the new mass audience than did the metropolitan middle-class culture represented by the 'live' studio drama.

The institutions of television and cinema had, by the mid-1950s, arrived at a perfectly equitable level of co-existence. As cinema audiences declined (partly, though not exclusively, because of the rise of television) the Hollywood industry was able to realize huge profits from the sale of its back-catalogues to television and to move its declining cinema production

capacity over to television production. For its theatrical productions, it could start to develop the film and cinema technologies that would allow it to differentiate its products for theatrical release from those made for television (though in the process, it created future technical problems when these were later shown on television). Television now had an ample supply of high-quality filmed drama which was what audiences wanted to watch and therefore what the advertisers wanted to sponsor. In this way, the networks were able to consolidate their power and go on to build enormous profits. 'Live' television programming (news, sport, variety and so on) and television's sense of immediacy became elements in a varied schedule now dominated by filmed drama and though they were undoubtedly important, they were no longer considered to be the medium's defining characteristic.

What can we say, therefore, about the aesthetic implications of these early developments, especially in regard to the 'cinematic imagination' and the 'cinematic experience'? It seems obvious to me that rather than view the relationship between film and television as one in which television 'boxed-in' the cinematic, it is more correct to say that film opened out the televisual experience and that it rescued television drama from its theatrical influences (where it would have continued to be merely a recording device for a pre-existing performance). This is not to say that television has become merely a relay device for pre-existing cinematic entertainment, nor indeed, would I want to argue that in its 'live' relay role (news or sport, for example) that the performance is itself untouched by television's presence. Quite the opposite, in fact. The point of resisting the notion that television is *essentially* a live medium, more typically and more successfully concerned with the immediate, is to acknowledge and understand better just how television has developed its own aesthetic, how the 'televisual imagination' has changed and developed in relationship to the institution's economic and strategic needs and in response to other media and other cultural influences. In other words, it is to consider television's *specificity*, rather than some so-called essence. To do this, I want to look briefly at the Western and its role in the early days of television.

There are two compelling reasons why the Western is an appropriate genre with which to consider the aesthetics of film and television. First, the Western was the big screen's most popular genre almost from the beginnings of the cinema itself and was to become the most popular genre on American television in its formative years. Second, if any Hollywood genre can lay claim to being about the 'width of history', then it is the Western. By exploring what happened when this most potent of the big screen genres encountered the specific characteristics of commercial television in its formative years, we can understand better the development of a 'televisual imagination' which goes some way beyond the caricature of 'talking heads'.

The impact of the Western on American television can scarcely be over-estimated. As William Lafferty has argued,

...the ubiquitous Western, a staple of both radio and motion pictures, became equally important in early television, as both recycled theatrical releases and as filmed television programming, leading *Sponsor* magazine to claim that television had 'literally grown on a foundation of Western programming'.[19]

The first Western series went on air in 1949 and the popularity of the genre grew rapidly so that at its peak, ten years later, there were forty-eight different series showing. The numbers then began to decline slowly in the 1960s and by 1984, for the first time in thirty-five years, there were none.[20] Its popularity, therefore, is at its greatest in television's formative years and this suggests that what it brought to the small screen, and what it gave to those early television audiences, was a sense of the epic and a feeling of width, which was in sharp contrast to the confined world of the 'live' studio drama. Now it might seem at first glance that this is a paradox. After all, as Horace Newcomb has observed:

> In the Western movie, panorama, movement and environment are crucial to the very idea of the West ... The sense of being overwhelmed by the landscape helps to make clear the plight of the gunfighter, the farmer, the pioneer standing alone against the forces of evil ... On television, this sense of expansiveness is meaningless. We can never sense the visual scope of the Ponderosa. The huge cattle herds that were supposed to form the central purpose of the drovers in *Rawhide* never appeared. In their place we were offered stock footage of the cattle drives.[21]

Newcomb is surely right to stress the importance of scale to the meaning of the Western but I feel he misunderstands how that sense of scale was actually achieved in the television Western's cinematic precursors. He mentions that the Westerns of John Ford and Anthony Mann 'consciously incorporate the meaning of the physical West into their plots' and again he is right. But Ford and Mann made big-budget A-movie Westerns and the panoramic shots of 'figures in a landscape' in *The Searchers* (1956) or the epic grandeur of *Winchester '73* (1950) were by no means typical of the cinematic Western. In fact, Ed Buscombe argues that they were a rarity. 'Of the 1,336 Westerns made by all producers between 1930 and 1941, only 66, or a mere 5 per cent, could be classified as A-features'.[22] The vast bulk of Hollywood Westerns down to the 1950s continued to be B-features and low-budget (verging on the no-budget) series and serials. They had to use stock footage in film after film and use and re-use the same film sets and locations. There was no problem, however, in imagining within such poverty-row resources, the scale of the West. A sense of the epic and a sense of place came already inscribed into the iconography of the genre as it developed from painting and photography in the nineteenth century through the dime novel and onto the cinema itself in the 1900s. Thus the dress, the settings and even the place names all carried resonances of the genre's epic space. Ed Buscombe points to the fact that a great number of

Hollywood Westerns contained a place name in their title (Texas, Wyoming, Kansas and so on). 'What is evoked is of course an imaginative rather than an actual geography'.[23]

This imaginative space was evoked through every aspect of costume, set design and *mise en scène*, no matter the budget restrictions. Thus, in the credit sequence to *Laramie* (1959-63), a coach and horses splash through a small stream, in an environment of mountains, horizons and sage bush, throwing the water up towards the camera to form the words of the show's title, and a perfect image is created of the epic space of the West. The fact that most of the stories then took place within the confines of Slim Sherman's ranch/relay station hardly mattered to the sense of the West thus invoked.

Warner Bros. was the first major Hollywood studio to produce regularly for the small screen and in *Cheyenne* (1955-63) it produced television's first Western hero. Cheyenne Brodie (Clint Walker) was a drifter of heroic dimension with a high moral sense. His world was the wide-open spaces of the West itself and this was successfully captured by playing on the generic conventions of the Western, establishing the locale and using stock footage when necessary. So successful was the series that by 1958, *Cheyenne* was joined by two other Warner Bros. drifter-heroes, *Sugarfoot* (1957-61) and *Bronco* (1958-62), and these allowed the production company to recycle its old Western plotlines and stock footage. Buscombe, quoting Michael Barson, maintains that the television Western differed very little from its cinematic antecedent. Crucially, though, Barson also claims that it differed very little from other other kinds of television series and serials and that any one of its plotlines could turn up later as the basis for a cop show or a family melo-drama.[24]

The point here, of course, is that television took the Western genre in all its different forms – the dime novel, cinematic serials and series, and A- and B-features – and then moulded them, in the form of the weekly series, into a specifically televisual aesthetic. It did the same with the cop show, the legal drama, the hospital drama and the family melodrama and in this weekly filmed series format, there is as much justification for recognizing something specifically 'televisual' as there is in television's function as a relay of 'live' events. Thus, John Ellis describes the series as ' a form of continuity-with-difference that TV has perfected'.[25] The characteristics of the medium played a central role in this process. Horace Newcomb, discussing the weekly series format in particular, has argued just this:

> In approaching an aesthetic understanding of TV the purpose should be the description and the definition of the devices that work to make television one of the most popular arts. We should examine the common elements that enable television to be seen as something more than a transmission device for other forms.

Three elements seem to be highly developed in this process and unite, in varying degree, other aspects of the television aesthetic. They are intimacy, continuity and history.[26]

Two of these concepts are familiar in discussions about television – intimacy and continuity. While these are important elements in all conventional art forms or genres they seem to be particularly so in the case of television. The intimacy results from the context of viewing – the home, most commonly imagined as the family home. But intimacy also comes from the continuity of the television series or serial, the recurring characters, locales and situations that become part of the habituated viewer's domestic experience. Television, in other words, has realized most fully, and in its most popular form, the intimacy and continuity that serials and series in other media also attempt and it has done so by marrying the aesthetics of the form to the domestic environment of the viewer. In this way, it managed to achieve a paradoxical situation as far as the Western was concerned. It revitalized the genre and successfully brought its epic sensibilities on to the small screen and yet, at the same time, it domesticated the Western (or at least completed the domestication process that was already implicit in heroes like Hopalong Cassidy, Gene Autry and Roy Rogers).

The characters in the Warner Bros. Westerns, for example, became 'family' friends to millions of viewers at home and this family atmosphere was reinforced by the fact that these lone heroes sometimes appeared in each other's programme, breaking to some extent, the the strict generic coding of the Western, while underlining the close kinship of siblings from the same corporate genesis. If, through repetition (and longevity, for example, in the case of *Gunsmoke*, which ran from 1955-75) the characters became so familiar as to constitute a family of friends, in many other cases, the basic setting was a family environment anyway (*Bonanza* 1959-73, *Laramie* 1959-63, *The Virginian* 1962-70).

The effect of this process is linked by Newcomb to the third characteristic of the series/serial form as he sees it – a sense of history. It is, however, a very particular sense of history.

> The television formula requires that we use our contemporary historical concerns as subject matter. In part we deal with them in historical fashion, citing current facts and figures. But we also return these issues to an older time, or we create a character from an older time, so that they can be dealt with firmly, quickly, and within a system of sound and observable values. That vaguely defined 'older time' becomes the mythical realm of television.[27]

This process is already inscribed into the generic conventions of the Western and the Thriller/Private Eye formula anyway, where the hero represents a high moral sense of decency and justice, but crucial to

Western iconography gives a sense of the epic and cinematic width to the small screen: Faith Domergue and Clint Walker in an episode of *Cheyenne* (1955-63)

the process in the television variant is the presence of an older father figure, often dealing with the problems encountered by a young surrogate, or actual, son. Many of the series of the 1950s and 1960s were generic replays of *Rebel Without a Cause* (1955) and worked around the opposition of a 'contemporary' male hero, embodying elements of youth sub-cultural attitudes, and an older, wiser counsellor who represented the mythic value-systems of the genre. Thus, in *Wagon Train* (1957-65) the young trail scout, Flint McCullough (Robert Horton) often played against Ward Bond's wise old wagonmaster, Major Adams; in *Rawhide* (1959-66), Clint Eastwood's trail scout, Roddy Yates, was a youthful contrast to the staid confidence of the trail boss, Gil Favor (Eric Fleming) and in the 'daddy' of them all, Ben Cartwright (Lorne Greene) in *Bonanza* (1959-73) had the problems of three sons to contend with. The formula worked in other genres as well. Most famously (in its day) was the character of 'Kooky' (played by Edd Byrnes) in *77 Sunset Strip* (1958-63) who had the high moral rectitude of Efrem Zimbalist Jnr. to confront each week and effected a 'hip' James Dean persona. Richard Chamberlain was more earnestly sincere in his dealings with Dr. Gillespie (Raymond Massey) in *Dr. Kildare* (1961-66). Many of these stars became youth culture icons and sex-symbols at the time, a process helped by the network publicity machine.

The basic format, then, allowed the series to raise a range of contemporary issues and offer solutions according to mythic values, represented by the father-figures. In this way, a very contemporary aesthetic developed that became most characteristic of television and presaged the dominance of the melodramatic serial on television in later decades. (It established, as well, the pejorative epithet 'horse opera' in regard to the Western series. Thus the Halliwell Guide's comment on the long-running *Gunsmoke* : 'Phenomenally successful family western which in its later years came perilously close to soap opera'.)[28] The Western faded in the 1960s not because television 'domesticated' it and turned it into soap opera but, as Buscombe argues because of demographics and 'the hick factor'. Its appeal was to rural men and this was economically the weakest audience sector as far as the advertisers were concerned. By the 1970s, the series began to give way in a general sense to the prime-time melodramatic serial (which addressed the female audience more directly, while retaining the problem-raising format of the series) and its dominance of the network schedules was eventually supplanted by a combination of such serials, prestigious mini-series and the television film. This televisual imagination in America, in other words, developed out of cinematic aesthetics as a result of the two institutions of television and cinema quickly establishing a rapport.

Before leaving the American experience it is important to consider briefly the rise of the television film and to attempt to guage the implications for the television debate generally. To do so, it is also important to re-consider Raymond Williams' influential notion of 'television flow'.

Event And Flow In American Television

> In all developed broadcasting systems the characteristic organisation, and therefore the characteristic experience, is one of sequence or flow. This phenomenon, of planned flow, is then perhaps the defining characteristic of broadcasting, simultaneously as a technology and as a cultural form.[29]

The concept of television flow was developed by Williams to explain the impact of advertising and competition on primarily American television (though the influence was also to be found in British television, whether public service or commercial). For Williams, the important thing about television is that its programming has been *planned* by the broadcasters as a flow of more or less indistiguishable sound and images and is *experienced* by the audience as such ('a single irresponsible flow of images and feelings'). The process is at its most obvious in the highly commercial American system, where discrete programmes are interrupted so frequently by advertisements and trailers for other programmes that they lose

their distinctiveness entirely and become part of the flow, designed by the schedulers to 'capture' and 'hold' the audience for as much of the evening's viewing as possible. However, the competitive nature of television in Britain has also created the same drive towards capturing the maximum audience for the whole evening. Thus, in discussing the BBC's schedules, Williams argues:

> ... there is a quality of flow which our received vocabulary of discrete response and description cannot easily acknowledge. It is evident that what is now called 'an evening's viewing' is in some ways planned, by providers and by viewers, *as a whole*; that it is in any event planned in discernible sequences which in this sense override particular programme units.[30]

Williams' notion of flow was important for two reasons. First, it focused attention on television as an institution, as a total system, and acknowledged the difficulty and problems in dealing effectively with its discrete units in isolation. Second, it allowed for a more sophisticated debate about television aesthetics by inviting comparison across television genres, between television's function as a relay of 'live events', whether news or sport, for example, and its characteristic narrative mode.[31] John Ellis offered a refinement of the basic flow model by arguing that the flow consists of 'relatively discrete segments: small sequential unities of images and sounds whose maximum duration seems to be about five minutes'.[32] The segmentation of television grew out of the 'spot-ad' of American commercial television and thus a segment might be as short as thirty seconds. Crucially, Ellis goes on to argue that, as Williams had implied, '... broadcast TV does not consist of programmes in the way they are listed in programme guides or magazines ... (it) is characterized by a succession of segments, of internally coherent pieces of dramatic, instructional, exhortatory, fictional, or documentary material.'[33]

But surely there is a problem here. The programmes certainly have an existence in the guides; they have their titles and their place on a schedule and their own start and finish times. More than this, though, they are often accompanied by a substantial ancillary publicity campaign which is designed precisely to distinguish one from the other and this is particularly so of those items in the schedule for which a special 'event' status is sought. This could, of course, be an item of 'live' coverage, like a cup final or a major state occasion, but it is often a piece of narrative fiction. Even if close analysis reveals a narrative segmentalization which resembles much of television's other output, nonetheless, considerable investment in both money and advance publicity has gone into creating an 'event' around the appearance of such a narrative item. There is an attempt, in other words, to lift it out of the flow and confer a special status on it.

In the highly commercialized world of American television, the special status of the Hollywood movie became a key element in this process.

Douglas Gomery argues that from as early as 1955, 'pre-1948 feature films functioned as a mainstay of off-network schedules'.[34] At this time, the networks only programmed feature films as specials, not as part of the regular schedules. This was not because the networks were unsure of the status of the Hollywood feature as an audience attraction, but because the studios themselves were reluctant to release their films to television until the networks were prepared to pay at a rate commensurate with the earning potential of old features in re-run theatrical release. By the early 1960s, all the major studios were satisfied with the deals that television offered and regular network screenings of Hollywood films became an established part of the prime-time schedules. By 1968, there were 'movie nights' seven nights a week on the networks. When television had exhausted the supply of Hollywood films, it took the next logical step and began to produce its own 'television movies'. This allowed the networks to continue programming 'special event' narratives, while at the same time, allowing for the development and testing of potential new series ideas through the 'pilot' feature.[35] With the development from the mid-1970s on of the 'mini-series' (expensive narratives with high-production values, that married the 'special event' prestige of the Hollywood feature with the narrative and scheduling characteristics of television) cinema and TV had established a mutually beneficial co-existence.

It is important to stress the 'special event' nature of the Hollywood film and its television-made variant because it considerably qualifies the totalizing tendencies implicit in Williams' and Ellis' notions of 'flow and segment'. In elaborating his initial concept of 'flow', Williams described his first experience of commercial television in America. He found the number of interruptions to the movie he was watching disconcerting but was further confused when the trailers of future films to be shown on that channel were constantly inserted into these frequent commercial breaks.

> I can still not be sure what I took from that flow. I believe I registered some incidents as happening in the wrong film, and some characters in the commercials as involved in the film episodes, in what came to seem - for all the occasional bizarre disparities - a single irresponsible flow of images and feelings.[36]

There is mis-recognition here (and Williams acknowledges that he was 'still dazed' after his Atlantic crossing) but it is a mis-recognition which results from being an 'unskilled' reader. As the experience of the Western series has shown, the segments within the flow address the audience through genre conventions and various elements of visual style and *mise en scène* and just as the viewer of early 'live' television drama could recognize and appreciate 'difference' in the filmed commercials between the play's scenes, so, we must assume can the 'skilled' reader (the habituated viewer) of later decades recognize and understand the different modes of address contained in any segment of the flow. It could hardly not be thus, given the amount

of effort involved at all stages of the production, marketing and scheduling process to highlight such difference.

There is, then, a profound commercial rationale in ensuring that the television flow is recognized in its difference and experienced as a plurality by the audience. If the development of the science of demographics can be held responsible, even in part, for the demise of the television Western, then it was also responsible for a growing awareness on behalf of the advertisers of the fragmented nature of the audience for television. Television programmes did not necessarily have to have huge overall ratings if they attracted what the advertisers saw as the 'quality' audience in terms of spending power (young urban middle-class adults, especially women). It was this shift to a demographic approach, for example, that allowed for the development of the 'quality' drama of MTM and explains the fact that, despite its initial poor ratings, the MTM series, *Hill Street Blues* (1980-5) was recommissioned for its second, break-through season (that was to bring it twenty-one Emmy award nominations and eight wins).[37] The quality of the MTM programmes was recognized in their 'difference' from the conventional network series, both in content and in formal characteristics (visual style, narrative construction and *mise en scène*). In other words, despite the undoubted insights that the segment and flow argument has provided, it does seem, nonetheless, to overstate the situation by insisting that 'the programmes do not exist', as it were, beyond their position in an undifferentiated, and for the audience indistinguishable, flow of images. Rather, it is closer to the case to insist that, just as Hollywood has always distinguished its production according to target audiences and attempted to give an 'event' status to some of its films, so it has been with television. In the field of television fiction, this differentiation, from the 1970s on, has resulted in a plurality of approaches that tend to be missed in insisting too schematically on the 'flow' argument. There exists a danger, too, that this argument can fall back on an essentialist discourse about the nature of television, with a consequence that the strategic and contingent nature of American television, evident in its relationship to the Hollywood industry, is lost.

However, the history of the relationship between film and television in Britain is very different. There were specific factors in how television was viewed within the British context which gave the debates a completely different character (a kind of mutually assured antipathy) which was to the considerable detriment of both.

Television Drama In Britain: The Play's The Thing

While most historians see 1953 as the key year when television found its audience, the occasions chosen as starting-points for the new era throw clear light on the differences between British

and US experiences. For British writers the key date is 2 June 1953 – the coronation of Elizabeth II – watched by an estimated 20 million people, although only 2 million sets were in use at the time. For the US historian, Erik Barnouw, on the other hand, the corresponding date is 19 January 1953 – the day on which Lucille Ball gave birth to her son and her screen *alter ego*, the heroine of *I Love Lucy*, did likewise, watched by 68.8 per cent of the US television audience.[38]

This contrast between Britain and the US in the early years of television carries some of the same force as the contrast between Lumière and Méliès does in defining, in its formative years, two trajectories for the development of film – the contrast between a definition of the respective media as mechanisms for the reproduction of reality or as mechanisms for stirring the imagination and creating fantasy. In fact, of course, both sets of contrasts have their problems. Lumière carefully constructed his 'actuality' footage and can lay claim to the earliest fiction film in his *L'Arroseur Arrosé* in 1895; Méliès went to great pains to re-create for the camera, some of the most exciting news stories of the day, including political assassinations, and then passed them off to audiences as 'actuality' footage. Likewise, the coronation ceremony in Britain certainly showed that television had considerable potential as a medium of pomp and splendour (perhaps even for capturing the width of history) while the birth of Lucille Ball's child was a major news story at the time and its portrayal in a fictional drama had an immediacy which carried a sense of the documentary.

Nonetheless, the contrast is suggestive of the very different trajectory of television criticism in Britain which has had consequences for the development of television drama. Significantly, for John Caughie, the notion that television was primarily a medium for the transmission of the 'live' event persisted long after it had disappeared in the US and continued to influence the nature of television drama right down to the 1980s.

> For early television, then, I would argue that, characteristically, the artistic values were those of the theatrical event or the studio performance, and the values of form and style were the functional values of relay: how well, or with how much immediacy and liveness, the technology and the technique communicated the original event.[39]

When videotape was introduced in 1958, allowing television drama to be pre-recorded and thus widening the scope available to the director in terms of visual style and editing, the notion of the live performance persisted. Indeed, the take-up of new recording technologies was very slow in Britain. As Caughie points out, 'For a decade or so after the development of recording technology, television seemed to prefer to think of itself as ephemeral, preserving liveness as an aesthetic long after it existed as a technological constraint'.[40] This had the effect of emphasising the

play *as written* by the author and *as performed* by the actors and thus denying the visual possibilities of the medium. It was the world of the theatre rather than of the cinema. In 1972, Malcolm Page, reviewing nearly twenty published scripts of various British television dramas, few of which contained even photographs of the productions, wrote: '... it is difficult to form much idea of what the play looked like, and these books force the reader to emphasize the screen-*play* aspect and neglect the equally important *motion-picture* quality.'[41] In truth, however, he need not have worried since the emphasis on the 'play' in Britain had already caused the neglect of the 'motion-picture' potential of the medium in the production process. The fact that Page could collect so many published scripts demonstrates the closeness of the values dominating the production of television drama with a literary/theatrical sensibility.

These values are familiar ones in terms of the so-called 'golden age' of American television drama, but as we have seen, they disappeared very quickly in the US because of the imperatives of commercial television. Ironically, the emergence of commercial television in Britain had the effect, if anything, of reinforcing these literary/theatrical values. Despite its commitment to popular television programming, and its pioneering attempts to break into the American market through filmed adventure series, it was commercial television which instituted *Armchair Theatre* in 1956. Committed to hard-hitting contemporary drama, this ran until the late 1960s in one form or another. Its greatest achievement was to insist on plays especially written for television but in all respects, it was premised on the dominant values of immediacy and theatricality. Its ratings success stimulated the BBC into producing *The Wednesday Play* in 1964 (re-titled in 1970, *Play for Today*) and thus the 'golden age' in Britain ran from the mid-1950s to, at least, the mid-1970s.

The theatrical tradition which television tapped into was a very specific one – as in the US, it mirrored the then dominant naturalist tendency of the stage, rather than its more modernist trajectory. The result was a specific naturalist aesthetic that also fitted well the relay ideology that prevailed. Great care was taken with surface detail. Character and dialogue took precedence over visual style. Content displayed a concern with the ordinariness of life and evinced a commitment to a social reformist politics. It was an aesthetic, then, that drew on the dominant trend in British theatre and literature in the late 1950s, a kind of 'working-class realism' evident in the work of John Osborne or Arnold Wesker in the theatre and Stan Barstow or Alan Sillitoe in literature.[42] On the other hand, the emphasis on character and personal problems, gave many of the plays a theatrical staginess requiring the kind of last act revelation which grounds the whole piece in an individualist ideology. Thus Page is able to claim, 'That television is most successful as realism confined to a few people, the "drama of talking heads" in Mercer's phrase, is almost a truism.'[43]

The dominance of this aesthetic extended to the series and the serial as well. In 1960, *Coronation Street* was launched as a popular serial which attempted to tap into the success of the single play in this regard. The contrasting directions taken by American and British television can be seen in the fact that the serial, which so dominates the viewing figures in Britain, has adopted this naturalist, social realist approach ever since while the peak-time American serial stems from the emotionally-charged aesthetics of the Hollywood melodrama.

Now I am arguing here that the development of television drama in Britain followed a very different trajectory than in the US and as a result, went up a *cul-de-sac* of its own making (or, to be more positive about it, you could argue that television drama in Britain is *sui generis*, as George Brandt suggests but worries about).[44] The reason for this can be located in the longevity of a particular essentialist notion of television as a medium of relay and immediacy. Linked to the patrician notions of public service broadcasting (which informed commercial television in Britain as much as it did the BBC), television drama was closely influenced by the artistic values of theatre and literature and naturalism became its defining aesthetic. John Caughie locates a kind of 'enthusiasm of the amateur' in its commitment to the studio and the performance and protected within this cocoon, its aesthetic development was slow.

> Within the cultural and creative privileges of a public service television which valued originality and venerated the uniqueness of the writer, television drama could never become a completed classical form.[45]

This is not to deny the real achievements of British television drama within this aesthetic. In the 1960s, especially, the single drama opened up and explored a whole range of issues which attacked the complacency of British society. As Caughie himself has argued, the single play seemed 'to function for television as some kind of cutting edge, working to extend television's social or sexual discourse' and he particularly argued that in its development of the drama-documentary form and its commitment to the radical and innovatory traditions to be found in the history of naturalism, it had achieved a level of sophistication which allowed for a radical politics, or a 'progressive realism', and which, ironically, was suffused with an avant-garde sensibility.[46] And for many critics, the tenacity of this aesthetic, and the institutional structures which supported it, preserved British television from the worst excesses of the industrialized commercial production of the US. The primacy of the 'author' and the commitment to the single play allowed for more radical confrontational issues to be explored than the 'machine-made series and serials' of American television.[47]

However, it would be wrong also to underestimate the substantial resistance to this dominant ethos, especially from within the television industry

itself. The attack on naturalism began as early as 1964, when Troy Kennedy Martin launched a broadside against it in the journal *Encore*. He recalled that debate twenty years later in his McTaggart lecture at the 1986 Edinburgh Television Festival and despite over two decades of drama production since his initial thoughts on the matter, he felt that the ethos was still as dominant as it had ever been. Interestingly enough, he cites the role of technological developments over this long period as being crucial to naturalism's dominance.

> One of the perennial problems we have had to face every time we have been confronted with a situation which calls for *imaginative change* is that we are let off the hook by new technological developments which allow the old way of doing things just a little more life. We started in the drama studio with black-and white, then went on to colour, then out into the streets with mobile tape, then film, then Super-16, then faster film, then 35-mil, now wall television. At each stage, when the process should have been thrown back onto the virtuosity of its creators, the new development has allowed the Establishment to keep pumping out the same old naturalistic tune.[48]

At the back of this argument lies the question of television's relationship to film and, writing in the same year as Alan Parker made *The Turnip-head's Guide*, Troy Kennedy Martin is thinking also of the impact of Channel Four's *Film on Four* on how television drama is to be thought about. In some ways, it is inconceivable that as late as the 1980s, there was an almost complete blindness to the aesthetic conservatism of much of British television's prestigious drama production. The presence on the schedules of more experimental approaches to drama, especially the drama of Dennis Potter, should have alerted critics to how mundane most of the rest was. In fact, in retrospect, it is probably truer to say that the occasional Potter or McGrath could be tolerated simply because their fleeting breaks with the dominant ethos were so rare and therefore, easily contained. Thus, when Channel Four began in 1982 and instituted a policy of funding films specifically for television in its *Film on Four* strand, it caused a copernican revolution in thinking about television drama and its relationship to film. The debate was framed by a basic question – is the single television drama a 'play' or a 'film'? This question, of course, would have made no sense to an American viewer and the fact that it became such a much-debated ontological inquiry during the 1980s says much about the levels of 'blindness' in traditional television criticism.

This blindness can be seen in the fact that so few critics seem to have noticed that most of the single 'plays' and many shorter series by the middle of the 1970s had actually been shot on film. This rather confirms Troy Kennedy Martin's opinion that the problem lay with the dominant artistic values of British drama production which failed to see the celluloid

through the script with the result that the artistic potential of film was rarely realized. David Hare offers another perspective on this matter. For him, the BBC in 1960s, under the controllership of Hugh Greene, was the high-point of British television drama, when there was a climate of adventure and a sense of 'mischief-making' about the place. By the 1980s this had been replaced by a management more sensitive to government, more responsive to moral pressure groups and less willing to take risks. This sedimented the aesthetic conservatism of television drama. Interestingly enough, Hare blames this more staid and more censorious climate on the fact the the management was dominated by ex-journalists or sports broadcasters who little understood the aesthetic concerns of the dramatist.[49]

He castigates the dominance of an artistic sensibility that grew out of the 'live' studio and remained there despite the technical innovations that followed. It is worth dwelling on his argument, because it gives a clear description from the perspective of the writer/director of the differences between the mentality of the 'play' and that of the 'film'. He says that from the earliest days of his involvement with television, he disliked working in the studio on videotape. 'The play is cast, rehearsed in a couple of weeks,

Waiting a year to shoot on film: Michael Mellinger and Hugh Fraiser in David Hare's *Licking Hitler* (1978).

then slung on through a three-day scramble in the studio which is so tech-
nically complicated and so artistically misconceived that excellence is rarely
achieved except by accident.' The depressing experience of this mode of
production determined him never to go through it again and in the case of
his script, *Licking Hitler* (1978) he was 'willing to wait a year until one of
the coveted film slots came free at BBC Birmingham'.[50] He makes the case
for the director as the 'author' of the film (only he knows how the images
are to be composed and put together). He praises the speed and flexibility of
film and the artistic potential of film editing. In contrast, he argues,

> Videotape lies between theatre and film, the hopeless hybrid,
> recorded in slabs with unwieldy machinery which, up till now,
> has lacked visual finesse, against sets which have no stylistic
> density or texture, and lit from a grid which is too high and too
> crude.[51]

The predilection of television directors for film over videotape is borne
out by the steady accumulation over many years of TV drama which was
actually shot on film. In 1977, for example, BBC producer Kenith Trodd,
drew up an index of such material, showing that the BBC began to make
television films as far back as 1964, the same year that American
television made its first TV movie.[52] The fact that this body of work was
hardly recognized as film is significant and can be looked at from a number
of perspectives. I have been arguing that they were conceived within a
literary/theatrical milieu and therefore the script and the writer were
foregrounded over the visualization and the director. This had two
consequences. First, as Troy Kennedy Martin argues, the fact that they
were shot on film did not stop them from being fatally tarnished by the
naturalistic aesthetic which prevailed. They were, in large measure, poorly
conceived films. Second, even when they were significantly successful as
films (for example the television work of Stephen Frears) they suffered
from critical misrecognition and neglect and fell foul of the union agree-
ments that defined them as 'plays' and limited their exhibition to two
television screenings. However, it might be argued, as Alan Parker would,
that the films are fatally flawed by being conceived of as television in the
first place and the medium's own essential shortcomings stymied their
status as film. They were not recognized as films because they were not
cinematic – too many talking heads, too much emphasis on the domestic
and the intimate, to the detriment of width. The tragedy, for Parker, is that
the directors trained in this way are for ever imprisoned in a small screen
mentality and fail creatively when given the freedom of the big screen.

These arguments became more frenetic after the launch of Channel Four
and I would contend that what was finally at stake was not the ontological
issues which were being discussed. Rather at the bottom of this philosophi-
cal debate was, and continues to be, a concern for the ailing body of the

British film industry itself. I want now to turn to the question of a national cinema and locate the debates over film and television aesthetics within this discourse.

Living With Hollywood

When Channel Four started, in November 1982, British cinema was going through one of its periodic highs. The previous two years had witnessed critical and box office success for *Chariots of Fire* (1981, four Oscars) and *Gandhi* (1982, eight Oscars). The novelty of the new channel's strategy in regard to film was two-fold and seemed to guarantee that this new optimism could be sustained. First, Channel Four was to fund the making of films which would be guaranteed a theatrical release before their television screening, whenever possible and wherever appropriate. Second, as a 'publishing house' rather than a programme-maker, the new channel would commission all of its programming from the independent sector and this promised beleagured film producers the possibility of a greater degree of security by increasing the amount of money available for filmmaking as well as allowing them to diversify into other kinds of production.[53] The result of this was that, despite the example of the US (and, indeed, that of other parts of Europe), it is only with the emergence of *Film on Four* that there is serious and sustained discussion about the relationship between the film industry and television in Britain.

This is hardly surprising, given that the film industry lurched from crisis to crisis over the years, providing no stable base or tradition upon which television might grow. The weakness of the film industry and the dominance of the literary/theatrical tradition in television drama meant that a false dichotomy was posed for what was essential to the two media. By the end of 1982, though, Mike Poole could argue that:

> ...the advent of *Film on Four* does seem to point to a more self-confident future for filmmaking within television ... on a broader front, it should help to prevent the fatal short-circuiting between television and cinema that for a time threatened to kill off British film culture altogether.[54]

This aspiration was also commented on by Vincent Porter in the early 1980s.

> In many other countries, including France, the Federal Republic of Germany and Italy, there have been moves for the television and film industries to come together in the name of national culture. In Britain such a move has not happened to date because of the linguistic and political connections linking Britain to the United States.[55]

This has been historically a problem with the British film industry and accounts for the other extreme in the polarization of the film and television debate. Periodically over the years, the industry has been tempted by these connections and, lured by the potential rewards, it has geared its films to the American market. Inevitably, time after time, it has failed to break into this controlled, if lucrative market, the occasional isolated successes only ensuring the inevitable collapse because of over-reach and over-ambition, as happened in 1986 with *Revolution*.[56] To put the matter simply, the economies of scale and the concentration of capital and production factors that make Hollywood the global centre for filmmaking, ensure that no other filmmaking centre can possibly take it on and break into its home market on a sustained basis.[57] The British film industry cannot compete with or emulate the American industry. It must find ways of *living with* Hollywood. The false oppositions that have bedevilled the debate in Britain stem from two misconceptions. First, the rather staid television drama associated with British television for over three decades has been viewed as somehow intrinsically and essentially television. Second, the big-budget Hollywood 'movie' has come to represent what is essentially cinema.

Thus, in the debate engendered by the arrival of Channel Four, the ontological arguments over the nature of the films being produced was really an argument over the future direction of the British film industry itself. In this regard, 1986 was, in retrospect, a pivotal year for this debate. Whatever judgement might be passed on British Film Year a decade later, it did at least focus attention on the wider issues involved – aesthetic, institutional, economic and technological. It aired for the first time many of the sedimented notions about film and television in Britain that were merely uninformed prejudices torn from any historical context. The assumptions and prejudices implicit all round in *The Turnip-head's Guide* showed how polarized the debate had become. But the signs of this polarization were evident elsewhere in film culture at the time. The success of a number of British films in the early 1980s set the agenda and skewed the debate away from an understanding of the importance of an integrated audiovisual culture as the only way in which the British industry could live successfully with Hollywood.

This misunderstanding can be seen, for example, in James Park's book on the 'new British cinema' of the 1980s, significantly called *Learning to Dream*. The dismissal of television is complete, again confusing the traditions and routine practices of British television drama with the medium itself.

> On the whole, there is little place in the cinema for static
> midshots of two people talking against a picturesque background
> or the flip-flop reverses during dialogue scenes, both so common
> in television. Television at its best does use all the resources of
> film, but it can never have the same impact as work for the

cinema. In consequence, little encouragement is offered within television for directors to develop visual sophistication, and an expressive style of which does more than merely follow action and dialogue.[58]

In fact earlier, Park had acknowledged the argument that had been made by people like Troy Kennedy Martin and John McGrath for over twenty years by then, that ' any limitations perceived in television's output should be ascribed not to any inherent aspect of the medium, but to the deficiency of imagination and aesthetic ambition on the part of those making television films'.[59] The problem is not, of course, the failure of any individual filmmaker, either, but on the prevailing ethos within which, whatever the scale of ambition, he/she had to work. Park makes a classic *reductio ad absurdum* – he dismisses the argument because he sees the limitations as being essentially those of the medium and to prove it all one has to do is to look at what the medium has produced!

In a special section in *Sight and Sound* in 1984, provocatively and signifi- cantly called 'Life before Death on Television' the then-editor, Penelope Houston makes reference to another element of the debate when she writes: 'Not so long ago, most "films for TV" were made in Hollywood, often with no more ambition than to fill the necessary breaks between commercials.' This despite the fact that films were being made on television in Britain for twenty years by that time and, that as far as America was concerned, film- makers as diverse as Stephen Spielberg, Peter Hyams, John Badham and earlier than these Don Siegel, Robert Altman, Sam Peckinpah and William Friedkin, had all worked in television. But Penelope Houston articulates the crux of the debate when she argues that, while not wishing to discourage television investment in film in Britain, nonetheless,

> ...there remains the nagging feeling that what we've got, or look like getting, isn't quite enough: that the movie movie, as opposed to the TV movie, enjoys not only a wider vitality but the power to probe more deeply, that there are crucial aesthetic differences, as well as differences in the quality of the experience, and that what is on view is a fleet of Mini Metros, nice little cars as far as they go, but not the Mercedes or Porsches or Jaguars that some of the more far-fetched publicity might suggest.[60]

This vagueness about the 'movie movie' is echoed by one of the contributers to this special feature, Mamoun Hassan, who opines that 'cinema is at its best when it concerns itself with the ineffable, with that which cannot be expressed'. Two years later, in the pusuit of 'the ineffable', Goldcrest went bankrupt and another false dawn for the British film industry was ended.

In the mid-1990s, there is an optimism once more. This time, this optimism extends to other parts of the UK, especially Scotland and Wales, and to the

Republic of Ireland. It is important for the continuing success of these industries that the lessons of previous failures are learnt and that the false polarizations that characterized the debates in the 1980s do not happen again. Since the Goldcrest debâcle in Britain, there is a greater realization that indigenous film industries, whether the British or other European industries, cannot compete with Hollywood in the making of big-budget 'movie movies' and that if there is to be a vibrant alternative to the global cinema of Hollywood, then it will be the result of a mutually beneficial alliance of television, the film industry and a regime of state support systems which have existed for some time in other parts of Europe and which were put in place in Ireland in recent years. The debate in Britain has been skewed by the polarizations that I have attempted to explore here. If the British industry is to learn to live successfully with Hollywood, then debate needs to move beyond these misconceptions and the television and film industries need to learn to live with each other in a more mutually beneficial relationship. In this regard, at least, Hollywood and the American networks have shown the way.

References

1. *A Turnip-head's Guide to the British Cinema*, (Wr./dir. Alan Parker, Thames Television, 12 March 1986). The other films were contributed by Lindsay Anderson and Richard Attenborough.
2. For example, Parker acknowledges the influence of both *Hue and Cry* (1947) and *Cathy Come Home* (1966) on his growing cinematic consciousness and yet seems to endorse Ken Russell's opinion that British cinema is too concerned with making films about 'England' that have no possible interest to audiences elsewhere and are likely to bore the audience at home.
3. Alan Parker in *A Turnip-head's Guide*.
4. This, of course, also highlights the political and ideological thrust of the film. After the scale of the tragedy has been shown, the film then concerns itself with Schanberg's very individual search for his lost friend, Dith Pran. The whole operation of the narrative works to emphasize the fate of one individual over the fate of the crowd.
5. *Revolution's* role in the demise of Goldcrest is painstakingly detailed in Jake Eberts and Terry Ilott, *My Indecision is Final* (London: Faber and Faber, 1990).
6. ibid, p.578.
7. ibid, p.349.
8. ibid, p.349.
9. ibid, p.348.
10. William Lafferty, 'Film and Television', in Gary R. Edgerton, *Film and the Arts in Symbiosis* (Greenwood Press: New York, Westport and London, 1988), p.290.
11. ibid, p.277.
12. Robert Vianello, 'The Rise of the Telefilm and the Networks' Hegemony Over the Motion Picture Industry', *Quarterly Review of Film Studies*, vol.9, no.3, Summer 1984, pp.205.
13. ibid. Also William Lafferty, 'Film and Television', pp.273-309.
14. ibid, p.210.

15. Kenneth Hey, '*Marty*: Aesthetics vs. Medium in Early Television Drama' in John E. O'Connor, *American History/American Television* (New York: Frederick Ungar, 1983) p.117.

16. William Lafferty, 'Film and Television', p.293.

17. Kenneth Hey, '*Marty*', p.112.

18. William Lafferty, 'Film and Television', p.283.

19. ibid, p.292.

20. Edward Buscombe, *The BFI Companion to the Western* (London: André Deutsch, 1988), Table 6, p.428.

21. Horace Newcomb, *TV: The Most Popular Art* (New York: Anchor Press/Doubleday, 1974), p.248.

22. Edward Buscombe, *The BFI Companion*, p.39.

23. ibid, p.17.

24. ibid, p.47.

25. John Ellis, *Visible Fictions*, (London: Routledge, 1982), pp.122-3.

26. Horace Newcomb, *TV: The Most Popular Art*, p.245.

27. ibid, p.258.

28. Leslie Halliwell (with Philip Purser), *Halliwell's Television Companion* (London: Paladin, 1985), p.254.

29. Raymond Williams, *Television: Technology and Cultural Form* (London: Fontana, 1974), p.86.

30. ibid, p.93 (original emphasis).

31. For a sense of how influential Williams' concept has been, see, for example, in the American context, many of the contributors to E. Ann Kaplan (ed.), *Regarding Television* (California: The American Film Institute, 1983) but especially Jane Feuer, Robert Stam and Tania Modleski. For a critique of Williams, from the perspective of audience reception theory, see John Fiske, *Television Culture* (London: Routledge, 1987), esp. pp.99-105.

32. John Ellis, *Visible Fictions*, p.112.

33. ibid, p.122.

34. Douglas Gomery, '*Brian's Song*: Television, Hollywood and the Evolution of the Movie Made for TV', in John F. O'Connor (ed.), *American History/American Television*, p.213.

35. ibid, p.213.

36. Raymond Williams, *Television: Technology and Cultural Form*, pp.91-2.

37. Jane Feuer, 'MTM Enterprises: An Overview' in Jane Feuer, Paul Kerr and Tise Vahimagi (eds.), *MTM 'Quality Television'* (London: BFI, 1984), pp.1-32.

38. Roy Armes, *On Video* (London: Routledge, 1988), p.60.

39. John Caughie, 'Before the Golden Age: Early Television Drama' in John Corner (ed.), *Popular Television in Britain* (London: BFI, 1991), p.34.

40. ibid, p.38.

41. Malcolm Page, 'The British Television Play', *Journal of Popular Culture*, vol. 5, 1972, pp.806-20 (original emphasis).

42. For a discussion of these trends and their impact on the British cinema of the time, see John Hill, *Sex, Class and Realism: British Cinema 1956-1963* (London: BFI, 1986), esp. pp.20-27 and 53-66.

43. Malcolm Page, 'The British Television Play', p.810. He is citing David Mercer, one of the leading television playwrights of the 1960s and 1970s.

44. George W. Brandt (ed.), *British Television Drama of the 1980s* (Cambridge: Cambridge University Press, 1993), p.5.

45. John Caughie, 'Before the Golden Age', p.40.

46. John Caughie, 'Progressive Television and Documentary Drama', *Screen*, vol.21, no.3, 1980, pp.9-35.

47. George W. Brandt (ed.), *British Television Drama* (Cambridge: Cambridge University Press, 1981), p.22.

48. Troy Kennedy Martin, 'Nats Go Home: first statement of a new drama for television', *Encore*, no.48, Mar/April, 1964, and 'Sharpening the edge of TV drama' (an edited version of the McTaggart lecture), *The Listener*, 28 August, 1986, p.12. In between these two attacks, John McGrath also joined the fray in his 1976 McTaggart lecture, reprinted as 'TV Drama: the case against naturalism', *Sight and Sound*, vol.46, no.2, Spring, 1977.

49. David Hare, 'Ah! Mischief: the Role of Public Broadcasting' in Frank Pike (ed.), *Ah! Mischief: the Writer and Television* (London: Faber and Faber, 1982), pp.41-50.

50. ibid, pp.46-7.

51. ibid, pp.47-8.

52. This index was published and updated by Jayne Pilling in Jayne Pilling and Kingsley Canham (eds.), *The Screen on the Tube: Filmed TV Drama* (Norwich: Cinema City Dossier No.1), 1983.

53. See David Puttnam on this point in Jake Eberts and Terry Ilott, *My Indecision is Final*, pp.103-4.

54. M(ike) P(oole), 'Films or Plays?', *The Listener*, 11 November, 1982, p.33.

55. Vincent Porter, 'Three Phases of Film and Television', *Journal of Film and Video*, vol.36, no.1, Winter, 1984, pp.19-20.

56. See, for an earlier example, Robert Murphy, 'Rank's Attempt on the American Market, 1948-9' in James Curran and Vincent Porter (eds.), *British Cinema History* (London: Weidenfeld and Nicolson, 1983), pp.164-78.

57. For a recent discussion of these issues, see Steve McIntyre, 'Vanishing Point: Feature Film Production in a Small Country' in John Hill, Martin McLoone and Paul Hainsworth (eds.), *Border Crossing: Film in Ireland, Britain and Europe* (Belfast and London: Institute of Irish Studies and BFI, 1994), pp.88-111.

58. James Park, *Learning to Dream: The New British Cinema* (London: Faber and Faber, 1984), p.85.

59. ibid, p.81.

60. 'British Cinema: Life before Death on Television', *Sight and Sound*, vol.53, no.2, Spring, 1984, p.115.

5

Speed, Film and Television: Media Moving Apart

John Ellis

Television and cinema are moving apart. Both are media of sound and image, but their divergence is becoming ever more marked with every new technological innovation. Both have profited from digital image technology; each has used it differently. Cinema uses the new potential to make ever more realistic, yet impossible, images. Television uses it to make constantly changing collages of images. In doing so, television has discovered a means of enhancing its particular social aesthetic.

The clearest example of this divergence can be found in cinema and television's differing uses of the potential of new digital image technologies. In cinema, computer-derived images give us the dinosaurs of *Jurassic Park* (1992). In television they give us sophisticated weather forecast simulations, wild mixtures of drawn and photographed images, single frames filled with multiple juxtaposed images. Digital image manipulation allows television to combine images; it allows cinema to continue to present a spectacle of reality.

Jurassic Park was a triumphant moment for the new technologies, the moment when the mass public were offered a spectacle of synthesized reality in an undisguised, unapologetic way. Here was cinema at its most

A tale of jepoardy in public space: Keanu Reeves in *Speed* (1994)

modern, yet at the same time its most traditional. No matters of aesthetic principle divide Spielberg's dinosaurs from Méliès' moon monsters or Schoedsack and Cooper's *King Kong* (1933). The project is the same, to amaze an audience with the real-seemingness of something that they know does not exist. The only difference is the level of technological expectancy on the part of the willing audience.

Television, though, has used the potential of digital image technology to take a decisive step forward. Television has at last been able to take advantage of the two-dimensional feel that its screen has when compared to the cinema screen. By treating the TV screen like a sheet of paper, by writing over images, by creating the feel of drawn images, by sticking video images side by side or overlaid on each other, television is exploiting its graphic rather than photographic qualities.

Magazine programmes used to rely for their identity on presenters and theme music. Now a graphic house-style has become just as important. The show's logo is repeated in its captioning; information is presented by a combination of writing and moving images; 'reference' images are vignetted in the corners of the frame; 'key' iconic images are frozen and then overlaid with other images. A news broadcast will show dramatically slowed footage of a minister entering a government building at a time

of crisis; this image will be frozen, bleached out or tinted, and then used as the base for a series of bullet point lines of writing, or a series of still images with words, or even a series of vignetted moving images which are then frozen and arranged with captions.

These are nowadays familiar and even natural aspects of television, even if we do not have terribly adequate names for them. Yet even a decade ago, they were almost impossible. As John Caudwell has pointed out, this is an unnoticed revolution in television aesthetics.[1] It is not too much to claim that this marks the moment when television has come into its own, and no longer regards itself as cinema's kid brother.

Recently, awareness of this change has crept out of the pages of academic speculation and into the arena of popular entertainment. Moving images themselves are beginning to explore the nature of this divergence. *Speed* (1994) is a film which highlights the emerging distinctions between cinema and television, albeit from a position that claims a certain superiority for cinema.[2] This hugely successful jeopardy film starring Keanu Reeves, Dennis Hopper and Sandra Bullock, is entirely set in public spaces. It runs its characters through three forms of public transport – a lift, a bus and an underground train – each of which is threatened by a crazed bomber. A significant degree of the film's success is based on the very ordinariness of those public spaces, and the creeping suspicion that we all share in these days that public spaces are unsafe spaces. *Speed's* power as a film derives in part from its choice of spaces which are routine, public yet at the same time enclosed: the particular nature of public transport. The film trades upon the feeling of risk that lurks in the mind of every modern city dweller when they leave their home, the insecurity that each individual feels when they are part of a crowd, particularly when there is no escape. It is just as well that the film does not show the cinema complex as another threatening public space. Indeed, it attempts to forestall any such fear as the film ends: the hijacked subway train crashes through to the surface... in Hollywood itself. At that stage, the film is able to allow itself a few arch jokes, as the risks are over. Hollywood, and, by extension, the cinema in which we watch the film, remains a safe place.

Up to that point, however, *Speed* has taken itself entirely seriously, and succeeds in persuading its audience in doing so too: a rare achievement for a commercial spectacle film nowadays. Something underpins this achievement: the role that television is given within the film. Television is a regular point of reference in the film, and provides crucial plot material. *Speed* unrolls its tale of jeopardy entirely in public, rather than domestic, spaces. The film seems to show us what actually happens to the film's characters; and we see how television's coverage diverges from what happens. Television, the film seems to claim, can bring the crises of public space into the home, but mediates them, explains them, makes them into the object of speculations and story-telling.

Yet again, a film succeeds in proposing its reality as in some way superior to that of television. This is scarcely new. *Speed's* originality in this respect lies in the way it conceives this superiority. *Speed* is a film which admits that it depends upon television.

Speed proposes a model in which television is ubiquitous, but cinema is omniscient. Television provides Dennis Hopper's Howard Payne with his chief means of keeping in touch with the drama of the bus with his bomb on board. The police, too, are well aware of this potential and want to have the TV helicopters removed from the scene. When Payne blows up the women who tries to jump off the bus, his only way of checking whether his device worked is through the stuttering incoherence of the TV commentators, struggling to make sense of what we, in the cinema, have already seen happen. Payne's triumphant comment defines his relationship with television's role in the crisis: 'Interactive TV, Jack, the way of the future!'.

It seems at this early point that television, beaming its reports indiscriminately to the good, the bad and the indifferent, provides Payne with all the information he needs. We see him with his five TV monitors and hear the low volume cacophony of their commentaries. Then events take a different turn.

We see the trusty Harry enter Payne's home, the only domestic interior of the film. All is preternaturally peaceful, and then the bungalow explodes. Things have become really serious. Then, and only then, it emerges that Payne is not depending solely upon broadcast coverage of the crisis. He also has a private view, a line into the surveillance camera that come as standard to all risky modern public spaces, including buses. Then we find the films's main reflections on the nature of television. Annie asks immediately: 'He can see me, but can he hear me?'. Ever obliging, the film shows us Payne looking at his black-and-white monitor showing the scene on the bus, but hearing a news commentary. The existence of this partial television, image but no sound, provides the means to Payne's downfall.

When the bus enters the airport, to cruise at its obligatory fifty mph on the runway, the TV helicopters have to go away. This is restricted airspace. Payne has to rely on eye-witness commentaries from TV crews at the perimeter fence, and on his own monitor. The police simply have a relatively obliging TV crew make a tape loop made of the bus interior from the surveillance camera, with the passengers making minimal movements. This is transmitted to Payne in place of live signals from the camera. Live television and taped television look essentially the same. The live can be faked, the film shows us, and television's low quality images can cover the fact of fakery. Or can they? For there is a jump in the image when the tape is substituted for the live. But Payne is not looking at that moment: he's taking a leak. So Jack and the police can fool Payne not only because of the quality of the television image but because of its very ubiquity. The constant

presence (present?) of television makes it impossible to give it the constant attention that it demands.

Speed claims that television provides only a partial view, and that its promise of immediacy carries a fatal flaw within it. As a result, *Speed* claims that cinema provides a superior means of viewing an event. We see Jack under the speeding bus, first checking out the bomb's arrangements, and then being dragged along, desperately clinging on with his heels grinding against the road surface. It is an impossible event; and we have an impossible view of it. The film's suspense relies upon the effortless omniscience of the view that it provides us. The cinema of *Speed* is an omniscient cinema. It sees everything that is necessary to be seen.

Speed leads us to an important insight into this omniscience. After we have seen the woman being blown up on the bus, from all the necessary points of view, we hear the television commentators struggling to make sense of what they have glimpsed on their monitors or heard through their talkbacks. Television here is struggling to make a narrative as the events unfold. It is a live medium in the devastating sense that it does not know what will happen next or how things will turn out. In this, it is no different from any of us as we live our lives. Live television can never run forward to the end of the story, and then structure itself towards that conclusion. As a film, of course, *Speed* is structured exactly in that way: *Speed's* end is always in view, hence its omniscience, the omniscience of the 'historic' as Benveniste defined it.[3]

Live television lives with the events as they unfold. Yet, as a medium of representation, it works under the demand that it should provide a narrative. After all, the medium itself refers to 'breaking news stories', and emphasizes the word 'story'. However, all stories gain their meaning retrospectively. The ending provides sense (or closure) to everything that went before. The beauty of a classical Hollywood narrative structure like *Speed* is that everything in the film works to a greater or lesser degree as an anticipation or delay of that end. Such an option is not open to live television.

In television, speculation takes the place of the anticipatory narrative structure. In the television news and current affairs arena, we hear (because speculation is a phenomenon of talk) constant musings on what may have happened; on what may be about to happen; on what would be the result if what may happen actually happens; and then on what could possibly happen as a result. All of this is bolstered by information on all the participating parties in the event, or participants who could enter into the narrative if events took a certain turn.

I write these words as the British Conservative Party deals with the resignation of John Major as its leader, precipitating a leadership election. My remarks could equally apply to coverage of the Gulf War or any other

delimited news story. As I write, the live media, press and television alike, are full of speculation about the Tory leadership crisis. All the minutiae of an election process with less than four hundred voters is explained in exhaustive detail to a population that is supposed (by exactly the same media) to be totally disinterested in electoral reform. Descriptions of the characters and even the clothes of candidates (real, possible and fantasy) assail us on all sides. The smallest events are attributed with multiple, shifting significances.

All of this is born out of a frustration with narrative. Media and audience alike are desperate to know the outcome, and not to have to wait for events to unfold at their own pace. From this frustration comes the welter of detail and the unstoppable flood of speculation. It is all a vain attempt to gain a position of omniscience, to feel that concentrated impulsion towards a conclusion that is the experience of the fictional narrative.

Of course, not all news comes in the convenient story form that is taken by a leadership crisis or a conventional war like the Gulf War. Most news stories are ongoing. Like the siege of Sarajevo, the battle for Kabul, the fight against inflation or global warming, there is no end in sight, however much we might desire for one. Speculation about these stories continues within the news media and especially on live television, but it is a more muted form of speculation. Immediately that a possible end lurches into view, then the pace and quantity of speculation increases. The story moves up the news agenda, not because it is a crisis, but because it promises a resolution.

Television covers – or claims relatively plausibly to cover – the main news stories of the day. As with *Speed's* bus in jeopardy, a major story encourages television to use its live potential by cancelling recorded entertainment programmes to make more space for the drama unfolding live. This is television demonstrating its ubiquity. Television's implicit claim is that it is everywhere where things are happening, as they happen. As *Speed* shows, this ubiquity is more a promise than a literal reality. The cameras and the presenters are excluded from the really serious business of crises. Television is condemned to be always on the doorstep, never inside the door. It has the ubiquity of the bystander, rather than the participant, the spy, or the confidant. Television makes us all a member of that small group of people who somehow materialize on the edges of the scene of any event or potential event.

Speed exploits this fact of television to mark itself out as qualitatively different experience. Cinema is superior, it claims, because it can get inside the doors which exclude television's viewers. In fact, such a claim is not one of superiority at all. Television's particular and distinctive approach guarantees the omniscience of this kind of classic narrative cinema. Television, in all its insistent ubiquity, remains a faulty and indiscriminate medium because it runs with events rather than narrates them from an

omniscient stance. The fact of television, as an explicit point of comparison, endows *Speed's* cinema with an illusionistic power that it might otherwise find difficult to maintain.

Speed is a confident use of a cinematic form which has tended to lose confidence in the power of its illusions since the arrival of television. Cinema's use of omniscient narration has become more problematic since television developed its easy ability to speculate on possible narrative outcomes. As a result, the omniscient form of thriller filmmaking has found it difficult to assume that audiences still have the credulity that it demands of them. Television's speculative regime has given common currency to the idea that narratives can move in all kinds of direction, that 'what happens next' is not necessarily pre-ordained.

Speed turns this growing sophistication or scepticism to its own advantage. It uses the social fact of television as the touchstone of the cinema audience's privileged view. This is the secret of the film's success, just as much as its shrewd awareness of the jeopardy of public space and public transport.

Yet, for all this, *Speed* remains a traditional artefact. It aligns itself with *Jurassic Park* in its use of digital image technology for illusionistic effects. How else do you get to see the underside of a speeding bus with a star's body slung millimetres above the road surface? Television, however, has found new uses for digital image technology which enhance its relationship with the present and with the live.

Television has employed digital image technology to give physical form to its speculations. For speculation on narrative outcomes is essentially an intellectual activity. Very few pictures come with it, apart from the sight of the speculating correspondent in front of some iconic building (nowadays often achieved by blue screen superimposition rather than by standing the speaker in an awkward place). It may seem contrary to the popular conception of television as a medium that cannot sustain ideas, but it does seem to me that thinking about possible narrative outcomes is a major televisual activity, and it is by definition a conceptualizing activity. Whether it be sport, soap or news, television is full of talk about possible outcomes. But television, as a medium of image as well as sound, needs to present this speculative activity with some kind of pictorial activity.

Digital image technology has at last provided the possibility of using images to provide more than mere wallpaper (to use a common 'technical' term). The ability to combine images within one frame; to make some move and others freeze or move in ultra-slow motion; to pick out successive details; to write fluidly in synch with commentary; to use a huge range of print styles; to manipulate colour; to reduce depth and recreate it; all of these techniques have been harnessed to enable images to take part in the activity of speculation.

It is now easy to display concurrent events together so that their concurrent, yet separate, nature is emphasized. Cause can be piled up on effect. Images can summarize a complex situation into an elegant sequence of graphicized images and writing. Whole situations can be encapsulated into maps, diagrams, punning graphics and borrowed emblems. The distinguishing feature of the modern news editor, the state-of-the-art factual programme-maker and the successful magazine programme editor is their willingness to use such techniques, and their ability to render them unobtrusive.

The use of digital image technology is particularly marked in television news. It has become an essential feature of news because it serves to anchor the wild and the unexpected within a very explicit framework of understanding and speculation. News graphics play an important role in organizing the incoherent world of news footage into the coherent world of news explanation. Wars become maps, the economy becomes graphs, crimes become diagrams, political argument becomes graphical conflict, government press releases become elegantly presented bulletpoints. It is all done with the aim of enhancing understanding: it helps communication by providing more redundancy, and provides emphasis by doubling information in both sound and image. But by the same token, such graphics also enable television to carry on more effectively its activity of speculation, to cope with the impatience that comes with not knowing the end of a story, yet wanting it to come.

There is no grand explanation lurking behind this effort to explain, to predict, to define, to encapsulate, to summarize, to give graphic shape to the formlessness of events as they happen. Television as a system has no position on the meaning of life. It may well have governing viewpoints in particular areas of its output, but it has nothing that can compare with the omniscience of a film like *Speed*. Television provides local and tactical summaries only. It does not totalize: indeed, television's ubiquity (as defined in a film like *Speed*) makes that impossible. There was a time when television used to aspire to provide global explanations. It was one of the more impossible aspects of the traditional creed of public service broadcasting, which has now been abandoned in that form almost everywhere. Television has established itself as a non-totalizing medium. All human life is there (plus that of a good few aliens), but it is not subjected to any totalizing vision. This is not to define television as 'postmodern' however. To claim for television the kind of radical relativism that passes under that label would be to make a serious mistake. For television may not provide an explanatory framework for everything that floats into its view, but it certainly subjects everything to an exhaustive processing.

Television is a vast machine for processing the random and perplexing data of the real world into some kind of order. Yet the order it provides is not stable: television tries out successive attitudes and models of explanation upon whatever comes its way.[4] It does not conclude anything. Rather, it

exhausts its subject, wearing it out with the multiple modes in which it treats it. The increasing use of graphics enables television to carry this out far more effectively. Indeed, it has given television a formidable new means of summarizing without totalizing.

The world enters television through the news. It enters as whatever footage that witnesses have managed to obtain. Technical standards for news footage are minimal, and we are all used to the unaesthetic framings, the action caught half-way through by a sudden pan, the dubious quality of the sound, the drop-out, the barely-lit images, the images shot against bright light. This is wild footage from a wild world. Television series like *Cardiac Arrest* or *NYPD Blue* spend large sums to reproduce the effect to lend immediacy to their dramas.[5] News footage is footage of the live world; some of it may even be live as we see it.

This wild, live footage is immediately processed. News anchor persons (in the felicitous American phrase) tie it down; graphics summarize it and provide a means to speculate and analyse. The next day, the events are swamped in talk as they are mulled over in the daytime chat shows. The events that have entered television by way of the news begin to be defined in various competing ways. Psychological explanations, which are scarcely available within the news vocabulary, begin to be applied. Further processing takes place through the hierarchy of talk shows according to time slot and distance from live events. Then the events begin to enter into the arena of the weekly current affairs programmes. They are investigated; they are renarrativized, and re-explained. Then come documentaries, which examine the background issues or observe particular examples of a general trend, which are often the kind of compelling personal stories that elude the news agenda. At the same time, drama begins to enter the process: soap operas build the theme into their plot-lines as well as having the characters discuss the issue. Finally, the theme is worked through in drama.

This whole process, presented here in a purely schematic form, takes several months. What enters television as news report ends as theme in drama. Television has processed the news event through ever more sophisticated forms. By the time that documentaries and drama become involved, the initial raw technical qualities of the event have been replaced by careful framing, sound post-production, extensive scripting and produc-tion planning. The initial event, the crisis, has become absorbed into a process that has piled explanation upon explanation, narrative upon narrative. Television may not have produced a totalizing view, but it certainly has exhausted the event by working it through so extensively.

This non-totalizing exhaustion is not an inherently democratic process, even though it allows a number of explanations of events to co-exist. It is no more democratic than the classic Hollywood narrative is anti-democratic,

as the Grierson school tended to claim it was. The terms are inappropriate as they seek to provide a defining closure on the openness of the relation between the medium and its users. Rather, the process shows just how much television is a leaky system, beyond the control of any single individual or collective intentionality. Television is ubiquitous. It accompanies us through the uncertain process of life, and applies the same rough and ready judgements to it that we do. We feel an intimacy with television as a result; but we also feel a frustration because rough and ready judgements are usually all that it has to offer. For television is too much caught in the flow of events to want to try to take stock. Television is a means of consoling ourselves in the face of stories that unroll all around us, yet have no predictable endings. Television provides modulated speculation, anticipation and explanation as a means of dealing with this uncertainty.

The new graphic potential of television is helping to move the medium decisively in this direction. Graphics provide a myriad of ways of summarizing. They enable ideas and images to be brought together into a containing frame which is defiantly not the three-dimensional space which we identify with that of 'reality'. Graphic space on television is a televisual space, containing yet not totalizing. Television graphic space enables points of view to be contained within one frame or one short sequence. It provides a strong visual means for carrying on, and enhancing, television's activity of speculation.

In this use of new graphics, television shows yet again that it has no ambition of becoming cinema in the home. Entertainment cinema provides an omniscient, totalizing narration which always has its end in view. In order to do that, it has to present discrete texts and discrete viewing experiences. It is trapped in a world of fiction. Television operates in a different way. It is continuously available. It has great difficulty in designating anything as a discrete text (apart from the cinema films whose prestige it borrows). Instead, it provides a distinctive, speculative approach to events that are taking place at the same time as television takes place. It absorbs them and exhausts them, rather than narrativizing them in the style of entertainment cinema. Television's fictions, from soaps and series dramas to made-for-TV films, are entangled in a world of fact. They gain their dramatic strength and bond with their audience as a result.

Digital image technology has enhanced television's ability to process information and to speculate on the ongoing narratives that it absorbs from the everyday world. This is the first time that television has used a new technical process in a way that differs fundamentally from its use by entertainment cinema. This demonstrates how much difference now exists between the two media.

References

1. See for instance John T. Caudwell, 'Televisuality as a Semiotic Machine: Emerging Paradigms in Low Theory' in *Cinema Journal,* no.32, Summer 1993.

2. *Speed* was released in the summer of 1994 and according to *Variety* grossed $121,000,000 in that year alone. Directed by Jan De Bont for Twentieth Century Fox, it is reviewed with a complete filmography in *Sight and Sound*, October 1994 pp.51-2. The same edition also includes an illuminating essay on the film by Richard Dyer entitled simply 'Action' (pp.7-10).

3. A succinct discussion of Benveniste's conception, drawn for his *Problèmes de linguistique générale*, can be found in David Bordwell, *Narration in the Fiction Film* (London: Methuen, 1985, Routledge, 1986) pp.21-26.

4. This conception of television has been explored by John Corner in his *Television and Public Address* (London: Edward Arnold, 1995).

5. *NYPD Blue* is a prime-time hour slot American police drama series, produced on film by some of the team who worked on *Hill Street Blues*. The series originally starring David Caruso and Dennis Franz. Caruso left the series after the first run and was replaced by Jimmy Smits. *Cardiac Arrest* is a half hour prime time British hospital series for the BBC. Produced on video by Tony Garnett's independent production company World Productions Ltd, the first series was made for BBC2. As a result of its success the series was repeated on the majority channel BBC1, and a further series commissioned.

<div align="right">**6**</div>

Nine Notes on Cinema and Television

Rod Stoneman

1. Border Crossing – the autobiographical.

*Caelum, non animum, mutant/They change their sky
or horizon, not their mind*

The context to these notes is the way that my work has moved forward and back across the shifting boundary, this refractory division, between cinema and television. I should begin, therefore, by interjecting a fragment of the personal. In 1980 I worked as Cinema Co-ordinator at the Arnolfini in Bristol, from programming the films to actually selling the tickets (and the box office change never exactly added up). A few years at the coal face of art house exhibition encouraged a specific sense of the motivation and decision-making patterns of those who pay to go to the cinema. This was followed by a period working as an independent filmmaker, and the production of several documentaries (including *Italy: the Image Business* [1984], on the changing relationship between cinema and television in Italy in the mid-1980s, and *Ireland: the Silent Voices* [1983], on the British media on Ireland). I had been involved in the Independent Film and Video Department at Channel Four Television on

a part-time basis from 1982, subsequently becoming Assistant and then Deputy Commissioning Editor. I then came to Galway in the autumn of 1993 to direct Bord Scannán na hÉireann/the Irish Film Board.

These changing job titles might take up a few lines on an apparatchik's curriculum vitae, but there is something else at play – different angles on the same shifting interface, a change of address towards audiovisual production, involving various perspectives on the two sites of a complex interdependence. If there is some continuity, it is that of exploring the interstices where a certain kind of braver, more radical work might be possible.

2. In, On and Through Television.

Beati possidentes/Blessed are those who possess

> The specifics of separate traditions, of the cinema and of television, in documentary as well as fiction film, must not obscure the way in which cinema lives in, on and through television in the late twentieth century. Whatever our vestigial affections for the focused experience, public space and higher resolution images of cinema, the social experience of the audiovisual is now overwhelmingly in the home.[1]

This slightly polemical paragraph was written in late 1991 while working for Channel Four: it was part of 'Sins of Commission', an article produced at a point when it seemed necessary to attempt to make some sense of ten years of the Independent Film and Video Department's project of radical television. This was at a juncture marked by the belated revelation that the Channel Four Board had made a clandestine decision to pay its Executive Directors a gross and mercenary bonus, a venal gesture which indicated that the organization was crossing an invisible but definite threshold into the corporate culture of commercial television.

From the very few of those involved in the making and the distribution of films for cinema that encountered the article in the esoteric reaches of the film theory journal *Screen* where it was published, it drew a testy response along the lines of 'But it is better to have a single spectator in one seat watching the silver screen intently than 300,000 glancing distractedly at a television while they do the ironing'.

This is a view, however, that can only be maintained if one is not concerned with the social function of cinema. One must address audience reach as well as audience reception (i.e. questions of quantity as well as the proverbial quality) if questions about who films are made for and how they function are to be considered. There continues to be a need for attention to be paid to the reception of films and the circulation of their meanings socially.

Now, writing these notes, a few years after the *Screen* article, placed again on another side of the fence, outside the fortified pale that surrounds television, the original formulation seems valid in that it points towards an economic reality and the site of the encounter with an audience. It counters filmmakers' unconscious but persistent disavowal of their actual audience.

Viewing conditions do, of course, inflect the work of the text. Hans Magnus Enzensberger does not understate the shortcomings in his description of television as a 'zero machine': 'The aesthetic fascination of the cinema cannot be repeated on the television screen, it is destroyed by the ridiculous format, the interruption of advertising breaks, and the indifferent endless repeats; the viewer's secret weapon, the dreaded zapping, gives the film the *coup de grace.*'[2]

This dissident essayist's anger, however, leads him to a manichean description and exaggerated dismissal of television as medium and institution – it is not monolithic as a structure nor in the viewer's experience of its output. Its product is not undifferentiated and the conditions of viewing vary widely and constantly between attentiveness and distraction. The range of television programming, and the presence of cinema as an integral part of the schedule, fluctuates greatly. The domestic is the primary site of the audiovisual for most people at the end of the twentieth century especially for, say, a single mother living in a rural setting far from a cinema. We should develop greater equanimity in relation to cinema's lives both on television and outside of it, although it is true that television and cinema still have a great deal of harm to do to one another.

3. The Cinematic Condition

Ultima ratio/The last argument

The distinctions between film and television, such as they are, certainly do not lie in some simple formal or format difference: the bubbling of the silver halide grains versus the pulsing of pixels, a preference for sprocket holes rather than helical scan. There are other connotations and expectations associated with the 'cinematic' – many of them often unconscious.

Cinema possesses itself of a kind of visual and aural intensity: at all its different levels it works to add value though production processes to a screen image. 'Money into light' in John Boorman's elegant phrase. This is manifest, for example, in the way in which the budget dictates the length of the shoot and the length of the shoot dictates how many minutes of 'on screen time' must be achieved on average each day.

Scale and size is supposed to be crucial in distinguishing cinema from television – often the role of the setting, landscape or cityscape is a factor,

although this is now subtler than the crude attempt in the 1950s and 1960s to mobilize the epic dimensions of cinema against the smaller screen of television, neat in its middle-class walnut cabinet. As Jean-Luc Godard remarked at the time, the very wide screen of cinemascope was 'suitable only for snakes and funerals'.

Cinema works through narrative power and the display of known actors or stars (the old industrial cameraman's adage about how to set up a scene was 'shoot the money') against a huge background. But although there are notable exceptions of films on a more 'domestic' scale that work as cinema – *The Snapper* (1993) was conceived for television but had significant success theatrically for instance – cinema's project is in a larger scale, wider image of the world.

One could also argue that, to some extent, there is often more space for political independence and dissidence in cinema production than in television structures. There is an enlarged role for cultural dissent, and in all its forms, film is at its most innovative when it is experienced as unexpected, challenging social norms or complacencies of taste, extending the boundaries of the possible. It offers a precarious cultural space for social contestation; as Oscar Wilde wrote 'A map of the world that does not include Utopia is not worth even glancing at'. Whether it's *Blue Collar* (1978) or *Priest* (1995), *Burning an Illusion* (1981) or *In the Name of the Father* (1993), *Missing* (1981) or *Land and Freedom* (1995) – the space to challenge the 'way things are' continues to exist in cinema... And to stretch the boundaries of form: figures as different as Jean-Luc Godard[3] , Krzysztof Kieslowski and Quentin Tarantino continue to play with narrative and composition.

There is considerable distance between the two traditions of cinema and television documentary. In broad terms, cinema documentary has had stronger visual and political emphases than the television version. As there is virtually no separate theatrical space for documentary in the cinema today, its formal and radical strengths have to fit within the truncated possibilities of factual television (on British commercial television, precisely 51 minutes 26 seconds).

The aspiration to longevity seems to be confined to cinema rather than television culture. The conception and purpose of television production is framed within shorter-term intentions. Fiction and documentary films are only a small part of its concerns; its special vocation is in series and serials, game shows and magazine programmes. Perhaps it is linked to the shorter attention span of television production in general - aesthetically weaker material, shorter-term aspirations for each individual piece. Television celebrates the ephemeral and there is little expectation that most of its output would be viewed more than once, circulated in cinemas or achieve posterity in the archives.

Cinema's force is desired, imitated and borrowed by other echelons of the audiovisual. Most pop promos are post-produced on video for television transmission, but they often retain an aspiration to cinema and all that it means, signified by a black border at the top and bottom of the frame – a wider screen format connoting the 'idea of cinema'. This disingenuously reflects the continued potency (narrative style, visual strength) that television seeks from cinema.[4]

Both in a catalytic role by affecting form and style, and in terms of its radical potential to frame and ignite issues, fiction can be used to argue with reality and to propose change, to achieve a certain intensity of hypothetical experience.

4. The Crux, the theatrical hold-off

Quis custodiet ipsos custodes?/Who will guard the guardians?

Theatrical exhibition is one channel amongst many but the cinema release is a key mechanism for introducing a feature film to its potential audience and for adding value to it. It enhances the text with the patina of pleasure promised through cinematic publicity.

Institutionally the provenance of an individual project's script development and balance of its financing will probably determine the way it falls within the theatrical/non-theatrical separation. It is a division of all its stages that will affect the approach of those working on it, its budget, its scale and aspirations, the way in which it will be made, presented and eventually understood...

There can be considerable conflict around the principle of a theatrical hold-off with television funders even before a film is made. Of course, both sites should be compatible and of mutual benefit as a result of the publicity and, on occasion, the direct profit of a theatrical outing. The whole constructed fascination with the cinema in our culture – advertising, newspaper and magazine reviews, even the television programmes devoted to cinema – enhances the impact of a feature film, even if it is solely financed by television.

When it is eventually transmitted on the smaller screen the label 'film' beside a title in the newspaper television listings will immediately multiply its audience. But there is significant difference in the way that film and television drama is treated in both previews and reviews. A newspaper's television critic does not have the space or the prominence to review television drama in the same way that the same paper's cinema critic writes about the new cinema releases each week...

However, from a television point of view there are constant pressures to feed hungry schedules, an impatience to achieve an early transmission while a film is still fresh. There are many notorious examples (such as BBC2's premature screening of *Utz*) which rule out a film's chance of theatrical release. There are also a few films (such *The Snapper, My Beautiful Laundrette* [1985] and *Hush-a-Bye Baby* [1989]) which have crossed the line in the other direction – conceived as television drama they become cinema fiction, and unexpectedly find theatrical success. This can even occasionally happen after transmission. Since few go to a cinema specifically to see a short film, when they are on the programme they function as an added bonus; shorts can inhabit both domains and move back to theatrical exhibition after a television screening with relative ease.

The theatrical may only be an aspiration at script stage - often it is easier to sense the subtle and ineffable differences between cinema and television, to decide whether a film has theatrical potential, when one can see the actual rough cut. But even then it is still a very inexact science. In the end it may simply be some hard-to-define aspect or factor in a film that prompts people (a more or less delimited section of the social formation, defined by gender, age, class, national culture, sexuality) to take half an evening out, make a journey, and buy a ticket for the experience of seeing it in a social space...

Conceived for television but successful in the cinema: Gordon Warnecke and Daniel Day Lewis in *My Beautiful Laundrette* (1985)

What is at stake for the audience in the difference between the public and the personal sphere of experience? What importance is unconsciously given to the question of image/sound quality? How much does the notion of an event hinge on the disparity of concentration and distraction between home and the cinema? How important is the facility and convenience of a video in relation to the focused experience and enhanced 'occasion' of a cinema? The polity watches its cultural artifacts together. In the semi-darkness there is a sense of the sound of an audience around each spectator and the experience of a socialized response to humour, tension and relief – the functioning of the text's formal machinery – the successive meanings, emotions and impulses of any film shared, indeed created, through interaction with the group of strangers that constitute an audience.

5. Advertising, the circumstances of film on television

Cui bono?/For whose benefit?

Two of the four terrestrial television channels in Britain and the two national television channels in Ireland are interspersed with advertisements.

The transmission of fiction features and all other material is interrupted by commercials, as is a large part of the audio and visual landscape (radio, billboards, newspapers and so on). This interruption is part of the very sinew of our audiovisual culture, an interference which is so much part of the surrounding audiovisual signal, it is difficult to notice, let alone criticize. As George Orwell wrote 'To see what is in front of one's nose needs a constant struggle.'

From the perspective of the underlying economy of television we should be clear that programmes are actually and merely the means to deliver an audience to the advertiser. Perhaps it is not widely known that it costs as much, if not more, to produce a sixty second television commercial as the programmes shown on either side of it.[5] Is it a wise or proud disposition of resources in our culture to devote so much budget per spare inch to advertising?

Since Vance Packard's *The Hidden Persuaders* was originally published in 1957, there has been much theoretically-informed debate in recent years about the information and attitudes that advertisements carry. So often, however, the valuable critique generated in academic institutions cannot penetrate the industrial defences of fortress television. Media academics have only interpreted television, but the point is to change it.

It is important to understand the motives at play in the economy of advertising. It is not quite the habitual logic of capital to invest money on advertising and expect to see that cost, plus added value, returned from the

specific result of the advertising campaign. In fact there is a double negative operating here - it is often a question of deploying advertising not to *lose* sales rather than a campaign to *gain* them. Companies are afraid of losing ground and profit if they don't advertise to create and maintain their product's presence and their share of the market. On the distant horizon there is always the elusive desire for the dream solution to make the brand name the generic title of the objects (biro, hoover, sellotape) that inhabit our everyday life...

Many television commercials aspire to the cinematic – recently some of them have become mini-fictions themselves. There is a visual opulence in their style, format, actors, and with serial advertisements a trivial narrative (love over coffee) that is stretched across a longer period. Sections of advertising production constantly search for perceptible novelty to replicate styles and techniques for more anodyne and often commercial ends. Thus the objective market demand to transform artistic product into a marketable commodity is fulfilled.

The culture *of* advertising has gradually grown to the point where new ads attract media attention to themselves, and not just in the pages of specialist trade journals like *Campaign*.[6] This connects with the arguments that are sometimes made about advertising-trained film directors – that their films are glossy but empty. The audience is already visually socialized into the grammar of films that shimmer with a meretricious vacuity. Some films seem to imitate the style of commercials and the circle is complete: the film that aspires to the ad that aspires to cinema...

What is the attitude of most viewers to the attenuated detritus of advertising – one of bemused scepticism, passive cynicism? The flow of advertising images is taken as a given, part of the audiovisual landscape of everyday life. Yet, these spurious fragments interrupt the structure and the pace of the text when a film is shown on television. Leaving aside the more aggressively provocative and asinine trivia that the advertising industry offers up, the general pattern places fiction features inside the framework of a culture of spectacular consumption.[7] Might one imagine that it could be other?

6. Risk

Novitatem meam contemnunt ego illorum ignaviam/They despise my novelty, I their timidity

In their different ways the commissioners and financiers of film and television nearly always avow some commitment to taking high risks, working with first time filmmakers, making films without well known actors or stars. Everyone manifests a predisposition towards the new, the innovative. Indeed television uses cinema to provide it with new ideas, new material,

to take its risks for it.[8] The desire to 'bring in new talent' has led to the proliferation of a plethora of short film schemes.[9] It is also a way to cordon off and place troublesome new talent in a safely separate zone in the schedule. Funders utilize a prudent safety net: surrounding a tyro director with the scaffolding of experience – 'they can't go too far wrong with a brilliant cinematographer in front, an experienced editor alongside, an established producer behind'.

But, despite good intentions, it is very difficult to achieve consistent risk-taking under sustained pressure. Hesitancy, timidity and conservatism take different forms in cinema and television. Television is governed by the ineluctable algebra of high risk equals low audience equals lower levels of investment. Actually it can be argued that the opposite is true: first-time directors need significant budgets, to support longer preparation, an editor working alongside from an earlier stage, five- rather than six-day weeks to take pressure off the shoot. But this would be to invert the logic of the market. However there are some advantages in working with lower budgets because there is less pressure on this production space.

The television micro debate about innovation and risk takes place as part of the dangerous change in the climate that has taken place over the last decade in European public service broadcasting. The insertion of commercial pressures has had an inevitable long-term effect on editorial postures even in some non-commercial stations. The conjuring trick by which the market represents the people's wishes and preferences continues, consumer choices are positioned as an expression of democracy in an ideologically self-fulfilling prophecy.

Although cinema is not immune from political pressure by any means, it is more lightly regulated. More or less explicit censorship occurs inside and outside the institutions; invertebrates can often be found in the official structures of television regulatory bodies and the organizations of film censorship, indeed within the funding organizations themselves! The constraints on sexuality, swearing, and drinking and even methods of suicide, are stringently defined in television, with different rules each side of the 'family viewing threshold'. Cinema, despite the bizarre Hays Code of the 1930s to the 1960s, has generally operated with less defined parameters except when screened on television.

Television commissioning editors might request 'comfort names' to strengthen the proposed cast list, and American distributors offer 'above the line' monies to the budget for star names. Many American cinema distributors apply a blanket formula – they will not invest in first-time directors until they can see a rough cut. As Sergio Leone explained 'American producers face their problems in a very realistic way – very drastic and very hard. "The Product is Money" and the Product must be defended, but sometimes they don't defend it in the best way'.[10] It is often worth reminding oneself that in film production there is always only risk; although producers

work to minimize the dangers every batch of newly released films serve to indicate how undependable even the biggest, most 'bankable' names turn out to be.

Creating a space where a greater range of calculated risks might be taken is essential for the project of pluralism. A perverse desire to embrace adventurous ways of working is necessary to open the envelope of the possible. Pluralism is the space of difference and the possibility of challenge through the suggestion of other, possible orders. As William Blake wrote, 'Without contraries (there) is no progression'. There should be contention between a very wide diversity of styles and of subjects: the urban and the rural, the contemporary and the ancient, the high-brow and the low-brow, the 'tragi-cal-comical-historical-pastoral, scene individable or poem unlimited...' in Polonius's words.

Natural selection and paradigm change can only occur in the argument between different films – arguments which take place on a decentred terrain where no single approach is privileged. Perhaps the variegated range of films achieved by such pluralist approaches will also in its way help to sustain radical and imaginative solutions to human and political developments.

7. Ireland

Mens agitat molem/A mind sets the material mass in motion

How can one account for the constellation of energy and activity in Irish cinema? What was the combination of factors that led to such a dramatic opening over the last few years? What has been the role of television in the exponential increase in indigenous cinema?

The sustained lobbying for the re-establishment of the Film Board that had been abolished in 1987 was eventually accompanied by a new species of economic argument.[11] There was also the role of the contingent - Jim Sheridan's *My Left Foot* (1989) and then Neil Jordan's *The Crying Game* (1992) winning an Oscar, entirely financed from abroad in contrast to his first feature film *Angel* (1981) which had been supported by the first Film Board.

Some combination of these factors led to a renewal of government policies; the recommendations of the Taoiseach's Working Party Report were taken up and extended with particular focus and vision and energy by the Minister of Arts, Culture and the Gaeltacht, Michael D. Higgins, initiating an integrated policy of the re-establishment of the Film Board, an extended version of the tax incentive Section 35, and legislation to enable RTE to take an increasing proportion of independent production into its schedules.

RTE had historically been involved in relatively few single dramas; in 1989 indigenous drama had retracted to a baseline that produced only twenty-seven hours of original drama in the entire year, twenty-four hours of that total being made up of soaps and series. There has been little tradition of indigenous independent television drama and the independent producers who had been involved in the argument for the re-establishment of the Film Board felt particularly disenfranchised as they had no outlet for fiction production through national television. Although made by a generation of filmmakers, many of whom had begun inside RTE, most of the fiction that had taken place during the 'lean years' since the first Board had been abolished was produced outside television.

RTE history involves an exacerbated version of television constraints – reflecting the historical context of particularly restrictive mores and subject matter in a conservative, clerical, national context. Financially RTE is a large, vertically-integrated broadcaster that has little cash to redeploy that is not already tied into its infrastructure. There is also an unhealthy proximity to government which does not help foster the climate of critical independence crucial for the broadcaster to play its full role in the process of social change. Whatever the particular politics involved, it cannot be sensible for a national broadcaster to have its entire Authority directly appointed every few years by the government of the day. The Conservative governments of the 1980s in Britain unashamedly increased their leverage on the appointment of BBC Governors, with unfortunate results.

Ireland has an extremely dynamic discursive context, a critical film culture providing a direct interface with creativity and production. There are three journals about cinema: *Film Ireland, Film West* and *Irish Film;* annual film festivals in Dublin, Galway, Cork, Belfast and Derry; continual debates and seminars like the one from which this book emanates, energetic activity for an island of five million. For many years, Irish filmmakers used to quote the example of others (New Zealand, Australia, Germany, even Iceland) as a way of indicating the lack of imagination in funding an audiovisual culture in Ireland. Now others are using Ireland as a stick with which to beat their own national governments and industries. It is crucial that we in Ireland retain the constructive critical dimension in relation to progress in film. Complacency is as bad as begrudgery. There is a potential productivity for the discourse moving through the audiovisual field. At its happiest Ireland, like Italy and India, is one of those rare cultures which is more tolerant of the notion of the circulation and activation of ideas. But it is also true that residual anti-intellectualism can rear its ignorant, scornful head in this relatively informal and discursive culture.

One does not have to subscribe to an instrumental relationship between the economic infrastructure and the cultural superstructure to see some connection between this dynamic cultural activity and the underlying movements in Irish society and politics. Cinema and television are catalysts

in a period of extremely rapid social and cultural change. The speed of the modernization and secularization of the society is unparalleled. There is also a gradual but perceptible shift in the fields of force that make up the complex dynamic of the national question, although this is accompanied by a dearth of independently-produced fiction emanating from the actual communities in Northern Ireland.[12] The productivity of the present conjuncture arises from the complex social and aesthetic formation which is in a process of constant change.

There are historical and artistic roots to the current constellation of activity – the provision of state finance to pump-prime a cultural industry is necessary but not sufficient. But this transitory configuration is given added capacity and potential by a critical film culture.

8. Europe: the Regional / National

Dolus versatur in generalibus/Danger lurks in generalities

The tectonic plates of the continent are edging towards one another and leading to the creation of a productive conflict between the things held in common, that confirm the cultural, historical designation 'European' and the things that are important correlatives of difference – the dynamic diversity of Europe. Different currents flow at different depths, taking Europe on the one hand towards increasingly large-scale continental, indeed global, economic organization but also increasingly encountering smaller scale movements of national and regional cultural self-definition.

Ireland suffers in the same way as many other countries from the cultural hegemony of the capital-as-centre. The metropolis exerts a centripetal force. Like Russian dolls, the relation between a region and the capital in a small country is broadly analogous to the position of that country as a whole to bigger countries.

But, to state the obvious, what is at stake in the terms 'regional' and 'national' is not cultural difference, which may be more divergent regionally, but the structures and material effects of power and the representation of autonomy, identity... Self-identification with the imaginary of region and nation, are not mutually exclusive, although by and large regional identifications do not have the same potential for conflict and carnage as the borderlines between nation-states.

These terms also raise the crucial question of scale - the difference between the dynamic of a smaller scale film and television culture and a larger one. The starting point for such comparisons must be non-competitive and non-evaluative. In a small country, an integrated approach works in a more concerted way but inevitably does not carry the same critical mass as a large industry.

In Europe as a whole, and especially in smaller countries, there is an economic imperative for co-production for most films and many television programmes. A mosaic of funding has to be put in place. The co-operation and interaction between independent producers in different countries in raising the budget may also increase the desire to cross borders and to address wider audiences. Making a film for an international audience is not necessarily any different to a local or national one, except that some elements of context may need to be clearer. There may be elements of specific background information that cannot just be taken as a given outside of the particular context. If approached with sensitivity, these are generally relatively minor adjustments and should not inhibit the creativity of inter-cultural interaction. The dangerous delights of an encounter with a culture that is distant geographically or historically are evident in the plays of Shakespeare and Chekhov, the films of Sembene and Ozu, the painting of della Francesca, the thought of Heraclitus.

9. Global: the Industrial and the Artisanal

Omnia mutantur, nos et mutamur in illis/All things change and we change with them

It is difficult to underestimate the seriousness of a situation in which American films have gained more than a ninety per cent share of cinema screens in Ireland and Britain and average thirty-five per cent of most European television channels. This has happened for a number of reasons, including the consistency and power of the Hollywood narrative product. American cultural fertility draws on its very hybridity (and not a few Europeans have been ingested into its production structures). It is worth being clear that the argument is not against American culture but against the hegemony of American market-driven cultural products.

We can begin to delineate the specific industrial mode of production that has evolved in the bottom left-hand corner of the United States; factors that have enabled American production to become the object of global consumption. There is a general paradox at the centre of cultural phenomenon: every one is different but the same. This desire to repeat is enhanced commercially by Hollywood – standardization is evident in the use of broad generic conventions, and a heightened version of the formulaic impulse may be seen in sequels, follow-ons and remakes.

The tendency to repeat is reinforced by marketing strategies. If you go to a mainstream American studio film there is a sense that it will operate and deliver its narrative pleasures within a very narrow band of expectations. But if you go to a new Swedish or African or English (or indeed American independent) film you must be prepared for the marvellous or the dreadful and everything in between.

There is some equivalence in beverage production: for example Coca Cola, that quintessentially American drink, is produced locally on a franchise basis and it is the same in Dallas or Dakar. In contrast, an accentuated diversity is part of the pleasure available in drinking European wine or a Scottish whisky. The range and variation of the field offers a more fascinating but less reliable experience.

American production structures are significantly hierarchical. An excessive degree of separation and division of highly paid and alienated labour is used to achieve this end. Powerful narrative machinery is fine-tuned by a large number of script drafts, input from distributors and the use of test screenings. The replacement of the original studio system by shorter term relationships between distribution and financing structures working with independent companies has replicated the very commercially-oriented command structure evolved by the studios.

It is also a question of scale, the large critical mass of American production leads to important economies of scale all the way through the production, distribution and exhibition processes. The co-ordinated release of a new film is timed to make maximum impact in different territories at the same time.

In contrast to the industrial, European auteur-based film culture is artisanal in scale, in intention and in mode of production. This is clearly less true of television in Europe, but even here the scale of production leads to textured differences - as any comparison of American soaps with *Brookside, Eastenders, First City* and *Glenroe* indicates. At its best European cinema and television can draw upon a particular cultural fertility where there is a depth of history and richness that comes from generations of imaginations coming to terms with a particular landscape, both in the sense of a terrain and as a set of political circumstances.

It is time to recognize the differences in cultural bases and modes of production and to play to those strengths, throwing out the fantasy, especially persistent in English-language cinema, of competing with Hollywood on its own ground. Whatever the illustrious histories of various European cinemas, their future does not lie in attempting to make an inadequate imitation of large-scale industrial production.

We must move towards the native film and television cultures of Europe, Latin American, Africa... Both to enhance the radical pluralism within and between each site and to build alliances which accept and celebrate the scale, diversity and difference of artisanal production. Any strategy to strengthen indigenous fiction will involve some concerted combination of the forces of film and television at various stages. New forms of co-existence will evolve from their mutual complementarity. But also, cinema will continue to challenge and change television through its adventurous divergence, its incompatibility.

References

1. Rod Stoneman, 'The Sins of Commission', *Screen*, vol.33, no.2, Summer 1992.

2. Hans Magnus Enzensberger, 'The Zero Machine' in *Mediocrity and Delusion*, (London: Verso, 1992), p.69.

3. Godard, a leading figure of the European avant garde, makes occasional forays into television which are increasingly within a cinematic frame such as *Histoire(s) du Cinema* and *2 x 50 Years of French Cinema* made for the centenary of cinema.

4. Rod Stoneman, 'Love, music, compromise: the pop promo', *Vertigo*, Spring 1993.

5. The relative costs of television production could be estimated as:

 1 hour documentary - £125-150,000

 1 hour drama - £500 - 750,000

 60 second advertisement - £100 - 300,000 or more

6. cf. Peter York's regular column in the *Independent on Sunday Review* section and a three page profile of commercials director Tony Kaye in the *Mail on Sunday Review*, 8 July 1995.

7. 'The spectacle is not a collection of images but a social relation among people mediated by images.' Guy Debord, *The Society of the Spectacle* (Detroit: Black and Red, 1973), para 4.

8. See John Ellis, *Visible Fictions*, (London: Routledge, 1982) p.224.

9. In Britain: *Short & Curlies, New Directors, Experimenta/Midnight Underground, One Minute Television, 11 x 11*; in Ireland: *Short Cuts, Northern Lights*; in Scotland: *Tartan Shorts, Prime Cuts, Geur Ghearr*.

10. Interviewed in *Italy : the Image Business*, part of the *Visions* cinema series, Channel Four, 18 December1985.

11. Coopers and Lybrand, *Report on Indigenous Audiovisual Production Industry* (Dublin, 1992). For a discussion of the political background, see Kevin Rockett, 'Culture, Industry and Irish Cinema' in John Hill, Martin McLoone and Paul Hainsworth (eds.), *Border Crossing: Film in Ireland, Britain and Europe* (Belfast and London: Insitute of Irish Studies and BFI, 1994), pp.126-39.

12. With the exception of Pat Murphy's *Maeve* (1981), Joe Mahon's *The Best Man* (1986) and Margo Harkin's *Hush-a-bye Baby* (1989). This is in contrast to the record in documentary production.

7

Television Programmes About the Cinema: The Making of *Moving Pictures*

Paul Kerr

Just before Christmas 1989, Michael Jackson, then editor of BBC2's *The Late Show* (and previously founder-editor of Channel Four's *The Media Show*), asked me if I would like to set up and launch a cinema series for BBC2. I joined the BBC in February 1990, and put together a staff from both in-house and freelance talent; we made a pilot in April and were then commissioned to make an 8 x 50 minute series to be transmitted on Saturday nights at 9.00pm from September to November 1990. Each programme was followed by a film which we selected in collaboration with the BBC's Programme Acquisitions staff. We carved out an implicit set of working assumptions/antipathies from our own backgrounds as programme-makers (at *The Media Show, The Late Show, Film Club, Saturday Night at the Movies*) and as lifelong viewers of television programmes about the cinema in particular and the arts in general.

The new programme, to be called *Moving Pictures*, was BBC2's first cinema magazine for more than ten years – *Arena: Cinema* had been the last – and Alan Yentob (then controller) had wanted another ever since. He wanted a series that took film and filmmakers seriously and gave viewers access to

them, more or less unmediated. Thus profiles of filmmakers (primarily but not exclusively directors) talking in fine detail about their art/craft, styles and subjects were important. He was keen that television should grant cinema the same sort of respect as it did the other arts. Redressing that balance was thus *Moving Pictures*' job but the price that had to be paid was a predictable reliance on personalities, that is on major filmmakers – the 'artists' of world cinema.

Michael Jackson had also wanted to make a cinema series (his BBC2 documentary series *Naked Hollywood* was gestating at the same time). He wanted to build on *The Late Show's* success (and resources) by launching a studio-presented magazine show about cinema. Like Alan Yentob, Michael Jackson wanted filmmakers talking about filmmaking but he also wanted story-driven items and craft pieces with filmmakers deconstructing specific sequences. (Alan Yentob seemed keener on straight interviews.) Jackson's emphasis was primarily on Hollywood and the UK, and he also liked business stories. Neither he nor Yentob were particularly keen on items about cinematic trends, both because *The Late Show* and *The Media Show* operated in those areas already and because they felt it was time to let artists – rather than critics – talk about their work themselves; time, that is, for television to give cinema the 'art' treatment.

We decided to take advantage of the existence on BBC1 of Barry Norman's *Film 90*, whose tried and tested consumer guide format freed us to do something entirely different. With only three or four items a show, we chose to be selective rather than encyclopaedic, to look in detail at specific aspects of a few films rather than cursorily at everything, zooming in on aspects and angles of individual films and of cinema in general. Finally we decided neither to review films nor to provide a survey of new releases. The ambition was to create our own agenda rather than simply respond to the release schedule.

In some senses, then, *Moving Pictures* defined itself by what it was not. For instance, it wasn't Barry Norman, or *Visions* or *Saturday Night at the Movies*. In other words it wasn't intended to be a presenter-led review programme rounding up all the new releases; nor was it meant simply to foreground previously marginalized areas of cinema, like third world and avant-garde movies; nor indeed was it to be a kind of youth-style, stand-up revamp of Barry Norman. But it was a magazine show, it did have a studio and a presenter, it did respond to selected new releases. It tried to mix accessible and even humorous pieces with items about films and filmmakers which would be pretty much outside the frame for mainstream cinema programmes – and to treat them with equal seriousness and imagination. In that sense it was always the mix of ingredients as much as anything else which distinguished the series from its predecessors and rivals. *Film 90* was thus very much to our advantage – since it freed us to have another agenda.

Television and the arts

The celebration of the centenary of cinema in 1995 provided an appropriate moment to take stock of the history of half a century of television programmes about the movies. For while the small screen busied itself reappraising the first hundred years of cinema, television itself, by then, had been reporting and reviewing films in Britain for almost half that time - more or less since British television began. Crudely, while cinema started silent, broadcasting began blind. Only with the advent of television was it possible to consider movies and the movie business in ways which were utterly beyond the capacities of either the printed or recorded word. This article aims to sketch out that history and to address some of the issues such programmes raise since these have also influenced the development of *Moving Pictures*. To understand this influence, it is important, first of all, to consider television and the arts in general.

Although film as a *subject* has not been a major feature of arts programmes, film as a *format* has nonetheless occupied a privileged place in their making. Indeed the institutional overlap between 'art' television (or those television programmes which aspire to the status of art) and the treatment of the (other) arts on and by television has taken place almost entirely on film. The emergence of so-called 'quality television', for instance, can quite precisely be mapped onto the development of television programmes made on film. This, perhaps surprisingly, does not apply to television fiction, at first, because of the dominance of the 'live' play and, in later years, because of Equity restrictions on the use of film in television drama as a means of protecting its members' residual payments.

Documentary and Arts departments suffered no such restrictions on their use of celluloid both because of the status of their output as non-fiction and because of their initial avoidance of actors. (The first Arts programmes made on film to employ actors even ensured that they were without dialogue.) Thus programme-makers like Peter Watkins, John Schlesinger, Jack Gold (in Documentaries) and Ken Russell and Schlesinger again (in Arts) were working on film long before their peers in Drama. For TV Drama, film continued to be used exclusively for location sequences and exterior shots; as late as 1959, when some 1500 BBC programmes included film sequences and fifty were made entirely on film, none of the all-film programmes were fiction.

As regards the nature of television's treatment of the arts, there are now several books which deal with this topic although none of them considers programmes about the cinema, perhaps reflecting the rather low status that film has been accorded generally as an art form.[1] Perhaps the most thorough and thoughtful approach to the study of television coverage of the arts remains that of arts producer and ex-TV critic, John Wyver.[2] Wyver describes three often overlapping categories of arts programme – *the artist*

profile, the dramatized biography and the *illustrated lecture.* These three approaches are in addition to what Wyver calls the 'relay', perhaps the most primitive of televisual forms, the all-but unmediated broadcasting of a non-televisual artistic work or event like an opera, stage play or ballet.

The Artist Profile

Of Wyver's useful categories, the profile is an artist-centred approach to an art form. In terms of film programmes, the profile was one of the first formats employed – as exemplified in the items on D.W. Griffith and Sergei Eisenstein in what may well have been Britain's first ever cinema series, *The Film.* In the absence, in both cases, of interviews with the respective directors, these profiles can also probably be said to fall within Wyver's definition of the illustrated lecture since they were both presented by film 'expert' Roger Manvell and presumably included extracts from their subject's films. It is interesting to note that directors were the subject of attention so early in television's treatment of cinema – long before French auteur theory provided a critical rationale for privileging directors as the artists of film. And while Griffith and Eisenstein may already have been critically acclaimed figures, the fact that *Film Profile* was also launched with a career profile of – and interview with – the director, Stanley Kramer, is suggestive. It is suggestive both of cinema being taking seriously as an art form by television at such an early stage and of the reliance on 'onlie begetters' in television's traditional manner when dealing with all art forms. *The Moviemakers* and *Movie Men* also adopted this approach to cinema.

As far as profiles of individual filmmakers are concerned, 'the portrait of the artist as a full length programme' is generally the provenance of editions of arts strands like *Monitor, Arena, The South Bank Show* and *Omnibus.* Far and away the most common subject of such profiles as far as the cinema is concerned are film stars, rather than directors, writers, producers or other behind-the-camera 'talent'. These profiles tend to take the form of interviews illustrated by clips and, where possible, footage of the artist at work.

Indeed, for Wyver one characteristic embellishment of – or variant on – the arts profile is 'the process film, where a new drama, opera or dance is followed from rehearsal to reception'.[3] He adds that as the form developed, a number of key conventions could be discerned: 'a focus on the individual (with a complementary stress on autobiography and introspection); a desire to suggest and interpret the emotion and poetry of a work and its creation (with a consequent preference for feeling over analysis and a reliance on linear narrative)'.[4] These observations apply to film programmes almost as accurately as to programmes about the other arts. One of the most impressive pioneers of the profile form was John Read and *Monitor*, the first regular magazine programme about the arts, rapidly built on Read's

achievement. Interestingly, among *Monitor's* earliest and most enthusiastic exponents of the form were young BBC 'filmmakers', John Schlesinger and Ken Russell.

The Dramatized Biography

If the profile is the *sine qua non* of the film programme, the dramatized biography is conspicuous by its almost utter absence from such series. (Recent exceptions include Chris Rawlence's film *The Missing Reel* for Channel Four about the mysterious disappearance of film pioneer LePrince and John Wyver's own production of *The Last Machine* about the pre-history of cinema, both of which employ dramatized sequences.) One reason for the relative rarity of dramatization in film programmes is that by definition their subjects are from the age of film and thus the possibility exists of there being archive film records of that subject and period. But perhaps this rarity is also a function of the present tense in which most such programmes (and film journalism in general) seem to exist – cinema is seen as a current medium and history is generally to be avoided. Hence perhaps the assumption that anyone worth featuring in a profile is probably alive and available to be interviewed. This is not just TV's oft-cited tyranny of the image but perhaps also a residue of the tyranny of television's origins in the 'live'. But the origins of this idea are extra-televisual – cinema, like television itself, is essentially still an *arriviste* in the world of the arts; it is a novelty and as such its interest is ephemeral, its history far less familiar to the cultural gurus than those of fine arts or literature. For painting or theatre, the retrospective or repertory exhibition or performance of a classic work is a commonplace. For the cinema it remains something only acknowledged in the broadsheets. Cinema's place in the culture essentially remains that of the new release.

There are two other reasons for the aversion to the dramatized biography in film programming: firstly, the subject of most such interest, the star, is neither awarded the artistic reputation necessary for such biographical treatment (nor, by virtue of his or her iconic familiarity, is a star easily 'impersonated') and, secondly, the biographical form is such a cinematic one (the biopic has become something of a cinematic genre) that television is reluctant to embark on it in its treatment of a filmmaker. Ironically Ken Russell took the form from *Monitor* and adopted it for several of his feature films.

The Illustrated Lecture

Monitor also experimented with what Wyver calls the 'illustrated lecture', a form of arts programming which swiftly graduated into stand-alone arts documentaries and series like *Civilisation* (BBC2, 1969), *Ways Of Seeing* (BBC2, 1972) and *Shock Of The New* (BBC2, 1980). The illustrated lecture

137

form has surfaced occasionally over the years, from Roger Manvell's *Film* and Victor Perkins' BBC schools series for sixth forms, *Cinema* to Robert McKee's *Film Works*. But what about major 'authored' documentary series about the cinema equivalent to *Civilisation* or *Shock Of The New*? There was, of course, Kevin Brownlow's *Hollywood: The Pioneers* series about American silent cinema – with another about European silent cinema, *The Other Hollywood*, in 1995. However, Brownlow himself does not appear and the cinema pundit has rarely been seen on our screens.

The Presenter And The Reviewer

However, if television programmes on film have not provided pundits or critics to match Lord Clark, John Berger or Robert Hughes, they have given prominence to the reviewer or presenter. One explanation of this is provided by John Ellis. Writing about Channel Four's first cinema series, *Visions*, of which he was the editor, Ellis categorized the programme's components under four headings: the report; the survey of a particular filmmaking culture; the auteur profile and the review.[5] *Visions* prided itself on regularly working with scripts by critics and avoiding the ubiquitous linking presenter. Ellis, however, singled out two fundamental problems for the serious film programme. The first is the relationship with the commissioning channel regarding the scheduling of films and film seasons; and the second is the creation of a working relationship with the American film companies. The simplest solution to both problems is the review programme which tends to avoid reference to TV transmission of films altogether and focuses exclusively on new releases.

The subject matter of most cinema series, at least until the advent of video and the art-house fad for the re-release, was thus the current theatrical release. Indeed, the review format was first adopted at least as early as 1952 with *Current Release* and has been with us almost without interruption ever since. The review programme is almost inevitably presenter(s)-led and is essentially a list of new releases (generally concentrating exclusively on mainstream cinematic fare in mainstream film venues), showing one or more extracts from each new release, providing a brief plot synopsis of each film plus appropriate critical comment and perhaps the occasional studio guest or location interview. Recently this recipe has been augmented by additional elements like quizzes, location reports of films in production and occasional pieces about odd aspects of film production and exhibition and controversies about film content.

The most familiar television face in this respect is that of Barry Norman (though Philip Jenkinson was a ubiquitous presence in the field in the 1970s). Excepting occasional absences, Norman has been presenting a film review programme since 1971 and shows no signs of giving way to recent rivals like Mariella Frostrup or Tony Slattery. In the case of Channel Four's

Howard Schuman presents *Moving Pictures*

Moviewatch, its reviews are provided by a changing panel of 'ordinary people' rather than professional presenters. Unlike TV's treatment of other art forms, cinema programmes haven't historically been deemed to demand specialist presenters. Indeed, as a popular art, most movie shows have all but insisted on non-specialist presenters. The exceptions to this rule of thumb include the very first film programme presenter, Roger Manvell (of *The Film*), Mark Shivas who was one of the presenters of *Cinema* (and had been an early contributor to British film magazine *Movie*), and the occasional edition of Channel Four's *Visions* fronted by film critics like Tony Rayns.

The curious place of the 'reviewer' in most film programmes prompts a question about the extent to which Wyver's categories map onto television's treatment of the cinema. None of the other art forms involves the role of a reviewing presenter. At the time of writing, with the important exception of *The Late Show* (which came to an end in June 1995), there is only one British TV books programme in which books are reviewed, BBC1's *Bookworm*; the theatre is all but ignored by television while the visual arts and music are treated in terms entirely different from what, in essence, is the consumer guide grammar of the film review programme. The 'review' is thus a necessary addition to Wyver's lexicon of the Arts Programme. Significantly, and perhaps rather sadly, the two elements of *The Late Show* to be spared the axe were its weekly 'review' programme *Late Review* and the full length interview format, *Face To Face*, neither of which were among *The Late Show's* many television innovations.

Over the years the agenda for *Moving Pictures* has struggled against the arts programming formulae identified above: the profile, the dramatized biography, the illustrated lecture and the review. It is, however, hard to avoid the profile as filmmakers and their PR companies much prefer this approach. The studio-based, presenter-led interview with the star or director is a much-favoured TV institution but since the first series we have ceased to be a studio programme and this option is one we tend to avoid. The problem with any profile which is more ambitious than a single career interview is that assembling a cast of collaborators and commentators as well as the protagonist usually necessitates the assistance of that person and tends to prohibit, or at least compromise, a critical approach.

Moving Pictures has also adopted in part the conventions of the illustrated lecture by adopting the film essay approach pioneered by the *The Media Show*. Examples include a report on Native Americans making movies in the wake of *Dances With Wolves* (1990); a look at the increasingly common narrative device of amnesia; Mick Eaton on the cinematic reappearance of Robin Hood; Chris Petit on the unmade films of J.G. Ballard; Alex Cox on *JFK* (1991) and Dusan Makavajev on the cinema of civil war torn former-Yugoslavia. In the last four examples, the on-screen 'author' in each case was also the director, employed on a one-off basis for their personal connection to their subject. In spite of these successes, the illustrated lecture remains, in a sense, a relic of television's past. All television is inevitably authored, inevitably subjective, almost inevitably illustrated. The to-camera address is today the pre-requisite of the presenter, but for *Moving Pictures* the reports are largely made in the absence of the presenter. Furthermore, the selectivity of interviewees, camera angles, film extracts and so on, not to mention their juxtaposition in the cutting room and the occasional inclusion of scripted voice-over commentary and/or graphic captions, ensures that every programme has an authorial/authoritative stamp.

The Problem Of Access

Whichever approach to the subject of cinema a new film programme opts for and notwithstanding whether there is a specialist presenter (or indeed no presenter at all), TV ought to be the ideal medium for discussing cinema for the simple reason that one can 'quote' rather than, as is the case with the print medium, being obliged to summarize the scenes or sequences being discussed. As a one-time freelance film critic – a background I share with several colleagues on *Moving Pictures* – the prospect of audiovisual 'quotation' was a considerable temptation. But, as many of us have discovered in making the transition from page to screen, 'film criticism' on television is subject to considerable constraints which simply don't apply to print. These constraints can be summarized as financial and legal. Both,

however, are increasingly exacerbated by the publicity process which, one might otherwise assume, was set up to facilitate such programmes and their print equivalents.

Over the years, television's access to filmmakers at work has become increasingly difficult. The power of the film companies, agents and, particularly, PRs has escalated in proportion to the increasing number of television outlets (and thus the increasing number of requests for such access) and the growing importance of movies to television schedulers. With the exception of live news-type programmes and the occasional TV phone-in, TV as an audiovisual medium cannot make do with telephone interviews (the *sine qua non* of newspaper journalism, not to mention radio broadcasting) and therefore requires both more time and money (for travel, camera set-ups, crews and so on). There is a hierarchy in which programme requests for interviewees are assembled according to the ratings of that programme (i.e. ITV/BBC1 programmes are privileged over Channel Four/BBC2 programmes and so on) in spite of the actual constituency of those totals in terms of cinemagoers. Meanwhile, the downside of TV's ability to use extracts is that they can be prohibitively expensive as the distributors impose considerable copyright charges for the use of clips from films other than new releases. Only programmes which are content with a pre-selected roll of extracts (so-called clip reels) from new film and video releases and are satisfied with the extremely limited access afforded to interviewees by packed press conferences (or so-called press junkets) can avoid these costs and constraints.

TV junkets are slightly surreal events to which each interviewer brings a blank video tape and a list of (sometimes pre-approved) questions. The interviewer then joins a queue of TV journalists from across Europe or the US (depending on the location of the junket) at the front of which is a static camera pointing at a sedate and somewhat shell-shocked celebrity. Once at the front of this queue the interviewer hands over his or her tape, sits down in the chair so recently occupied by the previous questioner and has a pre-set time (between five and fifteen minutes is the norm) within which to cue the same soundbites he or she has heard from that same celebrity in what are soon revealed to be the inevitably rehearsed, if only through repetition, responses to questions from the dozen or more previous interlocutors. At group junkets (at which, say, the stars and director are present) there are several such queues and cameras and a game of non-musical chairs ensues.

To supplement or perhaps subtly replace these increasingly frustrating events, the Hollywood majors now freely distribute what are called EPKs or Electronic Press Kits which are pre-prepared celebrity soundbites together with approved clips and the trailer from their respective films. These are produced in-house by the production companies involved in the films and not surprisingly avoid not only critical questions but any detailed questions at all. Equally frustrating are the clips themselves which are brief, often

badly edited, and revolve almost exclusively around dialogue describing key plot points, dramatic action and star performances.

The intended market of these EPKs is US cable and non-specialist programmes (breakfast TV, chat shows and so on) and their inappropriateness for non-American programming needs, let alone those of specialist film programmes, should be self-evident. These extracts are produced to American television's technical and editorial requirements. They are thus shot on American standard videotape (525 rather than 625 lines) and cut to American TV rhythms in terms of clip and synch length (i.e. image and sound bites). Increasingly meanwhile, some of the US distributors and their UK publicists seem to find it harder and harder to agree to the use of any extracts other than those pre-approved by their parent studios – or indeed by the celebrities themselves. (The interviewees on such EPKs rarely stretch beyond the stars and almost never stray further behind the screen than the director).

There is an unwritten code of PR etiquette which prohibits what are considered disrespectful interviews/reviews with severe penalties being imposed for what the film companies consider to be breaches of such unwritten agreements. In the press, advertising has on occasion been withdrawn when a distributor has felt slighted by a review; on television, Warner Bros. ceased trading with Channel Four when it felt that its copyright on *A Clockwork Orange* (1971) had been evaded. And such corporate sensitivity is by no means a recent development – BBC Radio's *Picture Parade* was brought to an abrupt end in March 1949 as a result of film industry opposition to its criticism of films.[6] One of the programme's regular reviewers, Mrs E. Arnot Robertson, was then dismissed by the BBC as a result of pressure brought by MGM and she also lost her subsequent libel action against the film company. Print journalists are still occasionally subject to pressure – from retrospective retribution through the withdrawal of advertising to pre-emptive restrictions through the granting in advance of agent/publicist approval of questions and even choice of interviewer.

Since the production schedules of a programme like *Moving Pictures* necessitate recording interviews with key filmmakers long before we get access to such EPKs – if not before their compilation – it would be impossible, even if it were desirable, to steer our interview questions exclusively around approved clips. This relatively simple point fails to persuade many of the majors' publicists. And this is largely the result of the fact that decisions about clips and indeed interviews are made in the US rather than the UK and are thus unlikely to be informed by a sensitivity to the nature of the particular programme making the requests.

On several occasions over the years we have had to ask individual filmmakers to put pressure on their respective production studio and/or distributor to make the clips we requested available to us in order to illustrate the

interview we had done with them. Unlike some publicists and distributors, the filmmakers themselves have always been remarkably helpful. But then our ciné-literate questions may be welcome to such people habituated as they are to more superficial interviewers or programmes; however these same questions prove far more labour-intensive to service for the PR operations of the distributors than do less specialist programmes whose extracts requests are usually answered within the available clipreel.

And this is merely the case at the easy end of the spectrum, the clearance of extracts from new releases which are free (bar transfer costs from film to video) within an agreed period just before and just following a film's theatrical release. (Similar, though even more restrictive, 'windows' for free use of approved clips also follow their release on video, first for rental and then for sale. There are often also promotional-use clauses written into the licence agreements with British broadcasters for a short period around the televisual transmission of licensed films.) But once the free-usage period has lapsed the distributors' clip charges come into operation and these can be prohibitive. Some Hollywood majors, for instance, charge in the region of $5000 'per minute or part thereof' which means that even a five second clip from a film can cost $5000 and that two such clips (however brief) can cost $10,000.

But even if the programme budget can stand such charges, the time it takes to clear clip requests – which have to be forwarded to the Los Angeles offices of the majors by their London publicists – can prove equally prohibitive and impracticable. On many occasions more than a month goes by without either a 'yes' or a 'no'. In some cases these charges and delays may simply be intended to dissuade programme-makers from even placing such requests. Other obstacles include the special clauses in the contracts of some directors and actors (e.g. Steven Spielberg, Dustin Hoffman) that any clip from their work to be used in a television programme has to be personally approved before such permission can be granted, which in the latter case requires an additional personal payment.

Recent changes in the British copyright law have promised (or threatened, depending on your point of view) to remedy this problem but to date it has still not been tested satisfactorily in a court of law. The key precedents so far concern (1) clips from the Warner Bros. film *A Clockwork Orange* used in an edition of the Channel Four arts programme, *Without Walls*, about that film and (2) extracts of highlights from the BBC's coverage of the 1990 World Cup (for which the BBC held the licence) used by BSkyB in its sports programmes. Warner Bros. brought an injunction against Channel Four preventing the transmission of the *Without Walls* programme but the Court of Appeal lifted the injunction and that edition went out at a later date. The Copyright Act has a 'fair dealing' clause which allows the screening of extracts for the purposes of 'review'. Warners had argued that the Channel Four use could not qualify for 'review' because *A Clockwork Orange* had not

been (legally) seen in the UK for twenty years since its director Stanley Kubrick had withdrawn it from release. The defence argued successfully that once in the 'public domain', the film remained there if only in the memory and that the context for the extracts was serious and clearly not exploitative. The football case also attempted to define 'fair dealing' but without complete success. Key factors for the judgement were the duration of excerpts, their representativeness of the complete work from which they were extracted, and finally the currency or contemporaneity of those works. The BBC lost the case. Most recently, in early 1995, Channel Four once again employed the 'fair dealing' defence in its use of Disney clips for a documentary profile of Walt Disney in the *Secret Lives* series. Whether or not Disney take this issue to court remains to be seen.

Warner Bros. could still take Channel Four to court for their use of *A Clockwork Orange*. In the absence of a decisive legal precedent it would be both difficult and dangerous to test the water. Difficult because although in law it might now be 'fair dealing' to use any clip from a new release (within reason – i.e. not giving away the end of the film or any key dramatic surprises) such clips would still have to be provided by the film's distributors and other reasons for their unavailability could easily be fabricated. (We have on occasion been regaled with tales that there is no print of such and such a film in the country when we know that there is.) More worryingly, any attempt to make use of a clip against the wishes of a major distributor could seriously endanger not just our own relations with these companies but those of the BBC itself. (Warner Bros. suspended all dealings with Channel Four in the wake of the *Without Walls* case.) But the pertinence of the 'fair dealing' clause to films other than new releases remains uncertain - as the case of *A Clockwork Orange* reveals. Aside, then, from any issues of style and content, it is issues such as these which will continue to affect the production of TV programmes about film.

Appendix

Television programmes about the cinema – Towards a chronology

As far as I can ascertain the first ever British TV series devoted to cinema was *The Film* (BBC, 8 May 1947 to 5 March 1948). It was presented by film historian Roger Manvell and produced by Andrew Miller-Jones. The first edition of the series was about D. W. Griffith and the final episode included items about film sets and Sergei Eisenstein – who had just died. What follows is an attempt to provide as comprehensive as possible a list of the cinema-based series broadcast in Britain since *The Film*. The list does not include one-off film programmes included in general arts strands like *Monitor, The South Bank Show, Arena* or *Omnibus*. Nor does it include film items or one-off specials included in general arts magazine series like *Late Night Line Up, Review* or *The Late Show*. Where possible I have

appended dates and production details but the BFI index has no entries under the category of Television Programmes about the cinema, so this list is very much a work in progress. The predominance of BBC programmes in this list is in part a consequence of the centralized cataloguing of the corporation's programme library.

The Film (BBC, 8 May 1947 - 5 March 1948). With Roger Manvell.

Current Release (BBC, 17 January 1952 - 13 March 1953). Produced by W. Farquharson Small and introduced by John Fitzgerald.

Film Profile (BBC, 13 May 1955 - 8 July 1963). The first subject was Stanley Kramer; others included J. Lee Thompson (19 October 1959), Edith Evans (2 August 1960), Fred Zinneman (17 February 1961) and Jeanne Moreau (1963).

Picture Parade (BBC, 10 April 1956 - 14 December 1962). Produced by Alan Sleath. The first programmes were introduced by Peter Haigh but other presenters included Robert Robinson. Some editions were devoted to specific films, like *Ben Hur* (7 December 1959) and *The Mountain Road* (10 May 1960) and others were focused on specific stars like Jim Backus (7 July 1960) and John Carradine (18 January 1961).

Film Fanfare (ABC, 1956). A quiz show chaired by Mcdonald Hobley.

The Cinema Today (BBC, 5 February 1959 -15 July 1963). A look at European cinema. Programme one was about Italy. Other programmes focused on experimental films (8 December 1959), War (11 November 1960), West Germany (16 May 1960) and Seymour Cassel (19 July 1960).

Movie Magazine (TWW, 1960).

Film Club (BBC, 9 November 1960 - 23 March 1962.)
The BBC used this title again in the late 1980s.

Cinema (Granada, 14 July 1964 - 29 August 1975).
Presenters included Bamber Gascoigne, Derek Grainger, Gordon Miller, Mark Shivas, Michael Scott, Michael Parkinson, Clive James. The focus was largely on individuals, mostly stars like Honor Blackman, Peter O'Toole, David Niven but also producers like Ross Hunter, directors like William Wyler, actor/writer Colin Welland and even a look at Shepperton Studios.

Film Preview ('A look at the week's future films on BBC television') began on BBC1, 7 January 1966 and involved Philip Jenkinson reviewing forthcoming films on TV. It subsequently became *Film Review* (about new releases) which ran until 10 May 1968.

Film Star (ABC, 1967).

The Movies (BBC, 2 January 1967 -10 July 1967). 'The weekly series about films and filmmakers'. *The Movies* devoted one programme to an interview with Joseph von Sternberg by Kevin Brownlow (16 January 1967) and another to film designers (30 January 1967). It was cancelled when *Late Night Line Up* began doing items about cinema.

Cinema For Sixth Forms (BBC, 30 September 1968 - 25 November 1968). Written by Victor Perkins.

Film Night (BBC2, 29 December 1968 - 8 April 1976).
Review programme with Philip Jenkinson. Began life as weekly edition of *Late Night Line Up*.

The Hollywood Image: 1: *The Silent Era* (*Omnibus*)(BBC, 3 May 1970).

The Hollywood Image: 2: *The Talkies* (*Omnibus*) (10 May 1970).

The Hollywood Image: 3: *Postwar* (*Omnibus*) (17 May 1970).

Personal Cinema (13 June 1969 - 4 August 1971). Stars choose their favourite films.

Movie Makers (BBC, 6 September 1969 - 26 March 1976). Occasional series based on interviews at London's National Film Theatre.

Movie Men (Thames, 3 March 1970 - 7 April 1970). Profiles of six directors.

Film 72 (BBC1). Barry Norman's review programme, still running as *Film 96*.

Clapperboard (Granada, 10 April 1972 - 1 January 1982). Presenter: Chris Kelly.

Ffilmiau Dros Y Byd (HTV, 24 August 1975 - ?).

Cinema Club (HTV West, 26 July 1976).

Electric Theatre Show (Grampian, 9 August 1976).

The Hollywood Greats (BBC, 4 August 1977 - 31 August 1978 and 7 July 1979 - 30 August 1979).

Arena: Cinema (BBC, 22 September 1976 - 28 March 1979).

Ffilmiau (HTV, 20 November 1979).

Screen Test (BBC, Manchester from 1979).

Hollywood: Pioneers (Thames, 8 January 1980 - 1 April 1980). 13-part series about American silent cinema.

Play It Again (Tyne Tees, 1980).

Moviegoers (Westward, 1980).

Movie Memories (Anglia, 21 January 1981 - 7 April 1982). Presenter: Roy Hudd

Film Fun (Granada, 9 April, 1982 - ?).

A Seat Among The Stars (UTV/Channel Four, 1984). Six-part series about the history of cinema in Ireland.

Talking Pictures (BBC2, 10 February 1984).

Visions (Channel Four, 10 Nov 1982 - 28 November 1985).

The Dream That Kicks (Channel Four/HTV, 1987). A four-part series about Wales and the cinema.

Saturday Night At The Movies (ITV, 1 April, 1989 -).

Film Club (BBC2).

Little Picture Show (ITV, 6 January 1993 -). Presenter: Mariella Frostrup.

Movies, Videos, Games (ITV).

Moviewatch, (Channel Four, 17 January, 1993 -).

Moviedrome (BBC2). Presenter: Alex Cox.

Filmworks (Channel Four). Presenter: Robert Mckee.

Naked Hollywood (BBC, 24 February 1991 - 31 March 1991). Six-Part documentary series about the workings of the Hollywood system with programmes about the Star, the Agent, the Studio Boss, the Screenwriter, the Director and the Producer.

Moving Pictures (BBC2, 30 September 1990 - 17 November 1990; November 1991 - Mar 1992; 9 January 1993 - 13 March 1993; 16 January 1994 - 27 March 1994; 12 February 1995-2 April 1995).

The Last Machine (BBC2, 1995).

Century of Cinema (Channel Four, 1995).

References

1. The most recent studies of the arts on television are Philip Hayward (ed.), *Picture This: Media Representations of Visual Art & Artists* (London: John Libbey, 1988) and John A. Walker, Arts *TV: A History of Arts Television in Britain* (London: John Libbey, 1993).

2. John Wyver, 'Representing art or reproducing culture? – Tradition and innovation in Britain's television coverage of the arts (1950-87)' in Philip Hayward, *Picture This*, pp.27-45.

3. ibid, p.29.

4. ibid, p.30.

5. John Ellis, 'Channel Four – Working Notes', *Screen,* Vol. 24 no. 6, Nov-Dec, 1983, pp.37-51.

6. See *Impact*, Spring 1949, p.16.

PART TWO:

ECONOMICS, PRODUCTION AND TECHNOLOGY

8

British Television and Film: The Making of a Relationship

John Hill

Historically, the relationship between film and television has been complex and varied. Although the film and television industries have often been seen as enemies, it is clear that this is a partial view of the past which largely derives from the disputes over sales of films to television in the 1950s.[1] Since then, however, the economics of film and television have become increasingly intertwined and it is now evident that television, along with the new delivery systems of video cassette, cable and satellite, have become crucial to the business of film production. This is nowhere clearer than in the tremendous resurgence of Hollywood during the 1980s and 1990s. Towards the end of the 1960s and the beginning of the 1970s, the Hollywood majors were faced with economic crisis. By the end of the 1980s, however, they were once again restored to financial health, with studio revenues rising from $2,495 million in 1980 to $17,022 million in 1994 (which, even allowing for inflation, represents a substantial growth). The key to this remarkable turnaround lay in the ability of the studios to adapt to, and take advantage of, the new video and pay-TV markets. Thus, whereas, in 1980, returns from theatrical release (both domestic and foreign) accounted for nearly seventy-six per cent of studio revenues these were only responsible for twenty-four per cent of rev-

enues in 1994. In contrast, revenues from pay-TV rose over the same period from 4.8 per cent to over seven per cent while, even more dramatically, revenues from video increased from one per cent to 46.4 per cent.[2] Thus, while cinema attendances between 1983 and 1993 have barely increased in the US and have actually fallen worldwide, this clearly does not indicate that films have failed to maintain their popularity – only that they have been increasingly watched on a television screen.[3]

Television and Europe

Similar trends are also in evidence in Europe. In 1992, cinema box office accounted for only 34.8 per cent of Western European spending on film while video (both retail and rental) amounted to 41.1 per cent and pay-TV, the fastest growing part of the European market, accounted for 24.1 per cent.[4] However, while European audiences, like audiences elsewhere, are increasingly watching films on TV and video, it is not, of course, European films which they are primarily watching. Thus, in 1990, US films had a 77.4 per cent share of the EC theatrical market and an even greater share of the video market.[5] In the case of the UK, the largest video market in Europe, US films took an enormous ninety-four per cent share of video rentals in 1991.[6] What this suggests is that while the Hollywood majors (which have increasingly become a part of media conglomerates with multiple media interests) have restored their fortunes by successfully capturing ancillary markets at home and abroad, the European film industries have been much less successful in exploiting the new outlets. Given the general downturn in cinema attendances in Europe (a drop of nearly twenty-four per cent across Western Europe between 1983 and 1993), this has inevitably contributed to the problems of European film production. Thus, while the US majors have been able to maintain a more or less consistent level of output during the 1980s, European film production has been in steady decline, dropping by nearly twenty-five per cent in the EU countries between 1980 and 1994.[7]

It is within this context that television has increasingly emerged as an important source of investment for European filmmakers. According to figures provided by *European Filmfile*, fifty-one per cent of European films in production in June 1994 were backed by television finance.[8] In some cases (Belgium and Portugal), television had a stake in all of the country's films while in France and Germany, Europe's leading film-producing nations, television was involved in seventy-four and sixty-three per cent of film productions respectively. However, the relationship between television finance and film which exists in Europe is fundamentally different from the one which prevails in the US. In the case of the US, it was the commercial pay-TV channels such as HBO (Home Box Office) and Viacom (which acquired Paramount in 1994) which, keen to secure a stable supply of popular films for cable, became a major source of film finance in the 1980s.[9] In Europe too, private television, as in Italy, has also

provided some film investment. However, in the main, it has been public service broadcasters, rather than commercial companies (unless required to do so by government), which have provided the bulk of financial support for European filmmaking.

This can be seen right across Western Europe: in the support for film of ORF in Austria, RTBF and BRT in Belgium, YLE in Finland, ERT in Greece, RTP in Portugal, TVE in Spain, SVT in Sweden and SSR in Switzerland. However, it is in the large film-producing countries of Italy, Germany and France that television support for film has been most notable. RAI, the Italian public service broadcaster, for example, has had a legal obligation to co-operate with film production companies and has provided significant support for Italian directors, including Fellini, Rossellini, Olmi and the Taviani brothers. In Germany, the public service broadcasters ZDF and ARD have also been closely involved with filmmakers. This relationship became formalized in 1974 under the Film and Television Agreement, which laid one of the cornerstones of the 'new German cinema' and provided assistance to directors such as Fassbinder, Herzog and Wenders. Under this agreement, the broadcasters have not only supported the Filmförderungsanstalt (FFA), or Film Support Agency, but also invested regular sums in film production. Thus, in the most recent agreement (covering 1993-6), the two broadcasting groups agreed to contribute DM 11 million per year to the FFA and a further DM 14.25 million to co-productions between themselves and film producers.[10] In the case of France, it was the state broadcaster, ORTF, which initially provided support for film. Despite the splitting up of ORTF (in 1974) and the increasing privatization of French broadcasting in the 1980s, television's relationship to film has remained heavily regulated and it is has remained a legal requirement for French television to support French film production. All five free-television channels – TF1, France 2, France 3, M6 and the Franco-German channel Arte – are obliged to operate a film-production subsidiary which, in 1993, led to them investing FFr 364.5 million in films. The pay-television channel, Canal Plus, has also been obliged to support French films (to the tune of ten per cent of its turnover) with the result that it has invested even more: providing, in 1993, FFr 454.45 million towards French film production.[11]

Television and the UK

Support of film production by television has also been a significant trend in the UK. At the start of the 1980s, no television company was directly engaged in film production (although prior to the new franchise agreements of 1980, ATV had begun to explore the territory).[12] In the years which followed, however, the number of films produced or co-produced by television companies rose dramatically, reaching a total of forty-nine per cent of all UK productions in 1989, a figure that would be even higher if the, nominally British, 'off-shore' productions of American companies were

excluded.[13] Indeed, so important had the relationship between film and television become by the end of the 1980s that, in 1990, the Policy Studies Institute suggested that 'the only factor which appears to have prevented the wholesale collapse of the British film production industry has been the increasing involvement of UK television companies'.[14]

Although it was the 1980s in which this relationship between film and television came to fruition, its origins may be traced to the 1970s. As early as 1973, the Cinematograph Films Council recommended, as part of its strategy for reviving the British film industry, that a levy be imposed on the showing of films on television in order to support film production.[15] Underlying this proposal was a recognition of the importance of film to the television schedules: more feature films were shown on television than in other European countries and these amounted to about thirteen per cent of the BBC's output and twenty per cent of ITV's.[16] However, the levels of revenue which television screenings of films generated relative to their theatrical release remained comparatively low. There was a suspicion that the prices which the television companies paid for films had been kept artificially low as a result of the BBC and ITV duopoly and that they certainly were not in proportion to the numbers who viewed them.[17] This was a theme subsequently taken up by the Terry report of 1976 on *The Future of the British Film Industry* which urged British film producers and distributors to seek better prices for films offered to British television. Even more significantly, it also recommended that film production finance should be raised from the levy on excess profits of the Independent Television companies which had just been introduced the year previously.[18] The issue was then considered again in 1977 by the Annan report on the future of British broadcasting. This included both a chapter on films on television and a specific section devoted to the issue of whether broadcasting companies should be required to finance the British film industry.[19] In answering this question, the report detailed a number of ways in which this might be done. These included a levy on film transmission, a rise in the cost to television of films shown, use of the ITV levy (as recommended by Terry) and the encouragement of BBC and ITV production funds. However, all of these ideas were rejected by Annan which concluded that the development of a formal relationship between film and television was unlikely to ensure 'the rejuvenation of the British film production industry' and that television should therefore not be required to support British filmmaking.[20] Given this decisive thumbs down, it is something of a historical irony that it was the Annan report, nonetheless, which was to lead to the cementing of relations between British television and film which occurred in the 1980s.

It did so, of course, by virtue of its recommendations regarding a fourth channel. The idea of a fourth television channel had been in circulation since the 1960s but it was not until the 1970s that it really gained momentum.[21] With the Annan report, however, its precise character began to take shape. The report was concerned that the new channel should not simply be

Wholly financed by Channel Four: Robert Carlyle in Ken Loach's *Riff-Raff*

an extension of the BBC/ITV duopoly and rejected the proposal for an ITV2. Instead it proposed a new fourth channel which would 'encourage productions which say something new in new ways'.[22] This would be run by a new Open Broadcasting Authority and financed from a variety of sources including advertising, sponsorship and grants. The following year the then Labour government published a white paper on broadcasting, which largely accepted these recommendations. However, before it found the time to pass the relevant legislation, it lost the 1979 general election. There were then fears that the incoming Conservative government, under Mrs Thatcher, would simply revert to the idea of ITV2 but the old-style Tory Home Secretary, William Whitelaw, persevered with the proposal, albeit in somewhat modified form, and Channel Four was successfully launched as the fourth national television channel on 2 November 1982.

Channel Four

Unlike the Open Broadcasting Authority envisaged by the Annan report, the new channel was to become a subsidiary of the Independent Broadcasting Authority (IBA) which also regulated the ITV companies. However, although within the IBA's ambit, the channel was nonetheless charged with a clear 'public service' remit to provide a distinctive television service. This meant that, under the Broadcasting Acts of 1980 and 1981, the channel was obliged to appeal to tastes and interests not generally catered for by the existing television services as well as to 'encourage innovation and experiment in the form and content of programmes'.[23] The channel was also provided with a clear set of financial arrangements which avoided some of the difficulties to which Annan's proposals for the OBA might have led. Thus, while its programme-making was to be financed purely by advertising, it was to be done so indirectly in the form of a subscription paid by the ITV companies as a percentage of their net advertising revenues. In return the ITV companies had the right to sell and collect the income from Channel Four's own advertising time. This arrangement provided particularly important financial protection for Channel Four in its early years as it was not until 1987 that the channel's advertising revenue exceeded its income from the television companies.[24] Finally, the channel adopted the 'publishing model' of broadcasting envisaged by Annan and which, in the context of British broadcasting, was to prove its most notable innovation. Thus, unlike the existing BBC and ITV companies, Channel Four did not itself operate as a production house but either purchased or commissioned work from independent production companies, the ITV companies or foreign sources. Its relationship to the independent sector was of particular importance and, by the end of the decade, over fifty per cent of the company's output was being provided by independent companies and a pattern of production had been set which other broadcasters were required to follow.[25] In fact it was this development which was probably at the heart of the channel's survival during the Thatcher years. For although it is often regarded as a paradox that the channel was able to support television programming which was so often at ideological odds with prevailing government attitudes, its ability to do so was partly reliant upon its role as a 'trojan horse' in the re-structuring of the economic basis of British television towards a more 'flexible', 'post-Fordist' mode of production.[26]

It is this combination of a commissioning model of broadcasting and public service principles which also provided the context for the channel's support for film. The channel's first Chief Executive, Jeremy Isaacs was aware of the role which German and Italian television had played in encouraging film and, in his application for the post in 1980, he expressed his desire 'to make, or help make, films of feature length for television here, for the cinema abroad'.[27] At this stage, he did not envisage a theatrical release for Channel Four films in Britain. This was partly because union agreements made 'TV only' films cheaper to produce and partly because a cinema

showing would make an early television transmission difficult. Under a barring policy operated by the Cinematograph Exhibitors Association (CEA), such films could only be shown three years after their initial cinema exhibition and this made television investment much less attractive than it might otherwise have been. Despite this obstacle, the channel did nonetheless proceed to provide some of its first commissions with a cinema release. Colin Gregg's *Remembrance* was the first of these and received a short theatrical run in June 1992, a few months prior to the channel beginning transmission. As David Rose, the channel's first Senior Commissioning Editor for Fiction, explained, 'no one was discussing theatrical windows of any kind when the early films were commissioned, but of course *Remembrance* and *Angel* (1982) were all made six, if not nine, months ahead of our going on air, so the filmmakers quite naturally began to look for these opportunities and we welcomed that'.[28] As a result, 'Films on Four' began to appear in cinemas on a selective basis and the channel was able to achieve some flexibility with the CEA regarding their early television transmission. This resulted in a formal agreement, in 1986, when the CEA agreed that the bar would not apply to films costing under £1.25 million, a figure then increased to £4 million in 1988. However, because of the channel's pressing requirements for programming, many of the early films enjoyed only a short cinema run. Thus, even successful films, such as The *Ploughman's Lunch* (1983), were denied as full a cinema release as they might have deserved.[29] In recent years, however, the channel has been able to build up a backlog of films and thus allow those films which merit it a proper cinema release. Thus virtually all of the films in the 1994 *Film on Four* season had been shown in cinemas and, in some cases (such as *The Crying Game, Waterland, The Long Day Closes*, all 1992), the television holdback had been over two years.

This use of a theatrical platform by Channel Four was not entirely without precedent: London Weekend Television, for example, had given a theatrical showcase to Peter Hall's *Akenfield* in 1975. However, what was new was the level of commitment to supporting film production and the numbers of 'television films' subsequently provided with a cinema release. The initial budget for *Film on Four* was £6 million out of which it was proposed to get twenty features made. As David Rose explained, 'the policy from the outset was to commission or set the cornerstone for some twenty feature length films a year ...Films made on comparatively modest budgets ...written and directed by established filmmakers and introducing new writing and directing talents'.[30] Since then the budget of *Film on Four* has risen (to around £10-12 million during the 1990s) but has generally been spent on fewer films (twelve in 1993, fifteen in 1994). The funding of the films themselves has taken three main forms: full funding, co-investment and the prepurchase of television rights. Full funding was more common in the early days when the track record of the channel was as yet unproven but it has continued to be an option. Thus, in recent years, films such as *Riff-Raff* (1990) and *Bhaji on the Beach* (1993) have been provided with one hundred

per cent finance. However, perhaps, the most notable example of full funding has been *My Beautiful Laundrette* (1985), a film which initially looked quite uncommercial but subsequently proved to be one of the channel's biggest successes of the 1980s and virtually became identified as the 'archetypal' *Film on Four*. However, such successes notwithstanding, the more characteristic strategy for the channel has been co-production and the vast bulk of films with which it has been involved have depended upon co-funding. This has usually involved the channel providing a combination of equity investment and payment for TV rights, although in some cases (such as *A Room With A View* [1985] and *Mona Lisa* [1986]) the channel has simply pre-bought the television licence. As a result the channel's financial stake in its 'Films on Four' has varied enormously, ranging from as little as £17,000 to over £1.3 million and from two per cent to one hundred per cent of the budget.[31] In terms of actual numbers, however, the *Film on Four* output has been substantial. According to the channel's own calculations, between 1982 and 1992, it had invested £91 million in 264 different works.[32]

Although there have been attempts to define a *Film on Four* film as a particular type, the actual range of films supported has been quite wide. The abiding commitment has been to original screenplays on contemporary British subject-matter and many of the channel's most popular or critically successful films have fallen within this category: films such as *The Ploughman's Lunch* (1983), *Wetherby* (1985), *My Beautiful Laundrette* (1985), *Letter to Brezhnev* (1985), *No Surrender* (1985), *Sammy and Rosie Get Laid* (1987), *Life is Sweet* (1990), *Riff-Raff* (1990) and *The Crying Game* (1992). However, the channel has also supported costume drama (*Heat and Dust* [1982], *A Room With View*, [1985], *A Month in the Country* [1987]), comedy (*She'll Be Wearing Pink Pyjamas* [1984], *Hear My Song* [1991]), crime drama (*Mona Lisa* [1986], *Stormy Monday* [1987]), the British 'art movie' (*Comrades* [1986], *Fatherland*, [1986], *Caravaggio* [1986], the work of Peter Greenaway) as well as a number of 'international' projects including Gregory Nava's *El Norte* (1983), Wim Wenders' *Paris,Texas* (1984), Agnes Varda's *Vagabonde* (1986), Andrei Tarkovsky's *The Sacrifice* (1986), and Krzysztof Kieslowski's *Three Colours* (1993-4) trilogy. It is therefore quite difficult to identify any one clear aesthetic or characteristic which 'Films on Four' have shared. Geoff Andrew has suggested that the bulk of the films have, in fact, fallen within the 'dramatically conventional'.[33] However, this would seem to underestimate the extent to which many of the films have also challenged the conventions traditionally associated with British film and moved towards a more European mode of film practice, even if it is then the conventions of the European art film which have set the outer boundaries of the films' experiments.

Films of a more radical and experimental kind than would characteristically fall within the ambit of *Film on Four* have, however, been supported by Channel Four. This has been done through the Department of Independent

'The growth of black filmmaking was a key development of the 1980s': Anni Domingo in
Sankofa's *The Passion of Remembrance* (1986).

Film and Video which, under its first senior commissioning editor Alan
Fountain, has not always been given the credit it deserves for its support
of British film.[34] Given the growth during the 1980s of a primarily com-
mercial independent sector, the term 'independent' can be misleading. In
the case of the Department of Independent Film and Video, however, the
idea of independence was specifically linked to a tradition of social and
aesthetic radicalism, outside of the mainstream of film and television
production.[35] As Fountain explained, the department was concerned to
support 'the sort of work unlikely to be taken up elsewhere in the television
system' and which would 'represent the alternative, oppositional voice'.[36]
The main outlet for this material was *The Eleventh Hour* which supported
work both from outside the UK (especially the 'Third World') as well as
more unorthodox work from within, particularly political documentaries
which defied the conventional TV norms of 'balance' and 'impartiality'. As a
part of its policy, the department also supported low-budget independent
cinema which typically deviated from the norms of mainstream cinema and
sought to find fresh formal means to deal with social or political content.
Films supported have included Ken McMullen's *Ghost Dance* (1983) and
Zina (1985), Sally Potter's *The Gold Diggers* (1983), Mick Eaton's *Darkest
England* (1984), Derek Jarman's *The Last of England* (1987), Peter Wollen's
Friendship's Death (1987), Lezli-An Barrett's *Business As Usual* (1987) and
Ron Peck's *Empire State* (1987).

The department also provided support to the independent film and video workshop sector which had first emerged in the late 1960s. Under the Workshop Declaration, agreed initially in 1982 with the ACTT, the British Film Institute, the Regional Arts Association, and the Independent Film-Makers Association, Channel Four committed itself to the financing of a number of 'franchised' non profit-making workshops. Such workshops were to be run co-operatively and would be committed to 'integrated practice': not only production but exhibition, distribution and the development of 'audiences, research, education, and community work' more generally.[37] Although only a proportion of all UK workshops benefited from the franchise system it undoubtedly helped to bring stability and financial security to those (about a dozen) which did. In return the channel was provided with a supply of programming for both its *Eleventh Hour* and *People to People* slots, including a number of notable film features such as Trade Film's *Ends and Means* (1984), Frontroom's *Acceptable Levels* (1984), Amber's *Seacoal* (1985) and *In Fading Light* (1989), Cinema Action's *Rocinante* (1986), Sankofa's *The Passion of Remembrance* (1986), Derry Film and Video's *Hush-A-Bye Baby* (1989) and, the first video feature designed for theatrical release, Birmingham Film and Video Workshop's *Out of Order* (1987). The particular importance of this work was its strong connections to the regions and concern to give a voice to those communities (blacks, women, the working class) which have traditionally lacked access to filmmaking. The growth of black British filmmaking, in particular, was a key development of the 1980s and was largely nurtured by the workshop movement.

Channel Four has also contributed to British filmmaking in other ways. As well as directly financing British films, it has provided support to other organizations involved in film production, including British Screen, the British Film Institute Production Board and the Scottish Film Production Fund. British Screen was born in 1985 when the government decided to 'privatize' the National Film Finance Corporation. Channel Four was one of three original funders who provided loans (subsequently converted to share capital) to the new company and the two organizations have subsequently been significant co-investment partners. Thus, between 1987 and 1992, Channel Four jointly backed forty-three films with British Screen and provided an average of around twenty-two per cent of British Screen's total film investments.[38] Since then, however, co-operation between the two has been in decline. This is primarily the result of a deal which British Screen struck with the satellite broadcaster BSkyB in April 1994.

Until 1994, satellite television had not been a significant contributor to British film production. British Satellite Broadcasting (BSB), launched belatedly in April 1990, had sought to follow Channel Four's example and did invest in a slate of original British films including *Chicago Joe and the Showgirl* (1989), *The Big Man* (1990), *Hardware* (1990), *Hidden Agenda* (1990), and *Memphis Belle* (1990). However, following its merger with Sky less than a year later, the company's investment plans for film were halted

and the new British Sky Broadcasting (BSkyB) restricted itself to the occasional pre-purchase of satellite rights. However, BSkyB's movie channels (with less than twenty per cent of European material) have fallen a long way short of the EU's *Television without Frontiers* directive on European programming and this has been criticized by the Department of National Heritage (which has itself been under pressure from the EU to take action). Partly in an effort to improve the European content of its channels, BSkyB, therefore, concluded a three-year deal with British Screen for pay-television rights to its films. Although British Screen sees this arrangement as a means of opening up a new revenue stream for British films, the deal has been opposed by Channel Four which wants the films with which it is involved to be genuine premières and which is sceptical about the amounts of additional money which will result from the deal (if, as it suggests, the amounts paid for terrestial TV rights drop in response). As a result, it is reluctant to participate in projects involving BSkyB and has scaled down its investments accordingly. Thus, during 1994, the channel invested in only two of the twenty films in which British Screen was involved.[39]

As well as British Screen, Channel Four has also provided valuable support to the British Film Institute Production Board. This began life as the Experimental Film Fund in 1952 when it was chaired by Sir Michael Balcon. Funding, however, was not regularized until 1966 when the BFI committed itself to an annual grant and the Fund was re-christened the Production Board. It subsequently received extra funding from the British Film Fund Agency but since the abolition of the Eady levy in 1985, which funded the BFFA, it is Channel Four which has provided the Fund's most consistent source of finance (other than that allocated by the BFI itself). This has consisted of around £500,000 per year towards features (including films by Terence Davies, Peter Greenaway, and Derek Jarman), the production of shorts and development in return for which the channel receives automatic television rights. In certain cases, the channel has also provided additional equity investment, including most recently *3 Steps To Heaven* (1995), one of the first features to be made under the BFI's policy of 'low budget' (i.e. not more than £450,000) production.

In a similar manner, Channel Four has also helped to fund the Scottish Film Production Fund which was established in 1982. Operating on an overall budget of about £400,000 by the mid-1990s, this fund has been committed to the promotion of Scottish cinema and has been involved in supporting a range of shorts, documentaries and features, including *Venus Peter* (1989), *Play Me Something* (1989) and the highly successful *Shallow Grave* (1994).[40] In the case of Wales, the significance of Channel Four has been the establishment of its Welsh-language television service, S4C. S4C has been responsible for about twenty-five hours a week of Welsh-language programming and has commissioned around five films or 90-minute documentaries per year. Most of these have been for television transmission

only but some have received a theatrical release, notably in the case of Stephen Bayly's *Coming Up Roses* (1986) and Karl Francis's *Boy Soldier* (1986). More recently, films such as *Elenya* (1992), *Gadael Lenin/Leaving Lenin* (1993) and the Oscar-nominated *Hedd Wyn*(1992) have increased awareness of the films which S4C has supported.[41] As for Northern Ireland, Channel Four has possibly had less impact than in the other 'national regions'. However, its support for the workshop movement did make possible the production of the first indigenous Northern Ireland film features since the 1930s, most notably Frontroom and Belfast Film Workshop's *Acceptable Levels* (1983) and Derry Film and Video's *Hush-a-Bye Baby* (1989).

ITV and BBC

However, if Channel Four, by a variety of means, has been the most consistent and committed of television companies involved in film production, it has not been completely alone. Indeed, the very success of its film policies, and the kudos it has enjoyed as a result of them, encouraged other television companies to become involved in film production as well. One company, Thames Television had, in fact, established its own filmmaking subsidiary, Euston Films, as far back as 1971 but, apart from the occasional TV spin-off such as *Sweeney!* (1976), had mainly been involved in the production of television series, shot on film. During the mid-1980s the company decided to return to film production, financing in part *Bellman and True* (1987), *A Month in the Country* (1987), *Consuming Passions* (1988), and *Dealers* (1989) (made with Rank) and financing in full *The Courier* (1987).

Central Television also established its own film subsidiary, Zenith Productions, in October 1984. Central had previously financed Stephen Frears' *The Hit* (1984) and Zenith continued with a policy of medium-budget feature investment, producing amongst others *Wetherby* (1985), *Sid and Nancy* (1986), *Wish You Were Here* (1987), *Prick Up Your Ears* (1987), and *Personal Services* (1987). In October 1987, the company was sold to Carlton Communications which then merged it with its own production unit, The Moving Picture Company. This had been acquired the previous year and, under producer Nigel Stafford-Clark, had been responsible for a number of early 'Films on Four' such as *The Bad Sister* (1983, shot, in fact, on video), *Parker* (1984) and *The Assam Garden* (1985). The new Zenith embarked upon a further slate of productions (including *For Queen and Country, The Wolves of Willoughby, Patty Hearst*, and *Paris By Night*, all 1988) but ran into financial difficulties as a result of problems with US distributors. In November 1989, Carlton sold forty-nine per cent of the company to Paramount, following which there was a greater emphasis on television production (although the company was involved in the two Hal Hartley movies *Trust* [1990] and *Amateur* [1994]). This emphasis on television drama continued when the company was acquired by Portman

Entertainment in 1993 after Carlton TV, a subsidiary of Carlton Communications, won the London weekday television franchise from Thames and was required to reduce its ownership share.

The third television company to establish a filmmaking subsidiary was Granada which set up Granada Film Productions in 1987. The company invested in three productions (all made, in fact, for transmission on Channel Four) – *Joyriders* (1988), *Tree of Hands* (1988), *Strapless* (1988) – before it was merged in 1989 with Granada's production division which, under Steve Morrison, was responsible for *The Magic Toyshop* (1986), *The Fruit Machine* (1988), and the Oscar-winning *My Left Foot* (1989). Other companies made smaller but, nonetheless, significant contributions. London Weekend Television put money into *A Handful of Dust* (1987), *The Tall Guy* (1989), *Wilt* (1989) and *Under Suspicion* (1991); TVS co-produced *The Innocent* (1984), *The Dawning* (1988), and *The Queen of Hearts* (1989)(all sold to Channel Four); Scottish Television was involved in *Gregory's Girl* (1980), *Ill Fares the Land* (1983), *Comfort and Joy* (1984), *Killing Dad* (1989), and *The Big Man* (1990); Grampian made a small investment in *Play me Something* (1989), as did Ulster Television in *December Bride* (1990).

As for the BBC, it had a long tradition of shooting drama on film but specifically for TV transmission. Indeed, in 1977, the producer Kenith Trodd drew up a list of television dramas shot on film, the bulk of which were the BBC's, in order to highlight the quality of British television films when compared with British feature films seen at the cinemas.[42] During the 1980s, however, the BBC too began to become involved in films intended for cinema release. It did so initially, through the Programme Acquisitions Department, which was involved in pre-buying television rights for films such as *Gandhi* (1982), *The Shooting Party* (1984), *The Bostonians* (1984), and *White Mischief* (1987). In the late 1980s, the drama department, under Mark Shivas, also began to invest in films with a view to theatrical release. Four films (*War Requiem* [1988], *Dancin' in the Dark* [1989], *Fellow Traveller* [1989] and *The Reflecting Skin* [1990]) backed by the drama department were given a cinema release and others followed: *The Object of Beauty* (1991), *Truly, Madly, Deeply* (1990), *Edward II* (1991) and *Enchanted April* (1991). However, the decision to proceed with a theatrical release was largely taken on an ad hoc basis (*Truly, Madly, Deeply* and *Enchanted April*, for example, were not originally intended for the cinemas) and the pressures for early television transmission led to distribution problems. No UK-based company was interested in distributing *The Object of Beauty*, for example, and a film such as *Utz* (1992) was denied theatrical distribution altogether despite its success at film festivals. In an attempt to address these problems, the policy of the drama department was refined in 1993. Mark Shivas became the new Head of Films with a responsibility for co-producing about five new features per year as well as investing in other independently-produced British features. The distinguishing characteristic of this strategy, compared to previous BBC policy, is that

such features are planned from the start to have full theatrical and video releases. *Priest* , *Captives* and *A Man of No Importance*, all given a cinema release in 1995, have been examples of this policy in action.

Television economics

However, if television – and Channel Four in particular – became the most significant source of British film finance during the 1980s, it should also be apparent that this was primarily the result of cultural rather than commercial factors. Although Channel Four has been party to a few spectacular box office successes (most recently *The Crying Game* and *Four Weddings and a Funeral* [1994]) the benefit of theatrical release to the channel has not been primarily the box office returns which they have generated but rather the critical attention and publicity which a showing in cinemas has attracted as well as the general prestige which has attached to the channel as a result of its support for 'quality' filmmaking. The 'film' label has also encouraged better viewing figures than might otherwise have been achieved for single television dramas. Indeed, two of the films in the first season – *Secrets* (1982) and *The Country Girls* (1983) – achieved the channel's second and third best ratings of 1983. Nonetheless, when measured according to conventional commercial criteria, most of the channel's films can be seen to have made a loss. Indeed, in its submission to the Monopolies and Mergers Commission, the channel cheerfully acknowledged that 'in ten years only a handful of films had actually made a profit for the channel'.[43] Of course, Channel Four is not dependent upon direct financial returns in the same way as conventional film production companies but it has to some extent 'subsidized' film production insofar as the relatively high percentage of the Channel's overall budget (6.2 per cent betwen 1982 and 1992) devoted to *Film on Four* has not been matched by the number of programme hours or audience ratings which it has provided. As Isaacs explained in the early days of *Film on Four*, he regarded such films as having 'a socio-cultural provenance and purpose' which went beyond their financial returns or contribution to the ratings.[44]

This indirect 'subsidy' of film by television is not, however, surprising. As with Europe as a whole, a growing dependence upon television by the film industry was related to the crisis undergone by the British film production sector during the 1970s and 1980s. During the 1970s, cinema attendances in Britain fell consistently and, by 1984, had reached an all-time low of 58.4 million. Audiences did begin to rise thereafter, managing to climb to over one hundred million again by 1991. This growth, however, was a response to the opening of multiplexes, from 1985 onwards, and was largely to the benefit of Hollywood rather than British films. Thus, in 1992, British features (including co-productions) only accounted for 6.8 per cent of the domestic box office while US films accounted for 92.5 per cent.[45] Inevitably, this decline in the domestic theatrical audience, combined with a

Defying the notion of a 'TV aesthetic': Frances Barber and Brian Deacon in Peter Greenaway's
A Zed and Two Noughts (1985)

growth of US box office share, has reduced the attractiveness of investment in British film, a situation not helped by the Conservative government's decision to end the tax incentives which had fuelled the 'renaissance' of British filmmaking in the early 1980s.[46] As a result, there was a retreat, during the 1980s, from film investment by both the City (especially in the wake of the Goldcrest debacle) and British distributors and exhibitors. The consequence of this is that there are now no integrated companies with interests in all aspects of the film business (as Rank and ABPC once did) and the industry is badly split between producers on the one hand and distributors/exhibitors – mainly devoted to the showing of Hollywood product – on the other. In such circumstances, it is only television, along with state-funded bodies such as British Screen, which have been prepared to finance indigenous production on a regular basis.

This is a point worth making given the grudging respect which has so often been shown towards television for its support of film. For ever since the early days of Channel Four, there have been constant complaints that the films which television finances have lacked the cinematic values associated with 'real cinema'.[47] However, what these criticisms have tended to assume is some kind of 'essential' difference between film and television which is difficult to sustain. There are, of course, a number of arguments which can be made in this respect but even a quick glance at some of the films made with television money reveals the problem. *Paris, Texas* (1984), *Room with a View* (1985), *A Zed and Two Noughts* (1985), *Sammy and Rosie Get Laid* (1987), *Distant Voices, Still Lives* (1988) and *Naked* (1993) have all, for example, been financed by Channel Four for its *Film on Four* slot. However, beyond their common destination it is difficult to identify any shared television influence or 'TV aesthetic'. What this would suggest is that it is not so much the television medium itself which is the issue but the use to which it is put. Indeed, what is often noticeable about the conventional criticisms of British 'television films' (literariness and lack of visual intelligence, on the one hand, or subordination to a realist aesthetic, on the other) is that these are simply the same criticisms which have always been directed at a certain type of British filmmaking.

At root, then, it is probably not the assumed diminution of film by televisual values which critics of the television film object to so much as its relative cheapness and absence of Hollywood-type 'production values'. However, the pertinent point here is that the British film industry would not have become so dependent on television if a big budget popular cinema had been a realistic possibility. The fact is that the might of Hollywood is now so substantial and linked to so many factors (the scale of its production, the concentration of resources and deal-making activity in Los Angeles, the size and relative homogeneity of the US home market, the successful penetration of ancillary markets, and the ownership and control of an international network of distribution and exhibition interests) that other national industries really cannot expect to compete with it.[48] Like it or not, the use of television resources to support indigenous film production in Britain and Europe has become a necessity. And television, especially public service television, simply cannot match the resources of Hollywood, where, in 1992, the average cost of a studio film (including marketing and advertising) was $42.4 million.[49]

On the other hand there is the possibility that television films can draw sustenance from television's public service tradition and speak to their own cultures in a way that Hollywood films increasingly do not. The big money-making films from Hollywood are now predominantly 'event' movies, targeted at audiences worldwide and increasingly lacking the close connection with US cultural experience which the best Hollywood movies once had. Thus, even in the US there has been something of a reaction in the form of a growth of low- and no- budget pictures (such as *Straight Out of Brooklyn*

166

[1991], *Swoon* [1991], *Slacker* [1991] and *Clerks* [1994]) which have sought to give expression to the experiences of social groups which have characteristically been excluded from the mainstream. And whatever its subsequent international success, it has also been a feature of the best British and European cinema that it too has been rooted in its own specific culture. It is this tradition of filmmaking which television, given its public service obligations, is most capable of assisting. The issue in respect of Britain therefore is not so much whether it is desirable that television should support film but whether it will continue to possess the means to do so. This question has become especially pertinent in the 1990s given that the climate of broadcasting, in Britain and across Europe, has become increasingly commercial and cost-conscious and has made support for film more difficult, as the examples of RAI in Italy and RTVE in Spain have demonstrated. In Britain the consequences of this new environment have also been evident in the experience of the ITV companies.

Television changes

As has already been indicated, a number of ITV companies were tempted to invest in feature film towards the end of the 1980s. Altogether, ITV companies were involved in about twenty productions between 1985 and 1989. However, in 1988, the government altered the way of collecting the ITV levy (in effect a tax paid by the ITV companies for the right to broadcast) by imposing it on advertising revenues rather than, as from 1974, on profits. This had the effect of increasing the amount of levy which the broadcasters had to pay (an increase of £17 million in two years) as well as closing off a form of 'tax shelter' whereby ITV companies had written off up to thirty per cent of their production costs against the levy.[50] As a result, the making of features became much less attractive than before and ITV involvement in feature production fell by one-third between 1989 and 1990.

This drop in production was also related to the anxiety surrounding the allocation of television franchises due to be announced in 1991 (and which did, indeed, result in two companies involved in film production – Thames and TVS – losing their licences). The now notorious system of competitive bidding used to decide the new franchise-holders also reduced the amount of money available for programme-making, and, given its high cost, feature production was destined to be less appealing.[51] Disputes over the involvement of Granada Television in film production were, for example, one of the factors which led to the resignation of Granada Chairman David Plowright in February 1992 while, more generally, ITV investment in British films virtually disappeared. It is hardly surprising, therefore, that the restoration of some kind of incentives to ITV companies to invest in film (such as relief on annual payments liability) has been among the proposals for which the British film community has been lobbying, returning ironically to more or less the same policy which Terry had recommended some twenty years previously.[52]

The legislation under which the ITV franchises were awarded was also responsible for putting Channel Four on a more commercial footing than hitherto. Under the 1990 Broadcasting Act, the channel became a statutory corporation and, from the start of 1993, was responsible for selling its own advertising. Although there were initial fears about how the channel might fare, it has actually done far better than many predicted. In 1992, the channel achieved a ten per cent share of the UK television audience for the first time (a target which Isaacs had initially hoped to reach by the end of 1985). As regards advertising, it has done even better – securing 19.8 per cent of terrestrial net advertising revenue in 1994. As the annual report for 1994 explains, the channel's commercial success in this respect has been based upon its ability to attract a younger and more upmarket (ABC1) audience.[53] However, this very success has also generated its own problems. Under the 1990 Act, the channel is required to pay, to ITV, fifty per cent of the revenue it earns over fourteen per cent of the joint advertising and sponsorship revenues of ITV and Channel Four. By the same token, if the channel's revenue were to fall below fourteen per cent, ITV would be liable to support Channel Four. Although this formula was intended as a safety net for Channel Four, it has instead become a subsidy to the ITV companies. Under the formula, Channel Four was obliged to pay the ITV companies £38.2 million in 1993 and £57.3 million in 1994. Ironically one of the biggest beneficiaries of this arrangement has been Carlton, the company which controversially won the franchise from Thames Television and which was cautioned by the Independent Television Commission in 1994 for its 'unimpressive' performance, particularly in respect of its networked programmes.[54] Understandably Channel Four has launched a campaign against this funding formula, arguing that it is money which is going into ITV shareholders' pockets rather than into quality programming. The significance for film in this respect is that the channel has committed itself to extra investment in film production should the funding formula be amended.

Of course, the other side of this coin is that the requirement to sell its own advertising has obliged the channel to become much more ratings conscious and possibly less equipped to fulfil its original programming remit. Anxiety, in this respect, may be traced back to the departure of Jeremy Isaacs, the channel's first chief executive, at the end of 1987 and his replacement by Michael Grade, the then Controller of BBC1. Grade's appointment was a controversial one and opposed by Isaacs at the time. Only a few months before his arrival at Channel Four, Grade had called for the privatization of Channel Four and his record of boosting ratings at the BBC through clever scheduling led many to question whether he was the best person to safeguard the channel's distinctive remit. After his first year in the job, the trade paper *Broadcast* ran a survey which suggested that in 1989 there was less drama (including *Film on Four*) than there had been under Isaacs but rather more light entertainment and imported shows.[55] Since then there has been a continuing concern that the channel has moved in too populist

a direction and made too much use of repeats and imported US pro-grammes.[56] Although it would be wrong to exaggerate the changes to the channel's output, which has continued to demonstrate great diversity (as the ITC 1993 performance review partly confirmed), it is nonetheless the case that the increasingly commercial climate in which the channel has had to operate has had consequences for the channel's programming commit-ments, including its ability to support film.[57]

As has been argued, the channel's investment in film production in the 1980s was, to some extent, 'underwritten' by the arrangements between the channel and the independent television companies concerning the sale of advertising. With the channel no longer guaranteed its income and in competition with the other television companies for advertising, there has inevitably been pressures not only to make programming more 'popular' but also to reduce programme costs and so provide less 'protection' to culturally prestigious, but relatively 'uneconomic', programming such as *Film on Four*. This has been manifest in the squeeze on programming budgets which has occurred since 1991 and the cuts which both *Film on Four* and the Department of Independent Film and Video have experienced. The 1994 budget for *Film on Four*, in this respect, was actually £2 million lower than in 1988.

It is, of course, clear that the channel remains committed to support for film and, given its Oscar nominations in recent years, it could be said that the profile of *Film on Four* is higher than ever. There is a danger, nonetheless, that the increasingly commercial climate in which the channel is required to operate may encourage less risk-taking and greater conservatism. A survey of 'Films on Four' backed by the channel in 1994 may be suggestive in this regard.[58] Out of fifteen new features which *Film on Four* was supporting, nine were with US partners. This is, of course, partly the result of the channel having to find new investment partners to replace British Screen but it also indicates a certain move towards the US market and a form of relatively 'safe' filmmaking (exemplified by *Death and the Maiden* [1994], *Vanya on 42nd Street* [1994], *Oleanna* [1995] and *The Madness of George III* [1995]). It is also notable that, of these fifteen films, the channel had equity investment in only five. In the case of the rest, the channel has paid for the television licence alone. Although in some cases the payment for television rights is substantial (£500,000) and above what might have been expected, this paring back on equity investment is also an indication of how the channel has become less prepared to take financial risks on films or 'subsidize' those with less obviously commercial prospects. The 'deficit-financing' of feature films that was a characteristic of Channel Four in the 1980s, and which was critical in getting some of the more unorthodox films of the period made, could therefore be becoming increasingly rare.

If this is the case, it is a trend rendered more significant by virtue of policy changes at the Department of Independent Film and Video which has ended

its ongoing support for the workshops and moved away from support for film features. The withdrawal of support for the workshops can itself be seen as a largely commercial consideration. As was the case with Film on Four in the 1980s, the channel's support for the workshops rested upon a belief in the social and cultural value of this sector and, hence, a commitment to provide it with 'subsidy' insofar as the number of programme hours the workshops provided (fifteen to twenty per year) was relatively low in proportion to their budget allocation (£1.7 million for the year ending March 1990). Given these economics (and the decline in support for the workshops from local and metropolitan authorities), the Department of Independent Film and Video sought to move towards a more project-based system of funding for the workshops at the end of the 1980s.[59] In doing so, it was hoped that the workshops' financial dependence upon the channel would be reduced and that they would be encouraged to find other forms of financial support. In 1991, the Department abandoned its separate budget for the workshops altogether, since when the workshops have been forced to compete for resources in the same way as conventional producers. At the same time, the department has also moved away from the low-budget feature work which had been one of its distinguishing characteristics. Under the new commissioning editor, Stuart Cosgrove, there has been a greater emphasis on documentary than fiction and an increased concern to widen the department's appeal, exemplified by the six-week season in 1995 devoted to the sex industries, *The Red Light Zone.* Cosgrove has argued that the department's agenda must change and has questioned whether 'encouraging formal innovation in film and video art, and providing support to small-scale international filmmakers' really coincides with 'independence in the 1990s'.[60] Certainly, it is appropriate that the strategies of independent film should not stand still.[61] However, without continuing support from Channel Four, an area of activity, once regarded by Jeremy Isaacs as critical to the channel's distinctive purpose, will certainly find it more difficult to flourish. [62]

Government policy

What this suggests is that the conditions which prevailed in the 1980s, and which allowed the relationship between television and film to develop so successfully, are no longer the same in the 1990s. Although it would be difficult to say that the government has actually ever evolved a policy on the relations between film and television, it is nonetheless clear that government decisions have been of paramount importance in determining how film and television have co-operated. It was government broadcasting policy which, probably unexpectedly, encouraged television to support film. It has also been the subsequent changes to broadcasting policy which have made it more difficult for television companies to continue to fund film in the ways they once did. However, despite a wish to assist the film industry, there has been a reluctance on the part of government to respond to this situation and

its attitude towards the role which television has played in supporting film has proved ambivalent.

This is most evident in the first policy document to appear since the White Paper on film in 1984, *The British Film Industry* (1995). This identifies the dependence of British film on television as a 'problem' even though it goes on to argue that 'the independent production sector created by the establishment of Channel Four and the introduction of the independent production quota is key to the establishment of a dynamic film and audiovisual industry'.[63] The equivocation here appears to stem from a certain hankering for a big-budget, internationally popular British cinema. Thus, television is blamed for 'producing mainly low-budget films' which lack 'prospects in the international cinema market'.[64] This in itself is a questionable conclusion: the experience of the 1980s and early 1990s suggests that not only can these films have an international appeal but that they often do much better financially than big budget, 'international' projects, such as those which precipitated the collapse of Goldcrest. Indeed, the document itself picks out three Channel Four films (*Four Weddings and a Funeral, The Crying Game* and *The Madness of King George*) as evidence of the vitality of British film. However, even if it were the case that the British industry needed to think 'bigger', there is no evidence that the government is prepared to provide the means for it to do so. Its strategy for increasing production finance, in this respect, consists only of lottery funding and an advisory committee of producers and financiers. It does not, as yet, consist of the kind of fiscal incentives which most other countries (including, of course, Ireland) have found necessary in order to make an increase in film investment a reality. It is surely for this reason that the DNH document, whatever its claims to represent a new milestone, really does not anticipate much change to the status quo and therefore identifies the independent sector created by television as the fundamental motor of British filmmaking. In acknowledging this, it could also have used the opportunity to fashion a more coherent policy for regulating the relations between television and film. It is, however, one of the disappointments of the document that it does not. It makes no reference at all to possible incentives to the ITV companies to invest in film and flatly rejects any change to the Channel Four funding formula. This latter proposal had been recommended by the National Heritage Committee's report on the film industry but, along with many of its other suggestions, was politely put aside.[65]

Conclusion

It is evident that in Britain, as in the rest of Europe, television has played, and is destined to continue to play, an important role in the nurturing of filmmaking. However, its ability and willingness to do so does depend upon government policies which are prepared to sustain public service broadcasting and protect it against mounting commercial pressures. Such a

cinema is not going to compete with Hollywood, which even if desirable is not realistic, but it can attend to the realities, the experiences and the imaginings to which Hollywood is unlikely to give voice. Although the history of the 1980s is sometimes portrayed as a period of decline for the cinema, and one in which it became debilitatingly dependent upon television, it is also a period in which British filmmaking became more culturally diverse and more aesthetically adventurous than in any previous period. That it did so was precisely the result of the involvement of television and the extended possibilities for filmmaking which a public service broadcaster such as Channel Four provided. However, the economic basis of this cinema has not proved sufficiently solid to withstand the increasingly commercial pressures of broadcasting in the 1980s. As a result, the range and diversity of British filmmaking may be beginning to narrow. This is not inevitable but, if it is a trend which is to be reversed, it will require more vigorous support for television, and its involvement with film, than current government policy appears prepared to provide.

References

1. For a discussion of the history of Hollywood's longstanding interest in television, see William Lafferty, 'Film and Television' in Gary R. Edgerton, *Film and The Arts in Symbiosis: A Resource Guide* (New York: Greenwood Press, 1988).

2. These percentages are derived from calculations made by Goldman Sachs which appear in *Screen Finance*, 5 May 1993, p.8 and 17 May 1995, p.10. The percentages for both pay-TV and video have, in fact, dipped slightly during the 1990s due to the growth of revenue from videodiscs and pay-per-view.

3. *Screen Digest*, September 1994, p.207. Douglas Gomery argues that movie watching, in fact, became more popular than ever during the 1980s as a result of the new outlets, especially video. See *Shared Pleasures: A History of Movie Presentation in the United States* (London: BFI, 1992), p.276.

4. *Screen Digest*, March 1993, p.60.

5. *Screen Digest*, April 1992, p.84.

6. *BFI Film and Television Yearbook 1993* (London: BFI, 1992), p.60.

7. *Screen Digest*, June 1995, p.130.

8. *European Filmfile*, Issue 7, vol.1, p.3.

9. According to Jim Hillier, HBO became the largest financier of Hollywood movies in the 1980s. See *The New Hollywood* (London: Studio Vista, 1993), p.35.

10. *European Filmfile*, Issue 7, vol.2, p.84. A detailed examination of the relations between film and television in West Germany may be found in Martin Blaney, *Symbiosis or Confrontation? The Relationship between the Film Industry and Television in the Federal Republic of Germany from 1950 to 1985* (Berlin: Sigma Medienwissenschaft, 1992).

11. *European Filmfile*, Issue 7, vol.1, p.96.

12. ATV, which became Central after 1980, had, through its subsidiary company Black Lion Films, invested in a number of films intended for television in the run-up to the franchise period. One of these, *The Long Good Friday* (1979), did, however, receive a cinema release following a controversy over proposed cuts for television. Two others, Stephen Frears' *Bloody Kids* (1980) and Ken Loach's *Looks and Smiles* (1981)('a film for television' according to its publicity materials), were also given a theatrical run after their television transmission.

13. Richard Lewis, *Review of the UK Film Industry: Report to BSAC* (London: BFI, mimeo, 1990), p.20.

14. Andrew Feist and Robert Hutchison (eds.), *Cultural Trends*, no.6, (London: Policy Studies Institute,1990), p.33.

15. Cinematograph Films Council, *Thirty-sixth Annual Report for the year ended 31 March 1974* (London: HMSO, 1975), p.6. The Council also recommended, following the example of France and Italy, that the television authorities should voluntarily restrict the showing of films on television to certain days and times. Members of the Council subsequently met with representatives of the BBC, the IBA and the Independent Television Companies Association to discuss the Council's proposals but no agreement was forthcoming. See Cinematograph Films Council, *Thirty-seventh Annual Report for the year ended 31 March 1975* (London: HMSO, 1975), p. 6.

16. These figures are for 1974-5 and are cited in the Annan report. See *Report of the Committee on the Future of Broadcasting*, Cmnd. 6753, (London: HMSO, 1977), p.336. More recent figures suggest that the percentage of films on the ITV channels has dropped a little and that the BBC percentage has slightly risen. In the case of Channel Four, feature films (excluding *Film On Four*) accounted for 16.7 per cent of output in 1994. See Channel Four Television Corporation, *Report and Financial Statements 1994* (London: Channel Four, 1995), p.22.

17. According to Vincent Porter, a newly-appointed member of the Cinematograph Films Council, the sums paid annually by British television for screening British features was about one-tenth the fees paid by German television for German films. See 'Can Germany's Experience Help British Film-makers?', *Vision*, vol.2 no.1, March 1977. The prices paid for features by television continued to be a bone of contention and both the Association of Independent Producers (AIP) and the Association of Cinematograph Television and Allied Technicians (ACTT) lobbied for a levy on television transmission of films in the early 1980s.

18. See *The Future of the British Film Industry*, Report of the Prime Minister's Working Party, Cmnd.6372, (HMSO: London, 1976). The levy itself had initially been introduced in 1964 but, until 1974, had been imposed on advertising revenue rather than profits.

19. *Report of the Committee on the Future of Broadcasting*, p.340.

20. ibid, p.342. A further report from the Interim Action Committee of the Film Industry, chaired by Harold Wilson, however, took the opposite view, arguing that 'the future health of both film and television lies in giving every possible encouragement to investment in production, whether of TV features, film for TV, or feature films intended for showing first in cinemas and subsequently by other means, including television' and recommending that investment in film should be deductable by the ITV companies against excess profits levy. See *Film and Television Co-operation*, Fourth Report of the Interim Action Committee of the Film Industry, Cmnd. 8227, (London: HMSO, 1981) pp.4-5.

21. A useful overview of the pre-history of Channel Four is provided by Sylvia Harvey, 'Channel 4 Television: From Annan to Grade' in Stuart Hood (ed.), *Behind the Screens: The Structure of British Television in the Nineties* (London: Lawrence and Wishart, 1994).

22. *Report of the Committee on the Future of Broadcasting*, p.482.

23. *Broadcasting Act 1981*, (London: HMSO, 1982), p.13.

24. Channel Four Television Company Ltd, *Report and Accounts for year ending 31 March 1990* (London, 1990), p.44.

25. In 1987, the government announced that it expected the BBC and ITV to take up twenty-five per cent of their output from independent production companies by 1992. This twenty-five per cent quota was subsequently enshrined in the Broadcasting Act of 1990. See *Broadcasting Act 1990* (London: HMSO, 1990).

26. See John Woodward, 'Day of the Reptile: Independent Production Between the 80s and the 90s' in Richard Paterson (ed.) *Organising for Change* (London: BFI, 1990) and Kevin Robins and James Cornford, 'What is "flexible" about independent producers?', *Screen* vol.33 no.2, Summer 1992.

27. Jeremy Isaacs, *Storm Over 4: A Personal Account* (London: Weidenfeld and Nicolson, 1989), p. 25. Isaacs also indicates that his experience as chairman of the British Film Institute Production Board made him conscious of the needs of independent filmmakers for an additional television outlet.

28. Quoted in 'Rose on"Film on Four"', *AIP & Co.*, March 1984, pp.21-2.

29. See Chris Auty, 'Films in Boxes', *Stills*, 8, September-October, 1983, pp.40-41.

30. Quoted in Nigel Willmott, 'The Saviour of the Silver Screen', *Broadcast*, 28 October 1983, pp.13-14.

31. John Pym provides financial information on virtually all 136 films transmitted as part of the *Film on Four* slot between 1982 and the end of 1991 in *Film on Four: A Survey 1982/1991* (London: BFI, 1992). Financial information on films backed by Channel Four in 1994 may be found in *Screen Finance*, 14 December 1994, p.5.

32. Monopolies and Mergers Commission, *Films: A report on the supply of films for exhibition in cinemas in the UK* (London: HMSO, 1994), p.151.

33. Geoff Andrew, 'Four Better, Four Worse', *Broadcast*, November 1992, p.29.

34. In addition to the Drama Department and the Independent Film and Video Department, the channel has also supported film through the Multicultural Affairs Department (which has provided pre-purchase monies for films such as *Salaam Bombay* [1988] and *Mississippi Masala* [1991]) and the Films Acquisition Department (which has pre-bought a number of films including *Drop Dead Fred* [1991] and *A Map of the Human Heart* [1992]).

35. A good overview of the history of independent cinema is provided by Simon Blanchard and Sylvia Harvey, 'The Post-war Independent Cinema – Structure and Organisation' in James Curran and Vincent Porter (eds.), *British Cinema History* (London: Weidenfeld and Nicolson, 1983), pp. 226-41.

36. Alan Fountain quoted in *AIP & Co.*, no.51, February 1984, p.18.

37. *ACTT Workshop Declaration* (ACTT: London, 1984), p.1.

38. See *Screen Finance*, 6 October 1993, pp.13-14.

39. British Screen Finance Limited, *Report and Accounts for the year ended 31 December 1994* (London: British Screen, 1995).

40. For a discussion of the Scottish Film Production Fund by its first chairman, see Ian Lockerbie, 'Pictures in a Small Country : the Scottish Film Production Fund', in Eddie Dick (ed.), *From Limelight to Satellite : A Scottish Film Book*, (Glasgow and London: Scottish Film Council and BFI, 1990). For a different assessment, critical of the Board's move into features, see Colin McArthur, 'In Praise of a Poor Cinema', *Sight and Sound*, August 1993, pp.30-32.

41. See David Berry, *Wales and Cinema: The First Hundred Years* (Cardiff and London: University of Wales Press and BFI, 1994), esp. Section Four "Television and a Welsh Film "Mini-boom"".

42. See *Vision*, vol.2, no.1, March 1977 pp.14-19. This list is reproduced, and added to, in Jayne Pilling and Kingsley Canham (eds.), *The Screen on the Tube: Filmed TV Drama* (Norwich: Cinema City, 1983).

43. Monopolies and Mergers Commission, *Films: A report on the supply of films for exhibition in cinemas in the UK*, p.151.

44. Quoted in Stephen Lambert, 'Isaacs: Still Smiling', *Stills*, no.6 May-June 1983, p.26.

45. 'UK Film, Television and Video: Statistical Overview', *Film and Television Yearbook 1994* (London: BFI, 1994), pp.42-4.

46. For an assessment of the Conservative government's film policy in the 1980s, see John Hill, 'Government Policy and the British Film Industry 1979-90', *European Journal of Communication*, vol.8, no.2, 1993, pp.203-24.

47. John Dugdale defends the tradition of television films against what he calls 'the Campaign For Real Movies' in *The Sunday Times*, 4 April 1993.

48. For a good discussion of the weak competitive position which the British film industry occupies in relation to Hollywood, see Steve McIntyre, 'Vanishing Point: Feature Film Production in a Small Country' in John Hill, Martin McLoone and Paul Hainsworth (eds.) *Border Crossing: Film in Ireland , Britain and Europe* (Belfast and London: Institute of Irish Sudies/BFI, 1994).

49. *Screen Finance*, 5 May 1993, p.9.

50. For the details, see Neil McCartney, 'Change in UK Levy system threatens ITV film deals', *Screen Finance*, 29 June 1988, pp. 9-11.

51. According to figures provided by Terry Ilott, the sums paid by the ITV companies to the treasury amounted to £330 million in 1993. See *Film and Television Yearbook 1994* (London: BFI, 1993), p.49.

52. In 1993, for example, the Producers Alliance for Film and Television (PACT) Film Strategy Group prepared a series of briefing documents for the Department of National Heritage which included recommendations that the ITV companies be granted relief on film production expenditure against Percentage of Qualifying Revenue (PQR) payments (i.e. the annual sums which ITV licence-holders had committed to paying in their licence applications). The same proposals may be found in Jonathan Davis and Geoff Mulgan, 'Britain: The Hollywood of Europe?' in Geoff Mulgan and Richard Paterson (eds.), *Hollywood of Europe* (London: BFI, 1993).

53. *Channel Four Television Corporation Report and Financial Statements 1994* (London: Channel Four, 1995), pp.35-6.

54. Independent Television Commission, *1993 Performance Reviews*, mimeo (London: ITC, 1994), p.14.

55. William Phillips, 'Has C4 Sold Its Soul', *Broadcast*, 8 December 1989, p.19.

56. See, for example, the report by Maggie Brown, 'Channel Four "has breached remit to win viewers"' in *The Independent*, 5 March, 1993, p.2. Jonathan Davis suggests that the growing use of repeats and bought-in programmes by the channel results from the failure of income to match growing transmission output. He points out that, between 1984/5 and 1990/1, total transmission output grew by 94.9 per cent whereas income growth was only 49.5 per cent. As a result, he argues that the levy percentage should be raised in order to encourage greater investment in original programming. See 'Four Needs More', *Impact*, no.2, January 1992, pp.16-18.

57. According to the ITC, a comparison of 1993 with 1992 did not suggest 'any general narrowing of range', although it did observe that 'the amount of entertainment in the schedule overall increased while films, in particular, decreased'. See Independent Television Commission, *1993 Performance Reviews*, p.70.

58. *Screen Finance*, 14 December 1994, p.5.

59. See Adam Barker, 'Film workshops face pressure from C4 and BFI', *Screen Finance*, 8 February 1989, pp.9-10 and Alan Lovell, 'That was the Workshop that was', *Screen* vol.31, no.1, Spring 1990, pp.102-108. A similar economic logic has also been at work in the department's changing relationship to the BFI which has involved a move away from long-term funding and an increased emphasis on case-by-case funding for its film features (*Screen Finance*, 19 May 1993, p.5).

60. Stuart Cosgrove, 'In the Midnight Hour', *The Guardian*, 6 March 1995, Section 2, p.15.

61. In a 1992 article, Rod Stoneman, then deputy commissioning editor in the Independent Film and Video Department, complained that independent filmmakers

had often failed to take 'the opportunity to extend their work to the specifics of a television space and ensure that the programme functions in that context' and called for more debate on how British independent film operated in relation to television. See 'Sins of Commission', *Screen*, vol.33 no.2, 1992, pp.141-2.

62. Concluding his Channel Four memoirs, Isaacs suggests that the continuation of the channel's support for low-budget features and the *Eleventh Hour* would be key indicators of the channel's faithfulness to its 'distinctive purpose'. See *Storm Over* 4, p. 198.

63. Department of National Heritage, *The British Film Industry*, Cm 2884, (London: HMSO, 1995) p.5 and p.18.

64. ibid, p.5.

65. National Heritage Committee, *The British Film Industry*, vol.1 Report and Minutes of Proceedings (London: HMSO, 1995), para.197. Following the publication of the *Broadcasting Bill* in December 1995, the government has, however, committed itself to a review of the funding formula from 1998.

9

Getting the Right Approach: Channel Four and the British Film Industry

Michael Grade

This paper is called 'Getting the right approach' and I'm bound to say that with *Film on Four* I think David Aukin and his editorial colleagues certainly have found the right approach. With *The Crying Game* (1992) and *Four Weddings and a Funeral* (1994) they certainly hit the commercial and artistic jackpot, but within a policy of backing innovation and risk over a decade. If we do have problems – and I will come to them – they mirror the situation of the British film industry over decades: there's no shortage of talent, but there are quite unnecessary hurdles placed in its path. Amid all the individual awards for films we've backed, I was particularly proud in 1994 to have been in New York along with my predecessor Jeremy Isaacs to collect a special International Emmy award for twelve years of *Film on Four*, along with the two men responsible for commissioning the films, David Rose, who created *Film on Four*, and his successor David Aukin.

It's worth going back a moment to consider the birth of *Film on Four*. British television, certainly the BBC Drama Department and to a lesser extent ITV, was making feature films long before Channel Four came

'A nice little earner': Hugh Grant and Andie McDowell in *Four Weddings and a Funeral* (1994)

along. They were feature-length dramas, shot on 16mm, but they weren't called feature films; indeed, the BBC's were still called plays – as in *The Wednesday Play* or *Play for Today*. So they couldn't enjoy the status of feature films, and since they were shot on 16mm under the broadcasters' own in-house union agreements, there was no hope of any cinematic screenings. ITV's most prestigious drama tended to be in series like *Brideshead Revisited* (1981) but, when I was at LWT, we did pursuade Dennis Potter to write several feature-length films for us. Think of *Cream in My Coffee* (1980), for instance, impeccably directed by Gavin Millar, and you had a work that might not only win the Prix Italia, as it did, but could have competed with many cinema works. The talent deployed on many of these films could easily match what could be found in British cinema movies, yet never the twain could meet. On Continental Europe, however, broadcasters had long participated in backing movies, helping to shore up their own home industries and guaranteeing themselves access to drama in their own languages.

But, in Britain, Channel Four was the first broadcaster to create a bridge across the great media divide. You could claim this as yet another example of the channel's innovations, and one of its most important ones. Its aim was to refresh British television, not shore up the British film industry. But the channel certainly decided that it would commit a major part of its drama budget to one-off feature-length dramas shot on film. If the channel invested a little more in some of them to raise their production values and

shoot on 35mm, it could use the freedom of independent production and the union agreements that went with them to seek cinema releases first and gain greater prestige for the films themselves and the overall strand, enhance their appeal to the audience – who are more drawn to anything labelled film than to 'single plays' – and also gain some economic return from these cinema screenings.

The rest is history, though it's worth remembering that only a proportion of the films were initially considered as having cinema potential. But it proved hard to judge. *My Beautiful Laundrette* (1985) had been shot on 16mm since nobody dreamt it had any cinematic legs. After the first Edinburgh screenings, it was indeed thought worthwhile blowing up to 35mm for the distribution that followed, including over half a year in New York. It is also worth remembering that in bridging the divide between the media, this sort of commissioning brings cinema features to us far more swiftly than with the old three-year holdback. Our holdbacks are far more flexible, depending upon the individual film and its cinematic success.

Over twelve years, the channel has invested more than £90 million in some 264 feature films for the *Film on Four* strand (and that's not to mention the other cinematic ventures, such as the Multicultural department's commissioning of *Salaam Bombay* [1988] and *Bandit Queen* [1994]). The commitment to innovation and difficult subjects is no shibboleth: it doesn't stop us backing established talents like James Ivory, or helping to revive the career of Mike Leigh and Ken Loach. But that commitment is enduring. One of the channel's first handful of commissions was *Angel* (1982), Neil Jordan's directorial debut, and we backed *Company of Wolves* (1984) and *Mona Lisa* (1986) before he went to Hollywood with rather mixed results. It was appropriate that he should return to us (and to the subject of the 'troubles' that he had last tackled in *Angel*) for his most controversial film – and his most successful in years – *The Crying Game* (1992). We've continued to launch new talent, often through the nursery slopes of *Short and Curlies,* the strand for 11-minute shorts shot on 35mm that, like *Film on Four,* was designed for both cinema and TV. Former actor Peter Chelsom graduated from one of those shorts, *Treacle,* to his first feature as director, *Hear My Song* (1981). Carl Prechezer demonstrated such potential with his savagely-memorable short *The Cutter* that he too has now made his first feature, *Blue Juice* (1995).

Our financial involvement can vary enormously, from small minority stakes in features to one hundred per cent financing, as with Ken Loach's three films, *Riff-Raff* (1990), *Raining Stones* (1993) and *Ladybird Ladybird* (1994). Even where we are a minority partner, our involvement can be crucial financially and also artistically. There are many occasions where, without our investment, films simply wouldn't get off the ground – or the page. And artistically, our editorial input can be considerable: for instance with *Four Weddings*. We invested only a third of the budget, but it is no disparage-

Forest Whitaker and Stephen Rea in Neil Jordan's *The Crying Game* (1992), an example of Channel Four's 'enduring commitment' to the filmmaker.

ment of Richard Curtis – one of the funniest and nicest writers in Britain today – to emphasize the role of David Aukin and his team in helping to focus Richard Curtis's comic genius to its ultimate effect through all the script revisions.

So, we have reached a point where we can command a quarter of the short-list at Cannes (as we did in 1992) or win more Oscar nominations than any other studio in the world except for Warner Bros. (as we did in 1993). And the BBC, at least, has flattered us most sincerely by copying the same trick, though they seemed unnecessarily to repeat the same errors that we made years ago, but which we had learnt from long before my arrival, rushing films onto TV so soon that it kills their chances as cinema, as happened with *Utz* (1992) and, in this country at least, with *The Snapper* (1993).

But where we go from here is limited by three sets of problems which I will outline. The first is distribution. The advent of the multiplex has not eased the perennial problems of distributing British movies at home. Historically, there were too few distribution chains; now, despite all those screens, they are dominated by vertically-integrated American majors. It's not a function of marketing. Even when we have targeted special marketing budgets at promising films, *Naked* (1993) and *Raining Stones* (1993), they still ended

up reaching fewer cinemagoers than in France. Experience with *The Crying Game* was similar despite a marketing budget of £150,000 and the feedback from the subsequent American success.

Four Weddings and a Funeral is indeed the exception. It is already the most successful home-grown film in British cinemas. And yet, what helped to boost the prominence of that film from its première onwards – and I'm not thinking primarily of Elizabeth Hurley and that dress? The expectations were raised because the film had already been launched in the USA and proved a hit. (*The Crying Game's* American success came only after a rather downbeat launch in the UK.) With *The Madness of King George* (1994), we were tempted to repeat the trick with a US release first. Shurely shome mishtake?

These are all quintessentially British projects: do we really have to go to the USA to achieve a kind of bandwagon effect? Just think of our more familiar experience in television and you recognize how strange this is. American television can be slow to appreciate even the best of British production, even when it's an all-American subject like *Tales of the City* (1993), as we've learnt to our cost. So it's even more remarkable that in the film business we should look to American cinema to overcome the problems of British distribution in promoting such British films. Though our distribution has improved, American films still dominate the UK market to quite an extraordinary extent and the structural problem remains.

Second, there is the issue of distribution windows and investment. Saving the British film industry was never Channel Four's primary aim; our first public duty is to our viewers at home. Nor is it our most pressing commercial interest to be making money out of cinema distribution. That's just as well, when you consider *Four Weddings* is our most substantial success and in the end we'll probably make about £3 million out of it. A nice little earner, perhaps, but hardly something to drive a company with a turnover in excess of £300 million a year in advertising revenue. No, to return to our original purposes: we back films to ensure that we can offer our viewers at home films that would not otherwise be made or reach them so readily. That involves a risk, whatever our level of investment, but we'll take that in return for getting the film fairly soon. Holding back for a cinema release is one thing; waiting for a satellite competitor is another. If we're buying completed feature films, as broadcasters have long done, we'll wait our turn - behind cinema, video, satellite and cable. But not if we're investing in a major commissioned strand like *Film on Four*.

But, finally, we come to the big climax. You've probably guessed it: the funding formula. Reports of the death of our campaign have been greatly exaggerated. It's still very much alive, and the argument is as strong as ever. On 14 February 1995, we handed ITV a cheque for £57.3 million. It was some Valentine's Day massacre: for what was massacred were all the

programmes and features that might have been made with that money if we'd retained it. That £57.3 million is equal to our total investment in five years' worth of *Film on Four*, more than sixty British features. Vowing to double our annual investment in *Film on Four*, if we retained that money, is therefore quite a modest guarantee. I make no apology for raising the matter again, though I'm going to spare any repetition of the argument. It remains as valid as ever. ITV companies will not spend any of that money on programming, because they have absolutely no commercial reason so to do: they are already spending enough on programmes to command sufficient audiences. They have even less commercial reason to contemplate gambling on cinema movies (though Granada Films may continue a modest investment).

For us, it's different. *Film on Four* may be helping to save the British film industry, and by now has more than repaid the debt that television owed the cinema. It may also clear some profit from the distribution of some of its films, though that will remain small change compared with our core income from advertising revenue. But the main purpose of *Film on Four* remains to help fulfil the basic remit with which the channel was charged in the 1981 Broadcasting Act, and which was maintained verbatim in the 1990 Act: to provide the most distinctive and innovative dramatic work that we can for our viewers at home.

10

Channel Four's Policy Towards Film

David Aukin

1. To encourage predominantly British filmmakers to make films that will work both in cinemas and on television.

2. To provide opportunities for filmmakers at the start of their careers.

3. To commission the most talented filmmakers available.

4. To commission films that would not be made without our finance.

5. To commission films so that they can be made as intended by the film-maker, with the proviso that we are not only Commissioners but also Editors.

6. To encourage filmmakers from all sections of society.

7. To encourage films which can work within the industry but at the same time retain an individual voice and identity.

8. To encourage the making of films from original screenplays dealing with contemporary themes rather than adaptations or the dreaded biopic.

9. To only commission films where the Commissioning Editor is passionately engaged by the material.

10. To ignore all the above except number 9.

11

The BBC and Film

Mark Shivas

I t is insufficiently known, but the BBC has invested in other producers' films for a long time through its Programme Acquisitions Department. Pre-buys of television rights and a position in the films' equity include, down the years, *Chariots of Fire* (1981), *Gandhi* (1982) and the recent *Henry V* (1989).

When I returned to the BBC as Head of Drama in 1988, one of the things I wanted to achieve was to move the Corporation into feature film production on a regular basis. And I did. As Tony Garnett said not long ago, it only took twenty years for the BBC to get there. People like Garnett and Kenith Trodd and myself, who were producing there in the 1970s, made valiant efforts, but there was a huge resistance. We were told that it wasn't the BBC's business, that the Charter didn't allow it and so forth. So we made films, with Loach, Roland Joffé, Michael Apted, Alan Clarke, Stephen Frears, Mike Newell, Alan Parker – to name a few of the most obvious – but they were shown only on the BBC and normally only once or twice, which seemed a waste. They outclassed many British films that turned up in the cinema at the time and, during yet another crisis in the so-called British film industry, it used to be said that the industry was alive and well and living in Shepherds Bush.

By 1988, though, Channel Four had been investing regularly in features for six years (I'd produced an early one – *Moonlighting* in 1982). The BBC, I felt, was missing out on a lot of talent that would otherwise come to us – writers, producers, and directors who wanted the prestige and publicity that a cinema film release before television would give them. The films wouldn't necessarily make money – in Hollywood the ratio is three in ten at the most, how should we be different? – but they would be noticed more than those which only played, with luck, twice on television.

The then controllers of BBC1 and BBC2 agreed that two or three a year could be held up, released theatrically, and come to their channels later. They didn't greatly like the wait for something they'd invested in a year or two earlier, but Jonathan Powell and Alan Yentob agreed. The first real fruits of this agreement were Anthony Minghella's directing debut *Truly Madly Deeply* (1992) and Beeban Kidron's film of Marcy Kahan's script *Antonia and Jane* (1990). Samuel Goldwyn had been shown the former and wanted to buy. Harvey Weinstein wanted both. Or nothing, he said. We called his bluff and ended with Sam taking *Truly Madly Deeply* and Harvey with *Antonia and Jane*. Both films were shot on 16mm using the BBC's only (then) available union agreements, so a long negotiation and technical process began to buy out rights and beef up the sound, blow them up to 35mm. Both opened in America and did nicely. No one there said they looked like television even though *Antonia and Jane* only ran seventy minutes.

In this country *Antonia and Jane* had already been on television. *Truly Madly Deeply* ran in a London cinema until a week before its transmission on the BBC. I wish it had been possible to run it through transmission and out the other side because I believe that can occasionally help the cinema screening. This flies in the face of the exhibitors' received wisdom; once I asked Roger Wingate, owner of the Curzon cinemas, whether he would ever play a picture after its television transmission. The curt answer was 'Hire your own hall'.

Truly Madly Deeply wasn't the first BBC film to get any kind of theatrical release in the UK. *Fellow Traveller* (1989) and *She's Been Away* (1989) probably have that honour, but it was the first to make a big mark. *Enchanted April* (1990) had a brief theatrical release here after opening the London Film Festival in 1990, indifferent reviews and poor business, but in America it grossed very high and received three Oscar nominations. Again it had been shot on 16mm, but no one knew. We also shot films on 35 mm, co-produced with independents using the right theatrical union agreements – *The Object of Beauty* (1991), Michael Lindsay Hogg's film with John Malkovich and Andie MacDowell was one – but our major theatrical successes at that time were films largely financed by the BBC and originally destined for television first.

BBC film with proper holdback: Ian Hart in *Land and Freedom* (1995)

In the case of Stephen Frears' film of Roddy Doyle's *The Snapper* (1993), Stephen had just come from making a vastly expensive American picture with Dustin Hoffman, Geena Davis and Andy Garcia called *Hero*, or *Accidental Hero* (1993) in Britain. He wanted to make *The Snapper* but thought it was too small for a theatrical movie and insisted that it be written into his contract that it couldn't be shown in cinemas. It was shown as a *Screen Two* in April 1993 to great acclaim and a very large BBC2 audience of more than five million.

At this point, Pierre Henri Deleau had already asked for it to open the Director's Fortnight in Cannes. Stephen said 'yes'. It was a triumph with the audience and that night he further agreed that it could go theatrical to all those buyers who had been waiting and hoping he'd change his mind. Amazingly, Liz Wrenn of Electric decided to buy it for theatrical release in the UK. It was the first film to be a success there *after* a television showing. The main difficulty was with the newspaper editors who felt they'd covered it and wouldn't write again. And with one or two reviewers who either didn't mention it or said it looked like a television film. As Philip French said about the film, there are plenty of close-ups in Bergman too.

Partly as a result of ignorance over *The Snapper*'s genesis, and partly because we have sometimes been unable to delay the transmission of a film that had always been agreed to go to television in the UK first, the BBC was

sometimes seen as unwilling to give the necessary theatrical and video windows. If this was ever true, it no longer is. We have a policy that I, now as Head of Films, invest in up to ten films a year from independent producers, with the proper holdbacks. In addition, two or three of the films originally designed for television and coming from George Faber's area of Single Drama will probably become features.

In 1995, films opening from the BBC has included the Antonia Bird/Jimmy McGovern *Priest*, which was both controversial and profitable; *A Man of No Importance* with Albert Finney and Brenda Fricker; *An Awfully Big Adventure* with Mike Newell directing Alan Rickman and Hugh Grant; *Captives* with Tim Roth and Julia Ormond; *i.d.* about soccer violence; Ken Loach's film about the Spanish Civil War *Land and Freedom* which competed in Cannes and Michael Verhoeven's *My Mother's Courage* with Pauline Collins. All these films have British or European subjects and British producers. This will probably continue to be our policy though we have one American subject in development.

There are no other contraints except those of budgets and the usual necessity for co-production money. And the films must be showable on television some way down the line.

12

Film and Television Policy in Scotland

Andrea Calderwood

1995 was a good year for film in Scotland. The year began with the release of *Shallow Grave*, a first feature for both the Scottish producer, Andrew MacDonald, and Scottish writer, John Hodge. At just over £1 million, its budget from Channel Four and the Glasgow Film Fund was at the low end of the feature film scale, but it was directed with big ambition by Danny Boyle (directing his first feature) and, on its release, it showed immediately that it could compete and win against Hollywood films of many times its budget. Top ten in London for seven weeks, reaching number one in Paris, and making money at the US box office, this low-budget film, set in Edinburgh and shot in Glasgow with a crew made up of mostly Scots, had become that thing which every film industry in the world seeks but only rarely finds: an international hit big enough not only to make its money back for its investors - but to make a profit as well.

On top of *Shallow Grave,* 1995 witnessed an unprecedented number and range of Scottish feature films on release and in production. Shot on location in the Highlands in 1994, and given a high profile European première in Edinburgh in 1995, *Rob Roy* is a Scottish-created, but Hollywood-backed, historical epic which also did good business at the international box office. Scottish producer Peter Broughan developed the script

Small Faces (1995): BBC Scotland's first venture into feature film production.

with Scot-in-exile Alan Sharp: a script of such a quality that it lured fellow exile Michael Caton-Jones back from Hollywood to make his first feature in his home country, attracted Liam Neeson to play the Highland hero, and created a package which found backing from UIP for a budget around thirty times that of *Shallow Grave*. Also home from Hollywood, but to work on a different scale, was director Gillies Mackinnon, whose personal film with universal themes of adolescence was co-written and produced by his brother Billy. Inspired by the brothers' experience of growing up in Glasgow in the 1960s, *Small Faces* was made on a budget of over £1million (from the BBC and the Glasgow Film Fund) and was BBC Scotland's first venture into feature film production. *The Near Room*, a contemporary Glasgow thriller directed by David Hayman from a first feature script by Robert Murphy, with a low budget from British Screen and the Glasgow Film Fund, also began production. Ken Loach began work directing *Carla's Song*, an international feature set in Glasgow and Nicaragua written by first-time Scottish feature writer Paul Laverty. And, following the success of *Shallow Grave*, Channel Four backed the same team to produce another Edinburgh-set and Glasgow-shot film, *Trainspotting*, based on the cult novel about the Leith drug scene by Irvine Welsh.

So, with two box office successes, and four new feature films going into production, 1995 was a good year for Scottish film. But although it represents an impressive range of subjects, talent and style, this slate of Scottish features - that is, films for cinema release which are substantially

189

originated, set, and produced to a commercial level in Scotland - still only adds up to six films. While six films is an unprecedented number, it is still not feature film production on a scale which could be called an industry, in the sense that Scottish feature films alone can sustain a sufficiently consistent level of production to maintain a viable and appropriately skilled workforce. When taken together with television drama production, however, a picture of something which can be called an industry begins to emerge – a film and television industry.

As well as the feature film *Small Faces*, BBC Scotland's Television Drama department has broadcast and produced in 1994/5 the following:

A major new series for BBC1, *Hamish Macbeth*, shot in Plockton in the North West Highlands and featuring the adventures of a Highland policeman in the fictional village of Lochdubh. The series of six fifty-minute episodes was produced by the London-based independent Zenith along with the Edinburgh-based independent Skyline. Lead writer Daniel Boyle created a series with a highly original and wickedly funny tone. At first feared by London executives as being 'too Scottish', it attracted an average of over ten million viewers across the UK when broadcast in the spring of 1995, becoming one of the BBC's biggest hits for some time. It made a household name of Robert Carlyle (also one of the stars of *Trainspotting*) as the eponymous hero, as well as increasing the attraction of Plockton to the tourist trade. A second series has been commissioned and went into production in July 1995.

The second series of the hospital drama with attitude, *Cardiac Arrest*, was commissioned from BBC Scotland in recognition of the fact that, although set 'somewhere in the north of England' and originated from London by independent producers Island World, the first high-impact series had been produced in Glasgow with a largely Scottish production team, including most notably producer Paddy Higson and director David Hayman. This second series of eight thirty-minute episodes was also a critical and ratings success, with an average audience of around six million. This compared well with any other half-hour drama on the BBC, and most critics welcomed the series' irreverent approach to the practice of medicine, as opposed to the reverential tone adopted towards the medical profession by most other hospital dramas on TV. A third series of thirteen episodes went into production in August 1995.

Writer Donna Franceschild's and director David Blair's six-part serial about a DJ in a psychiatric hospital, *Takin' Over the Asylum*, was shown to critical acclaim on BBC2. Although it received a relatively small audience of around 1.5 million, it was not overshadowed by other, higher profile serials when it came to the 1995 awards, winning BAFTAs for Best Serial and Best Editing and the RTS Writer's Award. A new four-part serial by the same writer/director team, *A Mug's Game*, has been commissioned for BBC1, and went into production on the West Coast of Scotland in July 1995.

As well as series, BBC Scotland has been active in television films. Emma Thompson returned to Scotland to appear in the supernatural drama *The Blue Boy*, writer/director Paul Murton's first full-length TV drama which was transmitted on BBC2 as part of the 1994/5 Christmas season. Writer David Kane's directorial début *Ruffian Hearts*, a contemporary Glaswegian romantic comedy; Howard Schuman's drama about the effect of an AIDS-related illness on a gay couple's relationship, *Nervous Energy*, set in Glasgow and London; and *Flowers of the Forest*, Michael Eaton's dramatic exploration of the effects of a case of suspected Satanic ritual child abuse on a small Highland town, were all produced for *Screen Two* in 1995.

BBC Scotland has also been involved in producing a forty-minute drama, *Nightlife*, as part of the BBC2 network's youth drama competition, *Double Exposure*, and the three shorts produced annually with the Scottish Film Production Fund through the *Tartan Shorts* competition. As well as this slate of production for the BBC network, we have developed new strands of drama for Scotland-only broadcast. This began in 1995 with the transmission of three half-hour one woman plays under the banner *Lambrusco Nights*. These showcased the work of newer women writers and directors and received a warm audience reception on BBC2 Scotland. Taken together, BBC Scotland's total slate of drama in 1994/5 added up to twenty-two hours hours of television, with £12million of investment in film and television drama production in Scotland.

Over at Scottish Television's drama department, meanwhile, production of their successful series *Taggart* and *Dr. Finlay* continued with thirteen episodes being made in 1995 for the ITV network, along with forty-eight more episodes of their Scottish soap, *Take the High Road*, and thirteen of the Gaelic soap, *Machair*, and a pilot for a new ITV series, *McCallum*.

Scottish Screen Locations, a body created five years ago to facilitate the use of Scotland as a location by foreign and domestic productions has been instrumental in attracting twelve foreign-based films to shoot in Scotland in 1994/5. As non-Scottish originated films, they are not included in the list of Scottish features, but by employing at least a proportion of Scottish crews, and spending a proportion of their budget in Scotland, these films make a significant contribution to the film infrastructure in Scotland.

With this level of drama production, we can claim to have an industry here: an industry in which television drama production has helped create and sustain the infrastructure which also facilitates film production; an industry that sustains the nearly five hundred freelance technicians and production staff listed in *Film Bang*, Scotland's production directory, as being based in Scotland, and over five hundred more employed by the broadcasters. Not all of these work in drama production, and of those who do, many divide their time between drama and documentary, but one of the ways that a viable industry has been kept alive in Scotland is the tradition of film and

television technicians working across genres, a diversity which is also one of its strengths.

As well as sustaining the infrastructure, the cross-fertilization between film and television has also been key to the development of most of the talent, and to learning most of the crafts, which are making a viable level of drama production possible in Scotland today. Highlighting a few examples of individual connections between film and television, and between television genres, creates a picture of a kind of family tree in which each genre and medium contributes to the other, and which has substantially contributed to this year's healthy range of productions:

The director of *Rob Roy*, Michael Caton-Jones' first professional directing job after film school was directing the Channel Four serial *Brond*, produced by Paddy Higson (producer of *Cardiac Arrest*). Paddy Higson also gave Scottish director Jim Gillespie his first major professional drama job on the second series of *Cardiac Arrest* and he has since directed a BBC2 serial, a 35mm short for the BFI, and was lined up to direct a low-budget film for Channel Four. Gillies Mackinnon (director of *Small Faces*) directed a film backed by Channel Four, and two television films for BBC's *Screen Two* before being hired for the two Hollywood-backed films which preceded his return to Scotland to make his feature for the BBC. David Hayman (director of *The Near Room*), and Daniel Boyle, Bryan Elsley and Stuart Hepburn (writers of *Hamish Macbeth*) all had their early drama breaks on BBC television films. Danny Boyle (director of *Shallow Grave*) directed single films and serials for BBC before his feature debut with *Shallow Grave*; Andrew MacDonald (producer of *Shallow Grave*) had previously produced a documentary series for Scottish Television before producing the feature; and Peter Broughan was a script editor and producer at BBC Scotland before developing the script that was to become *Rob Roy*. (A maverick branch of this family tree is the NHS, where John Hodge, writer of *Shallow Grave*, and John MacUre, writer of *Cardiac Arrest*, both learned their trade working as doctors, but that's another story.)

Co-operation between several of the film and television organizations and companies has lead to the development of a comprehensive ladder of development for emerging talent in Scotland. Scottish Television and the Scottish Film Council jointly run *First Reels*, which provides new film and video-makers grants of up to £4000 to produce short works, of which the highlights are broadcast on Scottish Television. Scottish Television, the Scottish Film Production Fund and British Screen have recently joined forces for *Prime Cuts*, a competition to produce six five-minute dramas on 16mm. The BBC Scotland-SFPF joint initiative *Tartan Shorts*, a competition to produce three cinematic shorts annually, has reached its third year. The quality of the films has been high, winning a number of UK awards and nominations, as well as an Oscar for Best Short Film in 1995 for Peter Capaldi's *Franz Kafka's It's a Wonderful Life*. BBC Scotland and SFPF are

also collaborating with the Gaelic Television Fund to produce two further shorts in the Gaelic language, in a new scheme called *Geur Ghearr*. As well as creating new filmmaking opportunities in their own right, these initiatives all provide a way into the mainstream industry for emerging Scottish talent. Several *Tartan Shorts* directors and writers, for example, have gone on to receive further commissions from BBC Scotland, for *Double Exposure* and the *Lambrusco Nights* strand.

Training has also become increasingly cross-sector. Growing out of the Scottish Film Training Trust, an industry body created by and for the independent sector of the Scottish film industry, Scottish Broadcast and Film Training is now an industry-wide training body funded by the broadcasters and film organizations which provides film and television training for broadcasters' in-house needs as well as for freelancers in the independent sector. But Scots having the talents and the skills is not enough: without access to the means of production – that is, the finance – all that talent will be, and has been in the past, exported. An analysis of the sources of finance of the six films listed earlier is revealing. Of the six, all but two are wholly or partly backed by broadcasters: *Shallow Grave, Carla's Song* and *Trainspotting* by Channel Four, and *Small Faces* by BBC. All but one have been developed by public film funds. *Shallow Grave, Carla's Song, Small Faces, The Near Room* and *Rob Roy* were all developed at some stage with the backing of the Scottish Film Production Fund; *The Near Room* had both development and production backing from British Screen. All but two have contributions to their production budgets from Scottish public film funds: *Shallow Grave, Carla's Song, Small Faces* and *The Near Room* from the Glasgow Film Fund. It seems reasonable to conclude, therefore, that this slate of feature film production would not exist without both investment from broadcasters, and the existence of sources of public film finance – particularly Scottish sources of film finance.

The role of a Scottish source of film finance is particularly key. As most other major sources of investment are concentrated in London, Scottish producers need some kind of lever to shift the cash from London to Scotland. As the 'too Scottish' worry about *Hamish Macbeth* showed, a London-centric industry like film and television is quick to jump to the conclusion that a Scottish project is likely to be of limited appeal south of the border – and even less likely to succeed across the Atlantic or the North Sea. However, money talks – even if Scottish money talks in a funny accent – and having the ability to bring some investment to the table seriously strengthens the producers' position. As the experience of our six films shows, it need not necessarily be a lot of money, just the appropriate amount of money at the appropriate time. The majority of the Scottish producers who had their scripts backed by SFPF and got their films made in this last year had little or no track record in producing feature films. It was only the ability to finance properly the development of their projects to the stage where the strength of the script could either allow them to create

a viable production package, or convince sources of production finance of the viability of the film, that put their projects in a position to make the leap from being nice ideas to being films that got made. And at the under £2 million budget on which many British films are made, the investment of around £150,000 per film available from the Glasgow Film Fund can make a significant difference to whether a film can be made on a feature scale, either providing top-up finance to a broadcaster's budget, or representing a respectable contribution which a producer making a film in Glasgow can propose as part of a co-production finance deal. Either way Glasgow Film Fund investment has made a sufficient difference to have been part of the deal in four of our six Scottish films, therefore apparently providing a successful incentive to film in Glasgow.

So without collaboration between film and television both to develop the talent which made the films, and provide the finance to back them, our six Scottish films would not have been made. Why does that matter? It matters because, although, as the BBC Scotland slate shows, television drama can cover an extremely wide range of subjects, there are some stories which, because of their scale, style, language – any number of reasons – can best be told in the cinema. And despite the wide variety of slots available on television, again particularly on the BBC, some of our best talent will always aspire to work in cinema; without the opportunity to make feature films in Scotland, there would be no incentive for that talent to return to or stay in Scotland and tackle Scottish subjects. So without access to feature film production, Scots would not have the ability to tell the full range of stories we want to tell – that is, to have as full as possible an expression of our culture using one of the most powerful media of the modern age.

And although television production spend represents significant investment in Scotland from UK domestic sources, feature films represent additional independent means to attract finance and investment into the Scottish industry, and the wider Scottish economy. This investment is not restricted to the production budget of the films; just as the broadcast of *Hamish Macbeth* on British television has attracted more British tourists to Plockton, *Rob Roy* is seen by the Scottish Tourist Board to have made a valuable contribution to the promotion of Scotland to foreign tourists.

There are therefore three main reasons for why making films matters: the cultural reason, the development of an industry reason, and the economic reason. The arguments in these three areas can be most strongly made for a combined film and television industry, and all three reasons contribute to the case for continuing and expanding the network of television opportunities and support for film production which exists in Scotland. British film policy has always seemed unsure whether to treat film and television as a business or a cultural activity. The arguments are strong for both, and are not mutually exclusive. We need to create opportunities to develop, attract, and keep filmmaking talent, which in turn can attract a consistent level

of investment to build an industry. And it is only with a strong industry that we will have the ability to tackle the range of subjects necessary to represent and explore our own culture. So both cultural and commercial sources of investment can and should be required to create the necessary opportunities.

The best argument in support of our industry is, however, what we produce. With television ratings successes and box office hits, politically and personally challenging films and award-winning serials, the talent in Scotland has shown that if given the opportunity, it can make good stuff - stuff that national and international audiences want to watch. And in the end, that's what it's really all about.

<div style="text-align: right">

13

</div>

Film and Television in Wales

Dave Berry

Introduction

Even the most cynical (or capricious) of observers in Wales are now prepared to concede the burgeoning potential of Welsh films. The critical and festival success of Endaf Emlyn's Welsh language features *Un Nos Ola Leuad* (*One Full Moon* [1991]) and *Gadael Lenin* (*Leaving Lenin* [1993]) and Paul Turner's *Hedd Wyn*, nominated in 1994 for the Hollywood Best Foreign Film Oscar, have helped to muzzle sceptics. Signs of increasing confidence in Welsh films were evident in 1995 when British Screen injected cash for the first time into a Welsh-language film, Endaf Emlyn's S4C and BBC joint venture *Mapiau* (*The Making of Maps*) and pledged to back, on a matching funding basis, an English language film from Wales (Marc Evans's *House of America*, from a screenplay by South Wales' leading playwright Edward Thomas). The budget for each of these films subsequently topped £1 million. Welsh stock has also risen with the demand on the festival circuit for work by exuberant, iconoclastic animators such as Joanna Quinn, Phil Mulloy and Vera Neubauer, all nurtured by television.

Yet you don't have to be a jeremiah to harbour serious reservations about a Welsh film mini-industry tied so securely to TV's purse strings or to realize

A 'critical and festival success': Ivan Svedov and Steffan Trevor in Endaf Emlyn's Welsh-language feature, *Gadeal Lenin* (*Leaving Lenin* [1993])

that there is, as yet, no solid, adequately-funded industry infrastructure in the region. This is a problem which runs even deeper, reflecting a disturbing imbalance of opportunities between English and Welsh-language filmmakers.

S4C and Film

The trouble is that most chances for indigenous filmmakers are supplied through S4C, the Welsh Fourth Channel, created to make programmes in the Welsh language and geared to a potential audience of scarcely more than 500,000 fluent native speakers or a paltry twenty per cent of the population. This reliance on S4C has serious implications for both English and Welsh language filmmakers. English language directors are starved of chances and funding, with few outlets for their work, and S4C, offering relatively small funding to its filmmakers, cannot sustain a regular supply of quality movies likely to obtain theatrical release and has met some marketing resistance in trying to gain cinema distribution for even its key features. It is also forced to bear an unreasonable burden of expectation in Wales – almost by default, as both HTV and the BBC in Wales are failing to provide the chances or the drama hours necessary to nurture talent.

S4C, for example, now spends £1.5 million a year on the dramas it earmarks for possible cinema release – out of a total drama budget, including series and serials, of a mere £11 million.[1] This compares unfavourably with the Channel Four annual budget of around £12 million for feature-length dramas alone. The Welsh allocation is scarcely enough to finance feature films, and individual movies intended for cinema release almost always require funding partners (often for back-to-back productions in Welsh and English, employing the same actors, with Channel Four). Yet even so, S4C's funding and commitment to Welsh film is infinitely more impressive than the financial backing or opportunities provided through the other channels in Wales. The BBC, for example, now has a drama budget of no more than £600,000 – crumbs from London's table – and it has cut back on training to prune costs. Budgets have shrunk as economies have been implemented across the board following well-publicized financial and accounting problems in London. Prospects for the immediate future seem bleak, despite the intriguing appointment of Karl Francis, Wales' leading filmmaker since the 1970's, as BBC Wales Head of Drama from january 1996. HTV, now virtually a satellite of its counterpart in Bristol, almost gave up producing drama between 1991 and 1994. It was shedding jobs even before its last successful franchise application, and has continued to cut the cloth since.

The problem with S4C is that its *raison d'être* sprang from the extraordinary circumstances of its formation in 1982 and the fast-to-the-death campaign by Plaid Cymru (Welsh nationalist) leader Gwynfor Evans which forced the Tories into a U-turn after the idea of a channel had initially been rejected. From its foundation, S4C's hierarchy has always seen its role as linguistic rather than artistic or cultural. Its prime audience, in the Welsh-speaking heartlands of north, mid- and west Wales, has a middle-aged profile, and is notoriously traditional in taste. This has often militated against innovative or unorthodox new work. Unlike Channel Four, S4C had no specific film brief when launched (and by mid-1995 had still to hammer out a worthwhile film policy document). Promotion of the language, and helping to ensure its survival, clearly took precedence over artistic or cultural aspirations. This led to a paucity of worthwhile work in the early years – flagship feature productions such as *Madam Wen* (1982) and *Owen Glendower* (1983) were woefully unambitious. Bearing in mind the heat generated by the debate over S4C and the ramifications of placing all Welsh-language programmes on the channel (a move that prompted fears of creating a Welsh ghetto) it seemed crass to centre a feature on a great Welsh hero Owen Glendower, yet conceive it as a children's drama.[2] Yorkshire-born, London-based, James Hill was brought in to direct, as S4C also betrayed a disturbing lack of confidence in proficient home-grown talent. *Madam Wen* went over its limited £335,000 budget by £200,000 – effectively sinking its producers (Bwrddd Ffilmiau Cymraeg, the Welsh Film Board).[3] The ballyhoo over these budget problems only highlighted S4C's unwillingness as a young channel to take risks and its inability to acknowledge that greater investment in drama might open theatrical doors.

'A break with the past and a new maturity in Welsh film': Iola Gregory mimics a song-and-dance routine in a closed cinema in Stephen Bayly's anti-Thatcherite comedy, *Coming Up Roses* (1987)

Too much early drama was conceived as small scale, with no designs on a larger market outside S4C and set in rural areas rather than urban South Wales, the scene of so much industrial turmoil and trauma in the 1980s. The dominant tone was idyllic/pastoral rather than a gritty realism attuned to the coalfield struggles and political climate of a Wales of high unemployment. Similarly too much documentary was cosy rather than combative, too often based on the 'great man' philosophy which concentrated on heroes rather than the broad sweep of politics and ordinary lives in Wales. But since 1986, this has changed gradually. There has been much more emphasis on the burning issues in Wales today and increasing evidence of directors with cinematic flair applying themselves to relevant contemporary and political themes and finding innovative forms to deal with them. In a remarkable few months in 1987, two contemporary Welsh-language films made by S4C for a mere £300,000 each, played in London's West End cinemas – Karl Francis' *Boy Soldier*, dealing explosively with a Welsh 'squaddie's' tribulations with the British Army in Northern Ireland and raising issues of language, culture, brutality and colonialism; and Stephen Bayly's anti-Thatcherite comedy, *Coming Up Roses*. Both films seemed to signal a break with the past, and a new maturity in Welsh film.

Welsh language directors, nonetheless, are increasingly worried that S4C, anxious not to erode its audience base, will settle increasingly for films which please its traditional strongholds. The channel cite the comparatively impressive 90,000 audience figure – low by BBC or HTV standards but the highest for an S4C drama in years – for the 1995 St David's Day film *Tom Nefyn*, made for a mere £450,000 by Cardiff's Scan Films. This was a mundane, unambitious film which privately disappointed its commissioners. A biopic about a cleric accused of heresy, it harked back to the past, like too many of the channel's previous productions, especially up to the mid-1980s. Yet the audience was much greater than for the £700,000 *Hedd Wyn*, which won the Royal Television Society Best Drama award in 1994 in recognition of its highly cinematic qualities, including an ambitious extended flashback and poetic stream-of-consciousness narration.

Deryk Williams, S4C's programme controller, argues that these ratings matter, especially with such a narrow audience spectrum.[4] The channel's former programme controller Euryn Ogwen Williams warns, however, that S4C is more obsessed with prime slots and ratings than ever before.[5] He fears the response to *Tom Nefyn* will encourage more of the same unambitious fare and that this could blight the prospects of a new, exciting generation of filmmakers. It could also damage the credibility of the channel which has established a growing reputation for quality, contempo-rary films in recent years and has begun to slough off its image within Wales of a station in a time-warp, obsessed with subjects that are 'bucolic and folkloric', to quote one of the channel's brightest directing talents, Stephen Bayly (speaking in the mid-1980s). S4C at that time produced the equivalent of Scotland's Tartanry and Kailyard (or cabbage patch) dramas, either harping on the exploits of Welsh heroes of history, or focussing far too intensely on parochial rural dramas of bygone days (such as the dramas by Wil Sam Jones, recreated, often lovingly, by Alun Ffred Jones from Caernarfon).

Another problem with S4C is that non-Welsh-speaking directors, mainly from the South Wales urban conurbations, are reluctant to compete for commissions in what they consider is an alien language (though some, like Stephen Bayly, have employed Welsh language 'dialogue' directors on their 'back to back' co-productions, using the same actors on the same sets). These filmmakers know that budgets solely for S4C programmes rarely extend to more than £600,000 – perhaps half the Channel Four equivalent.

Despite its past shortcomings – financial and creative – S4C remains easily the most visible channel in Wales providing outlets for talent, and its achievements, or lack of them, are inevitably seen as a barometer for the health of the indigenous industry. A mini-industry of independents, for example, financed through S4C, continues to develop mainly in Cardiff, Caernarfon and Bangor. In 1995 there were ninety company members

of TAC (Teledwyr Annibynnol Cymru, the Welsh independent producers association) including eighteen in Gwynedd, North Wales, alone. S4C's initatives have also helped Cardiff to become one of Europe's leading animation centres, twice hosting the 500-600 film International Animation Festival regarded as one of the world's première events. More significantly, S4C has built itself a niche in animation in world markets, with executive Chris Grace now spending an annual £1.5 million on a range of work, including the *Opera Vox* half-hour televised operas and the Shakespeare plays (well received in schools broadcasting slots if scarcely likely to find favour with critics). Some of these programmes have been made entirely in Russia – as S4C co-productions with the home industry – promoting accusations that the channel has been neglecting local animators. But, despite the cash-flow problems which squeezed out Welsh independent talents for a spell, S4C can still claim to have encouraged a string of impressive new animators since the 1980s. These include Joanna Quinn, whose *Girls' Night Out*, a good-natured feminist movie with a South Wales working-class heroine (and using valleys vernacular dialogue), gained three awards at the 1987 Annecy Film Festival, Clive Walley, an abstract specialist wooed by festivals the world over, the Czech- born collage and puppet artist Vera Neubauer and new talents such as Michael Mort and Gerald Conn. Between 1991 and 1993, S4C also financed the first all-Wales animation feature *Under Milk Wood* and the first Welsh co-produced animation feature (with Hungary), *The Princess and The Goblin*.

S4C may have become an oasis for filmmakers who would otherwise find it difficult to stay in creative employment but, with ninety companies serving the channel, many may find it hard to work regularly in future. Critics might also argue that regular commissions from S4C can stifle creativity, encouraging directors and companies to play safe and resist the gamble on anything more ambitious which might be developed into a cinema release. Few of the Welsh language subtitled films have found favour with English audiences anyway (though *Leaving Lenin* enjoyed a West End release, the reward for winning the London Film Festival audience prize). The problem has been compounded by Channel Four's reluctance to screen Welsh material – its attitude seems to be that S4C bears that responsibility. Karl Francis' *Boy Soldier* (1987) was only shown on Channel Four in the 1990s after the director threatened it with the Race Relations Board and *Hedd Wyn* wasn't screened until after its Oscar nomination. Outside Britain there have been successes – *One Full Moon* did extremely well in Australia and France, *Hedd Wyn* has enjoyed limited distribution in the US.

BBC Wales and HTV

Despite this resistance in England to Welsh-language films, alternatives for Welsh-based English language directors are stark. BBC Wales makes

no more than two network dramas per year – at £600,000 each. Another £150 - 200,000 goes on the *Wales Playhouse* series of half-hour dramas for new writers and directors and no more than a total £20,000 on *Shot in a Shoebox*, a slot for student shorts – both worthy ventures but not much help to proven filmmakers with a track record. The situation facing English language filmmakers in Wales is appalling, according to director Paul Turner: 'Wales is still treated as a colonial outpost by London' he claims.[6]

Former drama head Ruth Caleb admits that funding levels are deplorable, that Cardiff is seen as only a poor relation of London and there is a real reluctance to accept Welsh material on the network. The *Playhouse* dramas are at least a seeding bed for young talent. Other dramas financed from London, have provided outlets for promising directors like Marc Evans. *Thicker Than Water* (1993) allowed him to work with established stars like Welshman Jonathan Pryce and Theresa Russell. But the lack of English-language funding has inevitably meant that the well of writing and directing talent is drying up, although a new shorts scheme involving BBC Wales and the Wales Film Council offers some small hope.

The problems of non-Welsh-speaking directors are compounded by HTV. The channel, in the wake of its latest franchise award, has virtually settled for safe programming, although it did contribute £160,000 of the total £670,000 budget for Turner's *Dial* (1994) and co-funded the £1 million plus *Old Scores* (1991) with New Zealand. HTV's record since its 1968 launch is deplorable. It can boast only two or three significant one-off dramas and drama has been a prime target for costcutting over the years. HTV never had much clout on the ITV network and the Welsh side of the operation has taken a back seat to Bristol since early franchise promises of dramas starring their directors, Stanley Baker and Richard Burton, failed to bear fruit.

In the late-1980s, under drama head Alan Clayton, HTV Wales screened around eight hours of drama a year. This was an improvement on previously and followed IBA concern about the lack of Welsh drama on the network. Clayton was able to direct two vibrant television films of contemporary life, both made for around £3 - 400,000: *Ballroom* (1989), an earthy comedy set in the valleys, and *Better Days* (1988), centred on an ex-miner at odds with his middle-class offspring in Cardiff. HTV in those days was required to provide twelve hours of network drama at an average £600,000 an hour. Today, there are no network slot guarantees and HTV has only a small local drama budget. Small wonder drama reached its nadir. Apart from its involvement in *Dial*, the channel has been largely limited in the past three years to merely recording lunchtime stage dramas at Cardiff's Sherman Theatre – anathema to any creative filmmaker. In 1995 the channel committed itself to six half-hour dramas showcasing the world of new writers (effectively replacing the Sherman slots) plus one 90-minute co-production with S4C.

Conclusion

Despite the recent successes and new optimism, however, until the TV channels can be persuaded to invest more money in films, there seems little hope of developing a coherent film strategy or of producing movies in sufficient numbers to sustain the notion of a Welsh cinema. Nor will it be possible to gain theatrical release for those films which are made, or to develop any kind of alternative circuit prepared to commit itself to Welsh film. Apart from regional film theatres, there is a valleys cinema network in Wales using municipal venues and bringing working-men's institutes back to life for cinema screenings. But local authorities are generally unwilling to risk much indigenous material on audiences who are only just beginning to recover the cinemagoing habit after so many Welsh cinemas closed in the 1970s and 1980s. Confidence can only be increased if TV channels adopt much more aggressive marketing stances and set their stalls out, via separate film divisions to make cinema films. This would surely encourage more ambition, particularly on the part of filmmakers entrenched in their TV-only attitudes and content with safe television commissions. Even more vital is the need for channels to raise their sights. This might be done by investing in both Screen Wales and the Wales Film Council so that three or four feature-length movies, with good production values, could be made and marketed adequately each year.

Welsh programme and policy makers must be more bullish about their ability to compete in an international market. That would be easier if there was a healthy strand of English-language filmmaking in Wales. TV channels must have more faith in indigenous talent – a confidence which is markedly lacking to judge from procrastination in marketing and distributing strategies. S4C must also ensure that within Wales, films are given the chance to play in cinemas to boost potential audiences for small-screen viewing. Only then will audiences perceive the release of key Welsh films as an event and develop pride in a Welsh screen culture. The nation's directors can build on the shop windows offered since 1989 by the Welsh International Film Festival at Aberystwyth and BAFTA Cymru's own awards. Welsh filmmakers could develop their creative talent, and help to bring into being the eclectic cinema which bespeaks a healthy industry, producing the kind of genre films (for both TV and cinema) which invigorate any cultural tradition and signify the confidence necessary to boost interest and investment in the future.

References

1. Figures from Dafydd Huw Williams, S4C programme commissioner, 15 May, 1995 and Wales Film Council exhibition policy document 1995. The channel can, however, point to a growing expenditure on drama. Its eleven one-off dramas in 1994/5 included three intended for cinema release (requiring matching funding) and total drama hours climbed from fifty-one in 1992 to seventy-one in 1994. The cost per

hour rose from £142,614 in 1993 to £165,051 a year later. The total drama bill rose from £7,273,000 in 1992 to £10.2 million in 1993 and £11.7 million a year later (S4C figures supplied June 1995, based on annual reports).

2. Dave Berry, *Wales and Cinema: The First 100 Years* (Cardiff and London: University of Wales Press and BFI, 1995).

3. The film's director Pennant Roberts, interviewed by the author 13 June 1991 and producer Gwilyn Owen, interviewed 13 May 1991.

4. Deryk Williams, interviewed by the author, May 1995.

5. Euryn Ogwen Williams, interviewed by the author, May 1995.

6. Paul Turner, interviewed by the author, June 1995.

14

The BBC, Television Drama and Film in Northern Ireland

Robert Cooper

Television drama production by the BBC in Northern Ireland nearly collapsed a few years ago; the region had been neglected by the network, was too narrowly specialized in what it was allowed to do and too susceptible to changes of editorial direction beyond its control. The Drama department owed its existence to political and financial special pleading and, as a result, was left vulnerable.

Despite several notable critical successes, the department very nearly closed and would have done so had it not been for the arrival in 1991 of a new management in the region. Pat Loughrey (the then Head of Programmes) and Robin Walsh (then Controller, BBC NI) were prepared to listen, understand the problems and give financial support to an interim period of development which put the Drama department onto a secure footing – one based on the quality, range and cost of what we could offer to the networks, instead of special pleading, questionable financial relationships and unreliable and ephemeral political support.

My job, as Head of Drama, was to create an entirely different relationship with the networks from any that had existed before – a relationship where

BAFTA-nominated drama on film from BBC Northern Ireland: Richard Griffiths and Sam West in *A Breed of Heroes* (1994)

they would view BBC Northern Ireland as a natural supplier of a wide range of television drama and, in return, pay a realistic price for it. The task was two-fold: on the one hand, the BBC's metropolitan bias had to be challenged and, on the other, we had to show that we could deliver high-quality productions.

Three years on we have gone from producing one or two low-budget, single dramas a year (if we were lucky) to being an integral part of the BBC's drama output. The production slate over the last eighteen months has included popular series, single dramas and films and clearly demonstrates the change:

Life After Life. Set in post-ceasefire Belfast about life prisoners being released from gaol in Northern Ireland, Graham Reid's ninety-minute film enjoyed wide critical and audience acclaim when broadcast on BBC2 in 1995. Costing £950,000 it was fully financed by the BBC and shot entirely in Belfast.

A Man of No Importance. Starring Albert Finney, Barry Devlin's screenplay dealt with a Dublin bus conductor who tries to realize his dream of producing Oscar Wilde's play *Salome* with his passengers. A Little Bird production, it was released in the cinema in Ireland, UK and USA and benefited from Section 35 and Irish Film Board finance.

The Hanging Gale. This four-part historical serial set during the Great Famine was co-produced with the Dublin-based Little Bird company and was commissioned for BBC1's toughest slot – 9pm on Sunday night. It went 'head to head' with a new Linda La Plante series *The Governor* but defied the media pundits' predictions by beating it in the ratings. It did so on the basis of its intensity, quality and passion – increasingly rare attributes in the world of popular television drama. It cost nearly £4 million to make and, like *A Man of No Importance*, benefited from Section 35 and Irish Film Board investment.

Runway One. This light-hearted spy-thriller, set around Shannon airport during the Iran-Contra scandal of the early 1980s, was commissioned as a popular 2 x 90 minute drama for BBC1 and transmitted in 1995. It was produced with Burlington films in Dublin and shot in the Republic of Ireland and Southern California at a cost of over £3.5 million. It too benefited from Section 35 investment.

A Breed of Heroes. Written by Charles Wood, this ninety-minute film about a parachute regiment's tour of duty in Belfast in the early 1970s, was also made for BBC1 and received a BAFTA nomination for best film. It cost over £1.2 million and was fully financed by the BBC.

Ballykissangel. This six-part series about a young English priest posted to a small town in Wicklow was commissioned in 1994, also for BBC1. It was co-produced with World Productions of London and Ballyk Productions of Dublin at a cost of over £3.8 million, once again benefiting from Section 35 investment.

Loving. An adaptation of the Henry Green novel of the same name, this was filmed at Birr Castle and starred Georgina Cates and Mark Rylance. It cost over £1.2 million and also benefited from Section 35 finance.

The major change which allowed this rather extraordinary turnaround in the Drama department's fortunes came about two years ago when, under John Birt's philosophy of 'Extending Choice', we gained full access to the BBC's large drama development budget and to the network commissioning process. Birt also guaranteed that he would more than double the amount of drama produced from outside London – rising from fourteen per cent in 1994 to thirty-three per cent in 1997/98.

The catch, however, is that my department, like all other departments in the BBC, now has to pay its own way, unsubsidized by the region or the network. It does this by charging an 'overhead' (like a production fee) on the productions it gets commissioned. It is this (and this alone), that pays for the staff, the offices, the phones, the flights and so on that sustain a development operation costing around half a million pounds a year (excluding actual script development costs, which add another third of a million). To

achieve this my department needs to secure about £10 million of commissions from the networks each year. There are no quotas or favours; it is a highly competitive process where the channel Controllers select projects on the basis of quality and cost from a huge choice on offer from the London department, all the other regions and a dazzling array of successful independent producers. Ten million pounds represents a significant percentage of the total annual drama spend in the BBC. As that spend is mainly for popular drama it follows, therefore, that most of what we develop must be for that genre. This presents a peculiar problem for projects set in Northern Ireland.

Despite the ceasefires, the television audience considers Northern Ireland an unlikely setting for popular series drama, which may be one of the reasons why there are no series from Northern Ireland on ITV. So whilst we have been quite successful getting strong single dramas set in Northern Ireland commissioned (such as *Love Lies Bleeding* [1993] and *Life after Life*), popular series set in Northern Ireland are a harder sell. Consequently, in order to secure enough commissions to sustain the department, it is essential that we take an 'all Ireland' cultural view, taking advantage of the burgeoning talent in the south of Ireland and using the income derived on commissions from there to subsidize the development operation in Northern Ireland. Previously productions from the south of Ireland were made by the BBC Drama department in London, and the income benefited there, not Northern Ireland.

The recent creative blossoming which has taken place in the Republic as a result of the Irish government's far-sighted policy has been extraordinary. It has been achieved by an integrated financial approach to the problem i.e. a properly-funded Irish Film Board with £3 million per annum to invest in development and production, the government's active encouragement of and involvement in the industry through the Ministry of Arts, Culture and the Gaeltacht plus tax incentives for corporate and private investors to invest in the industry under Section 35 of the Finance Act. This policy has resulted in a huge increase in film and television production as well as enormous financial and cultural benefits to Ireland. However, while the policy has marginally depressed the film industry in England (which has lost two or three films to Ireland), Northern Ireland's film and television industry has suffered badly. Apart from the BBC, there has been virtually no film or TV drama production in Northern Ireland for the last three years.

The BBC Drama department in Northern Ireland is actively working to redress the imbalance of north/south production by nurturing writers and production companies in Northern Ireland, not only by commissioning the development of a large number of major projects both 'in house' and through local independent production companies, but also through production schemes such as *Northern Lights* (a co-operative venture with the Northern Ireland Film Council to produce three short films a year) and the

£225,000 *Double Exposure* initiative for emergent talent.[1] But, as can be seen from the production slate listed above, while we were able to raise £2.4 million extra finance in the Republic of Ireland, all production in Northern Ireland (except for *Northern Lights*) had to be fully funded by the BBC. We have many exciting, major projects we want to put into production in Northern Ireland, including popular series and feature films, but in today's competitive climate where quality drama costs a fortune and can rarely be fully financed by a single organization, it is going to become more and more necessary to raise additional investment. Northern Ireland needs to give its industry equality of opportunity, not just with the rest of Ireland where it is possible to raise over twenty per cent of the production finance of a film, but with 'national regions' such as Scotland, which has benefited hugely from a serious film production fund.

This is the reponsibility not only of government which has failed to show the kind of vision that has transformed the industry in the Republic but also the Arts Council of Northern Ireland whose support for film production (via the Northern Ireland Film Council) in 1994/5 was a mere £50,000 – about the cost of the catering on one, medium-sized feature film. We therefore need to increase the Arts Council of Northern Ireland's support for film (say to ten per cent of its budget to start with) and to ensure that the percentage of Lottery funds invested in film and television in Northern Ireland at least matches that in England, where it is expected that more than £70 million will go towards film production in the next few years.[2] The Government should also grasp the opportunity of seeding the industry in the same way as in the Republic of Ireland by putting £1.5 million per annum into a Northern Ireland Production Fund or an all-Ireland Film Board – thus matching the £1 per head of population invested by the Irish Government. These are the minimum measures required to help an industry which currently has huge potential but, in the absence of government and arts initiatives, fewer prospects than it should.

References

1. The first three film shorts to be made under the *Northern Lights* scheme were transmitted on BBC NI in July 1995. They were *Skin Tight*, *The Cake* and *Everybody's Gone*.

2. A promising beginning, in this regard, was the Arts Council's award of £200,000 towards a Northern Ireland film feature: *Old New Borrowed Blue*, written by John Forte.

<div style="text-align: right">

15

</div>

Film and Television in Ireland: Building a Partnership

Ed Guiney

Since 1993, things have changed very much for the better in the Irish film industry. A combination of factors, including the re-establishment of the Irish Film Board, the restructuring of Section 35 investment and amendments to broadcasting legislation (compelling RTE to spend larger amounts of its money on independent programming), have been the main driving forces behind this change. Other factors, such as the support of the various programmes of the EU's MEDIA initiative and Ireland's membership of Eurimages, have also had a strong and positive impact on the industry. Taken together, these developments have placed the Irish film industry and filmmakers in a better position than ever before. However, it is important not to get too carried away and to remember that things are still at a relatively early stage in terms of the development of a real Irish film industry. In terms of facilities, infrastructure and track record, the Irish film industry is still among the least developed industries in Europe.

In a sense the industry, as it now operates, can be characterized as involving two distinct types of activity. On the one hand, Ireland has seen huge

investment by large 'offshore' American and British productions attracted by a combination of Section 35 equity, good crews and a wide variety of locations. On the other hand, there is a burgeoning indigenous industry, fighting to make low-budget films using new Irish talent and providing real opportunities for Irish producers, directors, writers, actors and technicians. The offshore activity, because of its national and international profile, gives a slightly skewed impression of how healthy the Irish industry really is. It must be remembered that the international film industry is fickle. If, for instance, the UK were to introduce mechanisms similar to Section 35 or if the Irish pound/dollar exchange rate were to fluctuate to the extent that it became uneconomical to shoot offshore productions in Ireland, this could easily result in a sharp decrease in the level of production coming into the country.

In an ideal world, these two sectors of the industry should be symbiotic. Apart from their economic benefit, larger offshore productions should also provide high grade training opportunities for Irish people. Quite often it is the case, however, that these offshore productions bring in their own Heads of Department and lead cast. It is therefore generally left to indigenous projects to provide the real opportunities in terms of experience and career progression. It is also the case that these large productions can soak up crews and so make it difficult for native projects, operating at lower budgets, to compete for personnel. If we in Ireland are to develop a strong film industry for the future it must be one which we control ourselves. It is therefore imperative that we use the opportunities that currently exist to develop a strong indigenous industry and to establish a new generation of directors, writers and producers who will base themselves in Ireland and will be able to provide work for Irish actors and technicians when, and if, the offshore activity dries up.

However, because of the size of the market, the opportunities for new talent to gain experience are quite limited in Ireland. In the UK, there is an established trajectory through which new talent can emerge, particularily in the area of directing. This is provided by a busy pop-promo and commercials industry and by the large amount of television drama that is made there. In Ireland, however, virtually the only way a new director or producer can gain experience is by making short films and it is this sector of the industry which has perhaps been the most vibrant and interesting during the 1990s. Until very recently, home-produced television drama has been made almost entirely in-house by RTE, the public service broadcaster. As a result, it has failed to provide the opportunities for new directors and producers to cut their teeth on, especially after they have made a short film and before moving on to make a feature.

For these reasons, the talent which will drive the Irish industry in the future is most likely to come from the pool of short-film directors. In order to take advantage of the potential that exists and to build an industry in Ireland, it

Low-budget Irish filmmaking but eight different funders: Brendan Coyle in Paddy Breathnach's *Ailsa* (1994)

is necessary to help these filmmakers get into production on feature materi-al as quickly and efficiently as possible. The types of films I have in mind are extremely difficult to finance, yet they are the building blocks for the creation of a real industry and a genuine filmmaking culture. Their charac-teristics are: a first time director and producer, usually with some short filmmaking experience, working with an unknown cast and perhaps, on the surface at least, quite culturally specific subject matter. In any part of Europe, it is virtually impossible to attract commercial money to this type of filmmaking. In Ireland, the films of this scale that have been made over the last few years have been financed through an extremely cumbersome blending of support from national sources (the Irish Film Board, Section 35 investment and RTE) along with pre-sales to large public service broadcast-ers in Germany and France.

A case in point is *Ailsa*, a feature film which I produced in 1994 on a budget of IR£300,000 and which had eight different sources of finance: the Irish Film Board, the Irish Arts Council, RTE, Section 35, two of the MEDIA programmes, the European Script Fund and GRECO, and pre-sales to WDR in Germany and ARTE, the Franco/German cultural channel. Other examples are films like *The Bargain Shop* (1992), *High Boot Benny* (1993) and *Korea* (1995) which all obtained a key part of their financing from the German public service broadcaster ZDF. While I am certainly grateful for having had the opportunity to make *Ailsa*, it does strike me that this method of financing such a low-budget film is unduly complex. If we want the Irish

film industry to throw up five or six projects of this sort a year, which it needs to do, we must find another way of putting these films together. If nothing else, we cannot rely on the support and good will of continental broadcasters to finance these films indefinitely.

The situation is changing. In line with an increase in expenditure in the independent sector, RTE has also increased the opportunities for independent drama and feature film production. In 1995, RTE collaborated with the Film Board in financing a series of six half hour short films under the banner 'Short Cuts'. It also has ongoing plans to participate in the financing of feature films and has a separate budget for drama co-productions. But in its drama policy it is crucial that RTE gets firmly behind new filmmakers and allocates a reasonable proportion of its budget in doing so. If the Irish Film Board and RTE were to combine resources, as well as drawing on Section 35, it is easy to see how – for a minimal investment – this commitment to a pool of new films could be made real.

For the Film Board this is a relatively easy matter. The Board is charged with the development and production of new work from the indigenous industry and it has been active and supportive in this arena since 1993. In a sense its share of the money required to implement a scheme to produce a series of new films each year is already on the table. For RTE, the choices are slightly more complex. On the one hand, it has a duty to use its revenue (a combination of licence fee and advertising revenue) to produce and commission well-made home-produced product targeted at a large national audience and with a strong popular appeal. On the other hand, as the national public service broadcaster, it is also bound to take risks, to satisfy minority interests and to provide opportunities for new talents who will in the future go on to make challenging, reflective and entertaining work for both domestic and international audiences.

It is this latter duty that I would strongly invoke when proposing an investment, over three years, by RTE in the production of an annual series of five new films, costing around IR£500,000 each. If nothing else, for an investment of about IR£1million per annum, it would get around seven and a half hours of drama, made in a highly cost-effective manner. It would be providing a real opportunity for new filmmaking talent to emerge and, all going well, it would help to get some really great films made. If a scheme like this is to go ahead, it is of paramount importance that it happens in an atmosphere of mutual trust and with a willingness to take risks. This benefits both parties.

For instance, the conversations between filmmaker and RTE in advance of and during production will expose new filmmakers to the process of editorial negotiation and, by making them more aware of the audience and its particular needs, should improve the films made. Conversely RTE will have to take a view of the scheme which will lead to a relaxation of editorial

constraints with regard to the content and style of the films because some of these films may be on the edge of what is deemed to be acceptable. In the process RTE might also learn a thing or two about how far it can push the limits of the films it presents to the national audience. This is one of the most important things a public service broadcaster can do when operating in this area.

Good films, particularily when one is working with new talent, will only come through in an atmosphere of respect for the artistic integrity of the piece and for the vision inherent in the filmmaking process. An awareness of the prospective audience must be a part of the filmmaking process but it should not be at the expense of innovation or risk-taking. RTE certainly has a duty to its current audience. However, this must be balanced with a duty to help create a genuine film industry in Ireland which is capable of making films for the audiences of the future.

16

The Logic of Convergence

John Caughie

In the free preview magazine for the 1995 Drambuie Edinburgh Film Festival, there is a half-page Channel Four advertisement which announces

CHANNEL FOUR FILMS

AT THE FOREFRONT
OF BRITISH FILMMAKING

It then lists the films in whose success Channel Four 'is proud to have been involved':

The Crying Game (Oscar – Best screenplay; Six Oscar nominations; L.A. Critics – Best Foreign Film; National Board of Review Award; New York Film Critics – Best Original Screenplay; Chicago Critics – Best Film; Golden Globe – Nomination; BAFTA – Alexander Korda Award for Best Film; Writers Guild - Best Screenplay)

Howards End (BAFTA – Best Film, Best Actress; Oscars – Best Film, Best Actress, Best Art Direction, Best Adapted Screenplay & nine further nominations; London Evening Standard Film Awards - Best Film; Golden Globe - Best Actress)

Naked (Cannes – Best Direction, Best Actor; London Evening Standard Film Awards – Best Actor; IFP (New York) Spirit Awards Nomination – Best Foreign Film)

Backbeat (London Evening Standard Film Awards – Most Promising Newcomer; BAFTA – Anthony Asquith Award for Music; BAFTA Nominations – Alexander Korda Award for Outstanding British Film of the Year, Achievement in Film Music, Best Sound; London Film Critics Circle – Best British Newcomer)

Raining Stones (London Evening Standards Film Awards – Best Film, Best Screenplay; Cannes Film Festival Joint Winner – Jury Prize)

Three Colours Red, White and Blue (Krzysztof Kieslowski's trilogy of films has won individual awards including: Venice Film Festival, Joint Winner, Golden Lion – Best Actress; Critics Prize – Best Film, Best Photography; Berlin International Film Festival – Silver Bear Award; Oscar Nominations – Best Original Screenplay, Best Cinematography, Best Director; BAFTA, David Lean Award – Best Director; BAFTA Nominations – Best Original Screenplay, Best Performance by an Actress)

Four Weddings and a Funeral (Writers Guild of Great Britain – Best Film; British Comedy Awards – Best Comedy Film; Critics Prize – Best Film, Best Photography; Berlin International Film Festival – Silver Bear Award; Oscar Nominations – Best Original Screenplay, Best Cinematography, Best Director; BAFTA, David Lean Award – Best Director; BAFTA Nominations – Best Original Screenplay, Best Performance by an Actress)

Ladybird, Ladybird (International Critics Prize – Best Film; Berlin International Film Festival, Silver Bear – Best Actress; Scotland on Sunday – Critics Prize; Valladolid Film Festival – Best Actor; London Film Critics Circle Award – Best British Actress; Chicago Festival – Best Actress)

Shallow Grave (European First Film Festival – Best Film, Best Screenplay; BAFTA Alexander Korda Award – Outstanding British Film of the Year)

The Madness of King George (Oscar – Art Direction; Oscar Nominations – Best Actor, Best Supporting Actress, Best Adapted Screenplay, Best Art Direction [sic])

In a full page ad in the same magazine, the BBC lists fifteen new films to be shown at the Festival – including Ken Loach's *Land and Freedom*, screened as the opening gala – which trail fewer clouds of glory but nevertheless constitute 'an unprecedented number of films' from the BBC to be given festival screenings. The ad bears the logos of both BBC Television and BBC Films.

Clearly, something is going on here. At the most obvious level, the Channel Four ad trumpets again what we already knew: that most of the recent high

profile British films (and some European films) would probably not have been made had it not been for the support of British television – British film is alive and well and living in television. Only a little less obvious, the detail of the ad gives a shorthand guide to the criteria by which success in the British film industry is offered up to the public, and some indication of the skills for which its excellence is recognized. International awards weigh heavily in the scales of success, and Oscars (even Oscar nominations) tip the balance at the box office. Acting and writing – the marks of a theatrical and literate culture – come high in the skills which mark out the internationally perceived excellence of British cinema. Without the craft awards, however, there is little sense of the infrastructure which lies behind visible success and might ensure the continuity of a national cinema.

The reason I begin with these advertisements, however, and with British television's increased participation in national and international film festivals, is because both seem symptomatic of a British art cinema emerging in the 1980s and 1990s: an art cinema, balanced precariously between a European sensibility and the North American market, which is economically dependent on television.

The roots of this peculiarly British cultural hybrid reach back into the parallel histories of British cinema and broadcasting. They can be found in the 1920s and 1930s in the formative rhyming couplet of Grierson and Reith, and in their quite separate but simultaneous advocacy of a national

cinema and a national broadcasting founded on the principles of social purpose and moral responsibility. They can be traced in the critical unease around Hollywood entertainment values – Balcon's 'realism and tinsel' and the advocacy from C.A. Lejeune and Dilys Powell of a British 'quality' cinema – and in the BBC's centrality to the postwar cultural reconstruction – Director-General William Haley's support of the BBC's 'cultural mission'. The same terms of quality and responsibility reverberate in the discourses, suspicious at the same time of both flashiness and artiness: a cinema and a broadcasting which has the prestige of art but none of its difficulty or formal excess. The mix becomes particularly intricate in the late 1950s and 1960s, an earlier Golden Age for both British art cinema and for an emergent art television. The New Wave which appears briefly between 1959 and 1963 in the cinema of Anderson, Reisz and Richardson cannot be sustained in an economically fragile British cinema, but its impetus is picked up in television and flowers in the drama of Potter, Mercer, Owen, Loach/Garnett, protected by the injunction of the 1962 Pilkington Committee report that it is television's moral responsibility to shun triviality and risk challenge and controversy.

The complicated relationship between British cinema and British television as cognate components of a national culture has a history, then, and is not an invention of the Annan Committee, Channel Four or the 1990 Broadcasting Act. It seems clear, however, that since 1982 and the inception of Channel Four, it has entered a new phase of interdependency. It is no longer simply a case of a consistency of discourse producing a common culture between cinema and broadcasting; it is rather a case of a new economic arrangement producing relations of material dependency. Nor is the dependency one-way: the conventional image of a perpetually ailing film industry being given a leg up by a tough, muscular television industry. The economics of broadcasting which developed through the 1980s have produced a television industry which cannot operate at the most day-to-day level without a critical mass of independent filmmakers on which it may draw for its 'product', and which cannot flourish on the international market without a film industry to support it and to give it its cultural prestige. The cultural homology which has characterized British cinema and broadcasting since the 1920s has become in the 1980s and 1990s a structural, infrastructrural and economic interdependency.

What I want to do here is to offer some brief observations which arise from that interdependency: observations which may reflect some of the nagging cultural anxieties of a slightly detached, non-practitioner perspective.

To begin with the positive: it is important to stress the enormous difference which Channel Four made to the way in which British television functioned. For my generation, it seems almost as difficult to remember what television was like before Channel Four as it is to remember what television was like before recording, and for a generation which has grown up with Channel

Four as part of the natural order of things it seems important to point out that it was not always thus. From a perhaps nostalgic perspective, the 'moment' of Channel Four – early to mid-1980s – seems like a structural shift in film and television culture, and in the culture at large, of immense significance. In a way, it may turn out to have been the last structural shift in broadcasting conceived as a central component of a national culture or of the British public sphere. Subsequent shifts towards the proliferation of channels expand the private sphere of leisure choice but somehow at the expense of the public sphere: the public sphere becomes virtual. The Peacock Committee's advocacy of 'consumer sovereignty' in the 'full broadcasting market' appeals to a pragmatic sensibility in a way which makes the Pilkington Committee's insistence on social responsibility seem very old-fashioned, but it does so by addressing the individual as private consumer rather than as public citizen. Channel Four, whatever the charges of cultural elitism, seemed motivated by a desire to extend and expand what could be conceived in Britain in the 1980s as the citizenry. Whatever the dilutions which government made to the original proposals of the Annan Committee, the concept of a more open broadcasting arrangement (to be intitutionalized in an Open Broadcasting Authority) was retained at least as a principle, and was translated in practice into a diversification of access and dissemination. For producers and aspiring producers, the diversity may have had limits – it was easier to stay in than to get in – but it was nevertheless unprecedented in British audiovisual media. And for the public, there was an access to forms of filmmaking previously restricted to colleges, film schools and universities and to a few independent film exhibitors in London.

So what is the anxiety? At its simplest, it is a doubt that the full cultural remit of a national broadcasting system can be sustained within the economic logic of an international market in images and representations. More abstractly, it is a suspicion that the prestige of an art cinema and a quality television may submerge the local specificities and diversities and small recognitions of a complexly national television. Most concretely, it is a sense that a very fundamental shift in national representations has occurred between Ken Loach's *Cathy Come Home* (1966) and *Ladybird, Ladybird* (1994), and that the gain of a British art cinema may be at the expense of something quite valuable in a national television system. This is not a nostalgia for a lost Golden Age, and it is certainly not a criticism of Ken Loach's recent work. It is rather a sense that, whatever the intentions, the social anger of *Ladybird, Ladybird* circulates within an aesthetic and a cultural sphere which is given prestige (and an economic viability) by international critics' awards, whereas *Cathy Come Home* circulated as a national event and functioned as documentary evidence within the political sphere.

There are a number of logics at work here. There is a technological logic which transforms television from live transmission to recorded tape or film: a transformation which gave television drama a commodity form which encouraged it to operate with increasing success as a tradable good on the

Circulating as a 'national event': Ken Loach's *Cathy Come Home* (1966)

international market. There is another technological logic which dissipates television drama's capacity to function as a single national event, shifting it in time through tape recording or regionalizing it in space and time through cinema exhibition. These technological logics begin to erode an earlier specificity of television as a cultural form and break down the apparently essential differences which had separated it from cinema. Associated with this set of logics is an aesthetic logic which is extremely difficult to pin down, but which reflects shifts in the criteria by which television achieves prestige and earns its right to take itself seriously as an autonomous art form. However one accounts for it, there seems to me to be a directness and immediacy at the moment of transmission in *Cathy Come Home* which produced both its excitement and its provocation, and it is this directness which is hard to sustain within the conditions of an art cinema – or indeed of a television drama which has been filtered through art cinema. Other criteria come into play, no less valid within their own terms but bringing with them the distance of aesthetic judgement which qualifies the immediacy of political outrage.

There are also, of course, economic logics. Film is expensive; the domestic audience is small; the international market beckons as a way of spreading or recouping costs. It is hard to see how this logic can do anything other than make it more and more difficult to produce expensive, prestige dramas or films which have no possibility of appealing to the widest possible national and international audience. But even in the economic logic, there is an

important aesthetic issue at stake which it is important to make clear since generalized paranoia about globalization often misses it. It is not that the global market has no place for nationally specific representations: the international success of films like *The Snapper, Gregory's Girl, My Beautiful Laundrette* or *Ladybird, Ladybird* demonstrates that there will always be an audience for precise observation, however localized it may be. The point, I think, is that what the international market values in national specificities are precisely those qualities which transcend the local and make it universal: humanity, character, and, in particular, character in adversity. What is more difficult to sell on the international market are the material social conditions which produce the adversity. Characters coping with their social situations are universal and therefore marketable, but the political conditions which produce the situations can be very, very local and, hence, more difficult to sell. This is not meant as an appeal for a return to an exclusive diet of social responsibility and socialist realism, but simply to suggest the limits of the international market for a national television. There is a very genuine excitement about the development of a British art cinema and it should be celebrated, but it seems worth reminding ourselves of the gaps which begin to appear in its wake in representations of the local and the national. It is never that anything is impossible – market conditions make everything contingent (Ken Loach or Stephen Frears carry reputations which are themselves marketable) – but some things gradually become less possible than others.

This points finally to a general unease about the logic of convergence. While the convergence of film and television may have gained us the beginnings of an internationally prestigious British art cinema it may also have restricted some of the possibilities of a national television drama which gave television a particular edge within the British public sphere. And not only between film and television, but even within the independent film sector there are forces of convergence which may in time lose us some of the diversity which was introduced into film and television in the early 1980s by Channel Four. In the 1970s, the Independent Filmmakers' Association (IFA) argued for a cinema which was oppositional and autonomous from the mainstream - radically different rather than merely pluralistic. By the beginning of the 1980s, arguments were beginning to be made against casualization and for the development of a more secure, professionalized infrastructure, and these arguments fed into the development of the Workshop Movement. The Workshop Movement could only have existed through the support of Channel Four, the BFI and the ACTT; but there was always something conditional in that support : for Channel Four, the Workshops satisfied the remit which demanded diversity, and for the Union it expanded employment both geographically and economically, introducing new entry points and new training facilities at a time when the large institutions were being forced to 'down-size'. The Workshop sector was still different, but it was now institutionalized within the industry rather than apart from it or in opposition to it. Caught within an inescapable economic logic, when

A national art cinema television?: Derek Jarman's *Caravaggio* (1986)

Channel Four (caught within its own economic logic) withdrew revenue funding, the Workshops became so many small businesses, dependent for their commissions, like all the other small businesses in the independent sector, on the increasingly product-hungry broadcasters. There is no malice or oppression in this logic; no voracious capitalists gobbling up the last remaining vestiges of integrity; no 'big broadcasters' stamping out the economic untidiness of low-budget production. Increasingly, the 'big broadcasters' recognize the need for a diversity of entry points to the industry and the urgency of replacing the training facilities which they themselves have lost. Again, interdependency is the name of the game. BBC Scotland, for example, in collaboration with the Scottish Film Production Fund and the Glasgow Development Agency, has been creative in developing series strands like *Tartan Shorts* and *First Reels* as a way of introducing entry points for young and/or first-time filmmakers. It seems ungracious to do anything but celebrate this, and, within the prevailing logic, it is indeed to be celebrated. But the logic of this convergence of interests and dependencies, like the logic of convergence of film and television, is pragmatic rather than principled. It assumes a unified industry, the logic of a unified industry is a unified culture, and the principle which is at stake is diversity and difference. Without contesting the creativity of pragmatic solutions

to very real problems, particularly when the solutions have the aim of drawing in new talent, it is at least worth placing a question mark: where does the logic lead?

The 1980s produced a diversity in British cinema and television, the public profile of which can be captured in the names of Derek Jarman, Sally Potter, Peter Greenaway, Hanif Kureishi, Terence Davies, Isaac Julien, Black Audio Film Collective, Gurinder Chadha, but whose roots went down into the infrastructure of Channel Four, the Unions, IPPA, PACT and the Workshop Movement. That diversity was embodied as a principle in the establishment of Channel Four: a principle which was enshrined in an Act of Parliament as the culmination of arguments which circulated in the Annan Committee Report and debates which were being conducted in the independent film sector in both its mainstream and its oppositional manifestations. It is difficult to see where, in the convergence of tributaries and mainstreams and in the economics of film and television, such principles – particularly the pragmatically uncomfortable ones –- are to be defended. The principle seems to me to circulate around what it is we want to celebrate in the notion of a national cinema or a national television. Is it a national cinema or television as *representation* of the nation, capturing the images around which the complexity of the nation can identify itself as a unity, representing itself to the outside and securing its continuity on the global market? Or is it a national cinema or television as *representative* of the nation, offering channels for different voices, capturing its diversity and reflecting the fault lines which disunite the culture into differences and complexities rather than imposing on it the imaginary and marketable identity often implicit in the desire for a unified National Culture or a national cinema. If the terms of the opposition are rather obviously loaded, it is not because I seriously believe that one can exist without the other, but rather because I think that there is a danger that the celebration of a national art cinema – a cinema alive and well in television – may obscure what is local, awkward and complex within the nation, and that the logic of convergence may lose sight of the specific and divergent possibilities of a national cinema and a national television .

17

'Enmeshed in British Society but with a Yen for American Movies': Film, Television and Stephen Frears

John Hill

It is a common feature of profiles of Stephen Frears to observe his relative anonymity prior to the success of *My Beautiful Laundrette* in 1985. Yet, this is despite the fact that he directed his first film, the thirty-minute *The Burning* in 1967, made his first film feature *Gumshoe* in 1971 and directed some further twenty 'films' prior to his apparent 'breakthrough' in 1985. Of course, with the exception of *The Hit* (1984), these 'films' were made as television dramas and therefore were not generally regarded as constituting a part of British cinema. Ironically, however, *My Beautiful Laundrette* was in conception no less a television film. It was shot for Channel Four on 16mm on a budget of £650,000 and was not originally intended for theatrical release. It was only following a successful festival screening at the Edinburgh Film Festival that it was decided to show the film more widely with the result that it then went on to become one of the Channel's biggest critical and commercial successes.

The very first 'Film on Four' transmitted: Ian McKellen in *Walter* (1982)

My Beautiful Laundrette is, in fact, only one example of the way in which Stephen Frears' career has cut across film and television and confused the boundaries between them. His television work in the 1970s was often regarded as the perfect example of the argument that 'British cinema was alive and well and living in television'. Thus, for Bob Baker, writing in 1979, Frears was clearly one of Britain's best film directors and *Cold Harbour*, made for Thames TV, the best British film of 1978.[1] *Bloody Kids*, which Frears made for television in 1980, was one of the first British television films to receive a theatrical release after its television transmission while *Walter* (1982) had the distinction of being the first *Film on Four* to be transmitted – on the very day of the Channel's launch. The films which assured Frears' reputation in the 1980s – *My Beautiful Laundrette, Prick Up Your Ears* (1987) and *Sammy and Rosie Get Laid* (1988) – were also 'Films on Four' and, although Frears then began to make films for Hollywood, he also returned to his television roots by directing *The Snapper* in 1993. This last film also demonstrated the apparently fluid relationship between film and television evident in Frears' work. It was made immediately after the most expensive and most 'commercial' film of his career up to that point, *Accidental Hero* (US: *Hero*)(1992) starring Dustin Hoffman and Geena Davis. *The Snapper*, by contrast, was low budget, involved largely 'unknown' actors and was funded by and intended specifically for television (in this

case the BBC). As with *My Beautiful Laundrette*, a favourable festival screening led to a theatrical release even though, as with *Bloody Kids*, the film had already been shown on television. The film went on to do good business and, in doing so, put into question some of the standard oppositions between film and television. It was a self-consciously small, television film which nonetheless succeeded with audiences on the big screen, an apparently uncommercial 'local' drama which nonetheless, relative to cost, performed somewhat better than a big budget, 'international' film such as *Accidental Hero*.

Stephen Frears' career therefore throws up a number of questions about working in television and film and the relations between them, questions which have to do with filming methods and cinematic traditions, creative and political freedom, relationships with audiences and cultural address. Frears himself is sceptical of any fundamental difference between making films for television and making them for the cinema. 'I don't know that I acknowledge a great difference any more', he said in 1991, 'except in so far as certain material is more appropriate for television because it is not economically viable for the cinema'.[2] At the level of techniques, he has often sought to defy the normal expectations of what might be regarded as 'televisual' and what might be regarded as 'cinematic'. Thus, in the case of *Bloody Kids*, made for television, he was influenced by Martin Scorsese's *New York, New York* (1976) and sought to add intensity to the film's story of urban dislocation through a 'cinematic' use of camera movement. In the case of *Dangerous Liaisons* (1988), his first film for Hollywood, he moved in the opposite direction, abandoning 'long complicated developing shots' in favour of 'shooting close-ups', in a style more commonly associated with television.[3] Moreover, given his reluctance to distinguish between television and film, it is characteristic that Frears should have found television, especially in the 1970s, to be a more hospitable home for good filmmaking than the film industry itself. 'The first thing I was offered after *Gumshoe*', he reports, 'was the film of *Steptoe*. And at the same time, Alan Bennett asked me if I would do *A Day Out* (1972) at the BBC. Faced with a choice like that, what can one do? I just think it's ridiculous accepting poor films when you can make good films on television'.[4] As a result, he 'stumbled into a world where they needed films' and where he was 'embraced very generously and enthusiastically'.[5] However, this world and the 'enchanted conditions' which it provided did, as Frears recognized, depend upon television's relative insulation from commercial forces. 'In television in Britain', he explained, 'you don't have to do anything except good work... one has a responsibility to the material and to the world, but you don't have to make money on it. So, for a long time I made films for people who only wanted them to be as good as possible'.[6] Working for television also had other advantages.

As has often been noted, Frears rarely initiates projects and has tended to be reliant on projects which have been brought to him. Frears has therefore

A model of small cinema?: *The Snapper.*

been inclined to draw comparisons between his relationship to television and the relationship of contract directors to the old Hollywood studios. 'By going to television', he has explained, 'I chose the path to continuity and stability and regularity. I didn't actually come under contract to anybody, but I did go on and on working'.[7] As a result, he credits television with providing him with not only continuity of employment but also a regular source of material (from writers such as Alan Bennett and Peter Prince) and the opportunity 'to work regularly with the same cameramen and the same actors'.[8] For him this has meant that filmmaking has primarily been a collaborative activity and he has been reluctant to identify himself as the primary creative source behind a film. 'People come and ask me questions as if I were an *auteur*', he has said, 'but I'm not – I'm just the bloke who gets hired'.[9] Thus, while critics have repeatedly sought to single out the recurring elements of Frears' work (such as an identification with outsiders or the crossing of social and cultural divides), it is often the concerns of the writer (Bennett or Kureishi, for example) which are as equally apparent.

Frears has also identified other ways in which television has proved congenial. It allowed him, he claims, a degree of creative freedom which he would not have enjoyed in the film industry. 'I'm not embattled with the TV

companies about material', he explained in 1978, and 'nobody has ever tried to get me to cut a scene'.[10] The public service remit of television has also allowed, and even encouraged, the exploration of contemporary British realities. For Frears, it is part of the unique tradition of British television that it 'embraces the concept of social criticism, not at a particularly ferocious level, but simply by giving an accurate account of what it's like to live in Britain'.[11] As a result, he claims that television has often possessed 'more vigour' and been 'more interesting and more expressive.... of people's lives than the cinema'.[12] In this respect, he is keen to emphasize that a film like *My Beautiful Laundrette* was not a bolt out of the blue but emerged from a British television tradition. 'It's not so shocking to make a film that is accurate about Britain', he told one American journalist. 'Television has established that as the norm'.[13] It is, however, a tradition which is inevitably different from that of Hollywood. 'The Americans have an industry, and it's so much easier to make movies there' he has said. However, it then comes down 'to what you want to make films about. If you want to make films about life in Britain, then the Americans aren't very sympathetic to it'.[14]

British television's tradition of social observation has also been characteristically linked to a dominant aesthetic of social realism. This too has provided a set of conventions which Frears has both adopted and deviated from. He initially worked as an assistant to the 'new wave' directors Karel Reisz and Lindsay Anderson and worked for the BBC at a time when the influence of Ken Loach was still pervasive. 'When I started getting jobs in television, the great influence – like a giant, really – was Ken Loach. He and Tony Garnett somehow laid down the rules along which the game was going to be played, and they did it on a very high level of intelligence. And it spilled off into other people'.[15] However, Frears never fully inhabited this tradition and his films have often sought to combine a certain commitment to realism with a stylization more characteristic of Hollywood. He grew up watching Hollywood movies and has always been drawn to their power. 'American films have a feel for cinema', he has said. 'They entertain you in a way that other films don't'.[16] As a result, he suggests, he is 'a rather odd combination of somebody enmeshed in British society but with a sort of yen for American movies'.[17]

This is also a good way of describing many of the films that he has made. In the case of his first feature, *Gumshoe*, for example, he felt unable to make a straight British thriller which would be convincing and the result was a pastiche of the Hollywood private eye movie which was, as he put it, 'half...dream...and...half...realistic'.[18] This also seems true of the very different *My Beautiful Laundrette*. Although often identified as a seminal 'state-of-the-nation' film of the 1980s, it only partly depends upon the conventions of social realism. Indeed, Frears himself has suggested that, in it, 'realistic material gets treated in a rather odd way'.[19] Such oddness derives from the way in which the 'real' social issues of the film (the new entrepre-

neurial culture of Mrs Thatcher, race, and homosexuality) are filtered through a style of heightened *mise en scène* and cinematic quotation, including, for example, what Frears refers to as his homages to Nicholas Ray and Vincente Minnelli.[20] In the same way, the film cuts across and mixes different generic codes with the result that the film is not simply a 'social problem' film but also a romance, a comedy and a thriller (originally envisaged as a kind of Asian *Godfather*). In some respects, then, it is this 'halfway house' status (part television/part cinema, part British/part Hollywood) which has distinguished many of Frears' films and, perhaps, points to one of the reasons why the films which Frears has actually made for Hollywood have not proved quite so distinctive.

Frears' move into Hollywood filmmaking, therefore, raises some interesting questions. For Frears, making Hollywood films has been a 'completely different' experience from working in Britain: 'They give you access to things that you never dreamed you would have and they put pressure on you that you never thought was possible and sometimes it's exhilarating and sometimes it's frightening. It's a proper industry....They are very good at it and they make films that entertain audiences all over the world and that's quite humbling'.[21] He sees his move into Hollywood filmmaking as a way of reaching more people, but through a combination of European intelligence and popular American entertainment. A film of his, he suggests, may 'spin off into fantasies and B movies ... but it has to have some sort of emotional truth and some reality to it'.[22] He has also made a point of not moving to Hollywood and sees himself wrestling with the 'problem' of 'how to be English and make films for a large audience'.[23] He distinguishes himself, in this respect, from a director like Alan Parker whom he suggests has abandoned his 'Englishness' and remains unable to reconcile his desire to make '"international" films' with 'his belief in Ken Loach'.[24] Interestingly, he suggests, that Alan Parker's 'best film' is, in fact, his last film to be set in England, the television film, *The Evacuees*, made for the BBC in 1975.[25]

This is, however, an argument with a bearing on Frears' own career. Frears has argued that a part of his appeal to the Hollywood studios was his experience of shooting quickly and without unnecessary expense. He regards *Dangerous Liaisons* as comparatively low budget for a Hollywood costume drama and was conscious that he 'didn't want to be caught making a film for a lot of money where the possibility of earning the money back would be less than good'.[26] This strategy proved effective in the case of *Dangerous Liaisons* and *The Grifters* but partly came unstuck with the less than successful *Accidental Hero*. In these circumstances, the more modestly-budgeted world of television offered an attractive retreat. 'You discover what the international market is like and it's very rough', Frears has explained. 'So you try to protect yourself and in that situation the BBC offered circumstances in which I was less likely to lose my arms'.[27] The resulting film, *The Snapper*, moreover became a success despite 'clearly looking inwards' and paying 'no respect to mid-Atlanticism'.[28]

For David Thomson, the contrast between the two films is striking: *The Snapper* ('small, quick, cheap, funny, raucous, and overflowing with life') 'might have been made', he suggests, 'in the space (and on the budget) of one Dustin Hoffman tantrum'. This leads him on to the more general conclusion that Stephen Frears' work for television is actually superior to his work for Hollywood. Television films, such as *A Day Out*, *Sunset Across the Bay* (1975), *One Fine Day* (1979), and *Walter*, he argues, will increasingly come to 'look like models of "small" cinema – rich, honest and touching' whereas the Hollywood films, such as *The Grifters* and *Dangerous Liaisons*, are likely to be seen as little more than 'empty entertainment'.[29] It is, of course, possible to quibble with Thomson's judgements of individual films – *The Grifters*, for example, is certainly a more arresting piece of genre cinema than he allows. Nonetheless, his defence of 'small cinema' is a valuable one and a good indicator of the important role which television has played in supporting British film production. Frears himself has argued that 'there is no British cinema ... it is gone'. 'What happened', he goes on, 'is that we've been hiding behind television money. Using it to make films'.[30] However, what his own work has shown is how television has, nonetheless, permitted the emergence of a different kind of British cinema – precisely a 'small' cinema, rooted in local realities, and devoted to the kinds of experiences which Hollywood characteristically ignores.

References

1. 'Stephen Frears', *Film Dope*, no.17, April 1979, p.44.
2. Quoted in Jonathan Hacker and David Price, *Take 10 Contemporary Film Directors* (Oxford: Clarendon Press, 1991), p. 168.
3. Quoted in *The Sunday Tribune*, 10 March 1991, p.27.
4. Quoted in *Screen International*, 1 November 1975, p.18. He also goes on, 'The BBC certainly wasn't set up to be the most important producer of films in this country... But there isn't one film made for cinema distribution, which compares in importance with *Days of Hope* (Ken Loach,1975). Not on... It's *Days of Hope* or *Tommy*'.
5. Interview at the University of Ulster, 28 April, 1994.
6. Quoted in *Interview*, April 1987, p.92.
7. Quoted in Wheeler Winston Dixon (ed.), *Re-Viewing British Cinema 1900-1992* (New York: State University of New York,1994), p.235.
8. Quoted in David Badder, 'Frears and Company', *Sight and Sound*, Spring 1978, p.73.
9. Quoted in Zoë Heller, 'A Bloke's Life', *The Independent on Sunday Magazine*, 25 April 1993, p.9.
10. Quoted in 'Frears and Company', p.73.
11. Quoted in *Re-Viewing British Cinema*, p.224.
12. Interview at the University of Ulster.
13. Quoted in Mark Hunter, 'Marquise de Merteuil and Comte de Valmont Get Laid', *American Film*, December 1988, p.30.
14. Quoted in *Re-Viewing British Cinema*, p.234.
15. Quoted in *Stills*, November 1985, p.13.

16. *The Sunday Tribune*, p.27.
17. Interview at the University of Ulster.
18. Quoted in 'Frears and company', p. 72.
19. Quoted in *Stills*, p.13.
20. ibid.
21. Interview at the University of Ulster.
22. ibid.
23. 'A Bloke's Life', p.10.
24. *Take 10*, p.177.
25. Interview at the University of Ulster.
26. *Re-viewing British Cinema*, p.232.
27. Interview at the University of Ulster.
28. ibid.
29. *A Biographical Dictionary of Film* (London: Andre Deutsch, 1994), p.265.
30. *Re-Viewing British Cinema*, p.225.

18

Working in
Television and Film:
Verity Lambert

Sarah Edge

The study of film and television, from a feminist perspective, has been approached in a number of different ways. Some feminists have been concerned with images, asking questions about how women are represented in the cinema and on television. Others have looked at film and television from an equal-opportunities position, revealing the limited status and discriminatory position which women occupy within the film and television industries. It is of course possible, as is suggested by feminist critiques such as *The Female Gaze: Women as Viewers of Popular Culture*, to see a relationship between the two.[1] The preponderance of male producers, commissioners, scriptwriters, directors and cameramen in both film and television has worked, in many ways, to promote and naturalize a male perception of the world. In the 'postfeminist' 1990s, some women have gained entry into this predominantly male domain but they are, unfortunately, still the exception to the rule. However, this female presence, limited though it is, should not be underestimated. On the one hand, it challenges and reveals discriminatory employment practices, and on the other, it offers up accessible role models for other women. Moreover, women in positions of power in the media industries can

also work to challenge the traditional male point of view of the world offered up by the majority of productions on our television screens and in our cinemas.

Verity Lambert's career as an independent film and television producer may be profitably looked at in these terms. She began her media career, in one of the only areas of employment in the media dominated by women, as a secretary at Granada Television. However, at 27, she became one of the BBC's youngest producers when she began to work on the television series *Dr Who* (1963). From this point on, her career in both film and television has been both impressive and inspiring. She has worked on producing and commissioning productions for both the BBC and ITV, and in 1974 occupied the twin positions of Head of Drama at Thames Television and Chief Executive of its film production arm, Euston Films. In 1982 she was appointed Head of Production at Thorn EMI and was named Business Woman of the year. In 1985 she set up her own production company Cinema Verity which has become one of the most successful independent companies producing popular drama and comedy series for UK television, including *GBH* (1991), *Class Act* (1994), *She's Out* (1995) and the now notorious soap *Eldorado* (1992).

Verity Lambert's career, which straddles both film and television, reveals considerable achievements as a woman within both industries. In her position as an influential and respected female commissioner and producer she has worked both to support women in their media careers and also to challenge the mass media's often sexist representations of women. Furthermore, her very popular drama series *Minder* (1979) took a comical and satirical look at male bonding and friendship. Lambert's support of female writers led to such important productions as Lynda La Plante's challenging and popular ITV drama series *Widows* (1983). She supported La Plante's original ending, which had previously been rejected by other male commissioners, in which the women get away with the crime. Lambert also commissioned Philip Mackie's drama, *The Naked Civil Servant*, which had been rejected by every single television company because of its homosexual content. Her interest in positive representations of women is also reflected in her involvement in film production. This is particularly true of the film she produced in 1988, *A Cry in the Dark*. This was a personal project dealing with a subject in which Lambert had been interested since 1986 and which, in the face of dominant media coverage, gave a sympathetic and critical portrayal of the events surrounding the so-called 'Dingo Baby Trial' in Central Australia.

Lambert's career also raises other general issues of relevance to a consideration of the relations between film and television. By working at the more popular end of the television drama spectrum, especially on programmes with a particular appeal to women, she has been able to explore subjects in a way which would not have been possible in the cinema. The series

and serial formats of television, in this respect, are regarded by her as an advantage over film, not a restriction. However, precisely because this work has been within these formats, Lambert has not always received the critical recognition which attaches to more 'prestigious' single drama and film work. Lambert has, of course, worked in film as well. However, her experience as director of production at Thorn EMI highlights some of the problems faced by British cinema in the 1980s and goes some way to explaining why television became so important in sustaining British film-making. These are all the issues which Verity Lambert addressed in the following interview.[2]

Q. *Could you tell us how you see the difference between being a producer as opposed to being a director?*

VL. The producer definitely has the worse time because s/he always gets the blame for everything; the director only gets the blame for some things. In television it's quite different to film, particularly in series television. The producer is the person who is a constant. It may be an idea of your own or it may be an idea that you have developed with a writer, but, as producer, you get more of an overall view. This is particularly so on a series because you will probably choose the writer or writers, the directors and you will certainly have a hand in the casting of the main parts. On a series, as opposed to a serial, you may use more than one director, so you are responsible creatively for seeing that there is a continuity of style and for keeping the standards up. I think it differs on a film because a lot of American producers haven't come from the creative area - they come from being lawyers or agents. As a result, the producer is not considered the most important person on an American film and the director is the person who would be deferred to by the studio - that's the hierarchy. It isn't quite the same here because if you have a good working relationship with the directors you can have more of a collaboration.

Q. *You have been credited with giving a lot of women their first opportunity, writers like Lynda La Plante with Widows, for example. Would you like to say something about that?*

VL. I was running Euston Films at the time and I had as my script executive a woman called Linda Agran. She and I felt that (our programmes) were too male-oriented. I wanted to find a series with women as the main protagonists, so I rang round a few agents and came across *Widows*. Lynda La Plante had started life as a very good actress called Lynda Marchall. She had written some things but hadn't had anything made or performed. *Widows* was a treatment which was absolutely wonderful. In *Widows* these female characters planned this absolutely

Women getting away with it: *Widows* (1983)

brilliant crime; it was about these women who had to train themselves to do something. They came from a criminal area, which is a very male-oriented part of society. In *Widows* the women find their own sort of self-esteem by believing that they could pull off this crime and they did. The only thing was that initially, in the first treatment, they didn't get away with it. I said to Linda, 'I am not going to make this unless they get away with it', because it was so brilliant, it was not fair. Lynda was really pleased because when she had previously sent it to another television company, she had also wanted them to get away with it but had been told by the television company that crime couldn't pay and that the women couldn't get away. In the end, at least initially, they did get away with it. Really, *Widows* came out of a desire to show women as criminals which is perhaps not the best thing to do but they were awfully good at it. It was wonderful working with Lynda and I have worked with her since. In 1992 we did *Comics* together which was quite different and recently we worked on *She's Out* the continuing saga of Dolly Rawlins, the only remaining character from the two *Widows* series.

Q. *Women nonetheless have had quite a lot of difficulties in the industry. While there are some very successful women producers like yourself, such as Margaret Matheson and Linda Myles, there are fewer women*

235

directors. Have you got any idea why it is that women seem to have been able to succeed as producers in British film and television when they have found it very hard to get jobs as directors?

VL. Well it is true, I would consider myself to have been quite lucky because I was given an opportunity to produce, when I was fairly young and that's what I've done in one form or another ever since. I realize that is not the norm, but I think it is becoming more the norm than it was. There are lots of reasons for this. First of all there hasn't been a career structure for women in the way that there has been a structure for men. Nowadays, there's not really a career structure for anybody due to the way television is breaking up, so perhaps we will have a more equal opportunity as women. I also think that women are not naturally taught to push themselves. It is considered to be unfeminine, aggressive or tough. This is one of the reasons why I used to go on and on saying 'I can do this!' I think that as women gain more confidence in themselves that they will be able to put themselves forward. Margaret Matheson also started off as a secretary, actually she was my agent's secretary. Linda Myles came through a more academic background. In the end I think its being bloody-minded really and just keeping at it

Q. It has often been suggested that working in television is more restrictive than in film. You have worked in both, do you feel television is restrictive?

VL. No, I don't think it is very restrictive. I think certain material is better on television. *Bill Brand* (1976) was a political series that Trevor Griffiths wrote. We did twelve hours of it. I don't think we could have made a film as good as that series – the series needed the breadth to put forward what Trevor wanted to say and to give a proper perspective about what was going on. The British film industry has been in such dire straits for so long that, if it wasn't for Channel Four and the BBC, I doubt that there would have been very many films made. Most of the films that have been made have been partly financed by one or other of these broadcasters. However, I do think that certain films need the big screen. If you are doing an epic film, it is obviously going to look better on a big screen than on a little square box in the corner of your living room. However, if you take films that are about people, about relationships, I think there is a cross-over. If you get commissioned to make something for television, for example *The Snapper* or *My Beautiful Laundrette,* there is no point in looking at it and saying it could be a movie. I think you have to look at it and say, 'I am making this for television and I will make it and I will tell the story in the best possible way for this particular story'. I have also seen many films

made for the cinema that seem to work perfectly well on television. I don't think that there is such a demarcation, as long as you don't try and do both things at once.

Q. *What about the developments in television which have created more competition and reduced the money available – will that have a narrowing effect on productions?*

VL. I think that the deregulation of television will be very detrimental because the broadcasters have to pay so much money now for their franchises that they cannot take the chances or be as brave as they used to be. My fear is that the kind of material which needs a little bit of time for the audience to get used to, because it's original or different, just won't be there because people won't be able to take the risk. They want ratings and if they don't get ratings then it won't happen. Even something as mainstream as *Minder* in its first series did not get very good audiences. I had to go to the then Director of Programmes at Thames, Brian Cowgill and say, 'Look, I know this will work as long as you give us another chance for another series.' He was very supportive and said 'Okay, I believe you and I will back you'. I don't know whether anyone in ITV today would be able to do this or even want to do so now.

Q. *Eldorado wasn't so lucky. What did you want to achieve with it?*

VL. I wanted to achieve in a sort of ideal way, a wider understanding of people. I wanted to examine what it was like for people who had made a decision to live away from their roots which is completely the opposite to what most soap operas are based on. *Eldorado* was an opportunity to see what people did away from their roots and away from traditional class barriers in the sense that people who would not normally be living together in Britain, would be side by side in Spain.

Q. *It was very much an attempt to employ the popular soap or serial format. Was this a high risk?*

VL. I think that the high risk factor was that when we made it we didn't have enough time to put it on. That was where it went wrong. If we had had more time we could have started off in a better and more sensible way. Gradually people would have come to accept that community and its characters and through that acceptance, and being entertained by what happened to them, they would gradually have realized some of the things that I was trying to get at. I think that the soap format is actually a wonderful way of exposing people to problems and the atti-

tudes of everyday life. I mean, the best of *Brookside*, *Coronation Street*, *EastEnders* and *Emmerdale* do that. They have wonderful episodes about really important things that people experience every day in their lives. I don't think it is an area that should be despised; I think some of the best writing has come from it.

Q. *What about you experience in film? You have pointed out how dependent film has become on television and one of the reasons for this is that sources of funding outside of television became very scarce during the 1980s. A contributory factor here was the withdrawal from film production of Thorn EMI. You were in the difficult position of being the last director of production at Thorn EMI. What happened there?*

VL. Well, I have to say that the three years I spent at EMI were, I think, the worst years of my life. There were two things that happened. The most significant was that initially there was considerable tax relief available. You could get something like 100 per cent on any investment; this then went down to fifty per cent and then it disappeared. I think that this was one of the factors that most influenced investment in films from outside the television companies. During my period at EMI my brief was to make British films. What happens if you work for a film company is that somebody hires you and after about three months s/he gets fired, so even though you have negotiated a contract, which basically says how much money you have to spend, you suddenly find that the person who authorized this isn't there any more. You have a choice of trying to continue or resigning. I decided that I would try and continue. One of the problems was that while I was told I had to make British films, Thorn EMI didn't want to distribute them, so it was a very uneasy relationship. Nevertheless we did manage to get five films made. I did soldier on to the end of my contract. At the point when I left there was an attempted management buy-out. It was then sold to Cannon who didn't want to make British films either and then it was taken over by a gentleman called Parretti. I'm being a bit facetious here, but the main problem was that the fund of money that had been available for British films dried up as soon as the tax advantages disappeared. Every year we lobby the government to try and reinstate them and I honestly think that if it hadn't been for Channel Four and *Film on Four* then the British film industry would be in a desperate state.

Q. *Do you have any aspirations to pursue more fully a cinema career or do you feel that your real home is with television?*

VL. I like television. I would like to make more films but the thing is it takes so long. It's such a nightmare getting the money. I can go with a television idea and something I really enjoy doing and get it made much

quicker. In the end I really just want to make material that I want to make. I don't particularly mind whether it's for television or the cinema as long as it's something I feel strongly about or care about or feel is a good thing to do. I think that's what drives me more than anything else.

References

1. Lorraine Gamman and Margaret Marshment (eds.), *The Female Gaze: Women as Viewers of Popular Culture* (London: The Women's Press, 1988).
2. This is an edited version of an interview and discussion with Verity Lambert, chaired by Helen Doherty, which took place at the University of Ulster on 29 April 1994.

19

Dial 'M' For Movies: New Technologies, New Relations

Dan Fleming

ichard Collins' memorably titled essay 'Broadband Black Death Cuts Queues' from 1983 (he was ironically referring to Reith's tirade against those who brought dog-racing, plague and commercial television into Britain) remains a good starting point for any consideration of technology, policy and the media industries today.[1] Although the purpose here is to be much more detailed about the new technologies themselves, Collins' key points are worth rehearsing, bearing in mind that they were made over a decade ago. Collins was especially concerned about British government policy designed to encourage the development of cable TV. This was in the context of Information Technology Year's (1982) celebration of official faith in a shift towards 'the hegemony of the "Angestellten", to an emergent white-collar salariat charged with complex, technocratic control and information functions'.[2] (If one were to put a face on that in Britain today, it would be someone like BT's Peter Cochrane, head of the Advanced Applications and Technologies Group at the Martlesham Heath laboratories.[3]) This faith often seemed simply to involve the assumption, utterly taken for granted, that new information and communi-

cation technologies, brainchild of the technocrats, would inevitably lead to success and prosperity. Collins summarizes the over-investment and misplaced hopes that focused on videotex around this time. Cable TV seemed to be the next beneficiary. Both were being 'pushed' in a sense that Kumar, quoted by Collins, contrasted with 'need pull'.[4]

The new hegemony was based on the idea that if it was new enough and clever enough and was pushed hard enough people would want it. Collins' argument was that, at the time, UK government policy oscillated contradictorily between this 'force feeding the infant UK information economy',[5] on the one hand, and then abandoning things to the contradictions of the marketplace on the other. The queues that would be cut, evoked in Collins' title, would be the audiences for the domestic production industries, the latter unable to match the expansion of distribution capacity and consequently swamped yet again by a flood of material from elsewhere. This would be in stark contrast to the way in which, historically, the phased arrival of terrestrial broadcasting channels in the UK had allowed the domestic base of relevant skill and talent, supported by appropriate organizational and commercial structures, to grow in tandem. With a sudden expansion of the distribution infrastructure, prompted by technocratic zeal and the policies blinkered by its rhetoric, television production could go the way of the British film industry - simply unable to generate enough material and collapsing into a national 'niche' under pressure from those who could.

As Collins summarized it, the limited channels available for broadcast TV in any European nation (because of the need to keep them confinable within tightly packed national boundaries), led almost inevitably to a situation in which

> ...in a number of European countries a fortuitous 'fit' developed between the resources available for national programme (software) *production* and the (limited by spectrum availability) capacity of the *distribution* system. This 'fit' resulted in a stable broadcasting system ecology in which national broadcasting systems distributing substantially indigenous product developed, offering a model instance of the planned evolution of a viable and popular national cultural industry.[6]

Upset the 'fit' and the whole ecology could, probably would, go out of kilter. As we now know, cable TV has had as difficult a time expanding as did videotex, but Collins' warning has been lying dormant, as it were, for the moment when production and distribution in the UK veer even farther apart than they have been, thanks to the new technologies actually delivering on the technocrat's promise of massive and sudden expansion. Ten years later, that moment seems to have come. Satellite and cable are rapidly converging, in terms of numbers of homes connected to, and look set to race each

other to the next level of expansion. There are plans for digital broadcasting. And suddenly everybody is talking about video-on-demand: hundreds of movies that can be dialed up on telephone lines connected to domestic TVs. In part, this chapter is concerned to identify the changes to the media ecology that these new technological developments are bringing. I intend to do so by focussing on descriptions of the technologies themselves, rather than directly on issues of economics or policy. Aspects of the latter remain as contradictory as they were in 1983, but in part this is because the new ecology is not well enough understood in purely technological terms. An underlying question will remain whether the new forms of expanded distribution will indeed so alter the local ecosystem as to disadvantage filmmakers and broadcasters in Britain and Ireland. But I will also try to delineate the nature of the new opportunities that are arising.

Getting (asymmetrically?) wired

The idea that we are all getting 'wired', in one way or another, is now firmly embedded in the popular consciousness – even among people who have never been near a network. So too is the notion that TV, movies, computers and telecommunications are somehow all becoming the same stuff in this wired and 'multimedia' world. A moment's reflection reveals some exaggeration here – especially if one lives, as I do, in a part of rural Ireland where getting a public sewer to our kerbside might be construed as progress by some, never mind optic fibre. Clearly, though, something big is happening. To grasp precisely what, entails firstly a recognition of two important facts: going digital does not just mean getting wired; and, in any case, there is more than one way of getting wired.

There are currently three kinds of wire: the humble telephone line with its twisted copper strands (with which much of the world already is wired, constituting by far the biggest machine ever built); coaxial cable in which a thicker copper conductor is sheathed in plastic insulation with braided copper shielding (used for cable TV); and optic fibre, in which glass fibre strands in plastic sheaths have the capacity, or bandwidth, for vastly increased amounts of information. The concept of an 'information superhighway' is based on optic fibre serving clusters of between five hundred and a thousand houses (in the wealthier zones of the developed world, needless to say), with each home linked by coaxial cable to the local fibre 'node'. This fibre-coaxial network would, therefore, have a coaxial bottleneck which would limit the flow, especially that coming 'upstream' from home to node. There would be enough capacity to permit 'interactive' requests and simple responses via a remote control handset – calling up a video, selecting something from a home shopping service, answering multiple-choice questions on a gameshow quiz, and so on – but not enough for full two-way communication (except for conventional telephony). Fibre to

every home would be a genuinely symmetric, two-way system, but nobody is going to pay for that in the foreseeable future.

Why should one want two-way communication, the capacity to send high-quality video and audio in both directions? The answer is that one probably doesn't, at that level of sophistication. The problem is that, if the network is designed to carry broadcast-quality video and audio at all, it will tend to become an eighty per cent one-way system, thanks to those bottlenecks which will be mostly filled by all the one-way traffic. The twenty per cent of traffic possible in the other direction, or out through the bottlenecks and 'upstream', will only be enough for the simple form of interactivity just described. If we (predominantly in the wealthier societies where this is possible at all) settled for a network which was not optimized for full video and audio we could get two-way, many-to-many communication. In other words, the traffic could go from home to home as well as coming into our homes from various media providers, but would be at best more like low resolution desktop video-conferencing than centralized, broadcast-quality media services. It would be a communication medium rather than primarily an entertainment one. The internet is a taster for what that might be like, but it is not the model being pursued by the powerful 'dial M for movies' advocates.

The concept of 'channels' is also rather misleading. A telecommunications 'channel' is not the same as what we colloquially mean by a broadcast channel. The four or five hundred 'channels' on a fibre-coaxial network are data channels, rather than programme channels, with perhaps six at a time needed to transmit a feature film. This, combined with the bottleneck effect, means that we should be wary of inflated claims about the amount of programming that can be carried. Rather than a proliferation of simultaneously received programming channels, a fibre-coaxial network is better suited to an on-demand service in which the viewer calls up a single item, such as a movie, from a central data store. Getting that one movie through the coaxial bottleneck is hard enough. In fact, unless the demand is particularly high, economics will probably dictate some form of 'nearly on-demand' service instead; based for instance on fixed, staggered cycles of start times for programme material – rather like regular and more manageable 'waves' of data leaving the node for the final trip down the coaxial links, instead of a huge proliferation of material answering different demands from viewers. So when you ask for something big in bandwidth terms, like a film, you may have to wait for the next 'wave' or start time to come around. BT, a principal actor in this field, has been doing its best to overcome the bottleneck effect by using a technology called Asymmetric Digital Subscriber Line or ADSL, which packages digital video and sound as a high frequency signal and punches it down even the basic wire past subscribers' puny lower frequency two-way phone conversations. Note the word 'asymmetric'.... Only some five kilometres of line can be covered this way before the high frequency package runs out of steam, as it were, but over ninety per cent of UK homes are within that distance from a local exchange.

The very fact that highly clever technology such as ADSL is needed in the hope of forcing broadcast-quality video and audio through the bottleneck into our homes (with BT and others only achieving VHS-quality at the moment on conventional phone lines) suggests a certain desperation to implement the 'asymmetric' or predominantly one-way entertainment model rather than the many-to-many communication model. There may not be room for both if attempts to get messages upstream are persistently met by powerfully clever techniques like ADSL pushing its unwieldy content, such as movies, downstream towards us.

Asymmetric relations

Why is this happening, when an internet-style approach based on greatly improved many-to-many links, but not aspiring to full broadcast-quality media content, could secure large-scale benefits to users ranging from comprehensive distance education services to electronic participation in civic and community affairs? Clearly it is because making money from a many-to-many system is very much more difficult than it is from few-to-many, particularly if you are among the few – the consortia of content producers and network providers that have been forming in order to pursue the entertainment oriented version of the superhighway. All over the developed world, telecommunications companies are getting involved with TV companies, Hollywood studios, video game producers and retail chains to develop packages of movies and other programming, including home shopping, to shove down the wires at us. Feature films may well be something of a 'trojan horse' in all of this – the application which makes the whole idea look most attractive. Quite conceivably these entertainment and communication industry consortia do not ultimately care if video-on-demand turns out to be insufficiently demanded in practice: by then the highly 'asymmetric' technologies will be in place to their advantage and they can find other ways to profit from them.

The shifting relations between film and television charted by this book have one thing implicitly at their centre: the question of how and why film gets into the home. If we didn't want it there, cinema would be fine as a combined technology, cultural form and exhibition medium. But, along with so much other entertainment, we do want film at home. Those who control the various businesses which meet this demand are still wondering just how much of it we might be willing to take and in precisely what forms. There are five ways of getting it there – terrestrial broadcasting, satellite broadcasting, cable television, packaged media and telephone lines. In Europe the satellite movie channels have taken over from terrestrial broadcasting in terms of the sheer number of films carried. Cable in the UK and Ireland remains very much the poor relation, locally attractive but constrained by geography, demographics and economics to make only very slow progress into the mass market. Videotape has been the most successful

packaged medium to date, consigning video disc to a niche occupied by 'home cinema' buffs who can afford the technology. VideoCD is currently being positioned within another niche, from which it may or may not be able to expand depending on unresolved technical issues, in particular on overcoming the visually inferior results, compared with laser disc, of its video compression requirements. The phone lines in 1994 did in fact see their first movie traffic, in a series of rather tentative but hugely expensive trials. What all of this represents, around that core fact of getting film into the home, along with so much other media content, is the opening up of a series of questions about what 'film' really is, how much of it people are willing to take and in what forms, and about the technologies best suited or most commercially viable (not the same thing) to shift all of this stuff through our front doors.

Just under the surface, all five of those methods to breach the front door are discovering that they have something in common. All are now moving, with varying degrees of lassitude or urgency, from analog to digital. The frame of 35mm film, soaked with a brilliant light that carries its image onto a pure white screen, is now nicely symbolic of how information-rich but awkward a good analog technology can be. It is a symbol that has had to be worshipped in a crowd. To get that frame, and the twenty-fourth of a second of rich communication that it represents, to the people who want to be enthralled by it has meant taking the people to the image. Trying to take it to them, in their homes, has always meant accepting a degradation of its information: broadcasting a less highly resolved image, its frame cropped; distributing that already degraded image on a tape which wears out; and so on. So a growing body of technologists has been kept busy trying to counteract this degradation – their ideal, the domestically available image which is as good as the cinematic original. They still have a long way to go but it looks like an ultimately achievable goal. So where are we at the moment and is it, in fact, a goal that we are all headed towards? (For convenience here, and throughout this chapter, I take 'we' to mean a predominantly European readership, with a UK bias in the examples offered.)

Those five carrier methods have had an uneven historical development in relation to each other. Two of them (terrestrial broadcasting and the video shop) have experienced good times that may never come again, when briefly unchallenged by any of the others. The more recent may be driven, in part, by the belief that they too can have their moment of dominance. More likely is the possibility that we are seeing a fundamental moment of reorientation of these five methods in relation to each other, forced in part by the digitalization that they are all experiencing. Given this commonality, the industries which depend on one or other of these ways of getting into the home are trying to sort out which part of an inevitably limited territory is going to be most usefully and most profitably occupied by which method. The wistful notion that maybe the territory is unlimited – a sort of electronic 'new frontier' optimism – is already looking downright silly. People will only

watch so many films in a week, never mind all the other media content. It varies a bit with age and circumstances but, over a certain threshold of available choice, it is not extendable by simply extending the choice. Indeed, increased choice brings its own problems: choosing by looking at the newspaper to see what's on at the local cinema was easy and even a bit exciting once, glancing at a four-channel *Radio Times* was easy and routine, reading through the satellite listings is becoming something of a task in itself, browsing in the video shop tends to mean checking out the recent releases unless one really has time to kill, and navigating through an online video-on-demand system with thousands of choices might take longer than actually watching the movie in the end. So people discover ways of focussing their own habits and attention, of confining their own access to the available choices in ways that they find manageable, affordable and satisfying. For the reliant businesses, and the technologies on which they depend, the trick will be to stake a credible claim for inclusion in most people's limited orbit of consumption habits. Those habits are by no means infinitely elastic.

Better, as well as more, TV?

Before looking in more detail at the current relationship between film and television, as recontextualized by the changes evoked above, it might be interesting briefly to take a longer, more speculative view. Will the reorientation of methods for getting into the home only carve out a set of niches, or will it ultimately propel us towards something genuinely new and better? The very expression 'getting into the home' suggests that the current emphasis is on pushing media content through the front door (down through the roof, up through the floor, and so on), in the hope that the occupants of the house will not be averse to receiving it. But what digital technology is really about is giving people the capability of 'pulling' what they need, want and are willing to pay for out of increasingly vast streams of data that pass by their homes, whether on the airwaves or via a local optic fibre node.[7] That is the logic driving computer networks, where the clearest examples of the digital way of doing things are to be found. The established media industries are largely failing to recognize this (they use the internet as an advertising medium, for example, with fat glossy promotional pages on the World Wide Web – you can almost feel the desperation to push all this stuff down the line into people's choking computers). In fact, the five 'entry' methods will become domestic 'exit' methods, by which the user reaches out to collect what he or she wants from the passing data streams. The viewer will make choices about which 'exit' method to use, depending on what he or she wants to do with the material being accessed – or just on how he or she feels at that moment. Do I want a stroll down to the video shop? Do I want that feeling of watching a broadcast film along with millions of other people? Do I want to channel hop between several movies to see if anything catches my interest? Do I want to

set my digital VCR to tape half a dozen films simultaneously during the night, just to have them in case I ever want to view them? Do I want a big screen, high definition cinematic experience in my living room?

If we take a look at where the technology of television is right now, it is easier to judge where such options are headed. The VHS video recorder is now the box at the centre of it all, even though it receives little attention in itself any more. Whatever developments are technically and commercially possible, they will have to orient themselves around the now apparently humble but happily entrenched VHS machine. Its modest evolution has been based on an intimate and highly successful relationship with what people actually want. As the novelty of being able to record, timeshift and rent became commonplace, small improvements in the picture and sound quality of VHS kept people happy. The latest machines assess the characteristics of the tape in use and adjust their recordings for optimum results. Akai originated that, Sony and Panasonic now use it as well, and JVC will launch their improved version (BEST or Best Equalized Signal Tuning) in 1996. This will probably have taken analog VHS to its limit. Many VHS machines also now have a 'rental' setting for worn tapes from the video shop, which effectively blurs the image slightly so that the wear and tear is not so obvious. Now the point about such technical tweaks, shifting the picture 'quality' up or even down as required, is that they are deeply characteristic of a mature technology which is sensitively attuned to its users' wants. Most people are not looking for the audiovisual quality delivered by laser disc, so the VHS machine is perfectly adequate while it delivers what they want at a price they can afford and with a minimum of fuss. The VHS analog format cannot be pushed much further in terms of picture and sound quality but has found its level in relation to the current audience's expectations.

The same could be said of the television set itself for a long time, but it too is being modestly transformed by a few recent technical tweaks. Digital stereo is now well established as the first upgrade option that many people have in mind when replacing an old set. Surround-sound has been establishing itself as a minority but growing interest, first with three channels of sound (right, left and 'surround' or rear), more recently with a fourth or centre channel to prevent speech from getting swamped. A doubled picture refresh rate (i.e. scanning at 100Hz) is on the way, giving pictures a discernible crispness and sparkle, as does improved handling of the highest frequencies. These things are not revolutionary advances but, like the evolution of the VHS machine, are keeping the TV set itself in touch with viewers' slowly advancing requirement for a 'good' quality of image and sound. Inside the boxes, other minor improvements have kept pace, from better tape handling to automatic tuning. This all represents a very subjective standard, of course, since technologies certainly exist already for a marked and rapid advance in audiovisual scale and quality, but it is the standard that matters in selling television and video to a majority of viewers. Even if most people do not yet want to spend their money on some-

thing like four-channel Dolby Pro-Logic sound, its availability defines the outer edge of that subjective understanding of desirable quality.

Then there are the more tentative developments. The long familiar 4x3 screen format is now being supplemented by the 16x9 widescreen-format TV set which, while useful when widescreen films are broadcast (the picture can be switched to fill the screen without edge-cropping) seems to be a transitional step on the way to a supposed new format and higher definition picture for broadcasting generally - and maybe the end, once and for all, of television's pan-and-scan treatment of films (since even wider format films do not look annoyingly like a letterbox on a 16x9 screen).

The Pal Plus system currently being used in the UK to broadcast 16x9 ratio widescreen material is not high definition television, or HDTV. It is an enhancement of the standard Pal system that allows an adjustment of the height-to-width ratio, without being incompatible with the standard system. Pal Plus cleverly uses the black edge 'flaps', top and bottom, to carry additional picture information which compensates for the effective loss of resolution when a 625-line picture is expanded to fill a 16x9 monitor. With EC financial support, in 1995 Channel Four could use Pal Plus to transmit widescreen films in something closer to their original screen shape (as distinct from merely a widescreen film broadcast as a letterbox across a standard Pal screen) and other broadcasters could experiment with producing material in that format - hence the tell-tale black bands that have been creeping onto the top and bottom of our conventional screens of late. Most viewers will not be paying much attention and do not have to hand over any money either – unless they want one of the few, expensive widescreen TV sets now available (Nokia's having been the first). Only the latter are capable of showing full-screen Pal Plus. But it remains a widescreen format rather than high definition TV, as the picture is still based on 625 scanned lines. HDTV starts at around 1000 lines, at which point the image takes on a more 'cinematic' richness and presence, although some people subjectively find it more hard-edged and cold than film. NHK, the Japanese state broadcasting service, produces HDTV programmes for Japan's Hi-Vision (1125 lines) satellite service, launched in 1991, and spends nearly £20 million a year doing so.

In order to remain competitive, and to offset Japan's otherwise likely dominance of European HDTV technology (or so it seemed in the early 1990s), Brussels formulated plans to subsidize research by Philips and others and eventually to support broadcasters in experimenting with the new formats. The proposed European system, the 1250 line HD-Mac finally agreed upon, now exists in the laboratory (MAC, or Multiplexed Analog Components, being an underlying widescreen technology which would simply broadcast a 16x9 picture, leaving 4x3 TV sets having to crop the image, unlike Pal Plus which maintains compatibility with 4x3). The problem is that both HD-Mac and Hi-Vision are very costly and inflexible analog systems and have recent-

ly been overtaken by digital alternatives. In the US, digital satellite services PrimeStar and DirecTV, like Europe's Astra 1d (all launched in 1994), are platforms ready to be developed for HDTV if the demand is proven to exist. The Americans have recently agreed a terrestrial HDTV standard for digital broadcasting, approved by the Federal Communications Commission. The European Launching Group for Digital Video Broadcasting is currently trying to co-ordinate Europe-wide plans for an HDTV standard. In the UK, the August 1995 government White Paper on 'Digital Terrestrial Broadcasting' set out a possible structure for ownership and regulation of digital TV – based on bundles of programme channels on each digital frequency which could be used in various ways, including HDTV. One 'bundle' could carry multiple standard-definition channels or a few high-definition ones.

If HDTV services go ahead, cinema films will be broadcast with greatly improved picture quality and some 'prestige' TV productions will be shot on HDTV, but the bulk of transmitted material may well, at least initially, come from elsewhere. For years, over ninety percent of US television series were shot on 35mm film. That 35mm image is in fact the benchmark for HDTV's resolution. There are probably five to ten thousand hours of such material waiting for a new lease of life when they can go straight from the filmed originals to digital HDTV. *Star Trek* re-runs will take on a new interest yet again! So HDTV and widescreen are not inextricably linked. Pal Plus is being used to test the water for interest in a non-HDTV widescreen service.

Either some 'home cinema' or a lot more (digital) TV

It is not at all certain that the future will look the way developers of those more ambitious technologies seem to be predicting. We have to draw a sharper distinction than is usually made between, on the one hand, that edging outwards of the viewers' subjective sense of desirable quality to embrace features like stereo sound or the BEST optimization of the VHS picture, and, on the other hand, the attempted reinvention of the TV as an entirely larger, wider, much more sophisticated box of tricks capable of 'cinematic' quality. The latter is bringing onto the market currently some big, back-projection, widescreen TVs whose manufacturers are engaging in a minor price war to establish their foothold in the domestic arena, with TVs bigger than the current maximum for the cathode ray tube of forty-one inches. Somewhere behind such monsters, however, there is an almost science-fictional vision of the future domestic TV: a huge screen offering pictures and sound that are virtually indistinguishable from the real. Although some features of TV technology do seem to be advancing in that direction, it may well prove to be only one minority-interest future (expensive and with highly specific applications) rather than where a majority of viewers are headed on their sofas. Thin, flat, hang-on-the-wall TVs are more likely to enter the mass market as widescreen liquid crystal displays such as the 'Plasmatron', launched in 1995 by Sony and US company

Tektronix. These will add about ten inches to the maximum screen size available from a cathode ray tube, but are pushed to achieve good 625-line resolution, without aspiring to HDTV. Generally though, the crucial factors, the ones that will define our future TV, are those that come with the inevitable progress of digitalization.

The technical standards committee MPEG (Motion Picture Experts Group) has been defining the technical characteristics of digital TV recording and playback. The current standards, MPEG-2, have now been twinned with an agreed European standard for digital transmission called DVB (Digital Video Broadcast) and the privatized technical arm of the old IBA, National Telecommunications Limited, has been running trials of a digital TV service for terrestrial broadcasting. If successful, NTL will sell its technical services to broadcasters, based largely on its existing transmitter sites and accessible through the standard domestic aerial. Meanwhile the satellites that serve the BSkyB system (forty per cent owned by Rupert Murdoch) are being developed to carry digital material. The advantages of digital TV are, firstly, its capacity to deliver more channels – NTL says maybe twenty to our existing aerials, Murdoch says hundreds to a special tuner via a (probably new) receiving dish – and, secondly, its potential for on-demand or interactive services. What it does not necessarily deliver is any marked improvement in overall picture and sound quality – unless, that is, the other advantages are sacrificed and resources are put into a small number of high-definition, widescreen channels. The latter would have massive implications for TV production, which would have to shift resources into producing HDTV material for such a service. There is no reason at all to think that this would be a commercially sensible thing to do. HDTV in Japan remains a costly minority interest, for example; with, in any case, four times more viewers buying widescreen sets to get just the wider picture than purchase the fully HDTV-compatible monitors for both widescreen and higher definition.[8] Digital means flexibility, quantity, accessibility, interactivity. Those are the factors that will define the TV of the (very near) future. Importantly, digital broadcasting of a conventional or Pal Plus signal will ensure excellent reception for everybody – subjectively, this will seem to many viewers to be a great improvement over their existing television pictures, removing the slight 'ghosting' and other forms of interference that so many viewers accept without really being conscious of them any more.

As the message 'digital = flexibility' becomes clearer, it will probably serve to consolidate the rather expensive, enthusiast-attracting 'home cinema' niche as the focus for that vision of big screen, high definition, stereo surround sound TV with grandly cinematic pretensions. (Because off-duty media academics or producers like the thought of that, they may have a tendency to assume that a mass TV audience will as well.) As this will remain best suited to the domestic viewing of feature films, some are erroneously predicting a technical battle between laser disc and VideoCD – the other new medium flirting with Hollywood – to be the dominant

The look and sound of things to come?: JVC advertise home cinema

distribution medium. VideoCD, however, now offers only slightly better quality than VHS while a laser disc image is some sixty per cent more detailed, so the latter should retain its hold on this particular niche unless replaced by a small number of specialist satellite channels. How big the niche itself remains depends mostly on how many people want this particular form of access to films. That in turn will depend on how attractive the competing systems offering more choice rather than better quality prove to be. If anything, 'home cinema' based on laser discs and very large TVs will further diverge from mainstream forms of TV viewing as a luxury for those

who can afford the technology, which will develop ever closer to 'cinematic' standards. A handful of HDTV satellite channels, with high subscription rates, will probably serve the 'home cinema' niche as well, with up-market digital VCRs as an ideal domestic recording medium. Most people will simply go to the cinema instead, if that is what they are looking for, and use less feature-packed digital VCRs to tape more, and more flexibly, rather than better.

Digital video (although offering qualitative advantages such as better broadcast reception) has much more to do with compression and therefore quantity, than with ambitious improvements in picture quality. Take, for example, every fifteenth frame of video: if particular pieces of picture information have not changed between two such frames they need only be stored once – so store what has changed and discard everything that is redundant. That is very different from every frame of a 35mm film having to re-duplicate lots of the same information, even if it hasn't changed. Now, if only there were some way to refer back and forward along strings of these fifteen-frame sequences to organize instantaneously all the storing and discarding, it should be possible to compress and decompress the video so that, as a whole, it can be stored much more economically but 'expanded' in real time into full-motion glory. These would be significant achievements – especially if you wanted to squeeze video into places it had never gone before.

'These achievements', announced a trade journal in 1993, 'signal the convergence of such diverse industries as broadcast (including cable, satellite and terrestrial), telecommunications, entertainment and computing to a single, worldwide, digital video coding standard for a wide range of resolutions...'.[9] What was being reported was a meeting in Australia where two hundred and thirty experts from eighteen countries confirmed their acceptance of the latest version of the MPEG standard from the Motion Picture Experts Group, a committee of the International Standardization Organization. MPEG-1 was already in use for VHS-quality digital video, especially on computer screens. MPEG-2 pushed the quality up to include broadcast standard video and audio, providing manufacturers with the agreed international benchmarks they needed to begin producing digital equipment.[10] It also included agreed procedures for 'multiplexing' – combining multiple channels of video, audio and any other data into a single, simultaneous data stream out of which the various components can be decoded. (A concept embraced by the UK's White Paper on digital broadcasting, which proposed to organize ownership and regulation around multiplex bundles.) The standard included plans for what is called a 'hierarchical profile': the core technical standard, or Video Main Profile, is being rapidly extended to include compatible levels of increasing sophistication. This means eventually, for example, that a digital broadcast employing the standard could be received as a conventional TV transmission or, with the right equipment, as a high definition, widescreen surround sound transmission (if originally made as

such!). Similarly, the hierarchical profile will support a wide range of technologies, including video transmission on telephone lines, VideoCD and decoders feeding digital VHS tape.

What is especially interesting about that hierarchical specification is that if it were pushed 'up' to embrace HDTV it would lose the more basic levels – bluntly put, TV sets unequipped with the higher reception facility would go blank. So the increasingly important MPEG standard does not extend nearly that far. The European DVB standard, originally committed to a similarly hierarchical profile, has been forced to drop the concept in order to embrace HDTV, running the very real risk of basic TV receivers being unable to take HDTV at standard definition. This split in the digital domain, between mass compatibility (MPEG) and pursuit of digital HDTV at the expense of compatibility, is symptomatic of confusion over precisely what benefits viewers will want from digital TV.

D-VHS (actually standing for Data-VHS) is JVC's response to the question of how most viewers will make use of digital TV. It is based on the idea that the majority of viewers will not be in a position to acquire (or to want) the top-end technology. As with original VHS, however, a mass-market version which delivers some of the main benefits, without pushing to the technical limits, will stand a good chance of succeeding. In other words, we are looking at the imminent arrival of the modestly ambitious 'digital VCR'. A D-VHS tape could provide nearly fifty hours of recording time in 'long play' mode and the agreed multiplexing standard means that at least six channels can be recorded simultaneously. The material will come from digitally equipped satellites (there is already an Astra up there, ready and waiting), from terrestrial broadcasters (who have already been offered the transmission technology by the privatized technical wing of ITV) and from the cable and telephone companies who are competing with each other to get us all wired.

D-VHS has several things going for it. It looks just like the familiar VHS cassette which has become an accepted fact of life. D-VHS decks will play and record all our old tapes, switching to and from digital automatically. The standard quality digital recording mode will offer around five hours of recording on a tape, with up to ten times that if viewers accept picture quality possibly a little lower than standard VHS in 'long play' mode. It is likely that a very high quality mode will be offered, with say two and a half hours on a tape, of potentially high definition, surround sound material. Up-market decks may be optimized for that as their principal selling point. Interestingly, of course, none of this is dependent on the industry for pre-recorded video tapes shifting en masse away from VHS – the analog and digital technologies can coexist for as long as necessary, giving D-VHS a distinct advantage over other pretenders to the home video crown, such as VideoCD.

JVC are not planning to include an MPEG decoder in their digital VCR – instead they want to agree interconnection standards that will allow D-VHS to be plugged into everybody else's smart set-top boxes, making D-VHS the standard domestic 'media server' for storing and accessing video material wherever it has come from.[11] As long as the set-top decoders are made to plug into D-VHS decks, the latter should remain upwardly compatible with forthcoming levels of the MPEG or other standards. As JVC begins to define the mass market for digital TV, experiments with digital video-on-demand using the telephone system are important, not necessarily because they are revealing what is going to be a dominant delivery method (it probably will not be) but because they are demonstrating clearly the characteristics of digital video and are doing so before the other delivery methods go digital in a major way.

Video-on-demand and beyond

At the beginning of 1994, the business, media and technology sections of British newspapers were revelling in headlines such as 'BT gears up to fight cable TV'[12]. Twelve months later it was 'Enough TV to make you flip'[13], referring to the impending arrival of digital television. In between it had become clear that 1994 would be the year in which we all realized TV was changing, and perhaps in some very fundamental ways. Oddly, though, nothing fundamental actually did seem to be changing throughout 1995. It was, on the surface, very much business as usual, apart from some talk about the fifth terrestrial channel in the UK and how a lot of people would have to have their VCRs re-tuned (for reasons that nobody was very clear about, because it involved delicate fiddling with the old analog system). Had it all been hype? In fact, the major players had got so excited about what was happening that they were keeping their heads down, quietly trying to figure out how to make a lot more money once they knew for sure what viewers are going to be willing to pay for. Secretive market trials were underway on both sides of the Atlantic [14]. If anything, the breathless headlines of 1994 underplayed the extent of the changes that may yet take place. Whether they do or not, depends on a whole series of still unresolved issues about precisely what new forms of TV service people might want and about the relations in that marketplace among broadcasters, cable companies and the telecommunications industry. It has become clear that the technologies are falling into place to take us in several new directions simultaneously – or none at all, if those issues are not satisfactorily resolved.

BT's unexpected entry into debates about TV reveals a good deal about the larger context. Banned by its industry regulator, the Office of Telecommunications (Oftel) from broadcasting entertainment services of any kind over its network until at least 2001, BT neatly attempted to sidestep this measure, designed in the spirit of competition to encourage cable entrepreneurs, by developing the outline of an 'on-demand' service using the two-

way or 'interactive' traffic along its lines that computerization has made possible. A decade earlier, participants in a small-scale BT trial in London could phone an operator and ask for a movie on laser disc to be played on a BT-owned local cable. Advances in the computer technology which could be installed at both ends of the line by 1994 meant that the whole transaction could be handled not only automatically but also *simultaneously* for hundreds, perhaps thousands, of customers. BT, and telecommunications companies elsewhere, seemed to have the makings of a digital video shop on their hands. 'Dial M for Movies', they began thinking. Oftel agreed that this was not really what it recognized as broadcasting any more and, while grumbling about how BT would have to let other companies use its network commercially if the whole thing actually worked, relaxed enough to see BT make rapid progress towards providing television in an entirely new way, at least for a couple of thousand families in Suffolk in its 1995 trials there. The point is, of course, that once things go digital no broadcasting, or any other form of television for that matter, is really the same any more.

Video over the phone lines depends partly on getting near enough to clusters of homes using the remarkable capacity of optic fibre (which very few people in the UK actually have running past their doors) and then 'boosting' the video material across the shorter distances from a local node into individual homes, using the older lines. Backed by the Department of Trade and Industry, Oftel insists that the general restriction on BT still holds and cannot be reviewed until 1998.[15] Until then only a limited video-on-demand service is possible. BT is using the fact that it cannot, therefore, fully develop a range of broadcast entertainment services nationally in order to argue that it is simply not worth its time and money to install a comprehensive blanket of national optic fibre network connections, an 'information superhighway', even if asymmetrically structured in practice. This is in part a form of blackmail, employed in the hope of making life difficult for cable operators who are increasingly running telephony services on their systems. In actuality, a fibre network is being patched together in bits and pieces by the whole quilt of cable and telecommunications providers and a BT-controlled blanket provision may turn out not to be the only way of achieving a fairly comprehensive broadband network. But this is where it becomes a classic chicken and egg question. It all depends on whether people want the sorts of things a broadband network can carry – such as dial-up movies. BT say they would finish putting their own comprehensive network in place on the assumption that people will want the resulting services. The messier 'quilt' of networks is more likely to be pieced together in response to proven demand.

The term 'interactive television' has been in use for some time to describe the potential for various forms of feedback from viewers offered by two-way connections, either cable or telephone lines, with traffic routed through a set-top box. The traffic into the home may be conventional programming, including films, or some form of interactive material such as video games,

studio game shows or shopping services. As noted at the beginning of this chapter, the messages going the other way, in an extension of the power of the remote control handset, may be requests to view particular material, control of games, responses to quizzes or orders for goods. But in the more ambitious predictions, programmes are envisaged with multiple branching narrative options among which a viewer determines what direction the story goes in. While this remains unlikely for reasons of cost, as well as uncertainty about whether interesting stories can really be told that way, some experiments *have* taken place in which genuine interactivity has been introduced into a conventional programme format. In early 1993, a live football match between Newcastle and West Ham was 'interactively' carried by Videoway, the service run by Canadian cable company Videotron in London (since 1990) and Southampton (since 1989) with over 60,000 sub-scribers. In this case several channels of information, from multiple camera angles to instant replays, were simultaneously routed to viewers' set-top boxes, allowing an individual viewer to mix together, to some degree, his or her own coverage in real time. Independent television companies LWT and Carlton collaborated in the trial and, with Videotron, went on to provide Interactive London News a year later, allowing viewers to put together a tailored mix of news and information by switching among four simultaneous news channels with different emphases. This focus on increasingly flexible on-demand programming has emerged as the most convincing and work-able form of 'interactivity' in an asymmetric structure. Gimmicks, such as live voting by audiences on this or that, have migrated out into mainstream broadcasting (thanks to computerized rapid-response phone-in systems) but remain occasional novelties, unlikely candidates to be at the heart of what interactivity will mean in practice. The Videoway set-top boxes have been further developed since 1994 to handle increased two-way traffic but there is still considerable uncertainty as to precisely what kinds of interactive role most viewers will want for themselves: shopping and even tele-voting are still most frequently referred to as examples, although the feeling seems to persist among service providers that a 'killer application' is just waiting to be found. In 1994-95, movies on-demand, 'trojan horse' or not, became the prime candidate for that role.

It was as long ago as 1985, the year after its privatization, that BT ran its first movie on-demand trial on its own Westminster Cable, launched that year, using a laser disc collection in a kind of jukebox run by an operator who took subscribers' requests over the telephone. Since that brief flirta-tion, BT has been interested in what might happen when films could be requested and downloaded on the telephone lines themselves, controlled by computer rather than by a human operator. If the flexibility of on-demand programming, in which a viewer puts together his or her own schedule as it were, is the prime benefit offered by interactivity, then one key to delivering a successful service will be to deliver as much flexibility as possible. This means as much programme material as possible, all simul-taneously available for selection. For BT, the MPEG standard for video

compression (in fact MPEG-1, the first version, rather than the improved MPEG-2 being used by NTL for its digital broadcasting trials) was sufficient to sustain a technical trial of video-on-demand in the summer of 1994 at its Martlesham Heath laboratories in Suffolk, connecting to the homes of some sixty BT staff in neighbouring areas.[16]

Given the MPEG standard for digitally compressing video material, the key to running an on-demand service is to have a big enough digital 'warehouse' of films and a smart enough set-top box. The latter not only controls the viewer's access to screenfuls of information about what's available, and shunts his or her instructions down the line to the 'warehouse', but also receives the requested video material in thousands of packets of information which it seamlessly reconnects into a continuous whole. This allows, in effect, multiple simultaneous access to the same item as the first 'packet' can be released at micro-second intervals. In the BT trial the set-top box was an adapted Apple Macintosh computer, heavily disguised but much the same as their entry-level machines at the time, while the 'warehouse' was a supercomputer (called an nCube) running highly specialized database software provided by Oracle, a US database technology company. (Silicon Graphics, Hewlett-Packard and Microsoft are also competing to provide digital video warehouse hardware and software, with Microsoft lagging behind in order to learn from the others' mistakes.) The whole thing was tied together by the existing optic fibre and copper telephone lines. The picture and sound quality delivered was well up to the best VHS standard, at least subjectively which is what matters to viewers (as after all, many tapes are viewed when rather worn and incapable of delivering a top grade VHS picture, so viewers' sense of that standard is variable, even without differences among VCRs themselves). It rapidly became clear from the BT trial that a general programming-on-demand service is most likely to appeal to viewers, not merely a movie service. So an individualized schedule for an evening might just as easily consist of four re-runs end to end of old *Dad's Army* episodes as of a Hollywood film.

It also became clear to BT Human Factors researchers involved in the Martlesham trial that a compromise would have to be found between the theoretical 'customizability' of the system (which might be highly attractive to users) and its cost effectiveness. The on-screen interface that viewers used to browse or navigate through the available options in the trial was based on nested sequences of nine options at a time. In other words an initial, nicely designed screen, with attractive graphics, might offer 'Movies', 'Sport', 'Drama' and six other similar categories. Selecting 'Movies' (by keying a number on the handset) would lead to nine categories of movie, 'Recent Releases', 'Thrillers' and so on. This process would continue until a single-item selection screen would be reached, with a still from the film, an informational blurb, basic production credits, cost-per-view, and so on. In theory, this kind of system can be customized like a graphical user interface on a computer, to reflect an individual user's preferences. So, for example,

a household without children might not want 'Children' to be a category on their initial screen at all. The capacity of the supercomputer acting as a server or video warehouse is stretched, however, in simply shunting to and fro so much source material in compressed video format without supporting endless variations in how individual user's systems are set up to access that database. So the 'Me-TV' channel that is, in effect, offered by programming-on-demand will none the less be a fairly standardized one, individuality being expressed by the choices one makes rather than by the choices that are offered.

As BT moved into a large scale market trial in the summer of 1995, involving over 2,000 households in the Ipswich and Colchester areas, others were following suit. Online Media began testing a broadly similar system on the Cambridge Cable network, although the servers initially used (a twinned system with one to store programmes and another to control access requests and delivery) were considered inferior to the nCube at the heart of the BT trial, itself still prone to falling over under the strain. This illustrates one of the dilemmas of providing video-on-demand: a fully effective system depends on extraordinarily sophisticated and expensive technology. Compromise on the technology and, as a result, choice, responsiveness, flexibility and accessibility all begin to decline. It is increasingly likely that a number of near-video-on-demand systems will be attempted, where less sophisticated technology is available. Here, fewer options will be offered (at best, dozens rather than hundreds) with staggered, fixed access times rather than instantaneous responsiveness (e.g. fixed start times every fifteen or thirty minutes). It remains to be seen whether that will be enough to stimulate sufficient demand, but it is probably the route that will be most sensibly pursued by cable operators for instance.

N-VOD (near-video-on-demand) has also been a distinct possibility for digital satellite broadcasting since the launch of the fifth Astra satellite in 1995. In fact one of the reasons for the launch of Astra 1d, the fourth in the series, in 1994 when only some twenty per cent of UK dish owners could receive it, may have been to have a platform in place on which to experiment with N-VOD movie services (e.g. based on rolling starts, the same film coming up again every half hour or so). A digital satellite broadcasting service will entail convincing customers en masse to buy digital receivers, which Echostar, Grundig, Pace and other manufacturers are only just beginning to produce, so knowing for certain what one wants to do with the technology is an absolute prerequisite. Technically it could be either a high definition, widescreen service, which would rapidly eat up the available satellite bandwidth, or multiple VHS-standard movie channels flexible enough to make up an N-VOD service. What is particularly interesting, as cable and satellite operators all begin to think about the potential of N-VOD, is that the graphs of UK cable connections and dish owners will converge during 1996 or soon thereafter, with as many homes cabled as have satellite receivers. If both by then are committed to N-VOD services, there will be

a straight competition between them on the basis of cost and convenience to the customer. It is in part to await the results of that convergence that the UK government has prevented BT, under the terms of its telecommunications licence, from providing a national entertainment service until the turn of the century. If cable does not emerge from its rendezvous with satellite as a clear contender for very large scale networked entertainment services such as N-VOD, BT may be released from its rein sooner than expected and given its head.

More flexible mainstream TV with specialist niches

So a potentially confusing proliferation of new technologies in fact begins to fall into place. HDTV promises to consolidate a 'home cinema' niche, fed in the future by some satellite (and perhaps terrestrial) broadcasting in that form, including the back catalogues of 'classic' American TV material in 35mm format. A non-HDTV widescreen Pal Plus format for the majority of broadcasting output is a distinct possibility, running in parallel for several years with the existing format until most people upgrade naturally by buying widescreen sets. That will depend, to a great extent, on whether the production industry wants to move to widescreen. Aesthetically, the attraction for filmmakers will probably be irresistible. For most viewers, however, digital TV will also mean increased choice and, perhaps even more importantly, greater flexibility in how to handle that choice. D-VHS will be an adaptable mass storage medium, with broadcasters gradually shifting to digital in order to offer increased flexibility: recording options ranging from simultaneous channel recording to cheap 'trickle' downloading from satellites (leaving a digital VCR running all night to download a movie, for example) and viewing options centred around video-on-demand or N-VOD of various kinds, whether broadcast or wired. This will all increasingly approach the concept of 'Me-TV', highly individualized viewer-controlled scheduling and timeshifting from among an increased range of multi-layered given schedules. The precise forms this increased flexibility will take remain to be seen, but this is undoubtedly what digital will mean, rather than a mass movement towards 'home cinema'. This leaves a few remaining questions, such as where VideoCD will fit in.

Visit the set of any big-budget Hollywood production these days and you will see a BTS (Behind The Scenes) video crew pointing its camera at just about everything that is going on. Whether for a mixed media press kit, a TV 'Making of...' documentary or a fully-fledged multimedia CD-ROM ('Everything You Ever Wanted to Know About... ') which will be released along with the movie, BTS material is now itself big business. Increasingly CD-ROM is being recognized as the ideal medium through which to 're-purpose' everything from screenplays and storyboards to promotional material, stitched together around extracts from the film and interviews with cast and production team. Since much of this material is already generated for other reasons, the next step of releasing a CD-ROM is a fairly easy one. At

the moment, it is largely confined to the 'blockbusters' but it is a practice likely to spread as the costs come down, leading almost inevitably to CD-based magazines serving the interests of movie enthusiasts. World Wide Web experiments of this sort have already proved its viability – the *Pulp Fiction* site on the internet, for example, having been accessed 200,000 times by the end of 1994. CD-ROM is ideal for commercially exploiting that kind of interest and Californian company The Software Department (producers of the *Stargate* CD-ROM) have already trademarked a standard interface and structure (a 'chassis') called Movie-ROM into which BTS material on any film can be dropped.

Unsurprisingly, perhaps, Hollywood is showing some interest in whether movies themselves can be made in new ways to take advantage of CD-ROM's interactive flexibility, especially since CD-ROM titles can be readily converted to run on the latest generation of games machines as well. However, the latter are better suited to the creation of detailed 3D graphical environments, making interactive movies considerably less likely than video-enhanced games which merge graphics and live action (as in a handful of fairly successful games releases by Digital Pictures, one of the two production companies most committed to the concept).

Digital Pictures' main competitor, Rocket Science Games, nonetheless appears at first sight to be committed to the idea of interactive movie-making, especially given the fact that video games are now a bigger market than Hollywood films. If the latter can be made more like the former, perhaps a viable hybrid will result? The company has gathered under one roof an impressive team of Hollywood and Silicon Valley production experts. The basic idea is to run parallel video streams on a CD-ROM with regular 'branching point windows' through which a viewer can shift stream, taking the action off in a new direction. Current technology is bedevilled by 'click and wait', the frustrating delay of several seconds while the change of direction is effected. When the flow becomes smoother, as it inevitably will, there are those who believe that a new kind of moviemaking will have become possible. Bertelsmann and Sega have both invested in Rocket Science, convinced largely by the track record of its key figure Peter Barrett, a young Silicon Valley prodigy with a string of technical successes (mostly in video compression devices) to his credit. But in fact, while benefiting from the hype about interactive movies, Barrett is concentrating on 'adding value' to proven video game formats by treating them more like movies. What results is a rather movie-like video game, not an interactive movie in any sense that would justify the hype. Indeed the fairly standard-ized game formats are reflected in Rocket Science's 'Game Composer', like Movie-ROM a 'chassis' or standard structure into which games designers can drop their branching video sequences.[17]

As a linear or straight-playback medium for movies, CD has several obstacles to overcome. CD-ROM with multiple layers of interconnected material

in different media – i.e. as a 'multimedia' platform – is a technology doing what it is particularly good at. VideoCD is trying to emulate VHS, while interesting viewers in the extras it can deliver: no tape wear, perfect freeze frames, near-instantaneous rewind and fast forward. Production costs for a CD are also around a third those of a VHS cassette, so ultimately price could be a factor as well. However, these are all rather incidental matters. VHS wear does not seem to trouble people unduly and the uninterrupted, linear playback of a tape is still much more important than improved picture search facilities. VHS has also comfortably found its price level, for both rentals and sell-through. There are no obvious problems here that VideoCD can immediately address. 'Multimedia' CD-ROM of course remains a growing field, with rapidly developing applications to which filmmakers can contribute. Indeed, in many ways it would be sensible to confine our use of the term 'multimedia' to electronic publishing based primarily on CD-ROM applications and their online emulation, otherwise it becomes so vague as to be meaningless.

Much more interesting than inflated claims for VideoCD as a distribution medium for films is the fact that JVC, Sony, Matsushita, Philips, Samsung, Goldstar and 3DO (originators of a multi-purpose games console being backed by Panasonic), have recently agreed what they call the 'White Book' standard for VideoCD which, rather than following MPEG into digital broadcasting and online television, has opted instead for a sub-set of the MPEG standard giving maximum compatibility with games consoles and personal computers, leaving a system such as Philips CD-i sitting pretty, after a few fallow years, ready to reap sudden rewards. Just conceivably the White Book standard could be developed to the point where VideoCD took over in the laser disc movie niche (technically it has a long way to go), but that would only be a by-product of its success as a 'slightly interactive' playback medium for sixty minutes at a time of the sort of video material that is less narratively-driven than a feature film. In other words, VideoCD is the new platform for music video and will be stacked by youngsters along with their games and audio CDs beside the latest generation of multi-purpose consoles. Philip's new CD-i 450 and the 3DO console backed by Panasonic will compete for dominance in this, yet another niche of the digital future. About five hundred million dollars of research, development and marketing cash have been spent on each console to date (with others, like Sony's, trying to edge in as well). If successfully established, we will probably see more feature film based VideoCD releases in which the most memorable scenes can be endlessly replayed in any order – rather like music videos without much music. The motorbike scene from *Black Rain* (1989), the combat sequences from *Top Gun* (1986), the battles from *Street Fighter* (1995) or the *Mighty Morphin Power Rangers* movie (1995) – these are the sorts of sequence that can be repeatedly relished by predominantly young enthusiasts for whom the convenience of VideoCD in a multi-purpose console will have its own attractions. It will also boost interest in the movie-like games being planned by Rocket Science and others.

This completes the sketched outline of the digital future for TV and its offspring. The February 1995 issue of the glossy consumer magazine *Home Entertainment* ran an article on a man who had installed a £15,000 'home cinema' video system in his converted sixteenth century barn – perfectly evoking the socio-economic stratum within which HDTV is likely to develop as a pricey minority interest. Meanwhile, in most households the kids will be shoving their CDs into multi-purpose consoles to mix and match audio, music video, film and video game material. The rest of us will be watching digital TV that does not look much different from today's – unless widescreen is adopted as a production format and the Pal Plus experiment pays off, which it probably will. As transmitters go digital our reception will improve. But the main difference will be in the more flexible ways we can access and store video material, based in all probability on digital VHS and a wide range of near video-on-demand services (although it would not surprise me at all if the acronym POD, for programming-on-demand crept in somewhere along the way).

Understanding media convergence and divergence

If we look closely, then, at what is happening with each major domain of these new media technologies, a number of things become a good deal clearer than they are when disguised by generalizations about 'multimedia' or the 'information superhighway'. First, we see a divergence rather than the much touted convergence. The digital emerges as a distinct media domain, which will suck in a lot of content, but it impels specific technologies in a range of directions – as if they have come together through the initial stages of digitalization but then been repelled at the point of close contact between each other's opposing gravitational pulls. That is, of course, a highly abstract way of expressing something that should have a more concrete explanation. One explanation that fits the facts as detailed here is Brian Winston's in *Misunderstanding Media*. Winston proposes just such a process of attraction and dissipation when he says: 'Understanding the interaction of the positive effects of supervening necessity and the brake of the "law" of the suppression of radical potential is crucial to a proper overview of how media develop.'[18] His detailed history of media technologies up to the mid 1980s furnishes enough evidence of this interaction to be highly convincing.

'Supervening necessity' comes from the forces of change. Here, the supervening necessity is the coincidence of digitalization with post-industrial cultural and social changes that have been well documented elsewhere and which make the digitalization of media an inevitability (because deeply symptomatic of and embroiled with other, non-technical, changes).[19] The radical potential that is suppressed is nothing other than the creation of an 'information superhighway' of the kind briefly described at the beginning of this chapter – a symmetrical, many-to-many communication system

that would so disrupt established social relations, and a lot more besides, that it simply will not happen. The inflated bombast about a 'superhighway' that we get instead is in direct proportion to the extent to which it will not happen. As Winston's analysis of previous instances suggests, this is not a conspiracy to deprive us of something; rather it is the automatic way in which the complex systems which interconnect social relations and technology are self-regulating in order to maintain the maximum possible stability (apparently sudden changes are never as sudden as they look). This self-regulatory capacity is reducible to a myriad of small components, including markets that quiver when too much change threatens and industries that depend on selling us only slight variations on the same things. There is also our own lack of imagination about what is possible but also our often unpredictable responses and attachments to what is given, especially once it is thoroughly domesticated or consigned to the more footloose relations beyond the domestic. This is just to describe in very broad terms a cultural process within which all these things, necessity and suppression, self-regulatory relations and circumstances of use and attachment, form the context within which technological narratives construct themselves. This chapter has sought to interweave some fairly simple narratives of this kind, with an emphasis on the technological actors themselves.

The technologies that one gets emerge from a settling of narratives, a deeply cultural process rather than one reducible either to government policy in the communications sphere or to technological capabilities in the laboratory. In a sense, therefore, this chapter can be understood as only one way of telling a few of these narratives. A reasonably imaginative dénouement is consequently required.

So I want to end by imagining a near-future scenario based on the preceding discussion of the various technologies. HDTV is undoubtedly here, technically. TV 'filmmakers' will increasingly want to keep their options open by shooting in 1250-line, widescreen format, both with digital cameras and on super-16mm film transferred to digital media for postproduction. 35mm film production already is HDTV in effect. But the foregoing discussion impels one to suggest that a great deal of 'down conversion' will go on, which is good news for those filmmakers who cannot afford to contemplate full HDTV production costs. The bulk of broadcasting will remain at 625-lines. Advanced digital TV sets will be able to double the lines to recreate a pseudo-HDTV picture but their owners will rely on specialist sources to obtain the real thing – a small number of digital high-definition channels, terrestrial and satellite, and laser disc distributors.

Digital VHS, at its top end, will provide HD viewers with a convenient taping medium, but will also be the mass market workhorse for 625-line digital TV generally, while remaining compatible with analog formats. Digital TV will take a variety of forms, from Pal Plus widescreen broadcasting, which will quickly establish itself, to flexible N-VOD services provided by satellite and

wire via set-top boxes, the smartest of which will be capable of constructing a 'Me-TV' schedule for every viewer.

The kids, whose commercial importance can only increase, will have their multi-purpose CD consoles and portable TVs for games (including video-enhanced games), music videos, jog-and-play MPEG movies and multimedia CD-ROMs. The CD-ROM itself will continue to develop as an important electronic publishing medium, but is likely to remain part of a home computing set-up rather than being integrated with TV, and its formal features will increasingly be shared by World Wide Web publishing.

The domestic TV set will go gradually widescreen and there is likely to be increasing interest in flat, wall-mounted displays, but both developments will remain compatible with standard-definition 625-line sets (and hence the old 4x3 format) for the foreseeable future, severely restricting the scope for a wholesale mass movement towards HDTV. As a result, interest in the latter will veer towards new non-broadcast outlets, in addition to the specialized 'home cinema' niche. Chief among these will probably be the heritage industry, theme parks, museums, and so on, where poor quality large-screen 625-line audiovisual displays will soon be replaced by startling HDTV material, tailor-made for that particular context.

In the UK, the 'Digital Terrestrial Broadcasting' White Paper will have inaugurated a new system of ownership and regulation, based on the concept of the 'multiplex' owner who will provide a platform for bundles of digital programme channels by owning a single digital frequency data stream.[20] Broadcasters will have bought capacity from a multiplex owner (such as, undoubtedly, BT) and the Independent Television Commission will seek to ensure that each data stream carries an approved range of television services (according to criteria that have yet to be clarified), with some steps probably being taken to protect the public service ideal on given channels. Today's broadcasters, while buying capacity from a multiplex owner, will hang on to their analog frequencies until such time as viewers of analog TV have dwindled to relative insignificance (like viewers of black and white sets today).

Multiplex owners in the sphere of terrestrial broadcasting will have positioned themselves, in what is going to be a difficult and perhaps bloody process of carving up the marketplace, in relation to both digital satellite broadcasting (which means BSkyB and Murdoch in the UK) and rapidly expanding networked services, whether provided by cable TV or (more likely) BT. All these parties may simply go head to head over the same territory but a more reasonable scenario would see them realizing the inherent potential of digital media by constructing layers of different and flexible television services of various kinds within the data streams that will flow past viewers' homes. The increased choice for those viewers will partly be an increase in available content overall (though limited by the question of

who will pay for more content, as advertisers are unlikely to and subscription services have restricted appeal) but will be particularly characterized by increased flexibility in terms of how an individual pulls material in from the data stream and what form that material takes (making low-cost, high volume pay-per-view one answer to the question of how more content might be economically viable). Because it is not a straight-forward matter of more content, there are as many opportunities as threats in the new media ecology for programme and filmmakers who cannot simply ratchet up the volume of their output.

The ecosystem of media in Britain and Ireland is going to alter fundamentally but it will be a shift towards two things (if the narratives assembled here are to be believed): towards greatly increased flexibility of access by viewers and towards specific niches. All will clearly entail the sort of imbalance between distribution capacity and home-grown production capacity that Collins warned about when the British government tried to boost cable TV's fortunes a decade ago. But Collins predicted a simple increase in channels that would leave British and Irish producers stretched too thin. There would be a tidal wave of predominantly American material rushing in to fill up the empty spaces and, once flowing, that wave would not stop until it had forced everything else to be mere flotsam and jetsam.[21] That is not, however, what has been described here. Certainly HDTV will find it hard to resist the cheap availability of all that old 35mm US television material. But we are looking also at a combination of distinct niches, with highly flexible access mechanisms for viewers, which means that producers do not have to stretch themselves (their skills, talent, human resources, money, aspirations) too thinly to be successful.

They will colonize specific areas instead. Do they want, aesthetically as much as anything else, to make widescreen TV? Do they want to make CD-ROMs with original and archive filmed material, such as interactive, multi-layered, multimedia documentaries? Do they want to make minority interest material to be tucked away on a satellite somewhere for off-peak downloading to people's digital VCRs? Do they want to explore VideoCD by taking music videos in a more ambitious narrative direction, finding where the boundaries are in young people's tastes for the new, or by inventing new forms of short, episodic, intense films that can sustain endlessly re-sequenced viewing of their component parts? Do broadcasters, moving towards digitalization, want to explore innovative forms of scheduling based on near video-on-demand? Do they want to explore ways in which multiple video streams on a wired delivery system can offer viewers forms of engagement that have not yet been tapped by pedestrian notions of the interactive?

In general, if the hectoring tone can be forgiven, they have to stop making only the same tried and tested stuff while noticing in their peripheral vision that the technologies are changing. Otherwise their content will merely be repackaged and 're-purposed' by others in the long run, and the 'law' of the

suppression of potential will be re-applied within each of these technical domains. Finally, to generate on a large scale enough creative and worthwhile material in some or all of these domains may involve new alliances between education, training and the media industries in order to explore the new forms and aesthetics appropriate to each domain, alliances of a kind that have not properly emerged yet but which may be essential if tomorrow's producers are to be properly empowered.

References

1. Richard Collins, 'Broadband Black Death Cuts Queues: the Information Society and the UK', reprinted in R. Collins, *Television: Policy and Culture* (London: Unwin Hyman, 1990), pp.16-150.

2. ibid., p.119.

3. See, for example, the interview with Cochrane by Robin Hunt, 'Experience Required', *Wired*, May 1995, pp.72-76.

4. Krishan Kumar, *Prophecy and Progress* (London: Allen Lane, 1978).

5. Collins, 'Broadband Black Death', p.122.

6. ibid., p.128.

7. An excellent overview of what 'digital' means in terms of everyday communication, interaction and aesthetics is Nicholas Negroponte, *Being Digital* (London: Hodder & Stoughton, 1995).

8. *What Video*, September 1995, p.25.

9. *Interactive*, vol.1,no.1,1993, p.92.

10. For a technical explanation, see *Audio Visual* no.278 February 1995, pp.34-6.

11. As reported in *What Video*, June 1995, p.123.

12. *Independent on Sunday*, 30 January, 1994.

13. *The Independent*, 29 November, 1994.

14. See, for example, Evan I. Schwartz, 'Fran On Demand', *Wired*, September 1994, pp.60-62. Fran was a woman who pretended to be a computer answering customers' requests for online movies in Colorado, in a trial run by Telecommunications Inc., AT&T and US West.

15. *New Media Markets*, 5 May 1994, p.11.

16. The author was a Visiting Research Fellow at BT Labs, Martlesham Heath, during 1994 and worked there for two months on audience research issues related to the first video-on-demand trial. Much of the general technical information for this chapter was obtained from BT material in the library at the Laboratory.

17. See Burr Snider, 'Rocket Science', *Wired*, November, 1994, pp.108-112, 159-162.

18. Brian Winston, *Misunderstanding Media* (London: Routledge and Kegan Paul, 1986).

19. See especially, Margaret A Rose, *The Postmodern and the Post-Industrial* (Cambridge: Cambridge University Press, 1991).

20. *Digital Terrestrial Broadcasting: the Government's Proposals* (London: HMSO, 1995) Cm 2946. See also, *Broadcast*, 11 August 1995, p.1.

21. The precise processes by which this occurs have already been clearly analysed; see Janet Wasko, *Hollywood in the Information Age* (Cambridge: Polity Press, 1994).

Notes on Contributors

John Hill is senior lecturer in media studies at the University of Ulster. His publications include *Sex, Class and Realism: British Cinema* 1956-63 (1986), *Cinema and Ireland* (1988) (Co-author) and *Border Crossing: Film in Europe, Britain and Ireland*(1994) (Co-ed.).

Martin McLoone is senior lecturer in media studies at the University of Ulster. His publications include *Television and Irish Society* (1984) (Co-ed.), *Culture, Identity and Broadcasting in Ireland* (1991)(Ed.), and *Border Crossing: Film in Europe, Britain and Ireland* (1994) (Co-ed.).

Peter Kramer is lecturer in American film at Keele University and has published in *Screen*, the *Velvet Light Trap* and various collections.

Charles Barr is senior lecturer in film studies at the University of East Anglia. His publications include *Ealing Studios* (rev. ed. 1993) and *All Our Yesterdays* (1986)(Ed.). He also co-scripted (with Stephen Frears) the television documentary *Typically British* (1995).

John Ellis is an independent producer whose credits include the television programme on film, *Visions*. His publications include *Language and Materialism* (1977) (Co-author) and *Visible Fictions* (rev. ed.1992).

Rod Stoneman is Chief Executive of Bord Scannán na hÉireann/Irish Film Board. He was formerly Deputy Commissioning Editor in the Independent Film and Video Department at Channel Four.

Paul Kerr is series editor of the BBC's *Moving Pictures*. His publications include *MTM:Quality Television*(1984) (Co-ed.) and *The Hollywood Film Industry* (1986) (Ed.).

Michael Grade is Chief Executive of Channel Four. He was formerly Head of Entertainment and Director of Programmes at London Weekend Television and Director of Programmes, Television, at the BBC.

David Aukin is Head of Drama at Channel Four. He was formerly Executive Director at the National Theatre.

Mark Shivas is Head of Films at the BBC and has a long history of producing films for both the BBC and Channel Four.

Andrea Calderwood is Head of Drama at BBC Scotland. Before her appointment in January 1994, she was an independent producer in Scotland producing drama and documentary.

Dave Berry is a freelance writer and film critic. He wrote and devised the HTV film history series *The Dream That Kicks* (1986) is the author of *Wales and Cinema* (1994).

Robert Cooper is Head of Drama, BBC Northern Ireland.

Ed Guiney is an independent film producer. His productions include *3 Joes* (1991), *Ailsa* (1994) and *Guiltrip* (1995).

John Caughie is senior lecturer in film and television studies at the University of Glasgow. He is an editor of *Screen* and his publications include *Television: Ideology and Exchange* (1979) (Ed.) and *Theories of Authorship* (1981) (Ed.).

Sarah Edge is lecturer in media studies at the University of Ulster and has published on feminism, film and photography.

Verity Lambert is an independent producer with extensive experience in both television and film. Her credits include *Budgie*, *Minder*, *Widows* and *A Cry in the Dark.*

Dan Fleming is lecturer in media Studies at the University of Ulster. His publications include *Media Teaching* (1993) and *Powerplay: Toys as Popular Culture* (1996).

Stills Index